Game Feel

Morgan Kaufmann Game Design Books

Better Game Characters by Design (9781558609211)
Katherine Isbister

Game Design Workshop, Second Edition (9780240809748)
Tracy Fullerton

The Art of Game Design (9780123694966)
Jesse Schell

Game Usability (9780123744470)
Katherine Isbister & Noah Schaffer (Eds.)

Game Feel (9780123743282)
Steve Swink

Game Feel

A Game Designer's Guide to Virtual Sensation

Steve Swink

AMSTERDAM • BOSTON • HEIDELBERG • LONDON
NEW YORK • OXFORD • PARIS • SAN DIEGO
SAN FRANCISCO • SINGAPORE • SYDNEY • TOKYO

Morgan Kaufmann Publishers is an imprint of Elsevier

MORGAN KAUFMANN PUBLISHERS

Morgan Kaufmann Publishers is an imprint of Elsevier.
30 Corporate Drive, Suite 400, Burlington, MA 01803, USA

This book is printed on acid-free paper.

Library of Congress Cataloging-in-Publication Data
Swink, Steve.
 Game feel: a game designer's guide to virtual sensation/Steve Swink.
 p. cm.
 Includes index.
 ISBN 978-0-12-374328-2 (pbk. : alk. paper) 1. Computer games—Programming. 2. Computer games—Design. 3. Human-computer interaction.
I. Title.
QA76.9.H85S935 2009
794.8'1526—dc22 2008035742

ISBN: 978-0-12-374328-2

For information on all Morgan Kaufmann publications,
visit our Web site at www.mkp.com or www.books.elsevier.com

Printed in the United States of America

Transferred to Digital Printing, 2010

Dedication

For people who struggle and make beautiful things

TABLE OF CONTENTS

ACKNOWLEDGMENTS

I would like to thank the following people.

Mom & Dad, for their unwavering support of everything I do, ever. It must be exhausting. Special thanks to Dad for taking on the role of second editor, donating hours and hours to proofreading, editing, writing first-pass chapter summaries and helping me wrangle ideas. I love you guys. Thank you so much for being who you are. It gives me a standard to aspire to.

Amy Wegner, for unflinching honesty in editing and for putting up with me throughout the months of craziness. Guess it's my turn to do the laundry, bake cookies, do the dishes, take out the dog. Thank you for everything.

Beth Millett, for being a kickass editor and for being the other person who had to put up with my craziness.

Matthew Wegner, for help with the Raptor Safari, for many inspiring ideas about game feel, and for being the stable foundation of Flashbang. You make everyone around you better, smarter, faster and happier. We appreciate it, even if we don't tell you so as much as we should.

Mick West, for inspiring me to think about game feel at a deeper level. It was his article "Pushing Buttons" for *Game Developer* magazine that convinced me this would be a subject worth writing an entire book about, and he has graciously offered me feedback and guidance when I asked for it. He is the true master of game feel. If you're looking for someone to make your game feel better than anyone else can, ask him. I doubt he'll say yes, but there it is.

Allan Blomquist, for building pixel-perfect clones of old games and helping me understand how they work. Without Allan, the book would be much shorter.

Derek Daniels, for the brilliant insights about the role of animation in game feel and the importance of hard metrics for game feel. I hope you write a book someday.

Shawn White, for helping me with technical details about platformer games. You truly are the Captain of Rats.

Matt Mechtley, for additional help with technical stuff and for the fantastic attitude. I hope you someday meet and woo fast women. It must be plural.

Adam Mechley, for proofreading and helping me to achieve syntactic perfection.

Kyle Gabler, for being brilliant and inspiring, and for helping me understand the importance of sound and its role in game feel. I hope I can someday be half as good a game designer as you are.

Ben Ruiz, for making me laugh and smile always. You provide a constant reminder why we do what we do.

Jon Blow, for inspiring everyone to make better games and for teaching me about proxied embodiment.

Kellee Santiago and Jenova Chen, for making beautiful things and for taking the time to talk to me about how.

Chaim Gingold, for making brilliant things and for taking the time to talk to me about how.

Katherine Isbister, for the encouragement and opportunity to write a book.

Steve Swink is an independent game developer, author and lecturer currently based in Tempe, Arizona. As a game designer and partner at Flashbang Studios, he's contributed to games such as Off-Road Velociraptor Safari, Splume, Jetpack Brontosaurus, and Minotaur China Shop. Before joining Flashbang, he toiled in the retail game mines at Neversoft and the now-defunct Tremor Entertainment. He also co-chairs the Independent Games Festival, is an IGDA Phoenix chapter coordinator, and teaches the game and level design classes at the Art Institute of Phoenix. He sometimes forgets the importance of sleeping every night, not just some.

Close your eyes for a few seconds and imagine yourself playing Super Mario Brothers.

What did you imagine? The visuals? The colors? The iconic sounds of coin collecting and the Mario theme music? How about the *sensation* of moving Mario left and right, of jumping, colliding with blocks, stomping Goombas? What does it *feel* like to control Mario? Go watch someone unfamiliar with games—your mom, perhaps—try to play a game like *Rad Racer*. If it's a game which requires real-time control, she'll be leaning left and right in her chair, pulling the controller, trying to get the car to move just a bit farther, a bit faster. Ever seen someone do this? Done it yourself? This feeling of steering—this tactile, visceral sensation—is game feel.

For the purposes of this book, "feel" is meant in a very specific sense relevant to the experience of playing video games. Feel is not meant in the thematic sense (a Western feel, a Baroque feel) or in the expressive, emotional or physical sense (I feel sad, I feel pain, this place feels creepy). Specifically, game feel is the tactile, kinesthetic sense of manipulating a virtual object. It's the sensation of control in a game.

In digital game design, feel is the elephant in the room. Players know it. Designers know *of* it. Nobody talks about it, and everybody takes it for granted. It's not hard to understand why; if a game designer's done his or her job correctly, the player will never notice the feel of a game. It will just seem right. In this sense, game feel is an "invisible art," like cinematography. Feel is the most overlooked aspect of game creation; a powerful, gripping, tactile sensation that exists somewhere in the space between player and game. It is a kind of "virtual sensation," a blending of the visual, aural and tactile. In short, it is one of the most powerful properties of human-computer interaction.

Recently, I had the opportunity to play Spacewar!, the world's first video game[1] at the "Game On!" exhibit at the Tech Museum, in San Jose, California. What struck me is just how compelling the game still is. It's easy to imagine the breathless enthusiasm of the young technicians crowding around their PDP-1 supercomputer, exhausting hours of valuable computing time on endless rounds of Steve Russell's creation. Even today, as a product of a video game culture, having played hundreds of games, it feels great to me to steer the little rockets, fire off missiles and avoid black holes. Game feel has been with us since the beginning.

[1] William Higinbotham's Tennis (1958) is also a contender, but Spacewar! was the first to have something approximating modern game structure—rounds, scoring and so on.

It may be easy to bring to mind, but game feel is difficult to understand. Games are a nascent and complex medium, one which incorporates many previous forms. A single game might include painting, music, cinematography, writing and animation.

If that weren't enough, video games represent an unprecedented collaboration between creator and consumer. We abdicate authorial control to our players and get … something. We're not quite sure what yet, but we know that it has potential. To many, interactivity seems to be the most important medium of the 21st century.

It's surprising, then, that the luminaries of digital game design have devoted little ink to the phenomenon of feel. In Rollings and Morris, any mention of feel is conspicuously absent. Salen and Zimmerman dance tantalizingly close to discussing feel, but take a more holistic approach, focusing on game state at the higher intervals where scoring and more traditional strategic considerations occur. Chris Crawford's revered work, *The Art of Computer Game Design,* devotes only a sentence to game feel, saying "The input structure is the player's tactile contact with the game; people attach deep significance to touch, so touch must be a rewarding experience for them."

With due respect to these authors and all the great stuff they have taught us, what's missing is an appreciation of just how unique and beautiful an aesthetic game feel truly is. It exists outside of video games—driving cars, riding bikes and so on—but nowhere is it so refined, pure and malleable.

In addition, game feel is moment-to-moment interaction. If we examine the functional underpinnings of most video games, there is usually game feel at the most basic level. It has greater importance in certain games but it's always there. As a percentage of activities in the game, it's what you spend most of your time experiencing. If you break down all the activities of a game, it's the biggest slice of the pie.

This book is about examining feel in greater detail. Where does it come from? How is it created? Does it exist in the computer, the player's mind or somewhere in between? What are the different kinds of feel and why do they feel the way they do? In a clear, non-technical style intended to be accessible to professionals, players and aspiring designers alike, we will investigate feel as experienced by players, created by designers and measured by psychologists. The goal is to create a comprehensive guide to game feel: deconstructing it, classifying it, measuring it and creating it. By book's end you will have the tools to measure, master and create exemplary game feel.

About This Book

This book is about how to make good-feeling games. In many ways, it's the book I wanted when I first started designing games. So many creative ideas rely on a foundation of good-feeling controls. It should be a given that we can always create controls that feel good. We shouldn't have to start from scratch every time.

This book constructs a foundation of understanding and then builds on it, addressing at each step a particular gap in the knowledge base about game design. Figure I.1 shows the structure and flow of the book's topics.

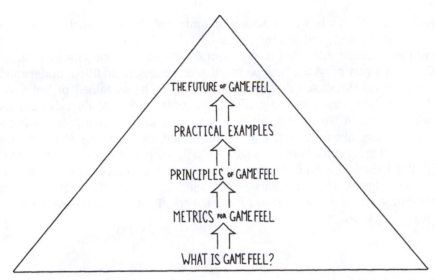

FIGURE I.1 **The structure and flow of the book.**

www.game-feel.com

To get the most out of reading Game Feel, I recommend going to www.game-feel.com, the companion website to this book. For many of the chapters, I've provided playable examples that will allow you to experience first-hand the ideas being discussed. In addition, the website contains interviews on the subject of game feel with folks like Kellee Santiago and Jenova Chen of thatgamecompany, Kyle Gabler of 2dBoy, and Johnathan Blow and Chaim Gingold of Number-None and Maxis, respectively.

If you're a student, the definition at the beginning will be interesting and relevant, but the real meat will be the examples. In the examples you can see all the tiny decisions and particulars of implementation that go into making games feel the way they do. This is the palette of game feel; if you want to make good-feeling games, these are the details you need to understand.

If you're a game designer, the definition stuff will not be news to you. But some of the theory bits may be useful and applicable, if only to better understand the deeper physiological phenomena. The examples will be useful because of the legwork I've already done—you can reverse engineer games yourself, probably, but it takes a lot of time. The principles of game feel may also be a useful way to think about building games. It's one way, at any rate, to which you can compare your own methods.[2]

If you're an educator, the theory and definition pieces form a solid basis for understanding game feel at a conceptual level. In addition, the examples provide a great way to illustrate the complexities of making good-feeling games without forcing students to program the games themselves from scratch. The most useful part,

[2]Which, by the way, I'd love to hear about. Email me at sswink@flashbangstudios.com.

however, will probably be the principles of game feel chapter, which lays out some guidelines for creating good-feeling games.

If you're someone interested in the medium of games, such as a journalist, the definition parts may provide a new perspective on genres. In addition, understanding the physiological thresholds that cause game feel to be sustained or break down may help explain why frame rate drops and other technical disturbances make games feel so much worse. But my hope is that in understanding and being able to measure things like frame rate and response time, you will be able to do a better job of separating medium from message. Yes, a developer is to blame if a game runs poorly. But I think this consideration is given too superlative an emphasis when games are critiqued. The experience of playing a game may still have some things to offer from a critical standpoint—as Jurassic Park: Trespasser did—even if they are technically incompetent.

What Is Game Feel?

One obstacle to understanding game feel at a deeper level is definition. This section offers a simple three-part definition of game feel based on the ways players experience it and game designers design it.

Each of the three parts of the definition is expanded to make it useful for classifying games as well as understanding what game feel is. Expanding the definition requires an exploration of some of the ways people perceive things, including measures for frame rate, response time and other conditions necessary for game feel to occur. These physiological thresholds and concepts of perception combine to form the "game feel model for interactivity"—a complete picture of the ongoing process of game feel.

The section ends by applying the definition to some games specifically chosen because they are on the fringes of game feel.

Metrics for Game Feel

Another problem facing game designers is meaningful comparison. How does the feel of Halo compare to the feel of Ikaruga? From a designer's perspective, this is tied to tuning. Why is one game "floaty" while another is "tight and responsive"? If a player tells me that my game is floaty, what should I do? How should I change the variables of my complex system? Is floaty bad? Is it good? What does it mean?

This section is about measuring the pieces of the game feel process that a designer can change. By measuring each piece—input, response, context, polish, metaphor and rules—we can make generalizations about what terms like floaty, tight, smooth, responsive and loose mean. Not only in a particular game, but across different games. Once we can measure game feel, we can master it.

Practical Examples

The metrics we developed in Section II are applied to specific games, providing comprehensive analysis of how the feel of these games function and providing a template for creating games with similar feel. This section will give you clear, practical steps for creating a game that feels a particular way. In addition, I have constructed playable and editable examples for each game (find them at www. game-feel.com) so you can follow along and experience how the feel of each game changes and grows.

Principles of Game Feel

What principles, if followed, will make all games feel better? This section generalizes the lessons of the good-feeling examples and measurable pieces of game feel into a set of best practices for game feel.

The Future of Game Feel

This section uses the lessons and definitions of the previous chapters to examine the input devices, rendering technology and thought problems that will define how game feel will be used in the future. With deep, expressive interactivity, can we provide experiences which don't require the backdrop of skill and challenge? Is it possible to express things spatially without competition? Could game feel be a form of deeply personal expression like dance or martial arts?

CHAPTER ONE

Defining Game Feel

There is no standard definition of game feel. As players and game designers, we have some beginnings of common language, but we have never collectively defined game feel above what's necessary for discussing a specific game. We can talk about the feel of a game as being "floaty" or "responsive" or "loose," and these descriptions may even have meaning across games, as in "We need to make our game feel more responsive, like Asteroids." But if I ask 10 working game designers what game feel is—as I did in preparation for writing this book—I get 10 different answers. And here's the thing: each of these answers is correct. Each answer describes a different facet, a different area, which is crucial to game feel.

To many designers, game feel is about intuitive controls. A good-feeling game is one that lets players do what they want when they want, without having to think too much about it. Good game feel is about making a game easy to learn but difficult to master. The enjoyment is in the learning, in the perfect balance between player skill and the challenge presented. Feelings of mastery bring their own intrinsic rewards.

Another camp focuses on physical interactions with virtual objects. It's all about timing, about making players really feel the impact, about the number of frames each move takes, or about how polished the interactions are.

Other designers insist that game feel is all about making the players feel as though they're really there, as though they're in the game. All their efforts go into creating a feel that seems more "realistic" to players, which somehow increases this sense of immersion, a term that is also loosely defined.

Finally, to some designers, game feel is all about appeal. It's all about layering on effect after careful effect, polishing every interaction—no matter how trivial—until interacting with the game has a foundation of aesthetic pleasure.

The problem is unity. How do these experiences become a cohesive whole? They all tell us something about game feel, but they do not help us define it. St. Augustine's comment about defining time comes to mind: "What then is time? If no one asks me, I know what it is. If I wish to explain it to him who asks, I do not know."

Game feel is the same way. Without close examination, we know what it is. Try to define it and the explanation quickly unravels into best practices and personal experiences.

This book is about how to make good-feeling games. But first we need to be clear about what game feel is. We need to separate medium from content. We need a definition that enables us to separate the conditions that are necessary for game feel from the judgments that make a game feel a certain way.

What is the underlying phenomenon, apart from our own experiences and the craft knowledge of building games? What are the building blocks? Just what is game feel?

The Three Building Blocks of Game Feel

Game feel, as experienced by players, is built from three parts: real-time control, simulated space and polish.

Real-Time Control

Real-time control is a specific form of interactivity. Like all interactivity, it includes at least two participants—in this case the computer and the user—who come together to form a closed loop, as illustrated in Figure 1.1, the concept couldn't be simpler.

The user has some intent, which is expressed to the computer in the form of the user's input. The computer reconciles this input with its own internal model and outputs the results. The user then perceives the changes, thinks about how they compare to the original intent, and formulates a new action, which is expressed to the computer through another input.

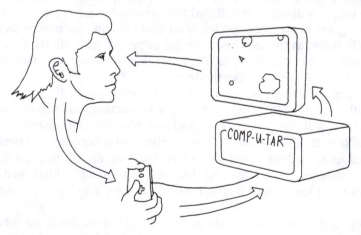

FIGURE **1.1 Interactivity involves the exchange of information and action between at least two participants.**

In his book, *Chris Crawford on Game Design*, game designer Chris Crawford likens this process to a conversation, a "cyclic process in which two active agents alternately (and metaphorically) listen, think and speak."

The conversation in Figure 1.2 begins when one participant, Bob, speaks. The other participant, Bill, listens to what was said, thinks about it, formulates a response and speaks in return. Now it's Bob's turn to listen, think and speak, and so on. In Crawford's model, a computer replaces one of the participants, "listening" to the player's input via the input device, thinking by processing that input and changing system state and "speaking" via the screen and speakers (Figure 1.3).

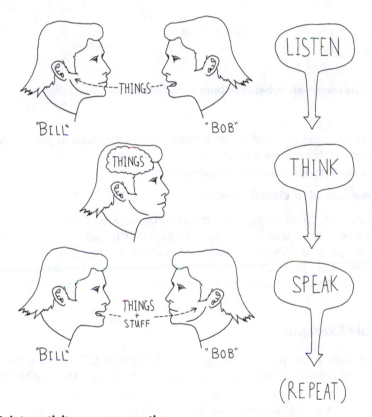

FIGURE **1.2 Interactivity as a conversation.**

However, the metaphor of a conversation between human and computer doesn't fit all situations. Real-time control is not like a conversation. It's more like driving a car. If a driver wants to turn left, it's more action than thought. He turns the wheel in the corresponding direction, using what he sees, hears and feels to make small corrections until the turn is complete. The process is nearly instantaneous. The "conversation" takes place in minute increments, below the level of consciousness, in an uninterrupted flow of command. The result of input feels as though it is

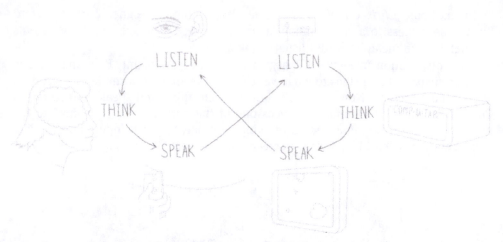

FIGURE **1.3 The conversation between human and computer.**

perceived in the same moment it's expressed. This is the basis of game feel: precise, continuous control over a moving avatar.

This is a starting point for our definition of game feel:

Real-time control of virtual objects.

The problem with this definition is context. Imagine a ball suspended in a field of blank whiteness. How would you be able to tell if it were moving? Without the backdrop of space to move through, there can be no motion. More importantly, there can be no physical interaction between objects. For the sense of interacting physically with the game world, there needs to be some kind of simulated space.

Playable Example

If you're near a computer, open game feel example CH01-1 to experience the necessity of context. This is a first-person shooter game. Use the WASD keys to move around and the mouse to aim. Can you feel the motion? No? Now press the "1" key. With a simulated space, there is feel.

Simulated Space

Simulated space refers to simulated physical interactions in virtual space, perceived actively by the player. This means collision detection and response between a real-time controlled avatar and objects in a game world. It also means level design—the construction and spacing of objects relative to the speed of the avatar's movements. These interactions give meaning to the motion of an avatar by providing objects

to move around and between, to bump into, and to use as a frame of reference for the impression of speed. This gives us the tactile, physical sense of interacting with virtual environments the same way we interact with our everyday physical spaces. Using the avatar as a channel for expression *and* perception, we experience game worlds at the tactile, physical level of the world around us.

Playable Example

Open example CH01-2 to experience the difference. Move around and feel the sensation of control. Now press the "1" key to enable collisions. Feel how different that is?

The other necessary component for simulated space is that it must be actively perceived. Perception happens on a scale of passive to active. The interaction of objects you see on TV and in films is passively perceived. Exploring a simulated space using real-time control is active perception. Game feel is active perception.

The key question is "How does the player interact with the space?" Some games have detailed collision/response systems and level design, but the player does not experience them directly. Starcraft is an example of a game like this, as we'll see in a moment. In other games, space is an abstraction. Games with grids, tiles and hexagonal movement use space abstractly. This is not a simulation of space in the literal sense, which is the sense we're after. Game feel as we're defining it means active perception of literal space.

If we add the concept of context to our definition, it becomes:

Real-time control of virtual objects in simulated space.

This definition is close, but with it we are ignoring the impact of animations, sounds, particles and camera shake. Without these "polish" effects, much of the feel of a game is missing. There are objects interacting with only simulated responses giving clues about whether they're heavy, light, soft, sticky, metallic, rubber and so on. Polish sells interaction by providing these clues.

Polish

Polish refers to any effect that artificially enhances interaction without changing the underlying simulation. This could mean dust particles at a character's feet as it slides, a crashing sound when two cars collide, a "camera shake" to emphasize a weighty impact, or a keyframed animation that makes a character seem to squash and stretch as it moves. Polish effects add appeal and emphasize the physical nature of interactions, helping designers sell those objects to the player as real. This is separate from interactions such as collisions, which feed back into the underlying

FIGURE **1.4 Street Fighter II without animation: just weird fighting boxes.**

simulation. For example, if you take away the animations from Street Fighter II, you end up with something like Figure 1.4.

If all polish were removed, the essential functionality of the game would be unaltered, but the player would find the experience less perceptually convincing and therefore less appealing. This is because—for players—simulation and polish are indistinguishable. Feel can be just as strongly influenced by polish effects as by a collision system. For example, a simple squash and stretch animation layered on top of a moving avatar can radically change the feel of a game, as the creators of the popular student game De Blob discovered. A post from Joost Van Dongen reported that "When the ball bounces or moves very fast, it slightly deforms, and while rolling it slightly sags. On screenshots this is quite a subtle effect, but when seen in action, it really looks fun. An interesting detail is that it changes the feel of the gameplay entirely. Without the squash-shader, the game feels like playing with a ball made of stone. Then with no changes to the physics at all, the squash-shader makes it feel much more like a ball of paint. Nice to see how the player can be deceived about gameplay using graphics only"[1] (see Figure 1.5).

Assembling these three elements—real-time control, simulated space and polish—into a single experience, we arrive at a basic, workable definition of game feel:

Real-time control of virtual objects in a simulated space, with interactions emphasized by polish.

The player controls the avatar, the avatar interacts with the game environment and polish effects emphasize those interactions and provide additional appeal.

Examples

The question that naturally follows is "Does game X have game feel?" With our basic definition, we can classify most games this way. For example, Sonic the Hedgehog has game feel while Civilization 4 does not. Sonic has real-time control while Civ 4 is turn based, placing it outside our definition. But to say that Civ 4 has

[1]http://www.gamedev.net/community/forums/topic.asp?topic_id=401276

no feel whatsoever seems wrong. It has polish effects—animations, sounds and particles—and these alter the feel of interacting with the game, especially when things are clicked and when armies clash.

What this indicates is that there are different types of game feel (Figure 1.6).

FIGURE **1.5 Squash and Stretch in De Blob.**

1. In the center, where all three intersect, is true game feel. Games like Half-Life, Sonic the Hedgehog and Super Mario 64 reside here. These games have all the components of game feel as we've defined it. This type of game feel is the topic of this book.

2. This is raw game feel. Even without polish effects, the simulation of collisions gives the experience of physical interaction between objects. But much of the appeal and sense of physical interaction is lost. Games are almost never released without polish effects, but you can play example CH01-3 to get a sense of what this feels like (press the "2" key once you've opened the game).

3. This is pure aesthetic sensation of control. There is polished real-time control, but no substance to the interactions. This feels weird. With sounds and particles

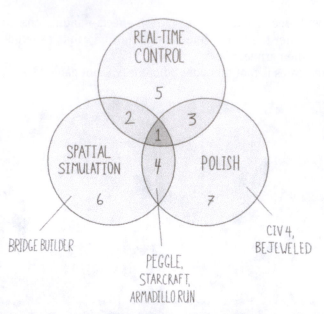

FIGURE **1.6 The intersection of the building blocks creates a wide range of levels of game feel.**

but no simulated interaction, it's like seeing behind the curtain. There's a disso-
nance for the player. The particle effects and sounds convey some impression of
a physical reality, but there's a mismatch between the motion of the object and
the polish clues. Without simulation, it's difficult to create a sensation of physi-
cal interaction. There are rarely games that have this combination of real-time
control and polish, but which exclude spatial simulation. (To experience this,
press the "3"key in example CH01-3.)

4. This is physical simulation used for vicarious sensation and to drive gameplay.
Games like Peggle, Globulos and Armadillo Run use simulation this way. In
these games, there's a detailed physical simulation driving interactions between
objects but the resulting sensations are perceived passively because the player
has no real-time control. In the same way, polish effects like sounds and par-
ticles may serve to emphasize the interactions between objects or make them
more appealing, but these sensations are perceived passively, as they would be
in a film or cartoon. (Press the "4" key to experience this in example CH01-3.)

5. This is naked real-time control, without polish or simulated space. Again, I can't
think of an example of a game that uses only real-time control without any kind
of polish or simulation effects. (To experience this you can press the "5" key in
example CH01-3. It's interesting to noodle around, but the motion doesn't have
a lot of meaning or appeal without simulation and polish.)

6. This is naked spatial simulation. The best example of this I'm aware of is the
freeware game Bridge Builder. There is a physical simulation driving the motion
of the objects, but is perceived passively.

7. Finally, there is naked polish. Games like Civilization 4 and Bejeweled use polish effects this way, without real-time control or spatial simulation.[2] In these games, polish effects sell the nature of the interactions, giving objects a weight, presence, volume and so on, but these perceptions are indirect.

Now let's apply. Where does, say, Starcraft sit on the diagram?

At first glance, Starcraft appears to have real-time control. You can click at any time to specify new orders for your units. While moving units, you can update their destination as quickly as you can spam clicks onto the screen. But control over the units is not an uninterrupted flow from player to game. Each click is a momentary impulse of control that ends as quickly as it starts. You set the destination but don't guide the journey. This is not quite real-time control in the sense we're after.

There also appears to be a simulated space Starcraft. Units can run into cliffs, structures and rocks. But precisely those things that would lend a physical, tactile sensation—steering around objects, aiming and choosing when to fire—are handled by the computer. This is a simulated space with collisions and interactions, but perceived indirectly by the player.

The one thing Starcraft has in abundance is polish. The units have detailed animations, sounds and particles that sell their interaction with the game world and each other. The feel of Starcraft comes from these polish effects, and it is solid. Zerglings scamper, Marines trudge and everything explodes spectacularly when destroyed. This puts Starcraft on the Venn diagram in 4, the intersection of spatial simulation and polish.

This is not true game feel. The control of units is not real time, and the player cannot interact with the simulated space directly. Because it has only one of the three criteria, Starcraft falls outside our definition for game feel. Okay, okay. Breathe. Be calm.

Before you get your Zerglings in a bunch, remember that definition is not value judgment. We're defining the medium of game feel, not saying anything about good or bad game feel or about whether a game is good or bad generally. The animations, sounds and particle effects in Starcraft are excellent, and as a game it's unrivaled in terms of balance and system design.

For the purposes of this book, "game feel" means true game feel, the point at the center of our diagram. That is, games that includes real-time control, spatial simulation and polish. This book is about creating good-feeling games of that particular type. The other kinds of feel are important, but we have to draw the line somewhere.

But what about a game like Diablo? This is where our definition gets a little murky. Does Diablo have real-time control or not? It seems real time, but the interface is lots of clicking. What's the threshold for real-time control? And what about simulated space? The character in Diablo walks around and bumps into things, but is this actively perceived by the player? Does it feel like navigating an everyday

[2]Actually, both of these games make use of a mouse cursor, which is a form of real-time control. In these cases, though, the cursor is intended to be a transparent interface to the interesting choices in the game. The usage is more like using Web page than playing Cursor Attack.

physical space? We'll delve deeper into real-time control and simulated space in Chapter 2 to answer these questions.

So what can we do with this definition and the three building blocks of game feel? To answer that question, let's now shift focus back to content, to expression and to the *experience* of game feel itself. Specifically, let's go through some of the different experiences of game feel and examine how game designers can craft them using real-time control, simulated space and polish.

Experiences of Game Feel

Game feel is comprised of many different experiences. For example, the simple pleasure of control, feelings of mastery and clumsiness, and the tactile sensation of interacting with virtual objects might all happen within a few seconds of picking up the controller. What we call game feel is the sum of all these experiences blended together, coming to the surface at different times. To understand game feel we need to understand the different experiences that comprise it; what they are, how they are crafted and how they interrelate.

The five most common experiences of game feel are:

- The aesthetic sensation of control
- The pleasure of learning, practicing and mastering a skill
- Extension of the senses
- Extension of identity
- Interaction with a unique physical reality within the game

The Aesthetic Sensation of Control

When I was young, playing Frogger and Rastan on my dad's Commodore 64, game feel was a toy. It was the delightful sense of puppetry I got when I controlled something in a game. But it felt like the game was controlling me, too. I'd start leaning left and right in my chair, trying to move just a bit faster or more accurately. I'd pull my head a little to one side to try to see around something on the screen. Most of all, it just felt great to see something on a screen move and react to my button presses. I wasn't coordinated enough to really engage with the challenge of the game, but there was a pure, aesthetic beauty to control. I loved this sensation and played with it for hours. This was the experience of game feel as an aesthetic sensation of control.

The Pleasure of Learning, Practicing and Mastering a Skill

A few years later, when I played Super Mario Brothers for the first time, I was super-inept. I was playing with friends from down the block who were older and more coordinated and could afford their own Nintendo. My turn was short, blustering and red-faced.

However, before I had to hand off the controller, I had the sense that even the smallest motion could produce a long chain of interesting events and feel intensely rewarding. Smash a block with your head and it jiggles and makes a silly little noise. Hit an attractive, flashing question block in the same way and a coin pops out, accompanied by a shower of sound and animation. All of this rich, low-level interaction served to cushion the fact that, at first, the game was very challenging for a nine-year-old. It was OK to suck because it was fun just to noodle around and bump into things.

There even seemed to be different skills, the same way you practice dribbling, kicking and heading in soccer. For example, I had to learn to time my jumps, holding down the button for the right amount time, and to feather my presses of the d-pad to control speed. Combining small, incremental improvements in these areas, I started to get better and better, reaching higher levels of the game. Three weeks later, when Bowser tumbled bug-eyed into the lava, I felt a powerful sense of accomplishment, like scoring the tie-breaking goal. I'd been playing soccer for two years, but this game gave me the same feeling of pride in just three weeks. In one neatly wrapped package, there were skills to master, rewards at every level and a hyper-accelerated ramp of increasing challenges upon which to test those skills. Even better, I didn't have to stop practicing because I was tired or because it was dark outside. This was the experience of game feel as a skill.

Extension of the Senses

I grew up a bit and learned how to drive a car. This learning was very similar to mastering the controls of a new game, but it seemed to take longer, to be less fun and to lack built-in milestones against which I could measure my progress. After a while, I began to develop a sense of how far the car extended around me in each direction. I could gauge how close I could drive to other cars and whether or not my car would fit into the parking space in front of Galactican.[3] To do this, I relied on a weird sort of intuition about how far the car extended around me, which made the car feel like a large, clumsy appendage. This was also like playing a game in a funny way. When I drove the car, as when I played Bionic Commando, I had a sense that thing I was controlling was an extension of my body. This was the experience of game feel as an extension of the senses.

Extension of Identity

After a memorable incident involving my parents' Volvo I realized that this sensation could flow in both directions. Late for class, I leapt in the car, threw it in reverse and slammed the gas, turning as I did. Scraaaaaape! I cringed, flinched and swore viciously. I pulled my hands off the steering wheel as though it were scalding hot. I had just smeared the car's side against a concrete pole. I still remember

[3]A now defunct but once totally sweet arcade in Cupertino, Calif. You got eight tokens on the dollar, all the games were two tokens or less to play, and they had four-player air hockey.

the feeling as the car ground to a halt. It was as though I'd stubbed my toe in a big, expensive, metal-rending way. Interestingly, I didn't think "Oh, darn, the car in which I'm sitting has come into contact with a concrete pole." I thought "Oh, crabapple, I hit a pole!" In that moment, when car hit pole, the car was part of my identity, both physically and conceptually. Then I thought of my parents' reaction, and I was quickly snapped back to thinking of car and self as separate. One of us was in big trouble, and it wasn't the Volvo.

Around this same time, I was playing Super Mario 64. It occurred to me after pole-ing the car that a similar process happened as I controlled Mario. My identity would subsume him when I was in the zone but the moment I hit a Goomba and was sent flying, I was suddenly pulled out, viewing him once again as a separate entity. This was the experience of game feel as an extension of identity.

Interaction with a Unique Physical Reality within the Game

This also made me more aware of just how physical it felt to pilot Mario around. As Mario obligingly collided with things in his world, skidding to a halt with puffs of particle dust or a spray of yellow stars, it felt tactile and physical. These artifacts gave me a sense of the weight and mass of the things in Mario's world, as did his interactions with them. Some things he could pick up and throw easily, like a small stone block. Some things, like Bowser,[4] required considerably more heft. Sometimes, things would seem heavier or lighter than I imagined they ought to be. For example, the eponymous snowman's head from the Snowman's Lost His Head goal on Cool, Cool Mountain. The snowball is small, especially at first, and yet it pummels poor Mario out of the way every time. This too seemed to have an analogy in the real world: sometimes I would go to pick something up—a grocery bag, a piece of furniture that was rarely moved—and nearly pull my arm out of socket trying to heft the thing because it was much heavier than I had expected. This was the experience of game feel as a unique physical reality.

The Experiences of Game Feel

The aesthetic sensation of control is the starting experience of game feel. It is the pure, aesthetic pleasure of steering something around and feeling it respond to input. When players say a game is floaty, smooth or loose, this is the experience they're describing. An analogy from everyday life might be the feel of different cars; a 2009 Porsche feels better to drive than a 1996 Ford Windstar.

Experiencing game feel as skill encompasses the process of learning. This includes the clumsiness of unfamiliar controls, the triumph of overcoming challenge, and the joy of mastery. Viewing game feel as a skill explains how and why players experience the controls of a game differently as their skill level increases, what "intuitive controls" means, and why some control schemes are easier to learn than others.

[4]When temporarily immobilized and grabbed by the tail, of course.

The everyday analogy is learning a new skill, whether it's driving a car, juggling or slicing carrots.

Skillful control can also lead to the feeling of being in the zone, being one with the game and the loss of self-consciousness. If you've played a video game and lost track of time, you've experienced this sensation. You sit down to play a game for a few minutes and zone out only to emerge hours later, exhausted, elated and fulfilled. In everyday life, this happens all the time. You can zone out while driving on the freeway, folding socks or playing basketball.

When players say "It feels like I'm really there," "It's like I'm in the game" and "The world looks and feels realistic," they're experiencing game feel as an extension of the senses. The game world becomes real because the senses are directly overwritten by feedback from the game. Instead of seeing a screen, a room and a controller in their hands, they see Azeroth, the beach at Normandy or Donut Plains. This is because an avatar is a tool both for acting on the world and for perceiving it. There's no real-life example of this experience because the experience is the senses extending into the game, into a virtual reality.

One result of this extension of the senses into the game world is the shifting of identity. Players will say "I am awesome!" during moments of skillful triumph and "Why did he do that!?" when they fail a moment later. With real-time control over an object, a player's identity becomes fluid. It can inhabit the avatar. The real-world analogy is identity subsuming a car. You don't say, "His automobile hit my automobile." You say, "He hit me!"

As the player's senses are transposed into the game world, they can also perceive virtual things the way they perceive everyday things: through interaction. In perceiving things in a game this way, objects seem to take on detailed physical characteristics. Objects can be heavy, sticky, soft, sharp and so on. When a player observes enough of these interactions, a cohesive picture of a self-contained, unique physical universe begins to emerge as the various clues are assembled into a mental model. This is the experience of game feel as a unique physical reality, as a game world with its own designer-created laws of physics. Figure 1.7 shows the whole thing put together.

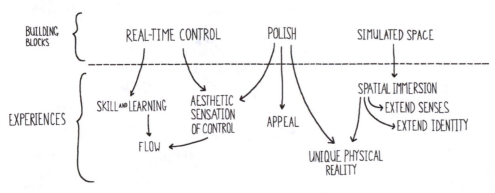

FIGURE **1.7 How building blocks of game feel translate into experiences.**

Creating Game Feel

For the remainder of the chapter, let's explore each of these different experiences in detail, with focus on how the game designer can shape and build them.

Game Feel as the Aesthetic Sensation of Control

There can be a thoughtless joy to controlling something in a game. People experience this while riding a skateboard, surfing, ice skating or driving a car. It's the kinetic pleasure of moving through space, creating flowing arcs of motion and feeling your body or the thing you're controlling respond instantly to your impulses. Even without a specific goal in mind, there is this intrinsic pleasure to control. These sensations of control have some known aesthetic properties, as in the earlier example of the Porsche and Ford Windstar. The Porsche is smoother, handles better, has tighter cornering and so on. In a video game, the same aesthetic properties of control are in play. An avatar in motion can create flowing, organic curves as it moves and enable a player to feel the aimless joy of control. These sensations are what players mean when they say a game feels smooth, floaty or stiff. These sensations are a wonderful palette for game designers to draw on and use to engage players (Figure 1.8).

When a game designer sits down to create a game and has an idea for a particular feel in mind, the first task is mapping input signals to motion. The expressive potential is in the relationships. When a button gets pressed, is the response gradual or immediate? Does the avatar move forward relative to the screen or relative to

FIGURE **1.8 The aesthetic sensation of control.**

itself? Or does it rotate rather than move? How fast does it move forward relative to its rotation? With the right relationships between input and response, controlling something in a game can achieve a kind of lyric beauty. The flip side is jarring, nauseating or otherwise aesthetically unappealing motion resulting from player input.

This mapping is a form of aesthetic expression. It defines how it will feel to control the avatar. As with most artistic endeavors, there's no formula for the "right" feel. It's up to the designer to make the hundreds of tiny judgments about the intricate relationships between input and response. We'll explore this palette of mapping and how it translates to game feel in greater detail in Chapter 7. For now, note that these are aesthetic judgments, and the resulting feel is an expression of the designer's sensibilities.

Now imagine all the motions possible with one mapping. Every turn, twist, jump and run. The sum total of all motions possible with a mapping defines a possibility space for the player. This is not defining what a player will do; rather, it is defining what he or she *can* do. Every movement a player can ever accomplish with an avatar is defined by the designer's choices about how to correlate input to response.

Each of the potential motions has an aesthetic character that will be experienced by the player if he or she steers the avatar through that action. This aesthetic pleasure has its own intrinsic reward and will encourage a player to explore the possibility space by moving around in whatever way seems most aesthetically pleasing to them. The problem is, without some kind of focus, even great-feeling controls will quickly wear thin.

For a game designer, the solution to this problem is to add some kind of challenge. With a goal, motions of control take on a new meaning. Now it's possible to compare intent to outcome. It's possible to succeed or fail. The aesthetic pleasure of control has become a skill.

Game Feel as Skill

As I'm defining it here, a skill is a learned pattern of coordinated muscle movement intended to achieve a specific result. To measure skill is to measure the efficiency with which intent can be translated, via action, into results.

If you're playing soccer, your intent may be to dribble through all the other players on the soccer field and bend the winning goal past a floundering goalkeeper. In reality, this is one of many possible outcomes. It is much more likely that your skill will not be up to this level of challenge, and you will be stripped of the ball before you can get to the center line. But skills can be improved, and increasing levels of challenge can be mastered. If your goal is to dribble past one defender and make a deft pass to an open teammate, your odds of achieving that are relatively good. While this may not be the glowing level of pleasure you'd get from scoring the goal yourself, there are great feelings to be had from small, incremental victories. Even a particularly skillful kick or dribble while practicing in the backyard can feel wonderful because you know it can be later applied in the context of a soccer game. Soccer

is a set of challenges so compelling that isolating and practicing the skills seems worthwhile even outside the context of the game.

This is similar to the experience of playing Counter-Strike. I was so compelled by the challenges of the game, I would boot up the level "cs_italy" without other players and practice three skills: shooting a specific spot on a wall while moving side to side, quickly moving my aiming cursor from one spot to the next; and keeping the cursor on a single spot while I moved left, right, forward and back. I would sit in the level, alone, practicing these three skills for two to three hours before I would ever play the game online. It seemed worthwhile to push myself into different, higher levels of skill.

What this indicates is that game skills and real-world skills are essentially the same. They are learned patterns of coordinated muscle movements. The muscle movements are smaller, the skills are more focused and the motions are not constrained by physical reality, but the same process of learning and skill-building occurs. The primary difference is that a video game designer has control over both challenge and physics. In the real world, there are a fixed set of properties—gravity, friction, the physiology of the human body and so on. The designers of soccer, whoever they were, had to work around these fixed properties to create interesting, meaningful challenges. Their palette consisted of lines on the ground, the size of the net, the physical properties of the soccer ball and rules like "you can't touch the ball with your hands." Minh "Gooseman" Le, the designer of Counter-Strike, was able to craft everything. He not only created the rules and challenges of the game, but also defined how fast players could move, how high they could jump, how accurate their weapons would be and what the values for gravity and friction would be in the game.

Tweaking how the player moves and the creation of challenges both alter game feel. Changing the global values for gravity, friction and speed of character movement defined the basic sensation of control. Adding rules and challenges then changed this sensation by defining a set of skills to be practiced and mastered. The question is, how? How is skillful control a different experience from just control?

The answer is that game feel and skill are related in three ways:

- Challenge alters the sensation of control by focusing the player on different areas of the possibility space of motion, rewarding him or her for exploring it.

- The feel of game changes depending on the skill of the player.

- Players find controls to be intuitive when they can translate intent to outcome without ambiguity.

Challenge Alters the Sensation of Control

From the point of view of a game designer, there is a problem even with the best sensations of control. Controlled motion is pleasurable, but that pleasure is fleeting. Even if the game feels great, aimlessly controlling something gets boring quickly (Figure 1.9).

Part of the problem is that if the aesthetic pleasure of control is the only encouragement, the player will experience just a small subset of the possible motions. If we

again imagine every possible motion of a mapping as a possibility space, the area explored by a player will be limited, as in Figure 1.10.

However, with a specific goal to pursue, control takes on new meaning. Aimless, pleasurable motion is replaced by focused, purposeful attempts to complete the challenges presented. This provides an incentive for players to find new areas of the possibility space, introducing them to sensations of control they would have missed otherwise. Challenge provides landmarks in the distance, encouraging the player to explore the aesthetic frontiers of the game.

For example, a first-time player of Super Mario World will not experience all the sensations of the flying mechanic. It takes a lot of practice to learn the timing of feathering the button at the right moment, sustaining Mario in his sine wave pattern of flight. And yet this is one of the most pleasurable sensations of control in the entire game. Having access to this sensation—even just being aware of it—makes the game more appealing and engaging (Figure 1.11).

FIGURE **1.9 Without focus, the joy of control can become boring.**

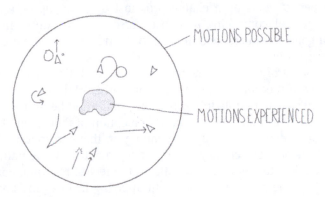

FIGURE **1.10 Players only experience as much of a game's feel as the area of this space they feel inclined to explore.**

17

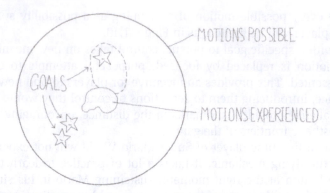

FIGURE 1.11 With challenges, there is a reason to explore more of the possible sensations of a particular mapping.

Challenges not only encourage exploration of all possible motions, but assign new meaning to them. This changes the feel of control. For example, think of a mouse cursor. This is a form of real-time control so engrained that we rarely notice ourselves exercising it. But against the backdrop of a different challenge, mouse control can take on a different feel, as in the Web game Cursor Attack. Cursor Attack requires the player to move the cursor in a very precise path as quickly as possible to reach a goal point. Normally, the goal of using a mouse is to navigate a Web page effectively and buy things like a good consumer, or to click, drag or otherwise manipulate the programs on your computer. In Cursor Attack there is an explicit goal (reach the end of the maze by touching the goal point) and an implicit goal (go as fast as you can.) The constraint is touching the wall of the maze, which causes an immediate game over. The result is a feeling of complete focus on the tiniest motions of the mouse. This feels very different from navigating a Web page. It makes the mouse cursor's movement feel very twitchy and much less precise. The cursor's size and its position in space suddenly become much more important. The skill requires a great deal of concentration, like threading a needle or trying to draw a perfect circle on a chalkboard. Just by changing two goals and one constraint, the feel of controlling a mouse cursor is new, fresh and interesting. Fortunately for game designers, real-time control lends itself to the creation of these kinds of challenges (Figure 1.12).

Challenges consist of two parts: goals and constraints. Goals affect feel by giving the player a way to measure his or her performance. With a goal, it's possible to fail or succeed. It's also possible to fail partially, and to do better or worse than the last attempt. This creates players' nebulous perception of their own skill, their own ability to translate intent into reality. Depending on this perception, the feel of the game will fluctuate between clumsy and intuitive. In addition, the nature of the goal shapes the players' focus. As in Cursor Attack, the feel of real-time control changes depending on how the player is tasked with applying it. Does the goal require the player to make extremely precise, specific motions like Cursor Attack, or is it more wide open like Banjo Kazooie? How fast do the characters move, how far apart are

FIGURE **1.12 Challenges give meaning to motion, enabling sensations of control to sustain engagement across a whole game.**

the objects they're being asked to move in reference to, and are they meant to avoid them, collect them or touch them lightly? This is much of the art of game design as it pertains to game feel: what the players are supposed to do is as important as the controls that enable them to do it.

A single goal can create multiple layers of intentions. For example, a high-level goal like "reach the top of the mountain" may require many steps to execute. But eventually it all trickles down to the level of real-time control. Reaching the top of the mountain means swinging to the next pole, and the next and so on (Figure 1.13).

Constraints affect game feel by explicitly limiting motion. Instead of emphasizing a motion, a constraint selectively removes some motions from the possibility space. For example, the sidelines on a football field eliminate some possible motions, rewarding players who can quickly change directions side to side and who are good at exploiting gaps in the opposing team's defense. If there were no sidelines in football, a player could run endlessly in a direction to evade defenders and the essential skills would change. The same is true when we say that hitting an asteroid causes you to lose a life in Asteroids. By limiting motion, the player is again focused on particular motions, which changes the feel of control.

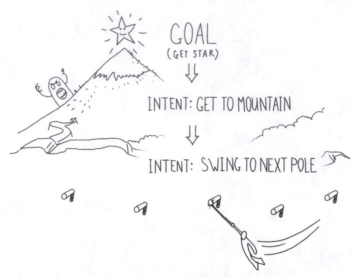

FIGURE **1.13 A goal trickles down to become different layers of intent.**

These two tools, constraints and goals, enable game designers to shape real-time control into a specific feel. Goals emphasize certain parts of the possible motion while constraints specifically eliminate others. The result is the feel as the game designer wanted it to be.

But what should the game designer's desired feel be? This is up to the designer, of course, but I find this question often answers itself through experimentation. With a prototype of real-time control featuring an avatar moving around an exploratory space with lots of different shapes, sizes and types of objects to interact with, control organically evolves into skills and challenges. Can I get up to the top of that mountain? Can I fly between these buildings without hitting them? Can I jump across this gap? What I'm looking for in such a prototype are the best-feeling motions and interactions. In this way, the job of a game designer in crafting game feel is to explore the possibility space of a new mapping, emphasizing the good with goals and pruning the bad with constraints.

Game Feel Changes Depending on the Skill of the Player

When picking up the controls of an unfamiliar game, a player will feel inept, clumsy and disoriented. To an expert player, the same game will feel smooth, crisp and responsive. The game's controls will always be the same from an objective standpoint—the cold precision of programmed bits allows no other reality—but feel will change for the players depending on how well they can translate their intention into game reality. Each player will start at a slightly different skill level depending on past experience and natural aptitude, will learn at a different rate and will attain different heights of skill depending on how much her or she practices. This means

that even for a single player, the feel of a game will change over time. This variability makes the feel of even a single game controversial. The argument goes like this:

Internet Denizen 1: "Whenever I think of what the perfect 'feel' for a game is, I think of Super Mario 64. Other than the camera, the controls were perfect."

Internet Denizen 2: "God, I hated Mario 64, the controls were terrible!"

Internet Denizen 1: "You don't like the controls because you suck at it, n00b!"

Because both parties are correct, this argument will never be resolved. For Denizen 2, who was unable or unwilling to master the controls of the game, the feel was clumsy and unresponsive. Denizen 1's point of view is equally valid. For him, controlling Mario felt like extending himself into the game world, every movement becoming as accurate an expression of his intent as turning a steering wheel or swinging a baseball bat in real life. The point he's making—that without reaching a certain level of skill a player cannot appreciate the feel of a game—is valid. This is true both for soft, emergent skills like rocket jumping in Quake and for deeply nested controls such as the blue sparks in Mario Kart DS. When you're new, you don't use all the moves. In this sense, skill is the price of admission for game feel.

But there are also instances when players learn to play a game at a very high level and will still say it feels bad to control. For me, the arcade classic Pac-Man embodies this paradox. I enjoy the game, but from an aesthetic point of view, the feel of moving Pac-Man around the maze is stiff, rigid and unappealing. For the opposite reason, a friend of mine never enjoyed Asteroids. The looping grace of the ship is aesthetically pleasing to control, but the skills of avoiding asteroids and shooting alien spacecraft were too unappealing to be worth learning. This implies a relationship between these two different experiences of game feel: the base, aesthetic pleasure of control and the sensations of learning, practicing and mastering a skill. This relationship is cyclical, extends across the entire time a player plays a game and changes game feel constantly. The cycle looks something like Figure 1.14.

When players first pick up a game, they suck. Players know this and accept it—skill is the price of admission—and they trust in the game designer. "If I take the time to learn this and agree to suffer through some frustration," the player says, "you agree to give me some great experiences later." The feel at this point is clumsy, disorienting and bad. It takes a great deal of conscious effort to perform the most basic tasks in the game. The pure aesthetic pleasure of control can be used as a tonic here, soothing frustration until the first success, but every game starts this way for a new player. Every new player feels clumsy, disoriented and frustrated during the initial learning phase.

Over time, skills are mastered and get pushed down below the level of conscious processing. The player gradually improves relative to the challenges presented, and the feel gets better and better. Eventually, the player learns the skills well enough and breaks through, completing the current goal. Without the oppressive feeling of clumsiness, the aesthetic sensations of control come to the forefront, combining with the satisfaction of a challenge overcome to provide a reward for reaching this

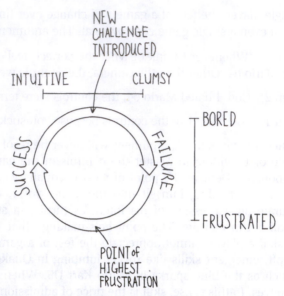

FIGURE **1.14 The cycle of skill and game feel. As the player's perceieved level of skill changes, so does the feel of control.**

level of skill. Then the next challenge is introduced and the cycle starts again. The clumsy feel of being unskilled relative to the challenges provided once again overwhelms the aesthetic pleasure of control.

Objectively, skill always improves over time. Subjectively, players will feel that the controls are alternately clumsy and intuitive depending on how their skill relates to the challenges the game is currently throwing at them.

The best game designers create feel at different levels of skill. By knowing the skill of the player and what he or she is thinking about and focusing on, a clever designer can tune game feel differently at each level of skill. This insight into a player's skill might come from knowing which level the player is currently on, from which items are currently in the player's inventory or from extensive play testing in a multi-player game. For example, if a player is on level 12 and the progression of levels is linear, you can assume he or she has mastered the skills necessary to complete the first 11 levels. You know the skill that was learned last (what the player will be focused on), which skills are completely reflexive (those already mastered) and which skills have not yet been encountered. With this knowledge, it's possible to shape the feel of a game across time. Guiding the player this way, a designer can leave breadcrumbs strewn across the possibility space of motion, emphasizing the best possible sensations of control while maintaining a balance of skill and challenge. When the player has achieved the highest level of mastery, the game will have fulfilled the designer's goal for the best possible game feel.

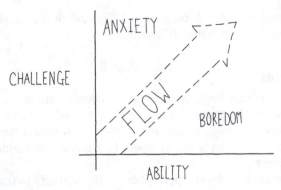

FIGURE 1.15 The flow state: when challenge and skill are balanced for maximum player engagement.

For this to work, however, players must never get so bored or frustrated that they stop playing. If this delicate balance between player skill and game challenge is perfectly maintained, players will enter the flow state.

Flow theory says that when a challenge you undertake is very close in difficulty to your current level of ability, you will enter the flow state, which is characterized by a loss of self-consciousness, a distorted perception of time and a host of pleasurable sensations. Researcher Mihayli Csikszentmihalyi (pronounced "chicks-sent-me-high") correlated these sensations with athletes, dancers and world-class chess players being "in the zone" and having things "just flow." The gist is that when your ability matches really well to a particular challenge you can enter the flow state. If your skill is much greater than the challenge offered by a given activity, you'll be bored. If your skill is far below the level of the challenge provided, you'll be frustrated. (See Figure 1.15.) Or, as in the case of rock climbing and other dangerous activities, you'll be anxious. Csikszentmihalyi says that "Games are the flow experience par excellence," and for good reason. Video games especially have numerous advantages in creating and maintaining flow, such as providing clear goals; a limited stimulus field; and direct, immediate feedback.[5]

From the perspective of game feel, flow is one of the ideal experiences. When players refer to being immersed in the game, part of what they're experiencing is flow. As the original researchers of flow discovered, entering the flow state and staying there is one of the most rewarding experiences it is possible for people to have. From surgeons to painters to rock climbers, everyone who experienced flow regularly was happier, healthier, more relaxed and more energetic. And they knew it, loved it and sought out flow-producing activities because of it. In a video game or in real life, fueling this addiction requires taking on ever-greater challenges to match ever-increasing skills. As these higher levels of skill and challenge are reached, the

[5]For a detailed description of the flow state, how you can tell if someone is entering or exiting it, how it enriches people's lives, and the conditions necessary to achieve it, reference Csikszentmihalyi's original work on flow, *Beyond Boredom and Anxiety*.

sensations of control change. A professional Counter-Strike player, like a professional soccer player, feels the game differently.

Intuitive Controls

Unlike real life, players may begin to feel that the controls are not accurately translating their intentions into the game. This is another place where game skills are slightly different from real-world skills. In real life, if you try to kick a ball and completely whiff it, you've no one to blame but yourself. In a game, the blame can actually lie with the game designer.

What's important is the player's perception: is the inability to translate intent into desired reality because of his or her lack of skill or some problem with the game? Players often blame the controls when they don't get the result they intended and sometimes this blame is justified. A game designer is unlikely to map an input to a random result, but there are many instances when unintentional control ambiguities disrupt the sensation of control by making the player feel as though the game is not accurately responding to their input.

When this happens, when the player feels the game is not accurately translating his or her intention into the game world, it's one of the worst feelings possible. It's game feel anathema. This sensation is the opposite of what players mean when they say "intuitive controls."

Intuitive controls mean near-perfect translation of intent into game reality. Players will be able to translate their intent into reality with varied degrees of efficiency, based on their skill. If the thing you're controlling does what you want and expect, accurately translating your impulses into the game, the controls are intuitive. Control over the avatar feels like an extension of your own body into the game.

There is a distinction between challenge (which makes the game more difficult in the dimension of skill) and interference (which obfuscates intent arbitrarily). Put another way, as long as the result of an action is predictable, the goals clear and the feedback immediate, it will fall on the scale of challenge. If not, it's interference, noise in the channel between the player's intent and the game's reality.

When constructing a game mechanic, designers seek the ever-elusive worthwhile skill. It's intuitive and easily learned, but deep. It has a lyric, expressive quality, but you can hang a game's worth of challenges on it and it never gets stale.

Game Feel as an Extension of the Senses

To play a video game is often to focus intently on a screen, to the exclusion of all else. While this may cause consternation among parents, educators and career-minded politicians, what's happening is not a trance, but a transposition of senses. The screen becomes the player's surrogate visual sense. Instead of looking around and seeing a TV, a couch and their hands on a controller, players look through the screen into the game world. When players sit and stare, they are not catatonic.

Rather, they've substituted their visual sense for one in the game world, extending it outward to a new place. They're looking around, keenly aware of their surroundings in the game. This is because an avatar in a video game is a kind of tool; it provides both a potential for action and a channel for perception.

Consider a hammer. When you hit a nail with hammer, you can see the nail head get lower and you can hear the pitch change with each strike, driving the nail downward. These are direct perceptions. But you can also feel the nail through the hammer. With each strike, you can feel the nail driving deeper, whether you've hit it square on, whether the nail is beginning to bend and so on. Tactile feedback is coming back to you through the hammer. The hammer has become an extension of the sense of touch.

Now consider the avatar in Katamari Damacy. Controlling the Prince of all Cosmos is an extension of three senses: sight, hearing and touch. As a player, I have a goal: to build my Katamari to a certain size. The first step in this goal is to pick up some thumbtacks I can see off to the left of my current position. Once that intent is formed, I begin to take action, pressing forward on the thumbsticks to move the avatar in the direction I want to go. To know whether I'm turning the right amount, and when to stop turning and straighten out, I'll use visual feedback from the screen. I'll estimate the distance between avatar and thumbtacks. Each moment I'll look at how much the Prince is turning relative to the pressure I'm exerting on the thumbsticks and make constant, tiny adjustments to maintain the proper course. This happens in a continuous cycle until I see that I've turned and hear the satisfying "collect" sound. If I run into something that's too large for my Katamari, I see the Katamari stop, see pieces fly off it, hear a crashing sound, see the screen shake and feel the rumble motors in the controller go off.

In each case, a device overwrites one of my senses. The screen becomes vision, speakers hearing and rumble motors the sense of touch. The feedback from these devices enables me to experience things in a game as if they were objects in my immediate physical reality. I have the sense of moving around a physical space, touching and interacting with objects. The screen, speakers and controller have become an extension of my senses into the game world. The game world becomes real because the senses are directly overwritten by feedback from the game. By hooking into the various senses, a screen, a speaker or a joystick can make the virtual feel real.

When game designers create camera behavior, implement sound effects or trigger rumble motors, they're not defining what players see, hear and feel. Rather, they are defining how players will be able to see, feel and hear in the game. The task is to overwrite real senses with virtual ones. In defining game feel, we must acknowledge this fact and embrace it. To experience game feel is to see through different eyes, hear through different ears and touch with a different body.

From the perspective of the game designer, the most important part is defining camera behavior. The camera is the player's point of view, the point in the game's world that represents his or her eyes, determining what view of the game world will be displayed on the screen. If the first task of a game designer creating a particular feel is

mapping input signals to motion, and the second task is to create a space and objects to give that motion a frame of reference, the third task is defining the behavior of the camera. There are no games I'm aware of that use sound or controller rumble as a primary feedback for real-time control. It's interesting to think about how real-time control could be achieved using mostly aural or tactile feedback, but most games are built using visual feedback only, with sounds and controller rumble added as polish effects. This is why creating the camera and its behavior is the third necessary component of a game feel prototype. Without any of these three—mapping, a basic-level layout and camera behavior—the feel of a game is not reliably testable. For a designer, these are the three foundations of game feel.

The two important decisions to make about a camera are where it will be and how it will move relative to the avatar. The combination of where the camera is and how it moves defines the player's impression of speed.

Because the camera is not just an object being controlled but is also an organ of player perception, its motion requires some special treatment. Usually, these problems handle themselves. If the camera's movement is too jarring or disorienting, or if the player can't see what they need to see to engage with the challenge of the game, the designer simply iterates until these problems are reduced or mitigated. The most common choices are: don't move the camera more than you have to, move it smoothly when you do and give the player control when you can't get a good result from programmed behavior. Otherwise, the camera causes interference between intent and result, making the controls less intuitive for the player. Worse than that, the motion of a camera can actually cause physical nausea. This is an interesting confirmation that feedback from the screen is truly overwriting visual perception. Motion sickness happens when the signals received by the inner ear don't agree with the signals received by the eyes. For a player who's sitting stationary in a room, playing a game on an unmoving screen to experience motion, visual perception must be extended into the game via the screen. It's no wonder, then, that things like sudden drops in frame rate are so jarring and feel awful to the player. It's as if you were walking to the grocery store and your vision suddenly started to stutter and break down. This is also how it's possible for motion sickness to occur when a player is sitting stationary in a room playing a game on an unmoving screen. If the player's eyes in the game are the camera, the flow of feedback from that sense needs to be smooth and uninterrupted.

Game Feel and Proprioception

One sense that we might not consider part of game feel is kinesthesia. Kinesthesia is the sense that detects body position; weight; or movement of the muscles, tendons and joints. To get fancier, we can talk about "proprioception," which is often used interchangeably with kinesthesia. Proprioception has the slightly more precise connotation of being a person's subconscious awareness of the position of his or her own body in space. To understand what proprioception is, close your eyes, extend

your arm directly out in front of you and touch the ring finger of your right hand with your left hand. The sense that enables you to figure out where your finger is in space is without using visual or aural feedback is the proprioceptive sense. When a police officer has you walk a straight line, this is the sense he or she is testing.

So how does game feel relate to proprioception? Proprioception comes from a complex and not especially well-understood bit of physiology that has to do with the movement of fluids in veins and the sensation of gravity pulling against tendons and muscles. Somehow this all gets assembled into a sense of the position of your own body in space. This is why most astronauts experience "space sickness" their first few days in zero gravity and sporadically thereafter. Even though they are highly resilient under extreme gravitational forces, as all astronauts must be, the body becomes disoriented by the lack of proprioceptive feedback. When gravity is taken away, the body loses its sense of "up" and reacts unpredictably, often in ways which involve a great deal of vomiting. In space. Gross.

When controlling something in a video game, there is no "real" proprioceptive sense; there can't be. As much as you feel your character has become an extension of your body, you will never receive the same kind of proprioceptive, muscle-stretching feedback from pressing a button as you get from swinging a tennis racket.

So where does that leave us? It seems like proprioception is an important clue, because the feeling of controlling a game is clearly something more than visuals and sound alone would indicate. If we can't actually experience the G-force of a hairpin turn when playing a game, how can we explain why it feels so similar? Why do we lean in our chairs? As an interesting example, consider the case of Ian Waterman.[6] At the age of 19, a viral infection destroyed the nerves in his skin and muscles. He can still sense temperature, deep pressure and muscle fatigue, but his proprioceptive sense is entirely gone. He is able to piece together the location of his body in space only by observing it visually or through other subtle cues. If he's standing in his kitchen and the power goes out, he crumples to the floor, helpless until the lights come back on. What's fascinating is that, apparently, his movement now looks mostly normal. With supreme mental effort, he uses whatever clues his senses will give him (he can also use sound and temperature as feedback about the position of his body) to gauge the position of his body in space.

On the surface, this seems in many ways to be similar to the experience of steering a virtual object around a virtual space. Based on limited feedback, we experience a kind of proprioception. We get a sense of the position, size and weight of a virtual object in virtual space. It would be a significant disservice to Mr. Waterman to end our assessment there, though. Even when manipulating something in purely invented, digital space, we have a significant advantage: we still use our sense of the position of our bodies to guide us. What a bunch of cheaters!

[6]For more information, see http://www.apa.org/monitor/jun98/touch.html

When you move a mouse, thumbstick or Wiimote, your proprioceptive sense is still active. Your thumbs, though their movements are small, are still giving you feedback about their position in space and about how much the buttons or thumb-stick on the controller is pushing back on them. You have a sense of where your body is in space, even if your primary feedback is coming from virtual objects in virtual space. In this way, controlling something in a game is a kind of amplification of your sense of space because you get a huge amount of reactive mileage out of very little real-world motion. It's like a megaphone for your thumbs. You're now concerned with how your real-world motion affects virtual objects; the process of motion and feedback is transposed. When we're controlling something in a game we're using not a debilitated proprioceptive sense, but an amplified one.

Part of the experience of game feel, then, is amplified impression of proprioception generated from visual, aural and tactile feedback. It's an impression created through illusory means, but is experienced as real by the senses. The sensation of game feel is more than the sum of its parts: visuals, sound, motion and effects combine to form another sensation altogether, one we might term "virtual proprioception."

Game Feel as an Extension of the Player's Identity

When perception extends into the game world, so does identity. It's the same thing that happens when you drive a car. As you drive, you have a sense of the position of the car in space and how far it extends around you. This enables you to parallel park, drive in a lane next to other cars and pull into your garage without crashing. Your senses extend outward, encompassing the car and receiving feedback. As this happens, the car becomes part of you, an extension of both body and self. This is why people who've crashed say "You hit me!" rather than "His car hit me!" or "His car hit my car!"

When an avatar in a game feels like an extension of your own body and senses, identity flows outward to encompass it in the same way. Game designer Jonathan Blow calls this "proxied embodiment"—identity extends to some kind of proxy, inhabiting it and making it part of one's own body. "My guy" becomes "me." What's interesting is just how capricious this transfer of identity can be. It can flow outward, encompassing something we're controlling and a moment later be withdrawn. We can say "Yes, I am amazing!" as we effortlessly wipe out a room full of Marines in Half-Life and moments later scream "No, Gordon Freeman, you stupid sumbitch! That's a bad Gordon Freeman!" as we accidentally fall off a cliff to grisly virtual death. For game designers, this flow of identity is great. It mitigates the frustration that comes from challenging the player. A little cursing at the avatar is always preferable to the player becoming bored or frustrated and putting the game down. It provides a nice release for the player, who avoids blame and maintains engagement, getting back to the pleasurable sensations of control more quickly.

The extending of identity also gives a player the sensation of direct physical contact. It's a muted sensation—getting hit with a rocket in Quake is, one assumes, not the sensation of being hit with one in real life—but intimate nonetheless. When I'm bumped, jostled, flung or impaled, it feels bad because it's as though it's happening to me physically. It's the same sensation I had hitting a pole in my parents' Volvo; it's not literally painful, but it feels like a personal injury. Likewise, when I'm grabbing, throwing, slashing or hitting, it feels good because I'm reaching into the game and affecting things directly with a part of my extended virtual body. This is where impression of physical interaction becomes really powerful. Through a combination of polish and simulation, the designer can have players feeling they've hit or been hit, shaping those interactions with great precision.

Extension of identity isn't something you can design for directly. It grows naturally out of real-time control, and it can be disrupted by too much frustration, boredom or ambiguity between intent and outcome. It can also happen to greater or lesser degrees depending on the sensitivity of control. For example, I don't feel particularly attached to each falling piece in Tetris. Our time together is fleeting, and I have a very low-sensitivity control over the block's movement. The blocks themselves are not anthropomorphic, but this fact is less important than the expressivity of the controls. In Asteroids, which also has a very simplistic avatar, the transfer of identity is much more pronounced because there is more sensitivity inherent in the controls. It twirls and curves, narrowly missing asteroids. You really feel the extents of the ship, focusing on its size and position in space as you steer it around. Even Pong, which itself used only blocks as representation, had a greater potential for identity transfer. The sensitivity of the paddle controller was high enough to feel like an extension of the senses and the identity. This is taken to an extreme in a game such as Quake; there's no barrier between identity and avatar. Tetris has a very low sensitivity of control, allowing only left-right movement and rotation in a grid. Quake maps a highly sensitive input device, the mouse, directly to rotation of the avatar. As long as it's not too frustrating and doesn't suffer from crippling control ambiguity, more sensitive controls will more readily accept a transfer of identity.

Game Feel as a Unique Physical Reality

Now I'd like you to help me in a little experiment. First, picture in your mind what would happen if you were to throw this book across the room and into a wall. Got it? Now please throw this book across the room and into a wall. Come on, no one's watching. *Throw it.*

I'll assume you've thrown or not thrown according to your personal code of Book Ethics and have returned to reading. How did your expectations compare to the actual outcome of the book being thrown? Now noodle the book around in your hands, feel its weight and heft and thumb quickly through the pages, listening to the pleasing sound it makes. What do you notice? A paperback book, like this one,

is heavy, floppy and will generally go where you throw it, landing in a heap as the pages fan out in the air. Based on your previous experiences with paperback books, this was probably what you assumed would happen when you threw it. But how did you *know* that would happen? If you see a strange book lying on your coffee table, how can you be sure this object you see and recognize as a book is truly an object made of sheaves of pulped, pressed wood bound together into a flimsy brick? The answer is action. You had to throw it to find out.

Based on your previous experiences with paperback books, you could make a reasonable guess about what would happen, but the only way to truly experience the physical properties of an object is to observe that object in motion. As an object interacts with other objects, including your hands, you quickly parse out its physical properties. In a game, this same process of physical perception happens. In this sense, the experience of game feel is a kind of faked Newtonian physics.

People are good at figuring out the physics of a virtual space because they're subconsciously familiar with the way things work in the real world. As soon as we encounter a virtual space, we piece together whatever clues we have about the physical laws that govern it into a mental model. We can't help it. It happens quickly and effectively and is based on what can be gleaned from the limited stimulus available: visuals, sounds, tactile feedback and motion. When all these harmonize, the fake physics are seamless; every tiny clue serves to support the same impression of physicality, from the simulated collisions through animations, sounds, screen shake and particle effects. Sometimes a piece of feedback will contradict the others, however, and this causes inconsistencies in the player's mental model of the virtual space. Even in the games that do a fantastic job of conveying the solid physics of their world, such as Gears of War, there are usually inconsistencies to be found (the characters' feet still clip through stairs, for example).

In a video game, you don't sit in the thing you're steering and manipulating. You can't—the object you're controlling has no physical form. Objects in a video game are a digital construct in virtual space. However successfully they attempt to mimic the real world, they can only ever convey an impression of physicality. Creating a good-feeling game is in one sense the process of building this impression. Using sound and motion, we give players an entire universe worth of physical laws to reconstruct in their heads, a mental model of the virtual space. This happens in the same way we map the physical space we experience every day. The thrown book makes noise, thuds when it hits the ground, flops in the air, takes a certain trajectory, falls in a certain way, takes a certain amount of heft to launch. But the impression, the generalization, comes from the combination of sound, touch and motion.

Consider the two bowling balls in Figure 1.16. You'd expect that if they roll into one another, they will make a satisfying clacking noise and roll away slowly. If, on the other hand, one ball deforms, makes a dull thud like a beach ball being kicked, and is flung violently in the other direction at the moment of impact, what can you surmise about the ball that was punted? At this point, you must assume that one ball is a clever visual forgery of a bowling ball, a beach ball in a bowling ball's

FIGURE **1.16 Bowling balls collide and behave normally.**

FIGURE **1.17 Bowling ball and Ping-Pong ball: who will win?**

clothing. Even though it looks like a bowling ball, the evidence offered by at least two other types of feedback, aural and motion, indicate overwhelmingly that it is not a true bowling ball.

Now look at the balls in Figure 1.17. What would you expect if these two balls rolled into one another at speed? What if the Ping-Pong ball made a low, ominous humming noise and proceeded to split the bowling ball in half with its crushing power? What would you assume about its physical properties then? There would be no real-world analogy for what you've just perceived.

Mentally you try to uncover the underlying physical reality. Clearly, even though it looks like a lightweight Ping-Pong ball, if it can destroy a bowling ball,

31

it must be made of something solid and heavy. We strive to resolve the dissonance by abandoning the visual cue because motion and sound outweigh it, evidence-wise. Likewise, a bowling ball, even if we can't hear the sound of it, still conveys heaviness by the way it moves and interacts with other objects. Even if visuals and sound are not congruent, motion will always trump them in creating the sense of impression.

This is why things like interpenetrating objects or bizarre, unpredictable motion are disturbing to the player. For example, the visuals in id Software's Doom 3 were exemplary. Each creature was rendered at a high, normal-mapped level of detail much greater than the games that preceded it, and it was the first major commercial game to use a true lighting model as part of gameplay. Corners could actually be dark, and the critters lurking there had to be illuminated with a flashlight. Unfortunately, these impressive visuals were belied by thin, tinny sounds (especially the shotgun and machine gun effects) and the implausible, jerky motion of the everyday objects scattered throughout the game. Some props would fly and spin like helicopters, taking on a life of their own, while others would not react or move at all. There seemed to be no logic to the motion or lack of motion, and it created a powerful dissonance between visuals and motion. The impression of physicality was shattered. As game designer Brian Moriarty puts it, "… One reference to anything outside the imaginary world you've created is enough to destroy that world."[7]

Compare this to the more recent, great-feeling Gears of War. Gears of War had a great use of particle effects (especially sprays of dust as the characters slammed against walls), cinematic tricks such as lens distortion and screen shake, and extremely well-produced sound effects. This gave rise to a powerful and compelling impression of physicality. As independent game designer Derek Yu puts it, "… In Gears it's like you're this giant wrecking ball with a gun attached to it, which is pretty sweet."

Summary

To answer the question of what game feel is, we started with a basic definition of game feel:

> Real-time control of virtual objects in a simulated space, with interactions emphasized by polish.

Using the three building blocks encompassed in this definition—real-time control of virtual objects, simulated space and polish effects—it's possible to create great-feeling games.

We further defined great-feeling games as games that convey five different types of experience to the player:

[7]"Andrew Rollings and Ernest Adams on Game Design" (page 59).

- The aesthetic sensation of control
- The pleasure of learning, practicing and mastering a skill
- Extension of the senses
- Extension of identity
- Interaction with a unique physical reality within the game

Of these five experiences, no single experience encompasses game feel. Rather, game feel is all of these experiences simultaneously. During play, one experience might come to the forefront. The player might feel supremely frustrated, be enthralled for a few moments by a beautiful sensation of control or feel the gory satisfaction of gibbing an opponent with a well-timed rocket. These experiences are not mutually exclusive and, at any time, each is present to some degree.

These five experiences of game feel tell us a lot of interesting things about the way players experience game feel and the ways game designers utilize game feel. What they don't tell us about are the processes—physiological and psychological—that give rise to these experiences. To understand what game feel is at these levels, let us now take a slight detour away from human experience and into human perception.

TWO

Game Feel and Human Perception

Understanding exactly how humans perceive the video game worlds we create is key to designing good game feel. We'll begin by examining our feedback loop model of interactivity from Chapter 1 in greater detail. By deconstructing each piece of this system and incorporating the concept of the Model Human Processor, we'll be able to define real-time control at the level of specific, measurable properties of human perception. This will tell us exactly when and how real-time control can exist and what will cause it to break down. We'll also look at the computer's side of things: what, exactly, are the parameters of machine illusion? Finally, we'll look at some of the implications of perception for game feel.

When and How Does Real-Time Control Exist?

In Chapter 1, we defined real-time control as the uninterrupted flow of command from player to game resulting in precise, continuous control over a moving avatar. It's more like driving a car than having a conversation, as we said. The part of the definition that needs clarifying is "uninterrupted." What if the player can offer new input at any time, but the game can only receive it at set intervals? Or what if the player gets locked out for a certain amount of time, unable to add new input until an animation has finished playing? In other words, what is real-time control and how do we know when it's happening and when it's not?

Let's again look at interactivity, this time with more specificity. There are two halves to this process, the player and the computer (Figure 2.1). On the player's side of things, there are unchanging properties of human perception. For example, there is a minimum amount of time in which a player can perceive the state of the game, think about how to act and pass that impulse along to his or her muscles.

On the computer's side, this creates boundaries. To sustain real-time control, the computer must display images at a rate greater than 10 per second, the lower boundary for the illusion of motion. The computer must also respond to input

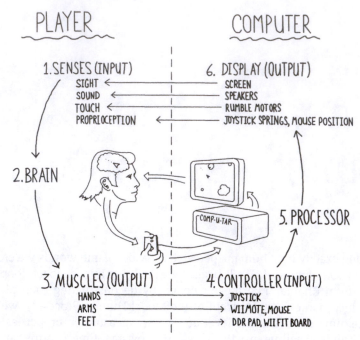

FIGURE **2.1 Interactivity in detail.**

within 240 milliseconds (ms), the upper boundary for response time. There's also a threshold for continuity; the game must be ready to accept input and provide response at a consistent, ongoing rate of 100ms or less. If the game responds to input sporadically, the flow of control is broken. The onus for maintaining real-time control, then, is on the computer. The computer's half of the process is changeable. The player's perception is not.

On the player's side, the minimum amount of time it takes for a person to perceive the state of the world, think about what to do and act on that impulse is around 240 milliseconds. This is a very short amount of time.

This correction cycle is the increment at which people make the tiny adjustments necessary to assemble a sandwich, drive a car or exercise real-time control over objects in video games. The measure comes from Card, Moran and Newell's "Model Human Processor," the collected result of many different studies about human reaction and response time. The figure of 240ms is an amalgam of three different measurements, one for perceiving, one for thinking and one for acting. They break down as ranges, like so:

- Perceptual Processor: ~100ms [50–200ms]
- Cognitive Processor: ~70ms [30–100ms]
- Motor Processor: ~70ms [25–170ms]

FIGURE **2.2 The three processors: perceptual, cognitive and motor.**

What's being measured here is the cycle time of each processor, the time it takes to accept one input and produce one output. The variation comes from physiology and circumstance. Some people have the capacity to process things more quickly than others and everyone tends to process things more quickly under intense circumstances, displaying a heightened sense of awareness. Likewise, processing speed goes down under relaxed or sub-optimal circumstances such as reading in the dark. In the model, each of these steps is defined as its own separate processor and has its own little cycle time (see Figure 2.2).

Try It Yourself

To appreciate the speed at which your processing functions, I highly recommend checking out humanbenchmark.com's Reaction Time Test (http://www .humanbenchmark.com/tests/reactiontime/index.php.) This will give you a clear sense of just how small the increments of time we're talking about seem when you're able to measure them against the computer. My best reaction time is around 170 ms. If you're like me, it will feel a bit weird to actually butt up against the limits of your own perception. But there it is: you can't argue with the precision of the computer measuring your reaction time. It's neat that we can measure this!

The idea is that perception, cognition and action are processed separately but feed into one another, enabling a person to see the state of things, think about how to change them and then act on that impulse. Note that this is an abstraction of human cognition—nowhere in the anatomy of the brain is there a structure called the perceptual processor—but it is a useful one because it lets us put hard numbers to components of our diagram.

The perceptual processor takes the input from the senses and makes sense of it, looking for patterns, relationships and generalizations. From all the sensory data, it creates recognizable state of the world for the cognitive processor.

The cognitive processor does the thinking. It compares intended result to the current state of things and decides what to do next.

The motor processor receives the intended action and instructs the muscles to execute it. After the impulses leave the body as muscle movements, they're out into wild, wooly reality, and the process starts again with sensory perception.

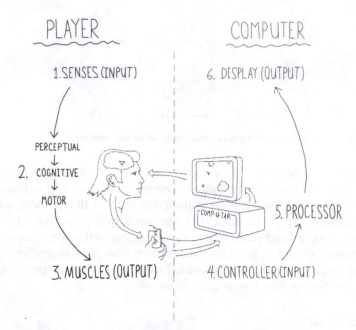

FIGURE **2.3 The three human processors in the interactivity diagram.**

All of this is happening at step 2 on our chart of interactivity, in the player's mind (Figure 2.3).

Correction Cycles and Game Feel

When all three processors (perceptual, cognitive and motor) work together in a closed feedback loop, the result is an ongoing correction cycle. A correction cycle happens any time you do something requiring precise coordination of muscles over time, whether it's picking up a book, driving a car or controlling something in a video game. Robert Miller of MIT's User Interface Design Group describes the process: "There's an implicit feedback loop here: the effect of the action (either on the position of your body or on the state of the world) can be observed by your senses and used to correct the motion in a continuous process."[1]

For example, imagine you want to reach out and grab a muffin that's sitting on your desk. You formulate intent: to grab the muffin (Figure 2.4). As soon as this intent is formulated, it is translated into action of your muscles—twist trunk in chair, activate arm muscles, open hand into "muffin claw" and so on. The moment this action starts, you perceive the position of your hand in space and see it start to move, responding to your impulses. The perceptual processor looks at where the hand is in space, passing that information on to the cognitive processor. The cognitive processor

[1]http://ocw.mit.edu/NR/rdonlyres/Electrical-Engineering-and-Computer-Science/6-170Fall -2005/8B87E671-1B67-4FEF-A655-0ABDF89F4F5A/0/lec16.pdf

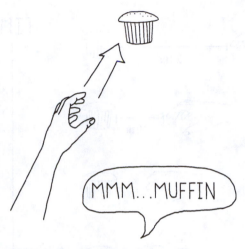

FIGURE **2.4 Intent: grab the delicious muffin.**

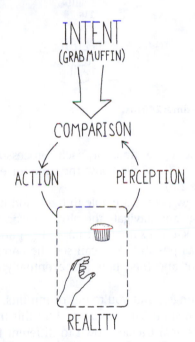

FIGURE **2.5 Grabbing a muffin: an ongoing correction cycle.**

thinks about where the hand is relative to where it should be and formulates a new plan to correct that motion. The motor processor then takes the new plan and translates it into action. From the moment movement starts to when you have the muffin in hand, you run this continuous process of action, perception and thought, increasing precision each time as a factor of distance and size of target (Figure 2.5).

39

FIGURE **2.6 Correction cycle time: 240 ms.**

Because we know the cycle time of each processor (perceptual = 100 ms, cognitive = 70 ms, motor = 70 ms) we know the time for each one of these correction cycles, 240 ms (Figure 2.6).

Correction cycles are how people are able to track and hit targets with precision, steer things, point at things and navigate the physical world successfully. To experience this first hand, check out example CH02-1. Try putting your cursor directly over the dots as quickly as possible. You can see the correction cycle in action as you overshoot, undershoot and then hone in, eventually coming to rest on your target.

Now imagine you're hungry, and you're out of muffins. You get in your car and begin to drive to the muffin store. The overall goal for this trip is to get a sweet, delicious banana muffin. This goal trickles down to different layers of intention, such as "Turn right on Elk Street." At the lowest level, it's about the moment-to-moment adjustments of the motion of the car to keep it in the lane, stop it at red lights and so on. As before, you perceive the state of the world, think about what corrections you need to make to the current motion and make the adjustments happen once every 240 ms (Figure 2.7).

The process is the same as when you were reaching across the desk except that this correction cycle goes on longer. The muffin on the desk was static and represented

GOAL: DRIVE TO MUFFIN STORE

⇓

INTENT: TURN RIGHT AT ELK ST.

⇓

INTENT: KEEP CAR IN LANE

⇓

COMPARISON

ACTION PERCEPTION

REALITY

FIGURE **2.7 The correction cycle of driving.**

a single target, a single intent. Driving to the store might take 20 minutes, fulfilling 20 different sub-goals.

In a video game, real-time control is an ongoing correction cycle of this type. As with driving a car, control is an ongoing process where higher-order intentions trickle down and become individual, moment-to-moment actions. These actions are a part of an ongoing correction cycle, where the player perceives the state of the game world, contemplates it in some way, and formulates an action intended to bring the game state closer to an internalized ideal (Figure 2.8). This happens at the same cycle time of ~240 ms.

The difference is, at the point where action normally goes out to physical reality, a video game substitutes a game world for the real world. It hooks right in there. The inputs to the perceptual processor come from the screen, the speakers and the feel of the controller. The output, instead of acting on objects in the real world directly, acts on the controller, which translates to movements of objects in the game world.

GOAL : SAVE THE PRINCESS

INTENT : REACH THE CASTLE

INTENT : STOMP GOOMBA

COMPARISON

ACTION PERCEPTION

GAME WORLD

FIGURE **2.8 The correction cycle of real-time control in a video game.**

Fitt's Law

There is a well-known formula, Fitt's Law, which can accurately predict how quickly you can move your hand to a target of a particular size at a certain distance. Fitt's Law is an unusually successful and well-studied HCI model that has been reproduced and verified across numerous studies. For reference, the formula is this:

$$MT = a + b \log_2 \left(\frac{D}{W} + 1 \right)$$

where:
MT = movement time
 a = start/stop time of the device
 b = speed of the device
 D = distance from starting point to target
 W = width of target measured along the axis of motion

The original formula predicted how long it would take to reach out and touch something of a certain size a certain distance away, as long as it was within arm's length. It was later discovered to be equally applicable to the time it takes to move a mouse cursor to an object of a particular size and shape on a computer screen, so it is applied and studied by user interface designers. For example, the menu bar in the Macintosh OS is always present and takes up the entire top edge of the screen. This means that the "size" of the menu bar is functionally infinite, enabling the user to get the cursor onto it quickly and easily, with very few correction cycles. Compare this to a tiny checkbox button or a hierarchical submenu.

The Computer Side of Things

Real-time control relies on the computer sustaining three thresholds over time:

1. The impression of motion (display above 10 fps). The frames displayed on the screen must be above 10 per second to maintain the impression of motion. The impression will be better and smoother at 20 or 30 frames per second.

2. Instantaneous response (input to display happens in 240 ms or less). The computer's half of the process must take less than correction cycle for the player. At 50 ms, response feels instantaneous. Above 100 ms, the lag is noticeable but ignorable. At 200 ms, the response feels sluggish.

3. Continuity of response (cycle time for the computer's half of the process stays at a consistent 100 ms or fewer).

The Impression of Motion

Similar to film and animation, the way that computers create and sustain the impression of motion is well understood. Think of each cycle of the player's perceptual processor as a snapshot of reality, incorporating visual, aural, tactile and proprioceptive sensations. Each 100 ms cycle, the perceptual processor grabs a frame of all these stimuli. If two events happen in the same frame—Mario in one position, then Mario slightly to the left—they will appear fused, as a single object in motion rather than a series of static images (Figure 2.9). This is perceptual fusion.

FIGURE **2.9 Ten frames per second is the threshold for the illusion of motion.**

From the computer's side of things, perceptual fusion explains how objects in a game appear to move. If the display is updated 10 times per second (100 ms cycle time = 10 frames per second) this is sufficient for the illusion of motion. This is right at the border, though, and won't feel very good—20 frames per second (fps) is better, and 30 fps is where motion begins to be pleasingly smooth. Most games run at 30 fps or higher for this reason. As game developers know, with frame rates that vary based on processing power used it's better to be safe than sorry. There's no such thing as a frame rate too high.

Instantaneous Response

Perceptual fusion also influences the impression of causality. If I flip a light switch and the light comes on within the same perceptual cycle, I will register this as a cause-and-effect relationship. My action caused the light to turn on. The same thing is true for computer response: if I move a mouse and the cursor seems to react immediately, I tend to assume that effect was caused by my action. An extension of this is the impression of responsiveness. Professor Miller describes the process: "Perceptual fusion also gives an upper bound on good computer response time. If a computer responds to a user's action within [~100 ms], its response feels instantaneous with the action itself. Systems with that kind of response time tend to feel like extensions of the user's body."

With reality, there's never a problem of lag. Response will always be instantaneous. In a game, response will never be instantaneous. Even a game running at 60 frames per second, a three-frame delay is all but inevitable. Three frames at 60 frames per second means 50 ms. (You can convert frames per second (fps) to milliseconds if you divide by 60 and multiply by 1000. So 3 frames at 60 fps is 3/6 * 1000 = 50 ms.)

Mick West, programmer-designer of the original Tony Hawk mechanic, defines this as response lag. "Response lag is the delay between the player triggering an event and the player getting feedback (usually visual) that the event has occurred. If the delay is too long, then the game will feel unresponsive."[2]

[2]http://cowboyprogramming.com/2008/05/27/programming-responsiveness/

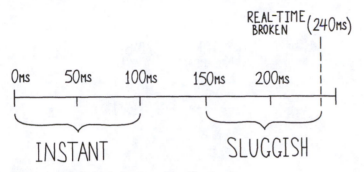

FIGURE **2.10 Response time and player perception.**

Mick notes that games with a response time of 50 to 100 ms typically feel "tight" and "responsive" to players. This is because 50 to 100 ms is within one cycle of the human perceptual processor. Above this level, a game's controls begin to feel sluggish. The progression, from responsive to unresponsive, is gradual (Figure 2.10).

Mick West on Responsiveness

Check out Mick's articles about programming for responsiveness at www .cowboyprogramming.com. He offers an awesome technical grounding for avoiding response lag as well as an engagingly practical way to measure response time in any game using an inexpensive digital camera (recording both screen and controller at 60 fps).

There's no exact point at which a game's response lag can be said definitively to have gone from tight to sluggish, because other factors, such as mapping and polish effects, can shape this impression of responsiveness. But there is a threshold above which the sensation of real-time control is broken: 240 ms. Past this response time, the player can perceive, think and act before the computer is ready to accept a new input.

Continuity

If it takes a player 240 ms to perceive, think and act, how is it that the computer has to finish its tasks and offer feedback within 100 ms for the response to seem instantaneous? This is because all the human processors run concurrently (Figure 2.11).

The perceptual processor passes information along to the cognitive processor, then starts cycling again. By the time the instructions from that original cycle have been sent out into the world as movements of the muscles, three perceptual frames have passed. In real life, this never matters because the response is always

45

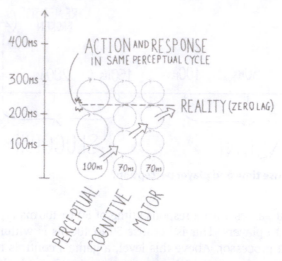

FIGURE **2.11 The three processors running concurrently, passing into reality and back with zero lag.**

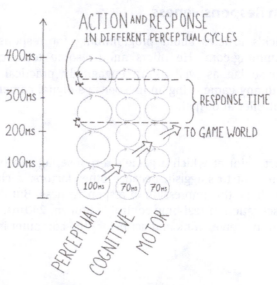

FIGURE **2.12 The three processors running concurrently, passing into a game and back. This time, there is some delay.**

instantaneous. When the motor impulse passes to a game, though, there will always be some lag (Figure 2.12).

What this means is that the game needs to update faster than the player's perceptual processor is running. If it doesn't, the feedback from the game will skip perceptual frames, and the player will be aware of the lag. The game has to enable input at any time even though the player won't be giving it all the time. This enables

46

the player to modulate an input over time, adjusting it incrementally. The steering wheel will remain pulled to the left and the car will continue steering to the left even though the player adjusts how much it's turning at 240 ms intervals. This is the threshold of continuity: the computer half of the process must update consistently at or below 100 ms for real-time control to be sustained.

Continuity is tricky to measure. Many games respond to input at some times and not at others. This can be a frame rate drop, a delay between the computer and the display or a problem with the processor being overloaded by too much awesome-ness in the game (not being able to pass frames along to the display in a timely manner). Any time the computer's half of the process takes more than a cycle of the perceptual processor, the player will notice. If it takes more than a correction cycle, real-time control is broken.

Other times, however, the delay is part of the game. For example, if I execute a fierce punch with Zangief in Street Fighter II, I lose control of the character for about 750 ms. This is longer than the threshold needed for an ongoing correction cycle by 510 ms. This temporary loss of control is ignorable, though, because I chose when to trigger that move. It becomes a risk-reward tradeoff rather than a disruption. It also makes sense in the context of the game's unique world. Big dude, heavy punch, does lots of damage. It should take a long time to execute. I knew what I was getting into. This shows that the continuity of real-time control can be broken without interrupting the player's feeling of being in control.

This makes interruption more than simply a response time too long or broken continuity. It means interruption can be smoothed over by other factors, such as metaphorical representation. Real-time control, then, is a gestalt. It primarily relies on the computer sustaining three thresholds over time, the impression of motion, instantaneous response, and continuity of response.

But the ultimate judge is the player. The designer may have done something clever with input mappings or animations to mask any interruption to the flow of control. The end result is an impression in the player's mind. If it feels like real-time control, it is.

Now let's explore perception and game feel implications for game design from a more general point of view.

Some Implications of Perception for Game Feel

To examine game feel is to see perception in a particular way. First, game feel includes many senses. Visual, tactile, aural, proprioceptive—experiencing game feel, these senses combine into one sensation. Second, the notion of proxied embodiment should be addressed. Game feel enables objects external to the body to be subsumed into body image and feel like extensions of the body. Third, game feel is an ongoing process of skill building and practice. It is part of the larger realm of human skill building and relates to skills like driving and playing tennis because it requires the same kind of repetitive practice to master. From n00b to l33t, as it were. Lastly, a model for perception for game feel needs to encompass the physical nature of game

feel. Experiencing game feel is like interacting with a surrogate reality which obeys its own rules and which must be understood through interaction and observation.

Expanding on the experiences in Chapter 1, here are five interesting ideas about perception that support our definition of game feel:

1. Perception requires action.

2. Perception is skill.

3. Perception includes thoughts, dreams, generalizations and misconceptions.

4. Perception is a whole-body experience.

5. Tools become extensions of our bodies.

Perception Requires Action

In order to perceive something, you have to see it in action. This has been verified experimentally with kittens and blind people.

The kitten study (Held and Hein, 1963) involved two groups of kittens, each raised in the dark. The first group was allowed to roam freely, while the second group was "kept passive" which we can only reasonably assume meant a Clockwork Orange style tie-down. The experimenters controlled the conditions such that both groups of kittens were exposed to the same limited stimulus: flickering lights, sounds and so on. Then, they released the kittens into a normal, lit environment. The ones who had been allowed to move around in the dark were able to function just fine, while the ones who were tied down helplessly staggered around as though blind. What this seems to indicate is that perception is an active rather than passive process. The lights and images used to stimulate the kittens didn't make much difference; being able to explore their surroundings and perceive things in motion relative to their own bodies did. To perceive, you need to interact.

Another study (Bach y. Rita, 1972) did something similar with a bunch of blind folks. The researchers created a special video-camera-driven matrix of stimulation points, shown in Figure 2.13. A TV camera (mounted on spectacle frames) sends signals through electronic circuitry to an array of small vibrators (left hand) strapped to the subject's skin. The pattern of tactile stimulation corresponds roughly to an enlarged visual image.

Each vibrator was mapped to a particular pixel of the image that the video camera was receiving, giving a sort of tactile image of what the video camera saw. When the participants were allowed to move the camera themselves, they were able to learn to "see" in a limited way. If they were not allowed to control what they were "looking" at, the image stimulus device was just a gentle, if unskilled, masseuse.

The concept that perception requires action has relevance to game feel because it accurately describes the sensation of exploring and learning your way around an unfamiliar game space. And it correlates physical reality with virtual reality in a meaningful way: the thing you're controlling in the game becomes your surrogate body, your hands. Humans are adept at learning the physical properties of a new and unfamiliar

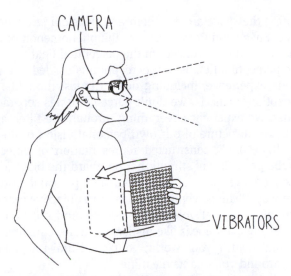

FIGURE **2.13 A blind subject with a tactile visual substitution system.**

object and do it very quickly. Noodle it around in your hands and you soak up a wealth of detail: weight, density, material, texture, color and so on. This same ability extends to virtual objects and, interestingly, to virtual worlds governed by different rules, laws and physics. For some reason, it's immensely pleasurable to suss out a new and unfamiliar world by probing around in it using a virtual instrument. The thing being controlled becomes both expressive and perceptual: as you control it and move it around, feedback flows back through it to your eyes, ears and fingers.

Perception Is Skill

If perception requires action, that action must be learned. We don't usually think of it this way, but perception is in some ways just a set of skills, honed across one's lifetime. From the moment we're born, we learn new distinctions, forge new neural pathways and generally undertake an ongoing process of becoming better at perceiving. Grab keys. Insert keys in mouth. Rinse, repeat and learn; so it goes until a fully functional adult emerges. "Perception is to a large extent an acquired bodily skill that is shaped by all our interactions with the world," as Dag Svanaes says.

Part of this process is making generalizations and learning abstract concepts like justice, freedom and cheesecake. Another part is bringing with us all experiences that came before. There's a concept from two venerable psychologists, Donald Snygg and Arthur Combs, that vividly portrays the role past experience, ideas, generalizations and fantasies play in perception: the perceptual field.[3] People have a great deal

[3]Near as I can tell, the idea started with Snygg and Combs in 1951 as the "phenomenal field." Combs changed phenomenal field to perceptual field in a later work, so we'll stick with that. I prefer that anyway, as it's more descriptive of the concept as it applies to game feel.

of practice navigating the space around them and developing relationships with the things in that space. Snygg and Combs capture the phenomenon of memory, perception and skill building with their concept of the perceptual field.

The idea of the perceptual field is that perception is carried out against the backdrop of all previous experience, including our attitudes, thoughts, ideas, fantasies and even misconceptions. That is, we don't perceive things separately from what's come before. Rather, we experience everything through the filter, against the background, and within the structure of our own personal vision of the world. Another way to put it is this: "one's constructed representation of objective reality; the meaning given to the profusion of stimuli that bombard the brain and are organized and conceptualized on the basis of individual and personal prior experiences."[4] And still one more way: "The perceptual field is our subjective reality, the world we are aware of, including physical objects and people, and our behaviors, thoughts, images, fantasies, feelings, and ideas like justice, freedom, equality, and so on."[5]

So your perceptual field is your world; your structural understanding of everything you perceive around you and its meaning.

This is a cool idea because it goes a bit beyond the notion of a simple mental model, which is more about the dry, clinical details of how a person thinks a thing functions (usually compared to the system image, the way the thing actually functions).

In the case of a video game, the brain recognizes that the "world" of the game is a subdomain, a microcosm of the larger perceptual field of reality that it understands. It's apportioned, separate and obeys its own rules. At the same time, the mind brings all its past stored experiences to the table to help it understand this new place.

The difference is that a game world is not necessarily governed by the rules of physical reality or bound by them. This is a useful way to think about the creation of game feel—as the creation of a separate but related physical world. Simplified, but whole, cohesive and self-contained. Many times, creating and tweaking a game feel system means literally the construction of a set of generalized laws and rules that govern all action within the system. It's like writing your own universe from scratch: you have your own gravity, your own simple momentum and friction, your own simplified definition for what collision between two objects means and how it should be resolved.

The world around you is objective and immutable. You're not going to wake up one morning and discover that gravity has suddenly stopped working as expected. I throw a grapefruit at a wall, it's going to hit the wall with a thud and fall to the ground. This kind of consistency can be frustratingly difficult to achieve in a game world.

Because the way we cope with and understand events in a game world is so similar to the way we interact with the real world, we expect the same consistency. The tiniest thing can break this perceptual immersion.

[4]http://phenomenalfield.blogspot.com/
[5]Dr. C. George Boeree, http://webspace.ship.edu/cgboer/snygg&combs.html

Unlike a film, which presents one framed perspective on a world and has only to maintain visual and aural consistency within that frame, a game has to stand up to active perception. The player can freely explore every possible permutation of every action and response in the entire world. This is the skill of perception, the one every human being has been constantly honing since birth.

Because people are extremely skillful at perceiving the world around them, any tiny inconsistency becomes glaring and obvious. A character's foot clipping through a stair, an invisible wall—these things never happen in the world around us. So this process of discovery is much closer to our experience of being in the world than the experience of passively viewing a film or reading a book.

The same mechanisms we use to cope with the world around us, to understand it and function within it, come into play when exploring a game world. It is the same process of expanding the perceptual field into this new world and probing around to make the generalizations and distinctions needed to interact with and succeed in the world.

This is why a consistent abstraction is so much more important than a detailed one. It's fine to create a simplified version of reality for players to interact with; they'll figure out the parameters of the world—its constraints, rules and laws of physics—within minutes of picking up the controller. Just don't violate the rules you yourself have set. If an object is portrayed as being large, heavy and massive, don't let it go flying off into space with the slightest touch, or pass through another object without interaction. Easier said than done, of course, but this is at some level a designer's decision. Better to have a simple, tight, cohesive world like Dig Dug than a weird, inconsistent world like Jurassic Park: Trespasser. People are going to figure out everything about your world either way—our physical reality is much more complex and nuanced than any game world, and we've got years of experience at perceiving it—better to make it simple and self-consistent than a broad inchoate mess.

Perception as skill is also correlated to the way people get better at things over time. You practice something, you get better at it. Your perceptual field includes an ever-growing body of experience about the task, which makes each new try at the task easier. It's not just a bank of information to draw on, but affects what happens at the moment-to-moment level of perception and action. Chris Crawford would say that the neural pathways are getting pushed farther and farther down, away from conscious processing and into subconscious, automatic processing.

Merleau-Ponty defines this distinction as abstract versus concrete movements. If an action is unpracticed and requires conscious thought and effort, it is an abstract movement. If it's so practiced that it happens automatically and without conscious thought—a pure translation of intent into action—then it's considered a concrete movement. By this process, people learn things incrementally over time, turning what was once difficult and requiring deep, conscious involvement, into an easy and subconscious action. Clearly, this is what happens with game feel, though the process is almost always much quicker when learning a game skill.

However we conceptualize it, it is obvious that humans get better at skills they practice. And if we consider all perception to be a skill, this handily explains why

game feel seems like such a skill-driven activity, why skill learning is the price of admission to experience it. Perception in a game world is just a simplified, modified version of perception in the real world. The rules are different, but the process is the same.

Perception Includes Thoughts, Dreams, Generalizations and Misconceptions

Another interesting offshoot of the concept of the perceptual field is that it encompasses not only physical reality, but attitudes and ideas. Perception of something is heavily influenced by biases, ideas, generalizations and worldview, all of which have become incorporated into the perceptual field through a lifetime of experiences. Of course, generalizations about a particular thing may not accurately reflect the objective reality of that thing.

For example, I have a central heating and air conditioning system in my apartment. One day I was cold and wanted to adjust the temperature. The wall mounted control unit displays the current temperature based on a thermometer which is ... somewhere in the apartment. I hope. I think. The current temperature is compared to a sliding blue control representing the desired temperature. I assume that if I move the sliding control to a temperature different from the actual temperature, the air will turn on and will adjust the temperature. The current temperature reads 61°. I move the control from 63 to 75. The cold air turns on briefly and then turns off. A few minutes later, the air turns on for a longer period, blowing warmer air, then turns off. Eventually I get fed up and turn the temperature to 90°. Again, the air turns on for a few minutes, warm, and then turns off. I get a blanket. An hour and a half later, I walk into my office, the door of which has been closed and I'm suddenly sweltering hot and realize I've left the temperature on at 90°. I toss the blanket, strip down to a T-shirt, and check the thermostat, which now reads 77°. I put the thermostat back down to 72. The air turns on for a few minutes, cold, and turns off. Gah!

What's going on here? In my conceptual model of the heating system, there is a certain threshold between the actual and desired temperature. If that threshold is exceeded—if the desired temperature is 3° above or below the actual, for example, the system turns on and applies an amount of heat or cold equal to the change in temperature that's necessary to bring actual back in line with desired.

The reality of the system is that it turns on and blows air, either hot or cold, for a certain duration. Five minutes of hot or five minutes of cold, depending which way the temperature is supposed to go. The hot isn't particularly hot, and the cold isn't particularly cold, but applied across a long enough time scale, they get the job done. In addition, the timer that governs how long each on state should last functions independent of the controls. That is, it's always counting down five minutes at a time. If you switch the heat on with 30 seconds remaining on its five minute cycle, you get 30 seconds of cold air because it takes a while for the heater to warm

up and there are only 30 seconds of "on" remaining before the system goes back to the off state. (Oh, and the thermostat, evidently, is in the office.)

Donald Norman would say that my mental model is out of sync with the "system image" of the heating system. I hold in my mind a logical construct, a picture of how the system works, but that picture is wrong. This construct frames my interactions with the system and dictates my expectations about what the result will be for a particular input. If my mental model differs from the system image, the way the system actually functions, errors occur. Norman would say that this is the designer's fault and go on to point out that the "design model"—the way the designer imagined the user would interpret the system—is out of sync with the user's mental model. This is definitely applicable to game feel as it helps greatly in designing what players refer to as intuitive controls. Norman suggests seeking out and exploiting "natural mapping" between input device and system.

For example, in Figure 2.14, Stove C makes more sense than stoves A and B and is far easier to operate because there is a clear, spatial correlation between the position of the knobs and the position of the burners they operate. Finding natural mappings in games is a similar process, though not always an obvious one. I like the

FIGURE **2.14 Three configurations offer three different correlations between stove burners and controls.**

FIGURE **2.15 The motion of the thumbstick in Geometry Wars offers a simple and clear connection to the action taken by the ship.**

example of the game Geometry Wars, which tends to be easy for people to pick up and play effectively—the movement of the thumbstick corresponds very obviously to the motion of the little ship in the game making this something of a natural mapping, albeit one in a virtual space (see Figure 2.15).

The only problem with Norman's concept of the mental model is its rigidity. To say I have a mental model of the world of The Legend of Zelda: The Wind Waker could be useful to isolate and tune certain mechanics, to eliminate ambiguities and make the controls more intuitive, but it ignores the fact that I have a relationship to that world. I feel a certain way about it and think a certain way about it, and breaking that down into a dry, clinical, logic diagram seems to ignore some of the most important parts of that relationship, some of the parts the designers understood and worked really hard to develop.

For example, it's extremely important to the success of the game that I feel a sense of freedom and adventure while sailing the open seas in the game. I could

distill that to a system image of my possible actions while sailing, but that would miss much of the point; it's not as important to track exactly how far objects are spaced apart or how far I can sail in one direction before hitting something or how long it takes to get from object to object as it is to make the space of that world feel open, free, but full of possibility. I can sail aimlessly in a particular direction and be certain of two things: 1) I'll be free to sail as far as I want in that direction and 2) eventually I'll find something new and interesting. The system, speed of the ship, sharpness of turning, distance between islands and so on, would be interesting to track, as would a player's mental model of that system. But it definitely misses one of the essential experiential qualities of the game. A few small changes to the system, making the ship move 20 percent slower for example, could make the oceans of Wind Waker feel imposingly large, tedious or lonely. The idea of a perceptual field that incorporates not only the system image, but the thoughts, ideas, feelings and generalizations about the system that players have brought with them, and is constantly forming and reforming, is a much more effective for understanding that experience.

Another important thing that Norman's mental model concept ignores is paradigm shifts. "Aha!" moments, as master puzzle designer Scott Kim would say. For example, another Zelda game I've been playing recently is The Legend of Zelda: Phantom Hourglass for the Nintendo DS. In that game, there is a particular puzzle that requires players to expand their perceptual field. In one particular part of one temple, players are told to step up to an altar and "stamp" their "map" with the location of a new area to be explored later (see Figure 2.15). At first, this puzzle threw me for a loop.

To access new areas in The Legend of Zelda: Phantom Hourglass, you first need a "sea chart" for that area. The new location to be stamped is outside of your current available areas, but clearly corresponds to the map you've had access to and used throughout the game. I systematically exhausted each possible action I had ever used in the game, and then some I'd only ever used in other games. I pressed buttons, I scrubbed the stylus back and forth in every conceivable pattern. I drew X's and O's, I traced the pattern of the Triforce over and over again. Nothing in my perceptual field equipped me to deal with this puzzle. Clearly, my current understanding of this system was inadequate and flawed somehow. I had to take a step back and reflect on my perceptual field. So I started thinking about other possible interpretations of stamping, and other possible ways I might stamp this stupid map, short of putting the DS on the floor and stamping it with my foot. The solution eventually occurred to me: close and open the DS quickly. It's sort of a stamping motion, as you can see in Figure 2.16.

The problem was my perceptual field: in my combined understanding of the DS, how the DS functioned and the possible actions in the game, there was no reference point for using the functional opening and closing of the DS as an action in the game. Across all my experiences with playing DS games—which are numerous—I had never come across a game that used the functional closing and opening of the DS' lid as a button. New Super Mario Brothers says "Goodbye!" in Mario's voice if

FIGURE **2.16 Closing the DS as an input = unexpected.**

you close the lid of the DS while the game is still on, but that was my only point of reference, my only hint in the entirety of my perceptual field. I solved the puzzle through a paradigm shift, by seeing the system in a new and different way. I felt a rush of pleasure and enjoyment as I incorporated this new information about the very nature of this game's universe into my perceptual field. I had amended and changed my mental model not only of this particular game, but of all games I'll ever play on my DS in the future. This was not an error or a breakdown in my ability to interact with this system, but the point of the puzzle and, in some sense, the whole game.

So what's going on here? I was rewarded with pleasure by expanding my perceptual field. Norman's mental model would call this an error, blaming the designer for misleading the player. Since this is one of the fundamental pleasures of playing this game, clearly something's missing. The perceptual field gives us a way to understand that game feel is as much about how players feel about a particular space and their relationship with it, as it is about the dry clinical details of the mental model of that space they keep in their minds to help them deal with and understand events in that game world. The dry details are important—they represent the player's understanding of the physics and rules of the game world and are a great way to find dissonance that causes player confusion—but they are not everything.

Perception Is a Whole-Body Experience

Eyes, ears, tactile sense, proprioception—there is no separation when a person perceives something.

For example, a fork. It's shiny and it has a pointy end. It's cold, hard and solid, but easy to pick up. I can eat food with it. It sinks in water. My ideas and perceptions about what that object is, how it behaves and what it means, combine into the concept of "fork." This is my attitude toward forks and generalizations I can apply later to other fork-like objects. The subconscious nature of perception masks a complex process, one which involves all the senses and which constantly and rapidly brings us closer to the world we inhabit.

The takeaway here is not to think of each kind of stimuli as somehow separate, but as an integrated part of perception. This is how a combination of visuals, sounds, proprioceptive sensations (from the position of the fingers on the controller or whatever) and tactile sensations (from controller rumble or haptic feedback) become a single experience in a game. A game world substitutes its own stimuli for those normally created by interacting with the real world, but the experience of perception is much the same. This also indicates why we're so sensitive to inconsistencies between stimuli. If a large hulking mass of a character steps through a staircase or has their arm pass through a wall, the brain says, "Hey, that's not right!"

The experience of perception of real-life phenomenon never has inconsistencies across stimuli so the brain has a hard time ignoring them when they happen in a video game.

Tools Become Extensions of Our Bodies

As we said in Chapter 1, a tool, once picked up, is an extension of the senses. It is used for both action and perception. Intent and action can be expressed through the tool as though it were a part of the body, and feedback flows back through it.

Another way to visualize this is to think about a blind man's cane. When the blind man first starts using a cane, it is unfamiliar and requires a lot of reflection. The tapping movements are unpracticed, abstract movements to him. As he gradually builds skill at perceiving the world through the cane, he is able to more accurately and effortlessly tap around, getting a clearer read on his surroundings. His intent begins to flow effortlessly from the cane, any barrier between himself and the cane is removed, and the cane becomes an integrated part of his perceptual field. The cane now acts just as his hand would; it probes around, touching things, interacting with the world around him and returning him crucial orienting feedback. This helps him establish a much larger personal space (also sometimes called the "perceptual self"). Quite literally, his perceptual field has been extended to a much larger physical area around him. Effectively, he's made his arm's reach much greater. We might say that by integrating the tool of the cane, he's changed his world.

So what does the blind man and his Cane of Reaching +3 teach us about game feel? One interesting distinction is between body space and external space. When we interact with the world, we perceive our bodies in two ways, as part of our self and as one object among the many objects of the external, objective world. As Dag Svanaes puts it: "The bodily space is different from the external space in that

57

it exists only as long as there are degrees of freedom and a skillful use of this freedom. The bodily space is mainly given by the subject's specific potentials for action. For a totally paralyzed body with no kinesthetic experiences, there is no bodily space. Different bodies give rise to different spaces, and so do external factors such as clothing, tool use and different kinds of prosthesis. It is important to notice that learning a new skill also changes the body space."

This idea, that bodily space is defined by the potential actions of one's body in the world, correlates very clearly to the way players interact with game worlds. Players tend to think in terms of abilities and constraints within a game world. It is possible, and often desirable, to create a game where abilities change across time, where the avatar itself has different tools that change across time. For example, if I'm playing as Samus Aran my abilities, my "bodily space" as Samus within the game world of Metroid, are defined by the abilities currently available to me. I may or may not have the Morph Ball. If I do, I can transform into a small rolling sphere and explore tiny corridors. The very nature of the world has changed, as has my potential to interact with it. The objective world of Metroid is the same as it ever was—every block is still in the same position it was before. My abilities, my verbs, my virtual bodily space have changed the world.

The interesting thing about this thinking is that it does not consider Samus Aran a tool. To say that we can incorporate a tool into our bodies, that the tool can become an organ of expression and perception, and that our identity and perceptual field subsume it is useful, doesn't quite define what happens when a player takes control of an avatar in a game. I wouldn't call Samus Aran a tool. Not just because she has an "identity" as a freestanding character that I'm temporarily inhabiting and controlling, but also because she has her own bodily space. She has her own tools which can become a part of her body and extend her own perceptual space. In this way, a video game world is truly a microworld, and perception within this microworld is a surrogate for real-world perception. It's an interesting idea—it seems to explain why identity in a video game is so very malleable. You can go from "being" Gordon Freeman one moment to cursing his vile clumsiness the next. This is because the constructed subdomain of a video game reality provides two other kinds of spaces: virtual bodily space and virtual external space.

A video game has its own model of reality, internal to itself and separate from the player's external reality, the player's bodily space and the avatar's bodily space. The avatar's bodily space, the potential actions of the avatar in the game world, is the only way in which the reality of the external reality of the game world can be perceived. As in the real world, perception requires action. The difference is that the action in the game world can only be explored through the virtual bodily space of the avatar. Players extend their perceptual field into the game, encompassing the available actions of the avatar. The feedback loop of perception and action that enables you to navigate the world around you is now one step removed: instead of perceiving primarily through interaction of your own body with the external world, you're perceiving the game world through interaction of the avatar. The entire perceptual apparatus has been extended into the game world.

To wrap back to our earlier discussions of identity and game feel, how does this concept of avatar as perceptual substitute, rather than extending tool, relate to proxied embodiment? Because a game world represents its own reality external to its avatar's bodily space in the same way that the physical world is external to our own bodily space, it seems much more like a substitution than an extension. The same might be said for identity. We said that objects outside ourselves—and objects in a game world—can become extensions of identity. Vessels for identity might be more accurate. The view of tool as extension of body defines the "self" is in terms of perception. The perceptual self is the immediate surrounding environment and your ability to interact with it, your potential for action. To say "he hit me!" instead of "he hit my car" or "his car hit my car" is an artifact of the way we perceive the immediate environment around us and the fact that an inanimate object can become a part of the perceptual self, part of the perceptual field. You literally perceive the world through the car as you actively control it. Again, though, the way we perceive game feel seems to be much more of a substitution than an extension. I perceive the world of Hyrule as Link, via his virtual body space. My identity intermingles with Link's as I take over and make my own his skills and abilities, his bodily space.

Summary

Where and when does real-time control exist? On the human side of the equation, we categorized three types of processors (perceptual, cognitive and motor), which work together in a closed feedback loop. This feedback loop results in an ongoing correction cycle. In a video game, at the point where action normally goes out to physical reality, the designer substitutes a game world for the real world. This reinforces the idea from Chapter 1 that game feel is an experience of a unique physical reality.

On the computer side, real-time control relies on sustaining three time thresholds: the impression of motion, perceived instantaneous response and continuity of response. Knowing the duration of the human correction cycle and the relationships between the three human information processors, we can say with certainty that a particular game has or does not have real-time control. The unknown variable here is the player's perception. In the end, game feel is an impression in a player's mind. Examining the frame rate, response time and continuity of response in a game and comparing this to the thresholds of 10 fps for motion, 240 ms for control and 100 ms for continuity gives us a baseline and is useful for classification. But motion at 10 fps feels stilted and a 200 ms response time feels sluggish. These impressions can be smoothed over by the use of gestural input or by playing back animations. In the end, the player's perception is what's important. The ultimate goal for game feel is to create an impression in the player's mind.

Finally, we looked at some of the other implications of human perception:

1. Perception requires action.
2. Perception is a whole-body phenomenon.

3. Perception is an effortless fusion of visual, aural, tactile and proprioceptive stimulus.

4. Perception is an ongoing process of skill-building.

5. Perception can be extended to tools.

These explain, in terms of human perception, the experiences outlined in Chapter 1. Understanding how human perception works offers us insight about the imperfect apparatus of human perception that we're designing for. Knowing this will help us to develop a palette of game feel that's separate from the emulation of reality and doesn't borrow from film or animation except where applicable. If we understand how perception works, we can build games that feel good instead of trying to build games that feel like things that feel good.

THREE

The Game Feel Model of Interactivity

Now we are ready to create an overall model of what game feel looks like. If we take the building blocks of game feel from Chapter 1, plus the five experiences of game feel we categorized, and add them to the interactivity diagram from Chapter 2, with its three human processors (perceptual, cognitive and motor), we have a model of game feel that looks like Figure 3.1.

The perceptual field is your constructed model of objective reality, of the "real" world around you. It provides the background for perception, whether in the game or in the real world. Shimmers of former experiences, skills learned, ideas, generalizations, thoughts, concepts, fantasies and misconceptions all form the construct within which perception occurs. Sometimes, when it's clear your perceptual field is inadequate to deal with a particular situation, you consciously reflect on your understanding of the world around you in an effort to expand your perceptual field. You try to find the holes in your comprehensive model of objective reality. This can be a pleasurable process, as when you undergo a paradigm shift to solve a puzzle, or a stressful one, such as when you lose your keys in the sofa.

The game world is a simplified subdomain of the real world. Your brain substitutes the stimuli it's getting back from the game world for those it normally gets from the real world. This includes sights, sounds, tactile sensation such as controller rumble and joystick or button push-back and the proprioceptive feedback it gets from the position of your fingers on the input device. All this feedback is extrapolated to a mental construct of the microworld represented by the game. This is an abridged, simplified version of the process by which you experience, learn about and cope with the physical world around you. As such, it includes not only the tactile, visual and aural experience of exploring the game world, but the higher-level implications of those experiences. For example, if my character always falls back to the ground after jumping, I assume there is some kind of gravity. If my character runs into things instead of passing through them, I assume those things are solid. As in the real world, simple interactions yield a wealth of

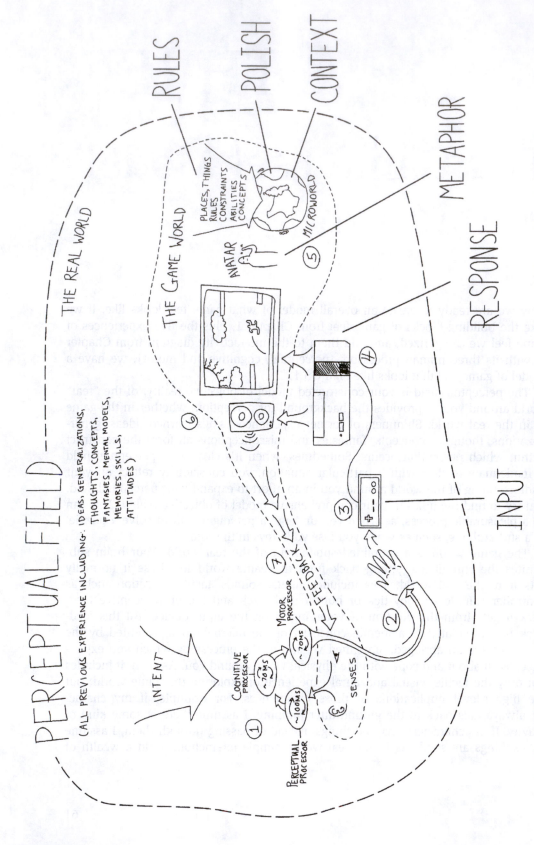

FIGURE **3.1** The model of interactivity brings together all the elements of the the gamer, the game and the world around him or her.

knowledge: generalizations, ideas, concepts and misconceptions about the nature of the world. All of these things are integrated into the perceptual field as they are experienced.

The avatar is the player's instrument within the game world, both for perception and for expression. The movement of the avatar provides indirect insight into the nature of the game world the same way our own hands may touch and probe and noodle things around in order to experience them while our eyes and ears observe the results. Perception requires action, as we've said, and all perception of a game world must pass through the avatar.

With those three elements in mind, let's step through Figure 3.1 and try to "bring alive" the active process of game feel. Remember, this whole thing is happening at a cycle time of around 240 ms, four or five times per second. Let's start with the human processor—the player.

The Human Processor

The human process is marked at "1" in Figure 3.1. Stimulus comes in through the eyes, ears, fingers and proprioceptive senses. It is perceived at a cycle time between 50 and 200 ms, depending on individual and circumstance. If two stimuli are perceived within the same perceptual cycle, they appear fused, as with multiple frames of an animation fusing into a single, moving character. If an action passes out through the motor processor and the response is perceived in the same perceptual frame, there is a strong bias toward experiencing action and response as causal ("My action caused this result").

If this is an ongoing process, where perception, action and contemplation of the same object happen in rapid succession over and over again, the experience is one of control fusion—through my actions, I feel I am controlling something external to me. This is what enables us to pick things up and move them, to throw and catch things, and to generally interact skillfully with our immediate bodily surroundings.

When this process of ongoing control is able to flow uninterrupted and the intent being served is more complicated than a single, simple action (grabbing a muffin, for example) then we have a correction cycle, which happens around 240 ms and which is, at its core, the experience of game feel. As this process is running, the perceptual field is in the background coloring, ordering and assigning meaning to all new experiences. As soon as the experience happens, it is incorporated into the perceptual field, expanding it. Skills are built, memories are formed, life is lived.

Muscles

Marked at "2" in Figure 3.1, the impulses from the human processor flow out into the real world. The muscles of the hand execute the orders handed down by the motor process, which has in turn been directed by the cognitive process. In

addition, the hand provides tactile and proprioceptive feedback to the perceptual processor, the "megaphone for your thumbs" mentioned in the Chapter 1 section on game feel as proprioception.

Input Device

The input device is marked at "3" in Figure 3.1. The input device is the player's organ of expression to the computer. All intent passes through the filter of the input device before it can be interpreted by the system and used to update the state of the computer's model of the game's reality, which is different from the player's. The motivation and experience of the player are more complicated than this in many ways, but if the goal is to better understand the pieces of game feel that are malleable to the game designer, it's convenient to think in these simplified terms. The player has a particular intent at a given moment in time, and he or she expresses that intent to the system via the input device. Whatever the input device is, it has affordances and constraints. It will lend itself to controlling certain kinds of motion more readily than others and has its own physical feel and character which will ultimately affect the experience of game feel as perceived by the player.

The Computer

The computer is "4" in Figure 3.1. In one sense, the computer does its own perceptual, cognitive and motor processing. It accepts input at a certain rate, thinks about it for a certain amount of time, and then responds, sending signals to its output devices. As with the human processors, the computer has a cycle time for this whole endeavor. In the case of the computer, though, the response needs to happen quickly enough for the player to perceive the response as instantaneous—within one perceptual cycle (as little as 50 ms) of receiving input from the player.

For game feel to occur uninterrupted, input from the player's muscles needs to travel through the controller, be processed and come back as changes in pixels and sounds before one entire cycle of the player's perceptual processor has finished. The computer needs to perform its half of the cycle faster than the player can perceive. If this occurs, the player will see the series of incrementally changed visual frames as a single moving object and will feel it reacting immediately to the input. The player will readily interpret a cause and effect relationship, and the impression of control is complete.

The Game World

The game world is marked "5" Figure 3.1. For our purposes, the game world exists primarily in the player's mind. There is also an internal representation of the game world that exists in the computer, one which is more precise and mathematical than

the rich, expressive world experienced by the player. But a game system is designed to output to an experience in the mind of the player. For the player, the output devices are a window into the game world, and the avatar acts as a proxy within that world. The player perceives the game world actively, through the "body" of the avatar. Experiencing game feel is feeling out the game world, making additional distinctions, and learning skills, concepts, and generalizations that make coping with the unique world easier.

This is essentially the same process we undergo in our everyday lives. A game world slots itself into the player's action → perception → cognition cycle, replacing the physical world's roles of accepting input and returning feedback. A game world is simpler, easier to understand, and has clear, finite goals. This makes learning game skills faster, easier to measure, and, in many ways, more appealing than real-world skills.

Output Devices

Marked at "6" in Figure 3.1 is the output device. The output devices, which may include a monitor, speakers, controller's rumble motors, haptic feedback device and so on, are the player's window into the game world. The monitor and speakers are where the processing of the computer reaches reality. They are the computer's organs of expression to the player. The completed processes have resulted in an updated system state for the computer, and it sends visual, aural and tactile feedback out through its various channels into the world and, as we looked at in Chapter 1, the position of the hands or other body parts on the input device offers the player proprioceptive feedback which can be reconciled with what's happening on the screen or coming through the speakers. Moving my thumb this far moves the character too fast, so I subconsciously ease off the thumbstick by a millimeter or two.

The Senses

The loop is complete at the player's sense, marked "7" in Figure 3.1. The senses take in the updated state of the game world. The eyes, ears and hands (both tactile and proprioceptive senses) perceive the new, changed state of the game's reality and pass them along to the perceptual processor. The cycle, having taken less than half a second, is complete. The motions are amplified into the game world but still have a real-world position that's being perceived by the hands via the proprioceptive sense.

I'm keeping the Model Human Processor and meshing it with the perceptual field. In my model, the perceptual field is fused with the perceptual and cognitive processors, being at once a filter for new perceptual information, a framework in which to slot it, and an ever-expanding reference library which contains not only information about the meaning to assign each new stimulus but your schematic diagrams of your world and everything in it.

The Player's Intent

To complete our model, we need to account for intent. On one level, it's an interesting question: where does intent come from? What motivates us to do what we do? This question is perhaps more satisfying as applied to game worlds because it can be answered definitively. Intent in a game world is designed by a game's creator; we don't have to wonder at its origins, divine or otherwise. As for real-world intention, French Philosopher Maurice Merleau-Ponty thinks that people have an "in-born intentionality towards the world." To say: "we're born with it,'" though, seems like a bit of a cop-out.

Maslow has some more interesting things to say about the nature of human motivation with his pyramid of wants (see Figure 3.2). At the bottom are things like satisfying your basic physical needs for food, shelter and warmth. Moving up, you find security, love, self-esteem and, finally, self-actualization. The idea is that at any time, if one of the lower rungs is unsatisfied, consciousness dips down to that base level until that need is sated. People are constantly trying to reach higher and higher on the pyramid, striving for creative satisfaction and whatnot. Sims, it seems, have a hard time getting above the toilet level.

The pyramid fits with how Snygg and Combs incorporate intentionality and motivation into their perceptual field. They envision a "perceptual self"—the vision of yourself that exists as part of your own perceptual field. This is a cool concept, as it seems to explain things like those self-immolating Tibetan monks from the Rage Against the Machine album cover. A person can do things that don't seem to serve his or her body very well—lighting oneself on fire being one possible example—but which enhance the perceptual self. You see yourself as a martyr, dying for a

FIGURE **3.2 Maslow's hierarchy of needs starts with the basic physiological needs and moves upward to self-actualization.**

cause greater than yourself. Thus your own self-image, the embodied qualities of yourself as you perceive you, is enhanced. And made more crispy.

Whatever the origin of human motivation is in reality, though, it is true that part of game design is crafting goals, implicit or explicit, to motivate action in game worlds. This is one of the dark arts of game design—creating meaningful, compelling intent from a seemingly arbitrary collection of abstracted variables. Think, for example, of the coins in Super Mario 64. Ask yourself: if you didn't get a star for collecting 100 coins or if they did not restore Mario's health, would you bother collecting them? No, of course not. These are the arbitrary relationships between abstract variables that give coins meaning in the game world of Mario 64. The star itself is given meaning only by being rare and powerful, one of only 120 in the whole game, each of which is a clear, measurable step toward unlocking the entirety of the game's levels, the (explicit) goal of defeating Bowser or the (implicit) goal of collecting all the stars.

This is one of the most appealing aspects of video games for many players. A game world's logic is simple, easy to understand, and provides clear incentives, rewards and feedback for effort invested. It's safer than the chaotic and arbitrary nature of everyday life. It's comforting. In many cases, it rewards mediocrity or at least makes it ignorable. Whether this is good or bad is a different question, but it is worth noting that most game worlds do in fact have in-born intentionality, and it's the game designer who creates it.

Summary

The game feel model of interactivity offers a comprehensive picture of how game feel occurs as a process. Each element involved in the process—the human processor, human muscles, input device, the computer, the game world, output devices, the senses and the player's intent—is necessary to keep the cycle running.

1. The human processor—where perception and thinking happen and motor instructions are created.

2. Muscles—The motor instructions are executed as muscle movements.

3. Input device—The muscle movements are translated into a language the computer understands.

4. The computer—Where all processing happens, including integration of input with the current state of the game world.

5. The game world—The computer's internal model of the game's reality.

6. Output devices—The updated game state is output into a form the player can understand.

7. Senses—The player perceives the updated state through sights, sounds, touch, and proprioception.

The player's side of things does not change because of the fixed properties of human perception, which limits the game designer's area of influence. On the computer side of things, a designer is unlikely to have a role in creating the input device, the computer or the output devices. The game designer's palette, then, is contained within steps 4 through 6.

Examining all the pieces in a cohesive model, we can finally make a firm delineation between games that have game feel and those that don't. The model provides a framework for understanding where things might be improved in a particular design, and a foundation for creating game feel from scratch.

CHAPTER FOUR

Mechanics of Game Feel

To wrap up our section on defining game feel, let's apply all the ideas from Chapters 1, 2 and 3 to some specific games. To do this, we'll return to our three-part definition of game feel: real-time control, simulated space and polish. The overall question to be answered is where a game fits on the diagram (Figure 4.1).

This breaks down, once again, into three questions:

1. Does it have real-time control?
2. Does it have simulated space?
3. Does it have polish?

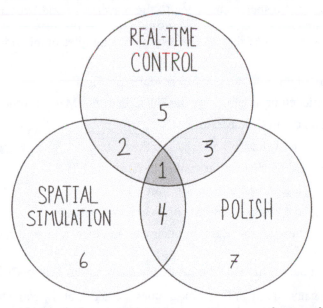

FIGURE **4.1 Types of game feel: we want to put every game somewhere on the diagram.**

From our model, we have measurable thresholds for real-time control to test against:

- 10 frames per second. The images are displayed at a rate faster than one cycle of the human perceptual processor, which will be 50 to 200 ms. Therefore, images displayed at a rate at or above a rate of 10 frames per second will appear fused into motion, and 20 frames per second or higher is necessary for a smooth motion. In the case of a game, this is not a series of linear frames played back in sequence but a series of states generated in response to input.

- Response time of 100 ms or less. The game's response to input happens within one perceptual cycle (50 to 200 ms) of the player's action, fusing into a sense of causality and instantaneous response.

- A continuous feedback loop. The game provides a continuous, unbroken flow of input and instant response, enabling ongoing correction cycles to occur.

But these metrics are difficult to apply to an entire game's interactivity all at once. To answer the question of real-time control more easily, it's useful to break down a game's interactions into individual mechanics. Then we can check each mechanic against the various thresholds from our model.

Mechanics: Game Feel Atoms

For our purposes, a "game mechanic" is one complete loop of interaction, such as a single mouse twitch, button press or foot stomp that can be traced through the game's programmed response and back to the player over and over again. Another way to think about mechanics is as verbs. What are the player's abilities in the game? What can the player do? By this definition, examples of individual mechanics include:

- Pressing the A-button to jump in Super Mario Brothers
- Steering Mario left and right using the D-Pad in Super Mario Brothers
- Strumming a note in Guitar Hero
- Using the mouse to steer left and right in flow
- Boosting forward by clicking the mouse in flow
- Drag-selecting a group of units in Starcraft
- Clicking to send a group of selected units to a new location
- Pressing a button at the right moment to advance to the next sequence in Dragon's Lair
- Clicking on a button to select the next technology to research in Civilization 4

In a typical game, many different mechanics are active at the same time and often overlap and combine. Running and jumping in Super Mario Brothers are separate

mechanics by our definition. But they combine to become a whole greater than the sum of their parts.

Mechanics can also change over the course of a game. For example, gaining a skill point in Tony Hawk's Underground makes your skater move forward faster. Mechanics can also come and go over the course of a game. In Half-Life, the player finds new weapons gradually, but then loses them at the halfway point of the game. Super Metroid gives the player a bunch of mechanics up front, then takes them away a short time later, forcing the player to start from scratch.

The question is whether or not each individual mechanic meets the criteria of real-time control and whether the system as a whole sustains real-time control.

Knowing whether a game has real-time control is most of the challenge. From there, it's just a matter of asking whether the game has literal simulated space, if the player perceives that space actively, and if the polish effects are used to emphasize physical interactions in that space.

Applying the Criteria

To put our definition to the final test, we'll apply it to four games: Street Fighter II, Prince of Persia, Guitar Hero and Kirby: Canvas Curse. Each game is on the fringes of our definition in its own way.

Street Fighter II

There are three primary types of mechanics in Street Fighter II: walking, attacking and jumping. The walking mechanic responds within 100 ms when the joystick is moved left or right, and it allows a sustained correction cycle. Input is constantly accepted, the game responds within 100 ms, and there is no lockout period. As soon as I perceive the result of my last action, I can adjust it with a new input. The movement mechanic has real-time control.

The "attack" mechanics—when the player presses one of the six attack buttons—have interrupted continuity. Pressing a button plays back an animation, which changes the shape of the avatar. The response time when the button is pressed is instantaneous, but then the player is locked out of further input until the animation is complete. For the "light" attacks, the duration is very short and will not interrupt the correction cycle of the walking mechanic. The heavy attacks can take almost one second to complete, however, disrupting the continuity of control. Either way, pressing a button to trigger an animation is not a continuous correction cycle. The attack mechanics do not have real-time control.

The jump mechanic adds upward force to the player when the joystick is pressed up. Once the jump has started, the player cannot alter the trajectory of the jump. This temporarily takes control away from the player, breaking the correction cycle of the movement mechanic. After leaving the ground, however, the player can still trigger attacks. This mitigates the fact that the player's correction cycle is temporarily

FIGURE **4.2 Street Fighter II has game feel.**

broken, as does the fact that the player gets to choose when to start the jump. The player feels they have real-time control over everything. The whole system, combining the movement, jumping and attack mechanics, has real-time control.

Street Fighter II also has simulated space. The characters collide with the ground, the edge of the screen and with each other. These interactions are perceived actively by the player, through the correction cycle of the movement mechanic.

Finally, the polish effects in Street Fighter II—the sounds, particle effects and animations—emphasize the interactions between objects in the game world.

Prince of Persia

The original Prince of Persia (see Figure 4.3) is an interesting edge case because of the disconnect between animation and control. The character moves fluidly, but the feel of control is stilted and uneven. A casual observer might assume that because the movement of the character is smooth and even, that the control must also be. This is not the case.

The individual mechanics in Prince of Persia are:

- Run
- Jump vertically
- Jump horizontally

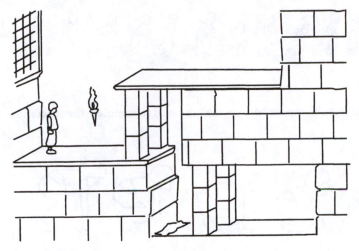

FIGURE **4.3 In Prince of Persia, animation reigns supreme.**

- Change direction
- Lower (down a ledge)
- Draw sword
- Sheathe sword
- Shuffle
- Parry
- Thrust
- Crouch
- Crouch-hop
- Walk
- Grab ledge
- Crouch-slide

Prince of Persia consists entirely of mechanics like the attack mechanic in Street Fighter II. The player presses a single button, and a single animation is played back. The response time is less than 100 ms, but further input is locked out until the animation is over, which often breaks continuity. Examining individual movement mechanics by this criteria, we can see which ones have real-time control and which don't. For example, going from Stand to Run (Figure 4.4) fails one of our threshold tests:

It takes almost 900 ms for the prince to go from standing still to a full speed run. In between, new input from the player is meaningless. There is a branch point of sorts; having reached the end of the "standing to run" animation, if the directional

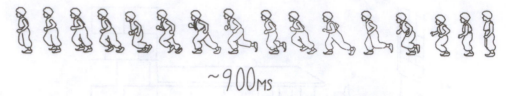

~900ms

FIGURE **4.4 Sixteen frames at 30 fps = 0.53 seconds to complete the animation.**

~150ms

FIGURE **4.5 The hopping animation takes only 150 ms to complete, so it feels almost real time.**

button is still held down, the prince goes into his full speed run cycle. If the button is not held down, the "run to standing" animation is played back, taking another few hundred milliseconds. This is not an unbroken correction cycle, so this particular mechanic by itself does not have real-time control.

Only the crouching mechanic, comprised of the fewest number frames, has real-time control. Because the user is locked out for a very short amount of time, the action not only feels instantaneous in response, but it feels as though it's ready to accept new input as soon as the player is ready to offer it. It's no wonder, then, that this is the mechanic of choice to use when precision timing is necessary. When navigating through a room full of gnashing blades, you want to use the crouch-hop mechanic (Figure 4.5). It feels like the most precise and responsive expression of your input and enables the smallest increments of movement spatially.

Out of all the mechanics of Prince of Persia, only one passes our threshold tests for real-time control. But the animation is fluid and appealing and covers up the lack of control to some degree. The player rarely has a sustained correction cycle and so rarely experiences true game feel. The fact that there are interactive branch points in the animations helps to some degree. In this case, unpredictability actually works in the game's favor. I don't know exactly when the jump is going to take place, so I instinctively just hold the up button when I'm close to where I want to jump. This makes me feel as though the system is listening to my input more often than it is.

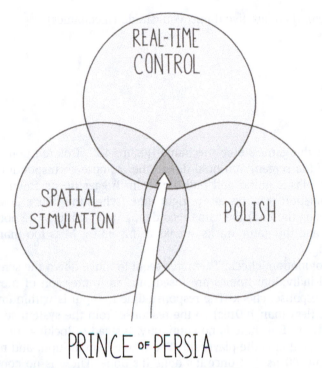

FIGURE **4.6 Prince of Persia has game feel, but it's pretty stilted.**

There is simulated space in Prince of Persia; animations can be interrupted when the character walks far enough off a ledge, and he can bump into walls. The player experiences these directly and actively, by pushing the character into them. The only polish effects that emphasize these interactions are the animations, which have a good sense of weight and presence against the floor.

So Prince of Persia has game feel, but just barely. The player is able to cobble together a correction cycle by imagining control when there is none and by using the mechanics with the lowest number of frames whenever possible.

Guitar Hero

Ahh, Guitar Hero. What a lovely game. It's rare to see technology infused with such a sneer, such sense of unabashed glee. In the Game Developer post mortem of the game, producers Greg LoPiccolo and Daniel Sussman name the one litmus test for every feature and piece of content in the game: "Does it rock?" The results of this simple vision speak for themselves. But does Guitar Hero have game feel as we've defined it? Again, let's examine the individual mechanics and the system as a whole.

In Guitar Hero, there are five things you can do (mechanics):

- Strum
- Whammy
- Hammer On
- Hammer Off
- Tilt

The strum is the game's core mechanic (Figure 4.7). Colored notes scroll down from the top of the screen. You hold down one or more corresponding buttons on the neck of the plastic guitar and pull the strum trigger up or down. If you strum the right combination of notes at the right time (when the note's position is close enough to crossing the line) the game records the note as hit. More notes hit means a better score, and the game tracks streaks of hit notes. Miss too many notes and you fail the song.

Impression of motion, check. The notes seem to move down the screen, from top to bottom, and individual frames are fused into an impression of moving objects. Instantaneous response, check. The response time to input is within one perceptual processor cycle (less than 100 ms) so the response from the system seems instantaneous with a strum. But there is no continuity. Instead of locking the player out as in Prince of Persia, it cuts the player off. The whole loop of input and response happens in less than 100 ms, but once it's done it's done. There is no continuous flow of input and response, no correction cycle.

The whammy bar mechanic, however, allows a constant stream of both input and response. The response feels instantaneous and continuity is maintained. The whammy mechanic has the potential to be an ongoing correction cycle. But there

FIGURE **4.7 The "strum" mechanic in Guitar Hero.**

is no simulated space. The waveform ripples and notes bend as the whammy bar is manipulated, but the size of the ripples has no meaning. Bending notes with the whammy mechanic does not enable the player to actively perceive a simulated space because there is no simulated space around it to interact with (Figure 4.8).

FIGURE **4.8 Bending the waveforms with the whammy mechanic is real-time control, but it lacks spatial simulation.**

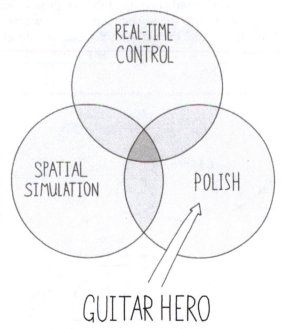

FIGURE **4.9 Guitar Hero has polish and (occasional) real-time control, but no simulated space.**

Guitar Hero is a relatively simple game. Strumming to hit notes in increasingly difficult patterns that are synched to songs is the vast majority of the game. Even considered as a whole system, however, it does not have the property we've defined as game feel. The notes may fly fast and furious, and you can wail on the whammy and tilt to use your star power, but there is no unbroken flow of action, perception and contemplation. There is the impression of motion, instantaneous response, but there no sustained correction cycle and no spatial simulation (Figure 4.9).

Kirby: Canvas Curse

Kirby: Canvas Curse (Figure 4.10) takes a very simple idea and executes on it brilliantly, enabling the player to indirectly control Kirby's movement by drawing. In Canvas Curse, you play as Kirby and as a disembodied paintbrush at the same time. There are three mechanics:

- Drawing (paintbrush)

- Tapping (on the avatar)

- Holding (enemies)

Using the paintbrush mechanic, you draw lines on the screen, represented by flowing rainbows. If Kirby comes into contact with these lines he will follow their path in the direction they were drawn (see Figure 4.11).

From the moment the player starts drawing the line, they're running a correction cycle to get the line drawn in the shape and direction they want. The response is instantaneous, but this is not real-time control per our definition. In this case, the DS stylus and screen are functioning the same way a piece of paper and pencil do.

FIGURE **4.10 The layout of Canvas Curse.**

The player is correcting the movement of his or her own hand in space rather than a virtual object in virtual space.

The other main mechanic is tapping. The player can tap Kirby directly with the stylus. This results in a state change and a speed boost. The spinning animation is accompanied by a burst of speed in the direction Kirby is currently facing. The response is instantaneous, but, as with Guitar Hero, the input is not sustained.

FIGURE **4.11 As you draw the rainbow trail, Kirby will follow its path if he makes contact with any part of the trail.**

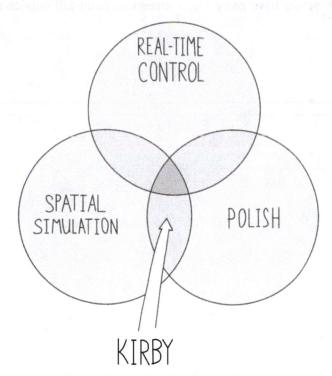

FIGURE **4.12 Canvas Curse has polish and simulated space, but no sustained real-time control.**

One tap equals one input. To express a new input, the player has to lift the stylus off the screen and tap again. This is not an ongoing correction cycle.

The ambiguity of Canvas Curse is in its simulation. Kirby moves around a simulated space, colliding with walls, enemies and other objects. Those interactions are emphasized with polish effects like sounds and particles. This is where things become fuzzy; Kirby interacts with simulated space in just the way it should to fall inside our definition of game feel. The world of Canvas is its own unique physical world. But the player does not experience the simulated space directly, perceiving it actively via Kirby's "body" in virtual space. Instead, the player guides Kirby indirectly, observing the results of his interactions and building a model of the game world from those interactions. Kirby: Canvas Curse falls outside the definition of game feel (Figure 4.12).

Summary

Breaking down game feel into its component mechanics on a game-by-game basis enables us to better understand which games have game feel and which don't, and why. Our definition is now complete: even games that are on the edge can be classified according to real-time control, simulated space and polish. Games that have these three properties have game feel. Games that don't fall outside the scope of this book.

FIVE

Beyond Intuition: Metrics for Game Feel

In this chapter and the next six, we'll explore the problem of measuring game feel. The goal is to compare the feel of one game to another meaningfully. This will give us a generic, working vocabulary for game feel and will offer insight into why some games feel good and others do not, even if the games appear similar on the surface. In Chapter 1, we defined the canvas of game feel and looked at some of the finished "paintings" of experience possible on that canvas. Now our goal is to identify the colors of paint.

Why Measure Game Feel?

As with definition, there are no standard measures for game feel. We as players and designers do not attempt to measure game feel or to compare the feel of one game to another at a level deeper than is necessary for casual conversation and game production. From players, we have vague descriptions like floaty, loose, tight and responsive. Some enlightened game designers measure response lag and move timings, but to most game feel tuning is intuition. When a game designer sits down to create a mechanic from scratch, this is a problem. As God of War designer Derek Daniels says, "One of the worst things about making video games is that you have to re-invent the wheel with almost every new project you work on. So even though Mario jumps like a champ, when you go to make your game, it's very hard to reverse engineer Mario's jump and port it into your game."[1]

This is frustrating because each new game we design feels just as complex as the last. If we don't directly copy what we did before, we're starting from scratch.

[1] http://lowfierce.blogspot.com/2006/05/why-some-games-feel-better-than-others.html

This leads to timid, incremental improvements over previous designs in an effort to keep things safe and comfy. We copy Mario's mechanics, or Banjo Kazooie's, or Grand Theft Auto's, trying to recreate, in the context of our own systems, what was good in those. This is the easy way to design.

The more difficult way is to ask the following question: Where did the feel of Mario come from? Or Spacewar! for that matter? Those designers didn't have something to clone from, so how did they arrive at good-feeling mechanics? We continue to use a handful of games as our exemplars of mechanic design and game feel. Yet we fail to identify what is special about these particular combinations of real-time control, simulated space and polish. We need to understand the unique relationships between the parts and how these relationships give rise to the experiences we cherish.

There are common elements in the physical design of a controller, the relationship between physical and virtual movement, and the design of the virtual worlds we interact with through game feel. If we can identify and measure these pieces of game feel, we can avoid constant reinvention. This requires us to wrap our brains around the game feel system as a whole—including the player, the input device, the programmed reaction from the game system and all the pieces (i.e., the Game Feel Model of Interactivity described in Chapter 3)—and identify which elements enable us to make a meaningful comparison between the feel of two games. Not only the pieces, but the relationships between the pieces. If we can do that, we can understand how to construct similar systems by insight instead of emulation.

Soft Metrics vs. Hard Metrics

Before diving down into specific elements from the Game Feel Model of Interactivity that we're going to apply as metrics, a few words on measuring game experiences. As every designer knows, the only valid way to take the temperature of a design in progress is to watch players play it. There's no way around it; the output of a game system is player experience. To master it, you've got to measure it. To measure it, you need live players.

Enter the dreaded play test. Nothing is more humbling. You have a vision in your head of the experience the player should have playing the game. Perhaps this vision lines up with the experience you as the game designer currently have when playing your game. Perhaps you feel exceptionally skillful and adept as you play and you think that playing your own game is pretty fun. Now put the game in front of some players and watch as your tower of hope gets hit by the oily wrecking ball of player reality. The players do unexpected things, are hung up on stupid little details or can't figure out the controls. They whine, they grunt, they say "this is stupid!" and they walk away in disgust. They ignore all instructions, mash their way around, and display all the insight and cognitive capacity of an indignant end table. They always tell you, "Oh, it's fun, but …" and list a litany of bizarre sounding changes they'd like to see. Brutal!

And it gets worse: this is not the player's natural environment. If you weren't standing there, if you hadn't invited or cajoled, or if the playtester weren't your friend or sibling or spouse, would they still be playing the game? The answer is usually no. The closer you can get to seeing players in their natural environment, displaying their actual, natural behavior, the further from "done" your design will seem to be. But this is what you want. You want a realistic read on how players will play your game in the wild, even though the closer you get to it, the more brutal the feedback becomes. It's horrid. Your game isn't fun. Players hate it. Maybe you should scrap the whole thing and start over.

For many designers, the solution is simply to drink from the fire hose. Put your head up in the stream and just take the full blast of feedback in the face. Actually, this works reasonably well. Big, serious issues tend to be very obvious, and the designer can usually figure out how to modify the system to correct the problems. Rinse, repeat, iterate. The more times you can iterate on this cycle of playtesting and modification, the better you game will be. However, there are some things that can be done to make this cycle take less time and be more effective.

Figure 5.1 is an example presented by Mick West in his article "Pushing Buttons" for Game Developer. "All I did was add a simple 'watcher' class which would record the value of a variable (such as a button up/down state or a physics state or flag) every frame and then display this as a scrolling state graph across the top of the screen, with a separate line for each variable that was being watched. To this state graph I added an event recorder which recorded events (jump, land, fall, super jump, late jump and crouch) and displayed them on the graph as a vertical line,

FIGURE **5.1 Measuring inputs over time: an excellent "hard" metric.**

labeled with the event. Finally I made the graph able to be scrolled and zoomed in and out by the joypad when the game is paused. So, whenever some control problem occurs, it's very easy to pause the game and then scroll over and zoom into the area on the graph that caused the problems."

This is a sophisticated, data-driven measurement of player experience. West's millisecond-precise graphing of player input and system output provides a clear, quantitative explanation for a soft, wishy-washy, subjective player experience. This is great stuff. It enabled him to tune his system more quickly and to provide a clear, unambiguous insight into a very nebulous problem of the controls not feeling right for the player.

West's graphing is an example of a "hard metric." Hard metrics are quantifiable, finite measurements. The player pressed the button 57 ms after the computer thought they were off the cliff. The final score was blue team 10, red team 3. The player played the game for 27:03. Hard metrics provide specific, measurable data that can be compared across playtests. Assigning meaning to the data is part of the art of game design—should every game of Warcraft 3 take 20 minutes to complete? Or is it okay to have a game that last seven hours? Answering that question depends on the experience the designer intends to create.

Contrast hard metrics with "soft metrics"—things like fun, laughter and requests for more play. Are your players really having fun? What does fun mean in the context of your game? It could be deep strategic thought, with players sitting in silence, pondering the ramifications of their next move. Or it could be raucous laughter and intense interpersonal connections. Or it could just mean a feeling of relief and relaxation, a nice escape after a hard day at work. These things are not easy to measure. Though it is possible to quantify certain aspects of behaviors—such as Nicole Lazzaro's excellent Four Fun Keys, which are based on videotaped recording of people's faces and resulting emotional categorization—this is not the norm for game designers. Usually, soft metrics combine to form a sense, nebulous but always evolving, about what the experience of playing the game is for all players everywhere.

It's important to note that soft metrics are just as useful to game design as hard metrics. People tend to assume that because hard metrics are fact-based, scientific and objective, they are somehow better. But it's just as important to keep track of whether and how people are enjoying themselves while playing the game. Examining soft metrics is part of the game designer's intuition, which gets honed as he or she completes more and more designs. To have an intuitive grasp of what system dynamics will create enjoyable, meaningful experience is to be keenly attuned to soft metrics. In our measurement of the game feel of various games, we will employ both soft and hard metrics.

What's Important to Measure

In the Game Feel Model of Interactivity, it is the pieces on the computer's side of the system that can be changed by the game designer. Out of these, certain aspects

are obvious candidates for metrics. The six most useful aspects in this respect—the most important to measure, in terms of framing principles for designing game feel and for comparing games—are as follows.

- Input—The physical construction of the device through which player intent is expressed to the system and how this changes game feel.

- Response—How the system processes, modulates and responds to player input in real time.

- Context—The effect of simulated space on game feel. How collision code and level design give meaning to real-time control.

- Polish—Effects that artificially enhance impression of a unique physical reality in the game.

- Metaphor—How the game's representation and treatment change player expectations about the behavior, movement and interactions of game objects.

- Rules—How arbitrary relationships between abstracted variables in the game change player perception of game objects, define challenges and modify sensations of control.

These are summarized in Figure 5.2. Some enable data-driven "hard" metrics, such as input, and others are on the "softer" side, such as metaphor. The rest of this chapter introduces these six elements as metrics in a general way. Chapters 6 through 11 describe the metrics associated with each element in detail.

Armed with this information, we can quantify game feel in a way that lets us design game feel from first principles instead of from *a priori* knowledge (i.e., by emulation). We will also have a detailed set of criteria for comparing games.

Input

The input device is the instrument of expression for the player into the game world. Therefore, the physical construction of the input device is important to the feel of control. The layout of inputs on the device, the tactile feel of the materials it's made from, its weight, and the strength of springs in joysticks and other actuators—all of these things affect the way it feels to hold, touch and use the input device. This changes game feel. It's like a musical instrument: while it's possible to play Fur Elise on a Playskool piano, there's a much greater potential inherent in a Steinway Grand Piano. When I create a prototype of a new control mechanic, it will almost always feel better to control using my wired Xbox 360 controller than using just buttons on the keyboard. At the highest level, this is because the Xbox controller is a well-designed consumer product made of sturdy materials and smooth, porous plastic.

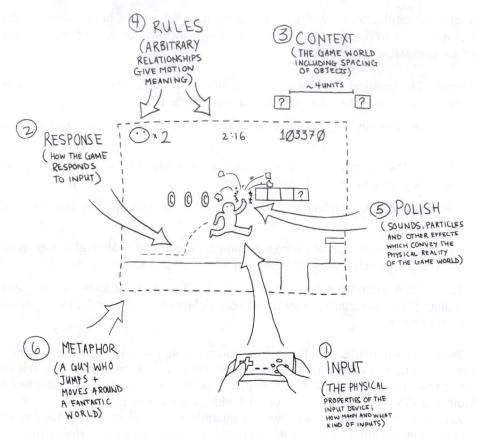

FIGURE **5.2 The six most important elements of game feel to measure are input, response, context, rules, polish and metaphor.**

Playable Example

If you want to experience the difference and happen to have an Xbox 360 controller hooked up to your PC, try playing example CH05-1. You can control the game with either the Xbox controller or the keyboard (WASD.) Controlling the object with an Xbox controller feels better, all other factors being equal.

From the designer's side of things choices about which parts of the input device to use and how to use them affect the feel of control over virtual objects. The designer rarely gets to choose which input device the player will use—this is almost the same as making the choice about platform—but the designer can always choose which inputs on the device will be valid and useful for controlling things in their specific game. If the input device is a Playstation 3 controller, does the player use the thumbsticks, the buttons or both? These decisions define what sensations of control are possible in the game.

By choosing which inputs will be used, the designer also makes a choice about the sensitivity of their input space. Input devices have an inherent sensitivity. The feel of using an NES controller to control something in a game is different from a typical computer mouse, for example. The NES controller has more total inputs than a mouse—eight separate buttons—but is less sensitive overall than a mouse. Of these eight buttons, six are commonly used for real-time control, and each of these buttons is a very simple two-state affair. It's either on or off at any given time, nowhere in between.

The mouse has two standard buttons. But it also has a rolling ball or laser mechanism that recognizes movement in two directions. This two-axis movement is much more sensitive than a single button. The signals it sends to the computer are much more complex than the simple ON or OFF of a button.

From the designer's perspective, an input device translates the complex goals and intentions of the player into a simple language a computer can understand and interpret. This language is a stream of values that change over time. The movement of a thumbstick to the left, for example, can be interpreted by the computer as a change in a single "float" value—a number between −1.00 and 1.00. As the player moves the thumbstick, the numbers change. A button is much simpler in terms of physical activation and in terms of the signals it sends. Having selected a specific input device, the game designer then chooses which inputs on the device will be used, and how they will be used. In other words, of the possible input space inherent in the physical construction of the input device itself, the designer decides which parts will be valid and applicable to control in his or her specific game.

To measure the effect these choices have on game feel in completed games, we want to look at the properties of each individual input and at the input space as a whole. As a whole, we want to know which inputs on an input device are used for control, and to keep track of any physical constraints and limitations of the input device. For example, on an NES controller most of the inputs can be combined with one another, except for opposing directions on the directional pad. It's impossible to press both left and right on the directional pad at the same time. Ditto up and down. But it is possible to press the A-button and left at the same time. This means that a game controlled by a directional pad will feel very different than the same game controlled by four keyboard keys simply because the inputs combine in different ways (see Figure 5.3). On a keyboard, it *is* possible to press left and right at the same time.

For each individual input, it's useful to examine how many possible states the input has, the degrees of freedom and types of movement it permits, and how, if at all, it's bounded. For example, a simple button on my Xbox 360 controller has two states, on and off. It moves in one axis, up and down, and it is bounded in two places, at its maximum and minimum. A trigger button on the same controller still moves along only one axis but has hundreds of discrete states between its boundaries of fully released and fully pressed. The thumbsticks on the same controller have complete freedom of movement along two axes, X and Y, and are bounded by the circular plastic casing of the controller, giving them almost unlimited possible states.

FIGURE **5.3 On a keyboard, it is possible—and likely—for a player to press left and right at the same time.**

FIGURE **5.4 Differences in sensitivity between input devices.**

We can say then that a thumbstick is overall a more sensitive and expressive input than a trigger button, which is in turn more sensitive than a standard button.

Another metric, though a soft one, is how the input provides proprioceptive feedback (spring strength, layout of buttons relative to one another). Joysticks, thumbsticks, triggers and buttons can feel very different depending on the strength and quality of their spring mechanisms. This physical feel of interaction is very difficult to quantify, but has some effect on the feel of control over virtual objects.

Response

Knowing all about the input device is half of real-time control. All inputs eventually become signals, which are mapped to the modulation of some parameter in the game. This modulation can be thought of as the game's response to input.

The game receives signals from the input device. Signals modify some parameter in the game in some way, which is defined by the game designer. This is mapping: hooking specific input signals up to parameters in the game and defining how the parameters will be modulated over time. As Mick West says, "On the face of it, this appears a simple problem: you just map buttons to events, [but] getting player control to work is inevitably a fiddly and complex task."[2] This is where most of the feel of control in a game is created.

An input signal can modulate any parameter in a game and can do it over time in many different ways. A button press can move an object a distance in a direction. Press the button once and a cube moves five units to the right, for example. Or a game can continuously move that object a small amount each time the feedback loop is complete, as long as the button is held. Alternately, holding the button could add a force to a simulation, which indirectly causes the cube to speed up and start moving. All of these are different mappings of one button to the movement of one object, and with each, the feel is different. But a press of a single button can also be mapped to changes in global parameters. Pressing a button might reverse gravity or holding it might change the friction value for a car's tires, enabling a different kind of control.

To measure the response of a particular game, we want to look at how each signal coming in from the input device is mapped to a change in the game. What parameter does it modulate, and how does it change that parameter over time? Or, more generally, what parameters are changed by what inputs, and what are the relationships between the parameters? For example, in Id Software's Quake, rotation of the avatar in 3D space is very closely translated from the mouse on the desk surface. Changes in the two signals coming in—X and Y for the left/right and up/down movement of the mouse—rotate the avatar left, right, up and down (Figure 5.5). There is very little processing of input. The movement of the mouse adds a value to

[2]http://cowboyprogramming.com/2007/01/02/pushhing-buttons/

FIGURE **5.5 Moving the mouse in Quake rotates the avatar—input becomes response.**

FIGURE **5.6 In Arkanoid, rotating the input knob maps to the left-right movement of the spaceship.**

the current rotation value of the avatar. Move the mouse an inch to the left and you turn 90 degrees to the left, a fixed steering ratio.

But in Quake, the steering ratio between horizontal mouse movement and horizontal in-game rotation is different from the one between vertical mouse movement and horizontal in-game rotation. For your up/down mouse movement, you get much less vertical rotation in the game. The relationship between these two values is just as important as the values themselves; in the context of Quake, the players will want to adjust their horizontal aim more quickly and over a greater distance than their vertical one.

Now compare the mapping of Quake with the classic Arkanoid, which maps rotation of a knob to the left and right movement of the in-game "paddle" space-ship (Figure 5.6). This is again mapped directly, though instead of mapping a linear movement to a rotation as Quake does, Arkanoid does the opposite, mapping the

FIGURE **5.7 In Halo, the degree of change of the thumbstick moves the reticule at varying degrees of speed.**

rotation of the knob to a linear movement of the ship. One degree of rotation of the wheel input is translated into a certain distance of movement for the Arkanoid paddle.

Contrast this with the "warthog" driving mechanic in Bungie's Halo, a more indirect mapping of input to motion. Moving left on the thumbstick changes the position of the "reticule." This maps thumbstick displacement to a rate of movement instead of to a change in position. Moving the thumbstick to the left a small amount will move the reticule to the left at a slow rate. Pulling the thumbstick as far to the left as it will go moves the reticule quickly, at a constant, maximum rate.

The reticule's position represents a heading in the 3D game world, one which the warthog vehicle will then attempt to seek on—imperfectly. Depending on the distance between the reticule and the actual heading of the avatar, it will rotate more or less per frame to try to return to being in line with the reticule, but it may overshoot or undershoot. This obfuscation between intent and reaction is pleasurable rather than annoying because it defines both an interesting challenge and a pleasurable sensation of control.

An input signal can also be mapped to a modulation across time, such as the jumping mechanic in Super Mario Brothers. When jumping in Mario, holding down the button longer yields a higher jump. There is a maximum height and an expressive range in between. A tiny tap on the button is a tiny little jump. To get a full height jump, you must hold down the button longer.

After looking at what parameter each input modulates in the game and how it changes it over time, the final thing to examine is the relationships between the

various parameters. No mechanic is an island. Just as important as how each individual mechanic is defined—how each specific input is mapped to a response—is the relationship between them. For example, the feel of Super Mario Brothers relies on the relationship between how fast Mario can move on the ground and how fast he can move in the air. In the air, he moves left and right, but more slowly than on the ground. You still have some control over Mario's trajectory in the air, but the feel is one of precise adjustment, giving you a better shot at landing on that small platform. The same kinds of relationships between parameters define the feel of any system of real-time control, from the speed-to-turning-radius relationship in a driving game to the size/speed tradeoffs present in most fighting games. As much as the basic mapping values themselves, it is the relationships between parameters that makes a game feel the way it does.

Context

Context includes simulated space and level design. Envision yourself playing Super Mario 64. Now imagine that instead of being in the middle of Bomb-Omb Battlefield, Mario is standing in a field of blank whiteness, with no objects around him. With nothing but a field of blankness, does it matter that Mario can do a long jump, a triple jump or wall kick?

If Mario has nothing to interact with, his acrobatic abilities are meaningless. Without a wall, there can be no wall kick. In this way, the placement of objects in the world is just another set of variables against which to balance movement speed, jump height and all the other parameters that define motion. In game feel terms, constraints define sensation. If objects are packed in, spaced tightly relative to the avatar's motion, the game will feel clumsy and oppressive, causing anxiety and

FIGURE **5.8 Mario is sad because he has no context for all his fancy moves.**

frustration. As objects get spaced further apart, the mapping of input to response becomes increasingly unimportant. It doesn't matter how fast a car moves relative to its turning speed when it's driving across a featureless landscape. Of course, the spacing of objects is irrelevant until two objects can interact. It could look as though you're driving in a densely packed forest, but if the car goes through the trees, it makes no difference how many trees there are or how they're laid out. In this sense, collision code is the other part of context.

Context, then, is the unique physical reality of the game world—the simulated space—including the way that objects interact and the layout of space. Like the abilities and actions of the avatar, it is designed. The game designer creates a game space that has its own unique physics, extents and constraints. The designer simultaneously creates the content that fills that world and defines its spatial relationships.

Almost every game has a contextual aspect of some kind, be it tracks in Gran Turismo or tracks in Guitar Hero. Tracks, puzzles, stages, levels, worlds: most games have some kind of designed context against the mechanics' functions. In most cases, this is called level design. The objective is to find the most interesting pieces of the mechanic and emphasize them by trying to provide the most interesting interactions possible with the mechanics.

The importance of this context will vary depending on the type of game, but almost every game includes some kind of level design. My favorite example is the difference between Slim Tetris and regular Tetris, as shown in Figure 5.9. Level design isn't as important in Tetris as it is in, say, a Tony Hawk game, but Alexei Pajitnov still

FIGURE **5.9 Normal versus Skinny Tetris: if the level design was different, it wouldn't be the same game.**

had to decide that the Tetris field would be 10 blocks wide by 24 blocks tall. If it were three blocks wide, Tetris would be a very different game. Change the context, change the game.

The default playfield of Tetris provided the right balance between constraint and openness. It was an artistic choice and reinforces the important aspect of context: spatial constraints define challenge. The sharpness of turns and spacing of obstacles in Mario Kart DS defines the challenge of a particular course. The more difficult courses have sharper turns that happen more frequently and include more obstacles, jumps and other challenge-making context.

The effect of context on game feel can only be expressed as soft metrics. There is a change in the sensation of control when the overall landscape of the game world is huge and open versus when it's constrained and claustrophobic, but the exact change is not quantifiable. It's a general impression of space. The feel of control also changes when objects are spaced closer together or further apart, and when objects are sharp, round, organic or blocky. If you bump into things all the time, the game feels different. At the lowest level, collision code again redefines feel as it makes interactions feel a certain way. The interaction of objects can be smooth, as they slide off one another or feel tacky, if they stick when they come into contact. If an object explodes instantly when it runs into something, this again changes the feel of the game. Steering around objects becomes much more important, and the thing you're controlling seems fragile.

The best way to measure these effects is to examine the feel of control in different contexts within the same game. In Asteroids, there are times when there are as few as one asteroid on the screen. When that happens, the feel of control is different from when the screen is covered in tiny, high-speed asteroid fragments. In these extremes, we see the way that the feel of Asteroids is changed when the playfield—the spatial topology—goes from empty to full.

Polish

Polish is any effect that enhances the interactions between objects in the game world, giving clues about the physical properties of objects. If all polish effects were removed, the functionality of the game would be the same, but the player's perception of the physical properties of the objects in the game would change. Perception is active, and polish effects further define the interactions that occur because of a game's collision code.

Measuring polish is another soft metric. How does the feel of De Blob (the student game mentioned in Chapter 1) change when the squash-shader is applied? This is not quantifiable as a hard metric. What we can measure is the resulting impression of physicality. Specifically, what the polish effects seem to tell us about the properties of the objects we're observing. The blob squashing and stretching is what makes it seem a blob. As Joost says, without the squash-shader, the game feels like playing with a ball made of stone.

This principle applies to all polish effects. All effects, even if they're applied only with the nebulous goal of making interaction more appealing, send signals about the physical properties of the objects involved in the interaction. When it's passive—when you see two objects in the distance collide—the impression is the same as in film or animation. When it's active, the impression is much more powerful, like experiencing something with your own senses.

A violent spray of particles, the screen shaking or a loud noise lend the impression of weight, heft and solidness to objects. Any interaction that can happen in real life, that has happened in film, or that can be imagined can be conveyed through polish effects. The thing that's interesting to measure is how the polish effects impact a player's perception of the objects in the game world.

Playable Example

See example CH05-2 for some different polish effects applied to the same system.

Consider the game Burnout: Revenge, a game with an almost preposterous amount of polish. A car in Burnout is a solid object traveling at high speed. When it crashes, the force of the impact is palpable, and the results are catastrophic. The car is deformed in a hail of glass and sparks. Its mass and high velocity carry it high into the air, spinning and burning, eventually to crash back down with all the weight of its two-ton frame. The crunching, shattering and scraping noises are gut-wrenching. A car in Burnout is a solid object traveling at high speed which has now been completely obliterated (Figure 5.10).

FIGURE **5.10 The cars in Burnout can be damaged to an amazing degree. This is some serious polish.**

But how do you know this? What tells your senses that this is the case? How can you know the physical nature of this digital object? What clues are you using to derive this understanding? Well, let's break it down a bit. First, we have the visuals: glass is spraying from the windows, pieces of metal and car parts are flying off in every direction, and dust and smoke are spewing from the engine. These are probably simple particle effects—two-dimensional images displayed at a particular point in the 3D scene but which are programmed to always be facing toward the camera. Often, these are a series of frames which play back linearly with some randomization, causing little pieces of glass to spin and puffs of smoke to appear to billow and froth. The sparks flying from where the car is contacting other pieces of metal or scraping against the divider or pavement are probably generated the same way, transitioning in color from white to yellow to red over time as they spray out. The tires leaving skid marks on the pavement are probably alpha textures, being laid down with created-on-the-fly geometry that has an alpha-blended tire tread texture mapped to it. Maybe it has two or three different layers and randomizes the texture so it's hard to see the textures repeat.

And what about the sounds, the screeching, the skidding and the shattering glass? The sounds of rending metal are all created, blended and triggered in real time. They even have locations in 3D space, using positional audio to further emphasize the link between sound and visuals. And then there's the controller rumble, adding a little bit of tactile sensation to the mix. It may not be especially logical, but it helps the impact seem more, ah, impactful.

So where did all these clues come from? Did a game designer simply press a button that says "insert car" and knock off down to the pub for a pint or two? Sadly not. Each tiny piece of interaction, each particle effect and sound, each deformation and broken piece of car sent flying is a hand-crafted response meant to do one thing: convey the physical nature of this interaction to you, the player. It must be a combination of various sights and sounds, too, because perception is a multi-sensory phenomenon. When you perceive things, you see, hear, touch and feel all at once. Perceiving something involves your entire body, even when it's an extension of your sense into a virtual body. More than that, your perception of something includes the meaning you assign to it based on past experiences, ideas, feelings and generalizations. If it looks like a car, you expect it to behave the way things that fit your idea of car would behave. This might be your experience of a real car crash, years of watching car crashes in movies, or both. The point is that the clues must be designed by a designer, created by an artist and programmed by a programmer. Often, all three will touch a complex effect. Often this is written off as "just polish" but as applied to game feel its impact in terms of conveying a convincing, self-consistent game world can't be ignored. Polish is important.

Metaphor

Metaphor is where a player's past experiences, ideas, feelings and generalizations come into play. Not only from playing games, but from their total life experience.

What does the thing you're controlling look like, and how do you expect it to behave based on your experience with similar things? If it looks like you're controlling a real car, the expectation is that it will handle like a car, sound like a car and crash like a car. But the expectations come from the idea of what a car is, not from objective reality. Players bring with them all their life experience—riding in cars, driving cars and so on—but they also bring their experiences of cars from films and animations. Convincingly behaving like a car, then, might mean exploding after being shot with one bullet or it might mean squashing and stretching as in a cartoon, taking no visible damage. Oftentimes, people will play a game—horse-riding gameplay is my favorite example—and they'll say, "This doesn't feel like a horse." And you'll ask them, "Well, have you ever ridden a horse before?" And they'll say, "No, but this doesn't feel like a horse." What this illustrates is that players carry with them preconceived notions about the way certain things move and, by extension, how it should feel to control them.

The expectations about how interactions should play out are also influenced by treatment—how the art is executed. A cartooned, iconic car has much more leeway when it comes to how it can behave and interact than a photorealistic one.

Try this as a thought experiment: instead of the car in Burnout, substitute a giant, balding fat guy running as fast as he possibly can, spraying sweat like a sprinkler in August. Without altering the structure of the game, the tuning of the game or the function of the game, the feel of the game has changed. All you've done is swap out a 3D model of a car for a 3D model of a giant fat guy running and you've got *Run Fatty Run* instead of *Gran Turismo*. This will change the feel of the game because you have preconceived notions about the way a car should handle.

FIGURE **5.11 Run, Fatty, Ruuuuuuun! This avatar sets up different expectations than a car does, which changes the feel of the game even if the underlying functionality is identical.**

You know how a car should feel and move and turn based on your experience driving a car and looking at cars. When thinking about a game feel system, it's important to understand the palette of preconceptions you're working with. The best designers use metaphor and treatment to set up expectations in the player that can then be exceeded by the game's interactions.

Rules

Returning to Super Mario 64, have you ever asked yourself "Why am I collecting these coins?" If it didn't refill Mario's health or if 100 coins didn't get you a star, would you bother? Would it be worth it? For that matter, why is collecting a star important? What "value" do these things have? Outside the system of the game, none whatsoever. They are abstract variables whose arbitrary relationships give them value within the cohesive whole of the game system. In other words, the meaning of a coin, a star or any other such part of a game is given only by its relationship to other parts of the game. It's manufactured from nothing. From thin air. Poof. It's a system that gives itself meaning. Isn't that weird? It works, though. You want those coins, and you want that star, and you're willing to undergo a lot of frustration, tedium and learning to get them. The intrinsic pleasure of learning and doing may be the fundamental appeal, but it's the carrot of the stars that gets you moving.

Traditionally, this is the role rules play in both game design and in game feel. They provide motivation and a structured way to learn, defining for the player the motions that are worth learning. Indeed, it is the seemingly arbitrary relationships between variables that give the motion meaning. A gradual ramp of increasingly difficult challenges matches the player's growing skill, keeping them in the flow state (Figure 5.12), introduced in Chapter 1.

In the context of game feel, rules as we've defined them provide motivation, challenge and meaning for motion. Context provides the immediate, spatial meaning while rules provide the long-term, sustainable meaning that games are built out of.

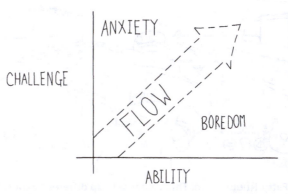

FIGURE **5.12 Csikzentmihayli's Flow.**

As in our earlier example, rules provide some, if not all, of the intent in a game system, as shown in Figure 5.13.

Race from point A to point B, scale this tall mountain, rescue five wayward puppies, escape the compound. These kinds of higher-order goals define game feel at the level of sustainability. They operate at multiple levels, with multiple goals and types of goals active at any given time. This promotes a high level of engagement and gives the player many choices about which activity to pursue at a given time. The low-level sensation of control and physicality, which we've defined as game feel, is a great foundation for quality game experiences, but it's the higher-order rules that provide the girders and scaffolding to build it out.

To measure the effect of rules have on game feel, we can look at rules in three different ways. Again, these are soft metrics, as they are not measuring specific quantities. What we're interested in is how seemingly arbitrary relationships between variables can change the meaning players assign to objects in the game world, changing the feel of control and interaction as they perceive that world.

At the highest level, goals focus the player on a particular subset of motions. These high-level goals provide a trickle down effect, giving objects meaning at various levels. High-level rules can also be things like health and damage systems, which again trickle down to give meaning to moment-to-moment interactions.

Separate from but hooked into the high-level rules and goals, mid-level rules can give meaning to objects in the game world, changing the feel of moving through it.

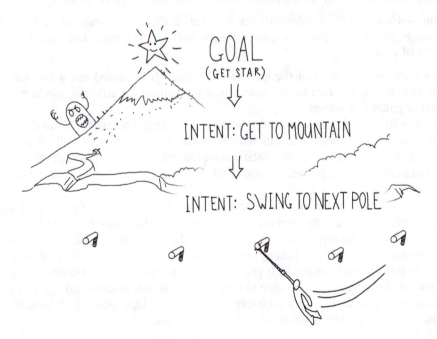

FIGURE **5.13 High-level goals trickle down.**

The flag in a capture the flag multi-player game is one example; for the player currently holding the flag, the game feels different.

At the lowest level, rules can further define the physical properties of objects. How much damage it takes an avatar to destroy an enemy changes the player's perception of how "tough" that enemy is. An enemy that takes one hit to destroy will feel fragile, while a boss monster that takes 20 hits feels much more solid.

Summary

The six pieces of the game feel system that are malleable for the game designer are:

- Input—The physical construction of the device through which player intent is expressed to the system and how this changes game feel.

- Response—How the system processes, modulates and responds to player input in real time.

- Context—The effect of simulated space on game feel. How collision code and level design give meaning to real-time control.

- Polish—Effects that artificially enhance impression of a unique physical reality in the game.

- Metaphor—How the game's representation and treatment change player expectations about the behavior, movement and interactions of game objects.

- Rules—How arbitrary relationships between abstracted variables in the game change player perception of game objects, define challenges and modify sensations of control.

For each of the six pieces of the game feel system, I've pointed out a few different things that are instructive to measure when examining a particular mechanic or a particular game feel system.

Each of these is discussed in more detail in Chapters 6 through 11. We'll be looking at what can be measured and what's useful to measure. We will be pursuing both soft and hard metrics. For each measurement, we'll go through why this is useful to know about a particular game and how it helps us compare the feel of two games in a meaningful way.

The point of measurement is to derive general principles about game feel which can be applied to future designs and to let us meaningfully compare the feel of two games. Instead of taking shots in the dark, emulating existing mechanics or trying to shoehorn someone else's tuning into your system, you want to be able to understand the tools at your disposal. If you want your game to feel like Sonic, Megaman or Burnout: Revenge, you'll be able to do it with a deeper understanding. You might not have the exact recipe—it's probably secret—but at least you won't be staring at a finished cake wondering what kind of sugar was used.

CHAPTER SIX

Input Metrics

The pianos (think input devices) of Ludwig Van Beethoven's day were flimsy, cheap things. In the course of his exuberant performances, he often broke 10 to 15 piano strings, sometimes damaging the piano beyond repair. It was not just his playing that destroyed pianos, but the music itself: it was not written for the pianos of his day. Part of Beethoven's genius was his ability to look beyond the physical limitations of the piano and define a space of a greater virtuosity and musical expressivity than the one actually presented by the piano itself. When he looked at a rickety Viennese piano, he saw the robust grand pianos of today.

What Beethoven was able to see clearly—and exceed—were the physical and mental limitations imposed upon him. He understood that a tool or instrument inherently shapes and influences the activities that can be carried out employing it, both physically and mentally. Consider a screwdriver. A screwdriver is used to fasten things together. But it is a very specific kind of fastening, and the nature of that fastening is implied by the screwdriver itself. For one, it must employ a screw that matches the head of the screwdriver being used. If it's a Phillips head screwdriver, it needs a Phillips head screw, and the grooves in the screw head must be machined to a size comparable to the head of the screwdriver. A large Phillips head screwdriver cannot be used to screw in a tiny screw. A screwdriver, like all tools, contains within it a specific subset of possible uses, a possibility space for its use. As a tool, it defines what it can do, and, more importantly, what people will expect to do with it. If you buy a sports car, you're likely to get speeding tickets. If you have a hammer, everything looks like a nail.

This is an interesting notion and one which we rarely apply to the input devices used to control video games. Just how much does the design of a particular input device affect the feel of a virtual object controlled with it, and to what degree is game feel defined by the input device itself? In other words, to what degree is the possibility space of a virtual object defined by the physical object used to control it?

To answer this question, we need to be able to measure the input space represented by a particular input device. Next, we need to be able to compare the input space of one input device to another in a meaningful way. Finally, we need to examine

how the feel of a particular game is affected by the physical construction of the input used to control it. To do this, we'll examine input at three levels:

- The micro level, examining each individual input that makes up the input device
- The macro level, examining the possibility space of the input device as a whole, its layout and construction and the types of actions it implies
- The tactile level, examining how the construction of the input device affects of input virtual feel of game objects controlled with it.

Micro Level: Individual Inputs

The first easily measurable thing about an input device is the number of separate, individual inputs it contains. My Xbox 360 controller, for example, has 15 separate inputs on it (Figure 6.1). This includes a couple thumbsticks; a directional pad; two "trigger" buttons; two "shoulder" buttons; four standard buttons; and some flimsy, seldom-used buttons for select, start, wireless resync and other miscellany. Culling out the inputs that are rarely used for game control, this leaves 4 usable inputs.

FIGURE **6.1 The Xbox 360 controller has 15 input options.**

- X-, Y-, A- and B-buttons (standard buttons)
- Right and left "shoulder" buttons
- Right and left "trigger" buttons
- Directional pad
- Left thumbstick
- Right thumbstick

The common element every input possesses is the potential for motion. A button can be pressed down, a thumbstick pulled away from center and a mouse slid across a flat surface. In each of these cases, the input sends a specific type of signal to the computer. It is interpreted, responded to and fed back via the output devices (screen, speakers and so on). This potential for real-time manipulation and signal-sending is the fundamental property of an input. If you can't move it in some way and have it send a corresponding signal to a computer, it's not an input. The key to correlating seemingly unrelated types of input, then, is in this motion.

The first way to classify an input is as either discrete or continuous. That is, does it send signals continuously (joystick, mouse, steering wheel) or does it send individual, momentary signals (keyboard key, mouse button, controller button)?

Inputs that enable continuous input can also be categorized[1] like this:

- Type of Motion: linear vs. rotation. A mouse measures movement linearly (in two dimensions) while a steering wheel measures rotation.
- Type of Sensitivity: position vs. force. A mouse measures changes in position, while a joystick measures how much force is being applied against spring resistance.
- Dimensions of Motion: A mouse measures linear movement in two dimensions, as does a thumbstick. A trigger button measures linear movement in one dimension. A Wiimote measures rotational movement in three dimensions.
- Direct vs. Indirect Input: A mouse is indirect—you move the mouse on the desk and the cursor moves on the screen. The touch screen on the DS enables players to directly tap on or touch the thing they want to interact with.
- Boundaries on Motion: The thumbstick on an Xbox 360 controller has a round casing enclosing it, while a mouse has no physical boundaries on its motion. The way that the motion of an input is bounded can change what it feels like to use it. For example, the slotted casing around the Nintendo 64's thumbstick feels different from the smooth round casing of the Playstation 2's.
- Sensitivity: Roughly, how many different states can the input exist in. A standard button is very low sensitivity; it has only two states (ON or OFF). A mouse

[1]This is adapted from Robert J.K. Jacob's excellent 1996 paper "The Future of Input Devices." Available online at: http://www.cs.tufts.edu/~jacob/papers/sdcr.pdf

FIGURE **6.2 Use three fingers to visualize axes of movement for input devices.**

is highly sensitive by comparison; it has no physical boundaries making each tiny motion another possible state. Though inputs can be mapped to in-game motions that make them more or less sensitive, individual inputs have an inherent sensitivity.

• Signals Sent: What is the format of the signals each input sends to the game, and how do they change over time?

One way to visualize these properties for a particular input device is to hold out your hand as shown in Figure 6.2. This will also be useful for comparing movement of an input device to movement of the object being controlled, which can indicate whether a mapping is natural (in the Donald Norman sense).

Imagine that lines extend outward from your index finger, middle finger and thumb, as in Figure 6.2. Now imagine each finger as an axis. If you move your hand along any of these axes, you're moving it linearly in a single dimension, X, Y or Z. If you rotate your hand around a particular finger you're rotating in X, Y or Z. Mouse movement is unbounded, so if you slide your hand around the plane described by the X- and Z-axes (index and middle fingers) this is a good way to visualize the unbounded movement of the mouse (Figure 6.3).

A Playstation 2 thumbstick has the same kind of motion, but it has a boundary, so we can think about being able to move in that plane, but only so far in a particular direction (Figure 6.4).

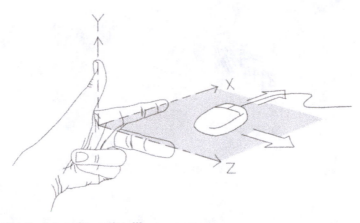

FIGURE **6.3** **The "axis hand" moving like a mouse.**

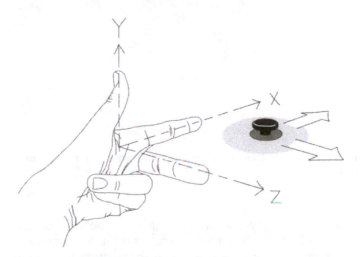

FIGURE **6.4** **The "axis hand" moving like a thumbstick.**

Every button has two boundaries—fully pressed and fully released—between which it moves. Whether it's a trigger button with a handful of states between the extremes of ON and OFF or a mouse button with only two states, there is a limit on movement. The same goes for thumbsticks and arcade joysticks with their circular plastic housings. (In contrast, Wiimotes and computer mice are two general-use input devices that have no built-in boundaries on their motion.) Boundaries are important to take note of because they reduce the overall sensitivity of the input to a particular range. Sometimes—as in the case of a thumbstick—the boundary can play an important role in defining the types of controlled in-game motions that are best suited to the input (Figure 6.5).

FIGURE **6.5 The boundary of the Xbox thumbstick is important for the feel of Geometry Wars: Retro Evolved.**

Now think about how many possible states there are between the boundaries as you move your hand around. For a thumbstick, it's a lot. For a mouse, even more. For a "trigger" button, it's more than 1, but less than with a thumbstick or mouse. This is a rough measure of the sensitivity of the input device.

The amount of sensitivity an input possesses is a soft metric. It is possible to calculate the actual, physical number of states an input can reside in—two for a standard button, something like 1,920,000 for a mouse on a 1,600 × 1,200 desktop—but that comparison doesn't accurately portray the sensation of using these inputs. It's more like the difference between an Etch A Sketch™ and a paintbrush. You can paint a picture with either, but the paintbrush offers a lot more versatility. The idea is that different inputs have different amounts of sensitivity inherent in their design. A standard button has the absolute minimum amount of sensitivity. It's either fully on or fully off. The dial on a classic Breakout paddle has a bit more; its one-axis rotation has a great deal of sensitivity in a limited way. More sensitive than either of those is an arcade joystick, which moves freely in X and Z, but which

is bounded on all sides by a circular plastic housing. Figure 6.6 shows a (rough) scale for input sensitivity.

More or less sensitivity in an input can be desirable depending on the intended feel, and how that feel is intended to fit in with the design as a whole. It's like the color blue—whether or not it's appropriate to use it depends on the context and the desired result.

The final thing to measure about an input is the types of signals it sends. This is the data you will be mapping to some response in your game, so it's important to keep track of the raw form in which it arrives in the computer. This is a hard metric—an input signal always ends up in a simple, numeric format a computer can easily understand—but it also supports our understanding of the soft-metric sensitivity of the input device. A single button sends a binary signal, "up" or "down." Measure this over time and you get signals for "up," "pressed," "down," and "released." A mouse sends a pair of values, one for each axis, that get updated every frame. So a mouse might send 60 different pairs of values in a second, like Table 6.1.

The signals sent by the mouse are more complex than those sent by the button. Figure 6.7 shows the types of signals sent by various input devices.

FIGURE **6.6 Sensitivity of input devices.**

TABLE **6.1**

Frame	Signal Sent
1	(0.52, 0.11)
2	(0.51, 0.21)
3	(0.50, 0.34)
4	(0.31, 0.42)
5	(-0.1, 0.61)

FIGURE **6.7 Signals sent by various inputs.**

Input Measurement Examples

Measuring all these properties for each input is useful for understanding game feel because it is an immutable part of the interface to a particular game. Every game played on the Nintendo Entertainment System was designed to respond to that particular configuration of eight simple, two-state buttons. If we understand just how simple those buttons are in functionality, it becomes all the more remarkable that expressive mechanics like the swinging in Bionic Commando or the slippery movement of Super Mario Brothers were created. More importantly, if we look at the number, type and sensitivity of inputs used to create a mechanic, we can begin to get much closer to a meaningful comparison between the feel of games created with different input devices. Comparing the feel of Halo to the feel of Contra becomes a

lot more viable if you understand that Xbox thumbsticks are inherently much more sensitive than the directional pad and two buttons of the NES controller.

Standard Button

The standard two-state button (Figure 6.8) is the most basic type of input in general use today. The button moves only in one axis, the Y-axis, and the motion is linear. A spring beneath the button pushes it upward constantly. A plastic housing or catch stops it at a certain point, which represents the fully released state. When the player presses the button, he or she overcomes the force of the spring and the button slides downward, in the Y-axis, into the controller. It's stopped at a certain point and then sits in the fully depressed or OFF state. There are no states in between these hard plastic boundaries for Y-axis movement. The button, then, has only two states: ON or OFF.

These characteristics also describes the essential functionality of a keyboard key, a mouse button or any other simple two-state button such as the "shoulder" buttons on a typical modern controller, though these are larger and can be depressed only a tiny amount. These buttons are remarkable for their lack of sensitivity. There's very little that can be expressed by a standard button alone. The feedback from the button is discrete rather than continuous, meaning that the signals it sends happen at one particular moment in time. The signals are binary; the button is either on or off at any given time. As brilliant one-button games like Ominous Development's Strange Attractors prove, however, it's possible to map a single button to a complex, nuanced, sensitive response from the game, but the button by itself is very limited as an input. It is not really possible to create functional input device with fewer states, with less expressive potential than a single two-state button.

The Y-axis movement of a standard button has hard boundaries at the fully released state (where the spring's pushing force is stopped by a plastic catch) and at the fully pressed state (where the player's pressing force is stopped by a plastic catch).

FIGURE **6.8 A standard two-state button. It has two states, moves only in the Y-axis and is by itself a very low-sensitivity input.**

TRIGGER BUTTON

STATE Ø
(RELEASED)

STATE 4
(PRESSED)

FIGURE **6.9 The motion of a trigger button.**

Trigger Button

Like the standard button, the "trigger" button (Figure 6.9) typically found on modern controllers moves in only one axis. In this case, I'd call it the X-axis, as it's usually on the front of the controller and is usually operated by the index finger. Again, though, this is all relative to the controller's position in space.

Trigger buttons are unlike standard buttons because they recognize many states between their boundaries. Between the fully pressed and fully released states, there is a zone of sensitivity inside which it's possible to have many different positions of the trigger. Fiddling around with my Xbox 360 controller, I estimate that there are four or five discrete states including fully on and fully off. Like a standard button, the trigger is spring-loaded and defaults to a fully extended released state. The major difference is in the button's range of motion. By carefully depressing the spring a certain amount, the player can keep the button a quarter, half or three-quarters of the way depressed without pushing it fully to one extreme or the other. This X-axis movement has hard boundaries at the fully released state (where the spring pushing force is stopped by a plastic catch) and at the fully pressed state (where the player's pressing force is stopped by a plastic catch).

A trigger button typically returns a float value, a number between 0.00 and 1.00. For example, across three frames it might return 0.63, 0.81 and 0.97 as it is pulled from off to on.

Paddle

Though they're not in common use anymore, it's interesting to note that the paddle controllers sold with many of the first home consoles used a hard-boundary,

FIGURE **6.10 An old school paddle controller: bounded rotational control in one dimension.**

one-axis rotation. There was one spinner input on the front of the controller (Figure 6.10). It was gripped between the thumb and forefinger and could be rotated left or right a certain amount before it reached a defined hard boundary point and the plastic would catch and stop it. Through a combination of factors, this input type fell out of vogue, but it was quite a sensitive input, with hundreds of possible states between fully left rotation and fully right.

A paddle controller returns a float value, in a range from −1.00 to 1.00. When the paddle knob is centered, it's at 0.00. As it is rotated left of center, it goes negative (something like −0.26) and as it is rotated right it goes positive (something like 0.41).

Thumbstick

A typical thumbstick is movable in two axes simultaneously, left-right and up-down (Figure 6.11). It's spring loaded in both directions, though, so it will always seek back to its straight-standing centered position. In most cases, the housing containing the thumbstick provides the hard boundary against which it stops when pushed fully in any direction, and it is usually smooth and round. With a thumbstick, it's no longer meaningful to track the total number of possible states. When using a thumbstick to control something in a game, there is no notion of discrete states, but a fluid, smooth sense of highly accurate positioning.

The thumbstick is often used as a direct or semi-direct stand in for the intended in-game motion. Rolling the stick across the edge of its round casing creates a carving turn for a ship in Geometry Wars, a quick heel-turn for Mario or a quick Jab in Fight Night. With a thumbstick, one can be said to "feather" or "flick" a

THUMBSTICK

STATES = 1,000's

BOUNDARY

FIGURE **6.11 A thumbstick controller offers fluid, accurate means of controlling game action.**

control; these are properties of highly sensitive input, one which vastly more sensitive than a standard or trigger button. From its centered position, the thumbstick can only be displaced until it comes into contact with the circular housing, which constrains its movement.

The thumbstick can be displaced from its centered position left to right and up to down, which creates a perceptually infinite number of possible states for the player.

The thumbstick returns two constantly changing float values at the same time, one for each axis of motion. Left to right motion (in the X-axis) returns one float value between -1.00 and 1.00, while up and down motion (in the Z-axis) returns another. The format of the signal could be: $(-0.16, 0.93)$.

Mouse

A mouse—and here I'm talking about the input which detects positional movement, not the clickable buttons—is similar to thumbstick in that it enables movement in two axes. In the case of the mouse, however, there are no in-built boundaries (Figure 6.12). There's a sort of a soft boundary in the sense that you need a small section of flat surface to rest the mouse on, and that potentially can lead to the mouse falling off a table or running into something. In practice, the boundary most often exists in software rather than hardware. The edge of the screen stops the cursor before the edge of the table.

Because there is no explicit boundary, the potential for different states is even higher than with a thumbstick. All position is relative, and there is no spring pushing the mouse back into a neutral position. These factors combine to make the mouse the most sensitive input device in common use today.

FIGURE 6.12 A mouse has tens of thousands of states and almost no boundaries.

The boundaries for a mouse's movement are in software, stopping the cursor (the meaning of further mouse movement) at the four edges of the screen (top, bottom, left and right). Technically, there's also a boundary at the edge of whatever surface you're mousing on, but this boundary is almost never reached due to the typical ratio of physical mouse movement to computer space movement. You get a lot of screen movement for a little mouse movement, so you don't run your mouse off the table very often.

The mouse is a highly sensitive input device. On my $1,200 \times 1,600$ pixel desktop, the mouse cursor can potentially rest on any one of 1.9-something million pixels. In practice, a user can't be expected to accurately hit targets smaller than a certain size (checkbox on a dialog), but the sensitivity is there.

Like the thumbstick, the mouse returns two separate float values in the form (0.18, −0.28). But in the mouse's case, what's being returned is a displacement. How far the mouse has moved in both the X and Z directions since the last frame, in other words. This is often mapped directly into screen space movement (as in the movement of a cursor) but the movement is not absolute. If it were, you would not be able to pick up the mouse, move it and put it back down to continuously move the cursor in one direction.

Table 6.2 compares all these input devices.

TABLE **6.2** Input Metrics

	Standard Button	Trigger Button	Paddle	Thumbstick	Mouse
Type of Motion	The button moves in only one axis, the vertical or Y-axis.	Linear. The button moves along one axis linearly.	Rotation. The paddle's motion is rotational around one axis.	Linear. The thumbstick moves linearly along the X- and Z-axes.	Linear. The mouse moves linearly along the X- and Z-axes.
Dimensions of Motion		The button moves in only one axis, the forward or X-axis.	Y-axis rotation only.	The thumbstick moves in the X and Z dimensions.	The button moves in the X and Z dimensions.
Direct or Indirect Input		Indirect; you press the trigger in your hand and something changes in the game. You don't directly touch the screen with the trigger.	Indirect; you don't directly touch the screen with the trigger.	Indirect input.	Indirect input.
Boundaries on Motion	Two hard boundaries, fully pressed or fully released.	Two hard boundaries, fully pressed or fully released.	Two hard boundaries, full left rotation or full right rotation.	One boundary, typically round (but can also be square or grooved, which changes the feel of using the joystick).	Four soft boundaries.
Sensitivity	The button has only two states, on or off. There are no states between the hard on/off boundaries.	Four to five possible states between on and off.	Hundreds of possible states between the two extremes of rotation.	Thousands of possible states between up/down, left/right movement, and all the positions in between fully released and pressed against the housing.	Millions.

(Continued)

TABLE **6.2** (*Continued*)

	Standard Button	Trigger Button	Paddle	Thumbstick	Mouse
Type of Sensitivity		Force. The button is sensitive to how far its spring-loaded mechanism has been displaced from its normal position.	Force (torque in this case). The paddle knows how far it's rotated to the left or right of center by spring resistance.	Force. The thumbstick is sensitive to how far its spring-loaded mechanism has been displaced from its normal position.	Position. The mouse is sensitive to changes in position; when it's dragged left, right, up or down, this changes the signals it sends.
Signals	Binary; "up," "pressed," "down" or "released."	Float value between 0.00 and 1.00.	Float value between −1.00 and 1.00.	Two float values, each between −1.00 and 1.00. One for the left/right axis, one for the up/down axis.	Float value between −1.00 and 1.00

Macro Level: The Input Device as a Whole

That takes care of the micro level of individual inputs. Now let's recompose the inputs into a complete input device and look at how inputs combine to create an expressive potential greater than the sum of their parts. To keep things simple, let's return to the NES controller, as shown in Figure 6.13.

Examining each input, we must concede that this is very low-sensitivity input device. There are six buttons for use in active gameplay, and each of them is a standard two-state button. More than that, certain buttons are mutually exclusive by design. You can't press up and down on the D-pad at the same time, nor can you press right and left simultaneously. But this controller has more sensitivity than its individual inputs would at first indicate. Even with six buttons and the limitations imposed by the D-pad, the possible combinations of buttons look something like Figure 6.14.

In order to truly come to terms with the input space of an input device as a whole, you have to consider it at both the macro and micro levels. How much sensitivity does each input have, and how do the layout and design of the controller reduce and/or increase sensitivity? In the case of the NES controller, the sensitivity is reduced by the mutually exclusive D-pad buttons and increased by the combined possibilities of the buttons, laid out as they are for use with both thumbs.

FIGURE **6.13 The whole input device is greater than the sum of the parts because inputs can be combined and overlap.**

FIGURE **6.14 Simple buttons combine to form a larger, more sensitive input space.**

Again, this isn't a hard metric. We can measure the total number of inputs and all the permutations of combining them as specific numbers, but that's not especially useful. We're interested in getting a rough idea of how the inherent sensitivity of an input device compares to the sensitivity of another device. It suffices to know that NES controller is much less sensitive than a computer mouse; from that point it is possible to make design decisions relative to our intended feel and to compare the feel of two games controlled with input devices of varying sensitivity.

Tactile Level: The Importance of Physical Design

It's also useful to understand how the input feels physically. This is an overlooked aspect of game feel: the tactile feel of the input device. Games played with a good-feeling controller feel better. For example, the Xbox 360 controller feels good to hold; it's solid, has the proper weight and is pleasingly smooth to the touch. By contrast, the first-run Playstation 3 controllers were lamented as being light and "cheap [feeling], like one of those third-party knockoffs."[2]

This difference in tactile feel of the input device has surprising implications for the feel of a given game. When I prototype something—platformer, racing game, whatever—it will feel noticeably better if I hook up the inputs to my wired Xbox 360 controller instead of using simple keyboard inputs. Of course, this is a very soft metric. It's tempting to simply say "de gustibus non est disputandum" (there's no accounting for taste) and leave it at that, but there are some noticeable, measurable qualities of various inputs that can be observed and taken into account.

Weight

The weight of a controller is an important quality for an input device. A heavier, more solid-feeling controller is perceived as being of higher quality. For a game's feel, this can go a long way toward making actions feel weighty, powerful or satisfying. Of course, it's also possible to push too far into the heavy direction, as the original Xbox controller seemed to, but in general input devices seem to trend toward being too light, flimsy and cheap-feeling. This significantly affects the feel of control of a virtual object.

Materials

The material used to construct the device has an impact on the way the user feels about the controller and, therefore, the game. The white plastic that houses my Xbox 360 controller has a smooth, pleasingly porous feel. It's almost like skin. My Wiimote and Playstation controllers feel like plastic. It's a subtle difference and measuring its impact on game feel is extremely difficult. All I can say is that

[2]By "Zeus" from http://forums.maxconsole.net/archive/index.php/t-19989.html

I prefer holding my Xbox controller. The Dell mouse I'm using currently has a similar porousness but is much coarser, making it less pleasurable to handle than my Xbox controller. This has a mostly subconscious effect on my interaction with these objects, and on how I perceive virtual objects controlled with them.

Button Quality

By "button quality," I mean the feel of the spring resistance. Particular buttons on input devices are often described the same way the feel of a game is described: tight or loose, quick-responding or sluggish. This feel is contingent on the quality, construction and type of springs that drive the motion of the input, whether they're on a button or a joystick.

As James Goddard of Crunchtime Games says, "There is a huge difference in how input devices—even similar ones—can have on the feel of a game. Most people can tell the difference in the feel of control when a game is cross-platform but most do not know what exactly is causing it. Even a majority of developers really are not trained to know. The usual argument is that a specific platform's controller is 'just better.' Assuming a game engine is truly ported equally across the platforms and button layout is close to the same, what people are perceiving as better is the actual mechanical differences in the sticks/buttons tension and mechanical 'travel' distance. This sensitivity can come down to millimeters."

The design of controllers has a lot to do with industrial design and product design. Controllers are consumer products after all, as are game consoles, computers, mice, keyboards and handhelds. Every piece of hardware upon which game feel is built is a consumer product. The physical design of hardware can change the feel of control over virtual objects.

Summary

To summarize, we can categorize an input device according to individual inputs, the input space of the device as a whole, and tactile feel resulting from the materials and physical construction of the device itself.

Individual inputs can be measured according to their dimensions and types of movement, whether they track position or force, whether they directly or indirectly change things on the screen, the boundaries on their motion, and the signals they send to the computer (hard metrics). They can also be measured according to their sensitivity (soft metric).

The input space of the device as a whole can be measured by looking at how many different inputs there are on the device, and the ways in which they can be combined (hard metrics).

The tactile feel of the device can be measured by the feel of each input (the resistance to movement, springiness, etc.) and the feel of the input device as a whole (heavy and solid versus light and flimsy, physical properties of the materials). Both of these are soft metrics, affecting the feel of games in a mostly subconscious way.

SEVEN

Response Metrics

When I say response, I mean the game's response to player input. The output, in other words. There are many different ways an input signal, once received, can be processed before returning to the player in the form of feedback, but the process has three essential steps:

1. Input signal comes in

2. Input signal is interpreted and filtered

3. Input signal modulates some parameter in the game

To measure the response of a particular game to input, we begin by looking at how each signal from the input device is mapped to a change in the game. What parameter does it modulate, and how does it change that parameter over time? And what are the relationships between those parameters?

There are many different ways an input signal can modulate a parameter in a game. While an input device is a physical object constructed out of plastic and springs, an avatar in a game has no such constraints. An input can be mapped to a change in the position of an avatar, as it is in Megaman. Inputs can also be mapped to rotation, as they are in Asteroids and Gran Turismo, where a forward thrust is steered via angular rotation. Or rotation and positional changes can be mapped to the same input, as they are in Jak and Daxter, Super Mario 64 and Geometry Wars, where pressing a direction with the thumbstick rotates and moves simultaneously.

. An input can also be mapped to the creation of a new entity, as when Megaman fires his weapon and "spawns" a bullet or when Guile throws a sonic boom in Street Fighter II. In this case, an entirely new entity is spawned by an input, often from the position of another avatar. This entity often has its own properties of movement and its own velocity.

Another possible response to input is the playback of a linear animation, as in the games Soul Calibur, Samurai Showdown 4 and Street Fighter II. You press a button and a "move" happens. A move consists primarily of animation, created by a professional animator, and some game-relevant spatial movement. It occurs at the position in space and time of your choosing, but once triggered, the animation plays back as a linear sequence of frames, as it would if it were an animation playing

back on a television. The duration of the animation may be short, but it's interesting to note that what's been mapped is still the linear playback of an animation to a particular input. This can be taken to ridiculous extreme, as it is in the original Prince of Persia, where the game can only be controlled via the playback of linear animations. Your input serves only to change which animation is playing at a given time, and you're tasked with managing the movement of the character in that stiff, robotic way.

Still another thing that input can be mapped to is a change in one or more parameters in a simulation. For example, in Mario Kart DS, there's a simulation running every frame which computes the game's internal model of the karts—their relationships to one another, their weight, their mass, their velocity, their rotational force and of course, their friction values—how the forces that are acting on the kart are reconciled with the friction value of the surface they're currently in contact with and how that affects their motion. You can map an input not only to moving the kart forward and rotating it, but to the friction value itself, altering the resulting motion of the entire system. When you enter the "powerslide" state by pressing the R-button, what you're really doing is changing the friction value. It's decreased, enabling you to corner better by carving less (sliding sideways instead of gripping the road, in other words).

Generalizing the possibilities, an input signal might:

- Set a new position for an object each frame.
- Set a new orientation for an object each frame.
- Add a force or torque to a simulated object, causing it to rotate or move.
- Modify a simulation variable, changing gravity or the friction of a car's tires.
- Play back an animation from start to finish, like a single move in a fighting game.
- Change the speed at which a looping animation plays back.

The process of hooking up input signals to specific parameters and determining how they will modulate those parameters over time is known as mapping. For real-time control, however, there is a specific subset of mapping required: mapping to motion.

If there is real-time control, the input signals will be mapped, directly or indirectly, to the motion of an avatar. The movement of that avatar can, for the most part, be measured using criteria similar to the ones we used to measure input.

- Type of motion: Linear vs. rotation. Does the avatar move linearly or rotate?
- Dimensions of motion: In what dimensions, X, Y or Z, does the avatar move or rotate?
- Absolute or relative motion: What frame of reference does the motion use? Is the motion relative to the avatar, as in Asteroids or the camera as in Mario 64, or some other point in the world?

MOVES IN TWO DIMENSIONS, Y and Z

FIGURE **7.1 The Mario Avatar moves in two dimensions, X and Y.**

- Position versus rate/magnitude: Does the input modify a position, a rate or a magnitude? A mouse cursor is usually mapped to changes in position. Pushing the thumbstick to the left in Halo changes the rate at which the avatar turns (halfway causes a slow turn, while fully pressed turns very quickly).

- Direct or indirect control: Does the input modify the avatar directly or does it add forces to a simulation or cause another object to move or rotate? For example, in Zuma, movement of the mouse cursor determines which direction the frog will face.

- Integrated or separate dimensions: Does the input change one parameter in the game or many? For example, Geometry Wars maps both thrust and rotation of the ship to the left thumbstick. Jak and Daxter does this as well, changing both speed and rotation with one thumbstick.

The point of taking stock of the avatar's movement in this way is to hone in on exactly which parameter each input is mapped to. We can look at the Sonic avatar and say he moves along in the XY plane. Or we can look at the movement of Crash Bandicoot and say, he moves in an XZ plane, but he can also jump or fall in the Y plane, as well as rotate in the Y-axis to change his direction. Kratos from God of War moves in a similar way. Knowing which dimensions an avatar moves in, we can identify which inputs control movement in which dimensions, and whether that movement is linear or rotational. For example, Mario's horizontal movement is controlled by the left and right directional pad buttons, while his vertical movement is controlled by the A-button.

Attack, Decay, Sustain and Release

Regardless what parameter an input is mapped to—position, rotation, animation playback and so on—the modulation of a parameter over time will have some kind

FIGURE **7.2 An ADSR envelope; modulating a parameter over time in four phases.**

FIGURE **7.3 The ADSR envelope for a guitar's volume when a string is plucked.**

of curve. One way to describe this curve is as an ADSR envelope. ADSR stands for attack, decay, sustain and release. An ADSR envelope describes the modulation of a parameter over time, in four distinct phases (Figure 7.2).

Such envelopes are used to describe the modulation of the sound of musical instruments. For example, when you play a note on a guitar, the resulting sound can be described in terms of attack, decay, sustain and response. The note is loudest just as the string is plucked, but it takes some time to go from silent to loud. This is the attack. From the loudest volume, the sound then drops down again before reaching a stasis point. This is the decay. The point at which the volume stabilizes is the beginning of the sustain part of the envelope. This lasts until the sound begins to fall off again, eventually returning to silence. This final period is the release. Graphed over time, it looks like Figure 7.3.

Contrast this with a pipe organ. The note starts at a constant volume, continues to play at that same volume and falls silent almost instantly when the button is released (Figure 7.4).

ADSR envelopes are often used to modulate the output of digital instruments to make them sound like their physical, real-world counterparts. They are also a good way to think about the modulation of parameters in a game relative to specific input. For example, look at the "left" input in Super Mario Brothers (Figure 7.5).

FIGURE **7.4 The envelope for a pipe organ is much more rigid.**

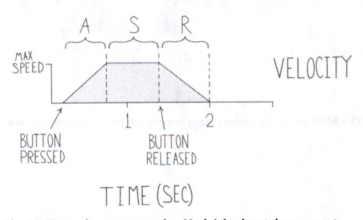

FIGURE **7.5 The ADSR envelope representing Mario's horizontal movement.**

In this case the vertical axis of the envelope is movement. There is an attack phase as Mario ramps up to his maximum speed, no decay, a sustain as long as the button is held and a long release when the button is released. The result is that Mario speeds up gradually over time (Figure 7.6).

Now compare Mario's left motion to Donkey Kong's, shown in Figure 7.7. When Jumpman (the pre-Mario character from Donkey Kong) moves, he has no attack and no release. The moment the joystick is activated, he moves at a constant speed in the appropriate direction (Figure 7.8).

Once we know what parameter in a game is mapped to what input, we can measure the modulation of that parameter over time relative to the input signals coming in as an ADSR envelope. Assuming that the parameter being modulated feeds into the real-time motion of an avatar, we can make generalizations about how players are likely to experience the sensation of control based on this envelope.

FIGURE **7.6 Mario speeds up gradually from a standstill.**

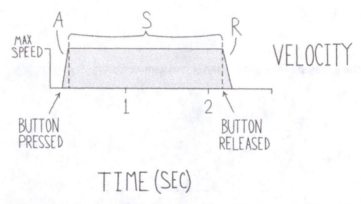

FIGURE **7.7 The ADSR envelope representing Jumpman's horizontal movement.**

FIGURE **7.8 Jumpman moves at a constant speed in the direction indicated by the input device.**

A longer attack phase results in a floaty or loose feel. This is not necessarily a bad thing; the thruster mechanic in Asteroids has a long attack, and players generally seem to enjoy that feel. When a long attack phase begins to cause trouble, however, is when there seems to be no immediate response to input (Figure 7.9).

This is problematic because it starts to erode the impression of instantaneous response. There may be some small change happening immediately, but if the player can't perceive it, the game feels unresponsive. An envelope like the one in Figure 7.10, which has a rapid initial attack but a long attack phase in general, will have both instantaneous-feeling response and a loose, organic feel. On the other end of the spectrum, a short attack phase will tend to feel tight and responsive (Figure 7.11).

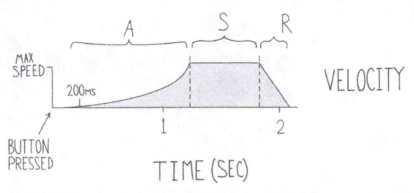

FIGURE **7.9 This feels unresponsive if the thing being controlled takes more than 100 ms to move (or if the player perceives it this way).**

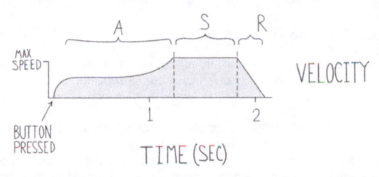

FIGURE **7.10 Even though the attack phase is very long (more than a second) there is an obvious initial response.**

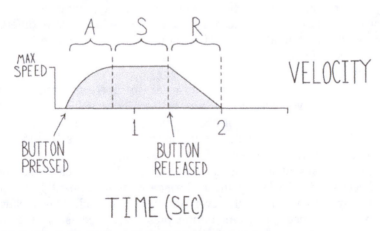

FIGURE **7.11 A short attack phase feels tight and responsive.**

125

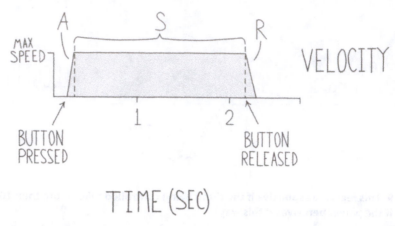

FIGURE **7.12 A short attack phase with a flat progression from on to off creates a twitchy feel.**

Playable Example

You can experience the difference in example CH07-1. Press the "1" key for an unresponsive, the "2" key for a responsive but loose feel.

Even with tight, responsive controls, the attack phase usually has some nonlinear curving to it. In other words, the attack phase is a curve, not a straight line. This keeps the flowing, organic feel while enhancing the perception of instantaneous response. On the other hand, when the attack phase is short and when there is a more linear progression from off to on, most players describe the feel as twitchy (Figure 7.12). This too can be desirable depending on the intended effect. If the attack is totally linear and very short, the controls can feel stiff.

What's interesting is that these sensations—floaty, twitchy, tight, loose, unresponsive—all exist on the same continuum. They're just slightly different envelopes, slightly different modulations of motion over time. That motion could be direct or indirect, a force or a rotation; regardless, changes in attack will alter the feel of control.

Attack and release are often mirrored, as in the horizontal running of Super Mario Brothers. After you release the button, it takes Mario the same amount of time to slow back down to zero as it does to speed up from a standstill to his maximum speed. The soft release maintains the loose feel after the button is released. Having no release, as in Donkey Kong, feels more abrupt.

When decay is present in game control, it's usually by accident. Sometimes a game designer will inadvertently make the speed of movement faster just after a change in input than during the eventual sustain period. This means that to maintain maximum speed, constant button pressing is necessary. This is almost never desirable for the simple, practical reason that it fatigues the player's hands.

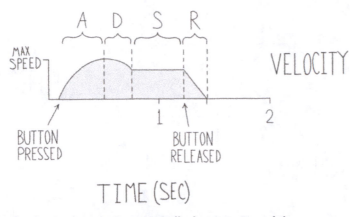

FIGURE **7.13 The decay phase in Counter-Strike became an exploit.**

For example, in some of the earlier beta versions of Counter-Strike, it was possible for those in the know to "skate" by angling slightly sideways and pressing forward and sideways rapidly. When moving at a particular angle and switching between going sideways and forward, there was a decay phase—the attack took the maximum speed above the level of sustain (Figure 7.13).

This gave experienced players a huge advantage because they could move one and a half times more quickly. This was an exploit to be removed because it gave an overwhelming advantage to veteran players and enabled the player to move faster than intended.

The level of sustain can be thought of as a limit, such as the maximum speed of a car or character.

Simulation

So where do these envelopes come from? For any game, it's relatively easy to track what parameter a particular input mapped to and how it modulates that parameter over time. But it is often difficult to discern exactly what sort of system gave rise to that modulation. Most often, envelopes are defined by relationships between variables in a simulation.

As a simple example, consider a cube that moves left and right. Both directions of movement have an ADSR envelope that looks like Figure 7.14.

Playable Example

To experience this, open example CH07-1. Move the cube left and right using the A and D keys. Enter new values by clicking on a parameter (such as "Max Speed"), typing in numbers and pressing enter to see how the envelope changes.

127

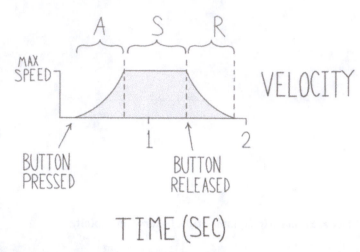

FIGURE **7.14 The cube has smooth, organic movement.**

Currently, an acceleration value is added to the cube's velocity each frame, creating a smooth quarter-second attack phase. This speeds the cube up gradually, giving it a loose, organic feel. Mirroring this, a drag value is also applied in each frame, causing the cube to slow back to rest again when the button is released. Without this drag value, the cube would keep going indefinitely (switch "Drag" to zero to experience this). The Max Speed variable determines the level of sustain, the constant movement value the cube reaches after completing the attack phase.

This simple test demonstrates how simulations give rise to the different modulations of parameters, and how changes in that simulation modify the sensations of control. It gets a lot more complex than this (as we'll see in Chapters 12–17) but simulations like this are the building blocks for sensations of control. How the simulation is built determines the sensations of control possible. A particular tuning can change the feel of control drastically, but the construction of the simulation—which parameters are available to tune in the first place—determines what tunings are possible.

For example, consider the feel of the left-right movement in Ghosts and Goblins, Donkey Kong and the original Metroid. In all three of these games, horizontal movement has very little attack or release (Figure 7.15).

In the systems that create this kind of envelope, pushing the joystick or pressing the button directly overwrites the position of an avatar. Every frame in which the game detects the button as held, it adds some amount to the current position of the avatar in the appropriate direction and places the avatar in that new position. In the same way, the release value brings the player to a halt instantly when the button is released. The result is a system that feels stiff but responsive. It feels crisp and is good for dealing with challenges that require precise positioning and accurate jumping. This same kind of feel applies to other mechanics with little or no attack

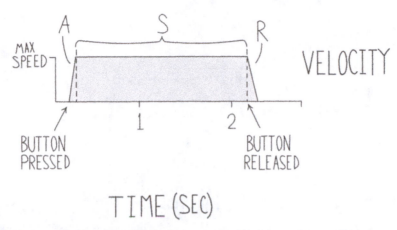

FIGURE **7.15 A responsive, but stiff, feel.**

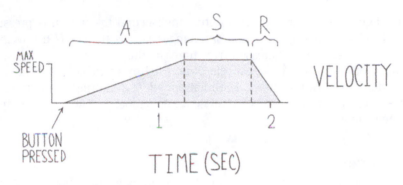

FIGURE **7.16 A loose, fluid feel.**

and release, such as the movement of a mouse cursor in response to mouse movement. Sometimes players categorize this feel as twitchy.

Compare this to the "thruster" mechanic in Asteroids. Pressing the thruster button has a long attack (Figure 7.16). In this case, it's because Asteroids keeps track of a separate velocity value for the ship. Instead of the position of the ship being set directly each frame, the ship keeps its own value for velocity and updates its own position based on that value. Pressing the thruster button adds to the velocity value in the direction the ship's currently facing. The result is that the ship speeds up gradually, a curved and gentle attack. It's a different kind of simulation and a different kind of feel.

The other way to define an envelope is by filtering input before it is plugged into the changes in the game system, as happens when rotating the Asteroids ship left and right. The envelope looks like Figure 7.17.

While the left button is held, the ship's orientation is changed by a certain amount each frame. There's a slight attack value, which is achieved by changing

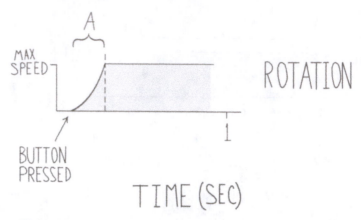

FIGURE **7.17 A slight softness in the attack.**

the input slightly as it comes in. At the first millisecond the button is pressed, the amount by which the ship's orientation changes is less than it is a few milliseconds later. The value gets increased over time. In this way, the feel is responsive but slightly soft. The player can tap the button lightly to make small adjustments or hold it down to turn full speed. The rotation is just a filtering of the input signal over time. This is another way to modulate an envelope: just change the input signals as they come in.

State Changes

Another interesting, measurable feature of simulation is state changes. States are artificially constructed changes in circumstance that modify the meaning of incoming signals. In Super Mario Brothers, for example, there are ostensibly three controls: left, right and jump. In Figure 7.18, we see different states that overlap and interact in different ways.

Mario has a "ground" state and an "air" state. As far as the simulation is concerned, Mario's potential for movement—his physical properties—change when he's on the ground or in the air. When in contact with the ground, the left and right buttons map to certain additive force. When Mario is not in contact with the ground, the strength of his left and right movement is greatly reduced, creating a different state. This is a very simple example of increasing sensitivity through state switching. Left and right movement means something different when Mario is in the air, meaning that one input is actually mapped to two separate actions that change depending on the state of the character. What's interesting is that this creates additional sensitivity in the system: there is greater expressivity when inputs are mapped to different responses across states which are altered and maintained by the simulation itself. You're getting two sets of responses mapped to one input, essentially.

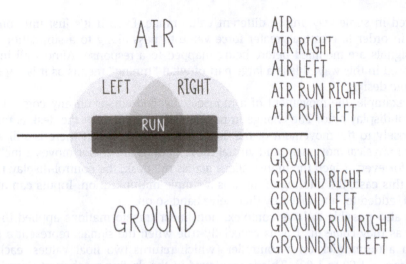

AIR
AIR RIGHT
AIR LEFT
AIR RUN RIGHT
AIR RUN LEFT

GROUND
GROUND RIGHT
GROUND LEFT
GROUND RUN RIGHT
GROUND RUN LEFT

LEFT RIGHT

RUN

FIGURE **7.18 Overlapping states provide additional expressivity.**

This is used to great effect in the Tony Hawk games where there are as many as six separate states, each of which assigns a different value to each button on the controller. Every button means something different in each state. A relatively small number of inputs becomes an interface to a huge number of moves. The game has artificially created different physical states for the avatar to exist in. If these state changes are clear to the player, they can correspond to a huge number of possible responses. The same principle is applied to fighting games, where being in the ducking, blocking or jumping states changes the meaning of each input.

Examining the type and robustness of the simulation a game is running can yield useful fodder for comparison. Without getting too crazy deep into the mathematical intricacies of a given physics system, we can see that while Super Mario's vertical movement uses a simple simulation, the jumping in Metroid is a predetermined set of positions. This lends Metroid a crisper, more precise feel. It's also useful to catalog whether or not the avatars have different states they can exist in. If the avatars do have multiple states, how many states do they have and how do the different states cause different input signals to be interpreted by the simulation and responded to?

Filtering

Input signals come in from the input device in various forms, such as Booleans and changing float values. It is possible to map "raw" input either directly to a response or to a force or other modification of a simulation. This rarely happens, because to directly map raw signals is to forego the opportunity to tweak game feel. Most often, an input signal is received raw and passes through a layer of code where it

131

is filtered in some way, into a different value range. Even if it's just multiplied by 2 or 3 in order to create a greater force value to pass along to a simulation, most input signals are modified before being mapped to a response. Almost all input is transposed in this way; this is a large part of what "tuning" means as it is applied to mechanic design.

For example, the movement of a mouse-controlled cursor on any computer has a control-display ratio. The change in position of the mouse on the desk is mapped very closely to the movement of the cursor on the screen, but there is still a ratio between physical movement and virtual movement. If the cursor moves 2 inches on screen for every 1 inch the mouse slides across the desk, the control-display ratio is 1:2. In this case, the filtering of input is a simple multiplication. Inputs can also be divided, added to, multiplied by themselves and so on.

It is also possible to have complex, non linear transformations applied to input signals as they come in. This is especially true when the signals represent a range, as with a thumbstick on a controller (which returns two float values, each in a range from −1.00 to 1.00). This is employed in the driving mechanics Grand Theft Auto 4 and other games featuring a driving metaphor. Instead of a constant car steering ratio (1 degree of steering wheel turn = 2 degrees of car turn) the amount of turning changes across the input space. The steering ratio increases the farther the thumbstick is pulled in a direction (Figure 7.19).

Pulling the stick about halfway to the right of center still yields a fairly small turn. This mitigates "twitchiness" that is present in some harder-core driving games like Vanishing Point or, to some extent, Grand Turismo. By making it much more difficult to oversteer, the mechanism is much more forgiving and creates a nice range between small avoidance adjustments and hairpin turns.

At this layer, there is the possibility not only for modifying input signals before passing them on, but for creating entirely new signals by further interpretation of the incoming signals. Think of the famous Konami code, which looks for a particular sequence of button presses over time. The game's code examines the input

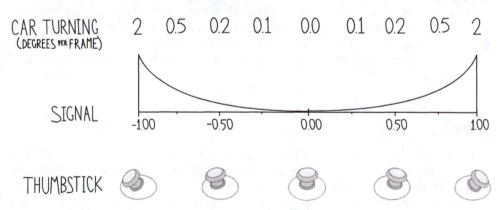

FIGURE **7.19 Turning changes as the thumbstick is pulled farther from center.**

signals it receives for specific, predetermined patterns and responds differently when it sees them. When a game is sensitive to patterns of inputs over time like this, the input space becomes larger. Moves in fighting games are fundamentally the same kind of interpretation. The Haduken in Street Fighter II or "Dark Metamorphosis" in Castlevania: Symphony of the Night each require a certain sequence of inputs over time to trigger. Ditto the gestures used in many games controlled by the Wiimote.

Fundamentally, what's happening is that an additional process is running in the layer between input and response. The signal comes in and a piece of code checks to see if it recognizes the signal as the first part of a pattern. If it does, it moves ahead and waits to see if the next part of the pattern is going to follow. Usually this is time-based, enabling only a short window of time for the next input to occur before resetting the sequence. Essentially, it's building additional sensitivity into the inputs coming through. After all, a sequence of inputs is not inherent in the signals coming from the inputs themselves. It's not a response per se, just the game listening for additional patterns among the input signals it's receiving. Once a pattern is identified, a special type of signal is generated by this interpretation layer and is passed along to the simulation, where the response is carried out. This response can be an animation, the unlocking of additional lives or the addition of a particular force into the game's simulation. The same thing happens in most current Wii games; it just happens to be a much more complex and sophisticated pattern-seeking algorithm because it has to make mathematical sense of all the crazy data that flows when you spew accelerometer and pointer data from a free-floating controller. Whether it's a Haduken or a Wiimote sword slash, however, I would categorize any time a game listens for a pattern of inputs across time as a "gesture."

Another way in which it's possible to create additional sensitivity through interpretation is spatially, either across game space or input space. For example, while pressing the A-button may have one meaning and pressing the B-button may have a different meaning, pressing both simultaneously yields a third response. This is similar to a gesture, but instead of looking to correlate a sequence of inputs across time, it looks for combinations of input signals happening at the same time. In other words, it assigns a different meaning to a combination of inputs than it does to each of those inputs individually. This is commonly called "chording" and is used to great effect in games like Tony Hawk's Underground, where every combination of a button and a direction maps to a different trick. Remarkably, chording is present even in early games such as Super Mario Brothers, where holding down the B-button modifies the meaning of pressing left or right (by adding more force).

The other type of spatial transposition happens across game space and is more commonly known as context sensitivity. For example, in Resident Evil 4, the position of the character in the game world can alter the meaning of a particular input. Standing by a window or a ladder changes the meaning of the A-button in a direct, one-for-one kind of way. It's not necessary for context sensitivity to be this rigid, however, as proved by the game Strange Attractors. Strange Attractors has only one input, which activates a series of gravity wells placed around the level. The gravity from a well will affect the ship relative to its distance from that well (following

the inverse square law, I assume) meaning that Strange Attractors features a fluid, ever-changing sort of context sensitivity. The meaning of pressing the button is constantly changing as the ship moves around the game space, closer to some wells, farther from others.

Drawing a generalization from all of this, transposition is either spatial or time-based. Spatial transposition can mean turning a linear curve into an exponential one, or it can mean augmenting sensitivity by recognizing groups of input signals from different inputs as unique, and passing along corresponding (new) signals. Time-based transposition assigns different meaning to input signals across time, forming gestures which themselves create new and different signals. This offers us another way to compare one game to another: the types of transposition the input signals undergo and the resulting values that get passed along.

Relationships

Examining individual mappings and envelopes takes us most of the way to understanding how a game's feel is built. The final piece of the puzzle is the relationships between parameters in a system. This is where much of the tuning of game feel happens. For example, in the game Sonic the Hedgehog, there is a parameter for gravity. Gravity is the foil of jumping; the two work in concert to produce the feel of jumping in Sonic. In the same way, to create the feel of "carving" in a driving game requires friction. Without friction, the car's turning seems floaty, as if it's driving on ice. With sideways friction applied to the tires, they seem to carve and dig in, as a real car would. Individual mechanics—mappings of one input to one response—work in concert to produce an overall feeling of control.

The whole process looks something like Figure 7.20. As shown across the top, input enters the system when the player manipulates an input device. From the physical manipulations of various inputs, the input device generates and sends to the game corresponding signals. A raw input signal can be mapped directly to response, as with a mouse cursor, or it can feed directly into a simulation. Alternately, some kind of filtering happens, where the input signal coming in is altered in some way before being passed along to simulation and/or response. The simulation layer represents the game's internal model of reality, the one which the player interacts with via input. Finally comes the game's actual response to the signals it received, whether transpose, raw or from a simulation.

To summarize, to measure response we want to know what inputs are hooked up to what parameters in the game. To do this, we want to know how many different things the player controls, how many avatars there are. We can then examine each avatar in the game relative to its type and dimensions of motion, the frame of reference for that motion, and whether the motion is direct or indirect. Knowing this, we can identify how each input stream modulates the parameter over time and can quantify this as an ADSR envelope. From this point, we can attempt to extrapolate the system that gave rise to this particular envelope. This could be a filtering

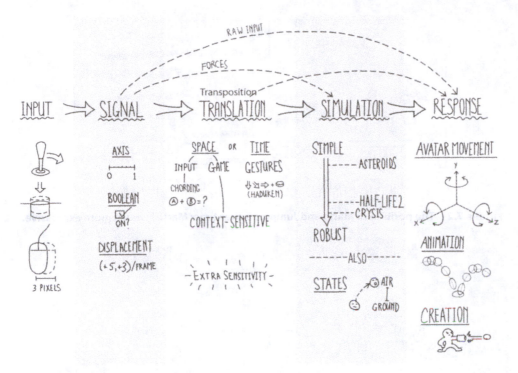

FIGURE **7.20 From input to response.**

of input signals directly, a change in a simulation or both. Ultimately, we want to understand what variables are being tweaked, the relationships between those variables and how they become the envelopes we've identified.

Input and Response Sensitivity

Out of the games discussed earlier, Donkey Kong is particularly interesting because it maps a relatively high-sensitivity input device (the joystick, which can return float values from −1.00 to 1.00 along its horizontal axis) to a very low-sensitivity response. Compare this to Super Mario Brothers, which has a very low-sensitivity input device but has a very sensitive response.

If we record the positions of these characters over time and include jumping as well, it's obvious just how much more expressive Mario's loose movement is (Figure 7.21).

From this comparison, it's apparent that Super Mario Brothers has a more expressive mechanic than Donkey Kong. The combination of input and response produces a fairly accurate picture of the overall "virtual sensitivity" of the system (Figure 7.22). This is a soft metric, of course, but useful for comparing the expressivity of two different games.

135

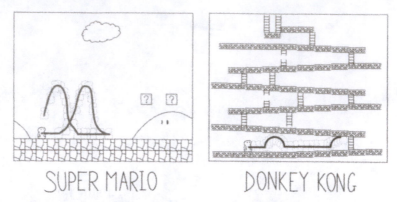

FIGURE **7.21 The position of Mario and Jumpman over time: Mario is much more expressive.**

FIGURE **7.22 Different games on a rough scale of input and response sensitivity.**

Playable Example

To experience this first hand, check out example CH07-2. There are four options for control that can be accessed by pressing keyboard keys 1-4.

To begin, press "1" and use the W, A, S and D keys to move the cube around. These controls have low input sensitivity and low response sensitivity. The input sensitivity is low because there are only four buttons, each of which only has two states, on or off. The reaction sensitivity is low because the game's reaction for each button has only two states, moving at full speed or not moving at all. This is not a very good virtual sensation, very stiff with very little fluidity or appeal. In some instances—the original Legend of Zelda, for example—this grid-like rigidity is desirable because it creates a more

136

contemplative, less visceral feel. As in Pacman, all rotation and superfluous directions of movement have been stripped away for simplicity. The result, however, is not a very compelling virtual sensation when removed from its context.

Press "2" to experience low input sensitivity and high response sensitivity. This time, the cube moves organically, loosely and smoothly. The simulation is adding forces rather than overwriting position directly. This is a much better feel, no? The lines of motion are flowing, curved and organic.

Press "3" to experience high input sensitivity and low response sensitivity. With this combination, you have very high sensitivity with the input device, the mouse, but almost zero reaction from the game. The cube has become essentially a very large cursor. This is a natural mapping; the position of the mouse on the screen matches the position of the mouse sitting on the desk, so it's very easy to feel oriented and get a sense of mastery and control. Bit boring, isn't it? Because the mapping is so internalized from years of computer use, there's nothing to learn, no motion translation to master. The motion is quick and snappy and leaves the cube with no feeling of mass, weight or presence.

Press "4" to experience high input sensitivity and high response sensitivity. There's a very interesting motion here, one that requires a bit of mastery. It feels nice to whip the block around again and again to hit the red dot and to experiment with trying to slow the block down again and reverse direction or to make little figure eight patterns. Even a game with high input sensitivity and low reaction sensitivity (a first-person shooter that ties mouse movement directly to looking around a 3D space, for example), smoothes that snappy, jerky input with a little bit of reaction from the game.

This is a simple demonstration of some of the different ways input and response can be combined to create different sensations of control. This rough measurement can be applied to any game.

Summary

Our final metrics are as follows:

- Hard

 1. How many objects the player controls
 2. The dimensions, type and frame of reference for the movement of each avatar
 3. The ADSR envelope representing each modulation of a game parameter by an input over time

- Soft

 - The overall sensitivity of the system as a function of its input and response sensitivity

Understanding the simulation and input filtering that give rise to particular sensations of control is craft knowledge. If you want to build real-time control that feels a certain way, it's useful to know how simulations give rise to what sensations. For measuring the sensation of control across games, however, measuring the output, the envelope, is sufficient. For measurement, as for the player, the underlying simulation is mostly irrelevant. What is relevant is the output, the sensation of control and the overall sensitivity of the controls.

EIGHT

Context Metrics

Context is a catchall term for the effect of simulated space on game feel. Simulated space is comprised of collision code, which defines how objects interact physically, and level design, the physical layout of space. Together, they give meaning to real-time control, providing a physical space for the player to perceive actively via the avatar.

Hard metrics are difficult to apply to the way that space redefines sensations of control because context is so bound up with the player's subjective impressions, which are difficult to graph in any meaningful, consistent way. But we can still identify some useful soft metrics. Let's start at the highest level of context: the impressions of space, speed, motion and size. Then we'll touch on the feeling of immediate space and object avoidance, which we'll categorize as medium-level context. Finally, we'll look at how context affects game feel at the low level of intimate, personal space.

High-Level Context: The Impression of Space

At the highest level, exploring a game world with an avatar you control will always experience some sense of space. With the freedom to explore and move about as you see fit comes the ability to mentally map a virtual space the same way you map your own physical space. In your mind, fed by the ever-on firehose of perception and against the backdrop of the perceptual field, you're constantly building and refining a concept of your surroundings. It's not quite accurate, but not quite *not*, and it enables you first and foremost to function and cope with your immediate surroundings. If you're like me, and like most people generally, you have a pretty accurate map of all the streets and points of interest within a mile or three of your home. Now think of a time when you took a trip, when your starting point was shifted to a hotel or a friend's guest room, somewhere new and unfamiliar. As you start to explore and trace paths, you begin to populate your mental model with landmarks and specifics. Before that, however, there is a period where your whole idea of this new place, your whole mental model, is based on a generalization. A general, but inchoate, spatial awareness. A feel.

FIGURE **8.1 Wide open space.**

This process of spatial learning, from macro to micro, is analogous to what happens when a player begins exploring a game space with an avatar. This is the highest level at which context affects feel: the general sense of space. It's not possible to measure this in a hard metric, finite numbers kind of way, but it's certainly possible—and useful—to catalog the general feel conveyed by the overall structure of a space. To illustrate this, let me share a personal experience.

Interested in the painterly textures and nursing a nostalgic fondness for Blizzard games, I fired up World of Warcraft. I had no intention of actually playing the game—an unfortunate, hygiene altering experience involving Ultima Online cured me of the MMO bug a long time ago—but I was interested in at least poking around and checking things out. What immediately struck me was the feeling of vast, sprawling openness. There was a sense that this was a world with some interesting and meaningful analogies to the world as I've experienced it. Specifically, trudging around felt a bit like hiking up to catch the glorious, breathtaking view from the top of the flatiron of Superstition Mountain, a grueling hike to the east of Phoenix, Arizona, which my friends and I do from time to time (Figure 8.1). From the top, there is no noise but there is plenty of wind. On a clear day you can see for hundreds of miles in every direction. The view is miraculous. Schlepping up to the top of the highest mountain I could find in World of Warcraft somehow felt similar. Here, in game form, was a little virtual taste of how it felt for me to stand at the top of a mountain and stare out.

Oblivion, like World of Warcraft, felt open and sprawling. Climbing to the top of something high, I could see for a great distance and, knowing that this was a contiguous world instead of the Potemkin villages you so often see in single player games, it felt like a realm of great possibility. If I saw something far away, I could travel there. Neat. By contrast, the worlds of Counterstrike seem always hemmed in, claustrophobic, and full of endlessly looping, twisting tunnels. Some levels

have open areas, to be sure, but there's never a sense that anything exists outside a Counterstrike level. As a player, you intuit within the first round of play that those far off buildings and skyboxes are just there for decoration.

To frame this concept another way, when the space is large and expansive, it warrants pondering and exploration, encouraging players to look outside the self and think about things like how small and insignificant they are. When it's tight and constrained, it causes more introspection.

With respect to game feel, this can mean the difference between an intense focus on the immediate surroundings and on the sense of exploration and possibility lauded by so many fans of Oblivion. Counterstrike does a great job of harmonizing its tight, twisting environments with other rules and systems that further emphasize the need for intense, all-consuming focus on moving through the immediate, medium-range space efficiently and effectively. Because one shot can kill you and you know that five enemies could be waiting just around the corner, you're careful, calculating and hyper-aware of every nook and cranny of the environment.

Without delving deeply into the notion of space as it is studied and employed by architects, we can at least appreciate the effect of high-level, large-scale construction of game worlds on game feel. Georgia Leigh McGregor, an astute student of the role of architectural concerns in video game design, observes the differences between the architecture of World of Warcraft and The Battle for Middle Earth II:

> An initial architectural reading of both video games reveals a dichotomy in the way they portray or produce architecture. ... Word of Warcraft privileges architecture as a spatial experience. It is concerned with the ability to move through space, constructing architecture as a series of solids and voids. When we interact with the architecture we are alternately channeled and impeded. ... This is a spatial architecture that mimics the ways in which we use architecture as containers for specific purposes in the real world. The architecture has what architects call program, so that Ironforge can be divided into circulation space and activity space. ... Conversely BFME II is not concerned with architecture as space.[1]

In terms of measurement, we can say, as a soft metric, that a space feels mostly open, like a seashore or a large city, or closed and claustrophobic like a subway tunnel or a cave, and to roughly chart the effect of that overarching structure on the feel of a game.

Impressions of Speed and Motion

The other high-level way a game's feel is affected by context is in the impression of speed of moving objects. Speed in a video game is a purely notional concept. There is no standard unit of measure for the movement of objects in a game. There can't be. Unlike our reality, where miles per hour means the same thing to a swallow in

[1]http://www.scribd.com/doc/268586/Architecture-Space-and-Gameplay

Saskatchewan, a bus in Burma or a Maserati in Munich, every game uses funda-mentally different units to measure (and tune) the speed of objects. Even in games such as Project Gotham Racing and Gran Turismo, where speed is measured osten-sibly in miles per hour, the metric does not correlate across games. The problem lies in relativity. Speed in a video game only has meaning relative to the number, place-ment and nature of the objects around it. Without at least one object to compare it to, the speed at which something moves in a game has no meaning.

Playable Example

To illustrate just how powerful this effect is, I created an interactive test of a car, example CH08-1. According to the game, the car moves at 100 miles per hour. The game's code says simply "when the space bar is pressed, speed = 100 mph." As long as a camera follows that car at the same speed, the number 100 is meaningless. The speed at which the car moves according to the game's code has no effect on the impression of speed for the player. However, add an asphalt road texture beneath the car, and the impression of speed springs to life. To experience this, press "2" on the keyboard. Simply put, without a frame of reference there can be no impression of speed. Add in trees and fences, cows and bridges, and the effect is enhanced. Have the field of view of the camera change as the car speeds up and the impression of speed is greater still.

So even if we could distill the speed of an object moving in a game to a mea-sure of, say, distance across the screen per second and compare that to the speed of movement in other games, the problem remains that what we're tracking is the game's internal model of speed rather than the player's. What we want to measure is the impression of speed as it exists in the mind of the player. So how do we do that? Again, this is a bit of a soft metric. We can never really know exactly how players perceive speed, only what they will tell us or what we experience ourselves. Thankfully, the impression of speed seems to have very little variability across dif-ferent players, probably because we spend so much of our time interacting with a world where things move around quickly, and where it's important that one be able to gauge the movement of those things accurately. Stepping off a curb three sec-onds earlier or later can mean the difference between a delicious muffin and grisly death, so people are pretty great at judging the speed of moving objects at various distances, especially with respect to their own visually verified point in space. That oncoming bus is getting larger at a certain rate and the sound of its engine is getting louder. The parked cars and lampposts it's driving past help you verify its size, and the rate at which it's advancing past them gives you still more data about how fast it's coming. Other cars driving nearby also give me a frame of reference for speed; if the bus is passing cars left and right, it's probably going quite fast. All in all, there are dozens of clues that enable me, in an instant, to judge, check and recheck my

concept of the bus' speed of approach. With that data I can decide whether a delicious muffin is worth the risk or whether it would be best to defer deliciousness for another few minutes.

The impression of speed conveyed by a video game offers these same kinds of clues (such as size of objects, their relative motion and changes in sound) to actively fool the audiovisual system into thinking motion is occurring. Depending on the apparent movement of objects across the screen, changes in perspective and field of view and effects such as Doppler shift and screen blurring, that motion will read as fast, slow or somewhere in between. For now, let's focus on the apparent movement of objects on the screen and changes to perspective. Effects such as Doppler shift and screen blurring are best categorized as polish because they are layered on, and have no direct effect on the simulation.

The best way to come to terms with the speed of something in a game is in comparison, again, to real-world objects. Is the impression of speed in the game similar to riding your bike or is it closer to driving on the freeway with the top down? For me, the movement of Daxter in his PSP incarnation seems most like that of a squirrel. The motion is quick; rather than having a very high speed and taking a long time to reach that speed, it is showing quick changes in direction and a quick ramp up to maximum speed, as happens when something very small moves around a small space very rapidly. Loco Roco seems like playing with a bunch of fast-rolling water balloons. All of this comes back to the balance between the speed of movement of the avatar and the nature, size and spacing of the objects in the world that avatar traverses. In this way, context is a second set of knobs for tuning real-time control. Effectively tuning a game's feel means tweaking a bunch of numbers which govern the resulting movement of the avatar, but it is the placement of the objects around, over and near which that motion that takes place that gives those numbers meaning. To tune, you must have some context to tune against.

The other thing that profoundly affects the impression of speed in a game is perspective. Returning to the example of watching a bus from a street corner, imagine instead being in one of the cars driving alongside the bus. How fast does the bus appear to be moving now? And what if you were instead in a news helicopter flying hundreds of feet above the bus? In that case, both the cars and the bus would appear to be positively plodding. Even if the helicopter was in a hover, the distance would make the traffic seem to crawl in the same way that a jet plane seems to amble across the sky when you're standing on the ground. Perspective changes everything. In the case of a video game, though, there is no real meaning to absolute speed. It doesn't really matter that the jet is actually moving at 600 miles per hour; there is only the player's impression of speed. From the point of view of a game designer, this is great news. We can easily change the distance from which objects are viewed, the size of objects and the speeds at which they move relative to one another. In addition, we can change the angle view of the camera. Wikipedia defines angle of view (perspective) as "As an effect, some first person games, especially racing games, widen the angle of view beyond 90° to exaggerate the distance the player is travelling, thus exaggerating the player's perceived speed. This effect

can be done progressively or upon the activation of some sort of 'turbo boost.' An interesting visual effect in itself, it also provides a way for game developers to suggest speeds faster than the game engine or computer hardware is capable of displaying. Some examples include Burnout 3: Takedown and Grand Theft Auto: San Andreas."

The Impression of Size

An extension of the impression of speed is the impression of size conveyed by the impression of speed. In other words, the size of an object and its motion have a relationship which can be used reciprocally to create an impression of slow speed or of massive size. In the game Shadow of the Colossus, for example, the colossi appear to move very slowly. When you watch a commercial airliner amble its way across the sky, the same phenomenon is at work. It is in fact moving 600 miles per hour, but the distance from which you are seeing it reduces the impression of speed to a crawl. As the hero approaches the colossi, however, it becomes apparent that they're not slow-moving; they're simply huge. The impression is created not only by the added frame of reference of the character being suddenly near the colossus' foot, but by the colossus' hefty, plodding movement. The interesting part is that it's the contrast between being very close to the colossus or very far away from it that conveys the impression of massive motion. The little avatar moves closer to the colossus over time, giving a fluid set of data points with which to form and inform a detailed concept of the mass and heft of the colossus based on its movement. The game also does some neat things with perspective, constantly looking along a vector from the character to the colossi, effectively guaranteeing that the colossi will always seem to be towering above you and bending the view angle nicely wide in order to exaggerate the impression of distance. The effect is such that the closer the player gets to a colossus, the larger it will seem and the greater the distance covered by its expansive motions. The sounds, particle effects, screen shake and other polish sell the notion of largeness, but it is the impression of speed which truly lends the colossi their impression of mass and size.

To see what happens when such an attempt at impression of size goes wrong, check out the bosses in the games Serious Sam and Painkiller. Both these bosses were similar in size to the colossi, if not larger, at least, judging by the relative speed of the avatar. Both of these games had the sounds, particle effects, screen shake and other polish necessary to sell the notion of largeness, but the impression of speed was lacking the requisite context to be effectively established. The motion was wrong. Even when you got close to them, the impression was not one of a massive, hulking beast. Rather, the impression was that a small creature had somehow been enlarged, but had retained all of its physical properties. That is, physics were the same for it at the size of a skyscraper as they were at the size of a dachshund. The speed of the animation playback was paramount. The colossi moved very slowly when you were far away from them but appeared to move appropriately quickly

when your frame of reference was changed to a closer aspect. The bosses in Serious Sam and Painkiller appeared to move quite quickly, even from a distance, thus destroying the intended effect of the impression of size.

So that's one great example of how the speed of movement of objects by providing context for one another can effectively sell the size, mass and weight of an object. The sounds and particles and screen shake also speak to those properties, but in this instance the sensation was really sold by the context of one moving object relative to another.

This is the same essential principle that applies to the apparently slow motion of Zangief relative to Chun Li in Street Fighter II. Zangief's motion seems ponderously slow relative to the motion of Chun Li. His movement would probably seem somewhat slow by itself, but with the added frame of reference of twitterbug Chun Li, the effect is enhanced considerably. To contrast that, imagine an alternate universe Street Fighter II where Zangief is the fastest character. Relative to those dullards, his motion would seem zippy fast.

Medium-Level Context

The medium level of context refers to the feeling of immediate space and object avoidance. At this level, changes in context can mean the difference between sensations similar to pushing through a crowded party, wandering an empty street or a playing in a basketball game. It's not space at the low level—intimate and interpersonal—and it's not the sensation of openness you get from walking along a beach. It's the layer where, with respect to game feel, context is the "second set of knobs" for game feel tuning. The first set of knobs is in the programmed response to input; you tune the speed of motion of the character in absolute terms relative to the game. For example, the character moves at 90 meters per second forward and can turn somewhere between 0.1 and 5 degrees per second. None of these numbers has any meaning, as we've said, unless they're related to spatial context. In order for the forward speed of a car in a racing game to have meaning relative to how fast it can turn left and right, it must have a track. You have to have a track laid out that has curves of a certain sharpness and that includes objects and obstacles to avoid. It is at the intersection between the tuning of the individual response to input numbers and the spacing of the objects in the environment that the feel of a game gets primarily tuned.

So this mid-level of context is about steering and object avoidance, about navigating an interesting spatial topology with enjoyable precision and deftness. In order to compare the avoidance mid-level feel between games, what we need to examine is:

- The number of objects
- The size of the objects
- The nature of the objects

FIGURE **8.2 Different configurations and types of space yield a different feel relative to the controlled movement of the avatar.**

- The layout of objects
- The distance between objects

Across multiple games, we can compare how far apart objects are spaced relative to the speed and motion of the avatar and can examine how this changes game feel (Figure 8.2). A great example comes again from World of Warcraft. Moving through WoW, I began to experience highway hypnosis. Highway hypnosis happens when, while driving, you begin to zone out, and are to be lulled into a somnambulant state by the flowing uninterestingness of it all. You're sort of flying across the land and your mind begins to expand in all directions, and you have this sort of powerful alpha brain wave truncation of time. Before you know it you've driven 200 miles and are suddenly nagged by the distinct feeling that yes, perhaps I should have been paying more attention those last three hours. My driving instructor in high school told us that 20-something percent of all accidents in some place during some time period were caused by this. For me, it tends to happen when I'm driving cross country. Traversing the landscape of WoW felt for all intents and purposes like driving the long stretch of straight, level freeway between Los Angeles and San Jose.

FIGURE **8.3 WoW-highway-hypnosis.**

Because the objects in World of Warcraft are spaced so far apart relative to the speed of movement of the avatar, and because the movement of the avatar across that terrain often has no gameplay function, running across this environment started to lull me into the same zoned out state (Figure 8.3).

In contrast, playing Vanishing Point is like another section of the route between San Jose and Los Angeles. After hours of mindless driving on Route 5, you arrive at Pacheco Pass. The contrast is striking. In Pacheco Pass, the wind blows right off the adjacent waters of Lexington Reservoir, buffeting your car and threatening to uncouple it from its reassuring grip on the road. The road twists at dismayingly car-commercial-like angles, and there's invariably some idiot who seems determined to get his Jetta's worth by driving the section at speeds he's witnessed in such a commercial. Playing Vanishing Point is like being the idiot in the Jetta. It's an insidiously difficult racing game from the Dreamcast era, with the most twitchy, difficult controls. The game tasked you with accomplishing the most horrendous and knuckle-whitening missions using those controls.

These two extremes, WoW and Vanishing Point, are two points on the scale of mid-level spacing. This is the primary dimension in which it's possible to create challenge. Along the gamut from WoW to Vanishing Point, you can have objects spaced farther apart or closer together. In tweaking that relationship, you also increase the challenge of navigating that space. So the alteration of the spatial context in which an avatar moves is one of the primary vehicles with which it is possible to change challenge. Again, to measure at this level, we're interested in the spacing of objects.

Low-Level Context

Finally, context affects game feel at the low level of intimate, personal space, at the level of tactile interaction between objects. At this level, what we're interested in examining is collision. Now, the maths involved in collision detection and response is a little bit scary. At least, it is me (being a lowly brain-dead

147

game designer). Regardless, there are several excellent books and online resources dealing with different kinds of collision and how to implement them. For our purposes, we want to compare different ways it is possible to model collision and the resulting feel is to simply draw comparisons to the interactions of physical objects in our everyday lives. Again, this is something of a soft metric and requires some conceptual leaps in terms of metaphorical relationships between objects moving in a game and objects moving in the real world. But the analogies are usually sound, and this is a useful tool for categorization and comparison.

For example, most racing games subscribe to the "waterslide" method of collision and response. The reason is that it really sucks if you're playing a driving game which requires a lot of precision and the car reacts like it's coated in glue when it comes into contact with another object. Or, you know, do something akin to what it would do if you were to scrape a real car against a barrier at 200 miles per hour. Instead of this quagmire, most modern racing games use collision schemes which essentially feel like a waterslide. There's almost no friction at all when the cars run into something. When you bang into a barrier, instead of crumpling or exploding, the car ricochets off and keeps on going. This is a very different feel from a collision system with a huge amount of friction, where if a car runs into a wall it might roll or get stuck or crumple sideways.

So essentially what we can do is look at the feel of collisions between objects in a game and compare them to the feel of everyday things and so to one another. For example, the collisions in Loco Roco feel like a big bowl of Jell-o or a bunch of water balloons banging into one another. It feels very soft, very jiggly, very spring-loaded. Very different from Gran Turismo, which has a very solid feeling to its collisions. It's a rigid, unyielding solidity, and an interesting comparison can be drawn between the crisp smooth solidity of the collisions in Gran Turismo versus the dirty, broken, mushy collisions in Burnout Revenge. In Burnout, they still employ the waterslide model at some level, but they're doing some rather sophisticated damage modeling. This causes the car to compress and mush up even if there's nearly zero friction applied to the collision so the car can continue driving apace.

As a final example, consider the low-level feel of World of Warcraft. While the high-level feel of WoW was open and boundless, it felt barren and empty. It was tactilely sterile. When I climb Superstition, I can reach down and feel the rocks beneath my hands. Indeed, doing so is mandatory—to make it to the top requires a short section of light rock climbing. In WoW, I never really interacted with anything. It felt very sterile. There was no reason to pay attention to what was nearby or whether I was running into a building, running through a desert or running off a cliff. The collisions felt smooth but dead in the sense that there was no energy coming back out of them. You can't smack into something and rebound or indeed see any interesting interaction. It's a bit like playing only with Nerf toys. Everything is soft and mushy and safe to play with indoors. You're never going to put your eye out with them.

Summary

Context metrics can be categorized into three different levels:

- High-level context—The impression of space, speed and motion inherent in the overall conception of the game world

- Medium-level context—The immediate space around a character and how the character interacts with objects moving through that space, for example, object avoidance

- Low-level context—The intimate, tactile, personal interaction between objects

At each of these levels, we identified soft metrics that, while not strictly quantifiable because of the subjectivity impressions of each individual player that must be taken into account, are nevertheless useful in game design. At the high level, our metric is the general sense of space, speed and motion as it relates to the player and the effectiveness of the game world. At the medium level, our metric is the spacing of objects. And at the low-level, our metric is how objects collide, and how these collisions feel compared to everyday objects in the real world.

NINE

Polish Metrics

Polish is any effect that creates artificial cues about the physical properties of objects through interaction. In this case, artificial means "not simulated." When two objects collide and the code tells them that they're each solid and so should rebound with a certain force in a certain direction, this is not polish. This is part of the simulation, part of the game's response to input. Instead of "artificial," the terms "nonessential" or "layered on" could also be used. The point is, if these effects were removed, the essential functionality of the game would be unaltered. What would be changed would be the player's perception of the physical nature of the system. In this way, polish has a huge impact on game feel: it provides the visual, aural and tactile clues a player needs in order to create a detailed, expansive mental model of the physics of virtual objects. Polish "sells" interaction, to put it another way.

The tendency is to wave a dismissive hand at polish, saying, "Oh, well, it's not actually a very good game, it's just really polished." This does a great disservice to the impact that polish can have on game feel and on the experience of playing a game generally. It is in the polish that much of the impression of a physical reality different from our own exists. With that comes the sense of possibility and wonder that attracts so many to games as a medium. In a few minutes spent feeling their way around, players can extrapolate a universe of possible interactions based on their observations and, in so doing, can experience a great joy of discovery and learning which is rarely possible in everyday life. Much of what makes something interesting and enjoyable to control is the perception that the thing is huge and weighty; lithe and nimble; or that it is grinding, scraping, carving, blasting, smashing, caressing or otherwise interacting with other things around it. The question is, how do we measure the effect of polish on a game's feel and compare it to other games?

First, we need to define exactly what we mean by an effect. For example, the squeal of car tires is separate from the smoke particles that shoot out when pedal hits metal. This is obvious enough—these are separate effects. One is a visual effect; one a sound effect. To create each requires entirely different skill sets. What's interesting is that these two effects will be perceived as one by a player. As they are correlated in physical reality, so they are assembled into a single event in the mind of a player. By an individual effect, then, we mean either the smoke or the squeal. Both support the same perception of interaction—the friction of tires spinning against a

road under various powerful forces—but each is distinct and is constructed differently. At the higher level, we're interested in the interactions that are supported by these various effects. Many different effects, even across senses, can support and enhance the perception of the same interaction.

Next we want to identify individual effects and categorize them according to the impression of physical interaction they are designed to support. A neat ancillary benefit in doing this is that it provides a quick and dirty check of intent versus outcome. A certain effect may be intended to enhance the impression of weight or mass, but it may be clashing with other effects and conveying something different than intended. Returning to Chapter 8's example of the impression of size and weight in Painkiller versus that in Shadow of the Colossus, the animated Colossus walking has a much greater sense of weight and presence than that of the gigantic bosses in Painkiller. In the case of Shadow of the Colossus, the sound effects featured deep, reverberating booms and the sound of detritus being strewn in time with the Colossus' footfalls. The particles were correspondingly huge plumes of dust and sprays of gravel as the animated foot slammed into the ground. In addition, when the player was within a certain distance of the colossus, the screen would shake to further indicate a massive impact. In Painkiller, the animation and effects clashed. The sounds were similar to those in Shadow of the Colossus, but the animation lacked the slow-moving weight and follow-through necessary for the intended effect. Also, there were too few particles spewing up to enhance the apparent impact of a massive foot. Though the creatures themselves were technically massive, their motions and accompanying effects tended to convey an impression of something much smaller.

Finally, before beginning our discussion of polish metrics, it's important to note once again that in the realm of polish, as with metaphor and many other areas of game feel, we are dealing with *soft* metrics. This is because it's very difficult to aggregate and quantify players' individual perceptions of the exact feel created by a polish effect. Player perceptions are relative, not absolute, and arise almost entirely from world-view created by game, rather than real-world physics. As we will see, however, there are a number of soft metrics associated with polish that are extremely useful to game design.

Let's start by defining the kind of soft metrics we need to measure how polish affects interactions between objects.

The Feel of Everyday Things

As we start to examine the interactions between objects, the temptation is to identify each object simply, with respect to individual physical properties. But the properties of objects are not as simple as one might suppose. Under the heading "physical properties," Wikipedia offers the following list: absorption, acceleration, angle, areas, capacitance, concentration, conductance, density, dielectric, displacement, distribution, efficacy, electric charge, electric current, electric field, electric potential, emission, energy, expansion, exposure, flow rate, fluidity, frequency, force, gravitation, impedance,

inductance, intensity, irradiance, length, location, luminance, magnetic field, magnetic flux, mass, molality, moment, momentum, permeability, permittivity, power, pressure, radiance, solubility, shininess, resistance,spin, strength, temperature, tension, thermal transfer, time, velocity, viscosity, volume, scattering light.

Apart from being a rather exhaustive list, this isn't quite what we want. Most of these properties are not easily perceived by visual, aural or tactile observation; they must instead be measured by sophisticated instruments. The problem, apart from our inability to measure things like this meaningfully across games, is that these properties are mostly irrelevant. As far as the player is concerned, the perception is the reality. The game can think an object weighs ten tons, but if it moves like a squirrel the player will perceive it as such. What we want are more things like Figure 9.1.

We need unscientific terms like "pointy" or "springy" because the feel arising from polish effects is based on the individual player's perception, which is subjective,

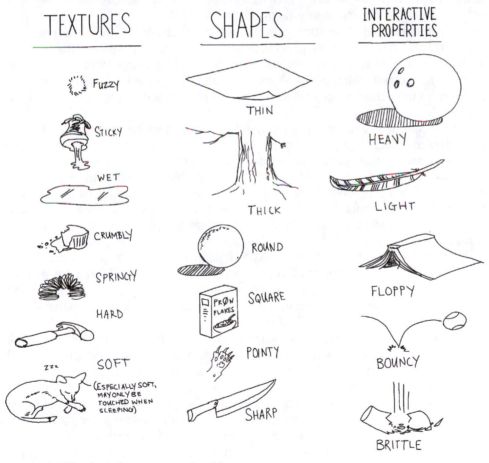

FIGURE **9.1 The feel of some everyday things.**

153

relative and general. This is in some ways the opposite of measuring something in the real world, which is typically thought of as objective, absolute and specific. We measure the weight of a brick by placing it on a scale. The scale (an objective, impartial instrument) gives us a measurement in pounds or kilograms (an absolute measurement—the same for all objects everywhere) of this (specific) brick. By contrast, the physical properties of a brick in a game are entirely based on a player's subjective perception.

This means that the properties of objects in the player's mind can only be measured in the way that the perception of color, loudness and temperature are measured, by the *expected* response of a group of observers when perceiving the specified physical event. For example, out of a group of 50 people who touch a glass of ice water and a mug of hot tea, everyone will be able to identify that the tea is the hotter of the two, but no one will be able to say with certainty what the temperature of either is. The hotness of the thing is only measured against the other thing (a relative measurement), and we cannot guess the specific temperature of either object by only measuring them relative to each other (the measurement is general, not specific). The same goes for polish effects. What we're interested in tweaking, and tracking, is the general, relative, subjective sense that players have of the various objects they control and interact with in a game. With that, we can examine the corresponding physical properties that the players are inferring in their minds from the nebulous, general sensation and trace that down to the level of individual effects.

This means that what we're actually interested in tracking are not the physical properties of objects in a game but the players' perception and the clues that cause players to perceive the properties of objects in a certain way. The nature of things in a game cannot be decoupled from their observable properties, in other words. To *be* a bowling ball, something only has to look like a bowling ball, act like a bowling ball and sound like a bowling ball. There is no ultimate nature of matter to be measured by complex instruments. What the player perceives to be real is real.

From a player's perspective, things can be light or heavy, rough or smooth. An action can be weak or powerful, an impact gentle or jarring. These are perceptions. They have a relationship to measurable quantities such as mass, velocity and weight, but are more about a gestalt, the general sense of physical nature that something conveys.

Take the property of mass, for example. When we describe objects in a game with respect to their mass, what we really mean is perceived mass, which is derived from a bunch of small clues, each of which must be designed, often as a polish effect. Every tiny change, every little spray of particles or sound effect, can make a huge difference. The mass of an object will seem completely different depending on when a spray of particles is triggered as it collides with another object, and if that spray of particles is gentle or violent. The simulation of the collision between the objects is unchanged but changes in polish have completely altered the perception of their masses.

In the end, then, it's useful as designers for us to examine polish effects from three different angles:

- As individual, free-standing effects whose motion, size, shape and nature can be measured separately from the simulated objects in the game
- As groups of effects which convey nebulous, general perceptions to the player
- As observable physical properties that are inferred from groups of perceptions (such as mass, material and texture)

Individual effects enhance and support specific perceptions. These perceptions—when taken as a whole—imply certain things about the physical objects in a game. These physical properties, things such as weight, material, friction and so on, are assembled by players into a cohesive concept of game world physics. As they interact with the game, this conception, this model, is updated constantly to incorporate any new interactions. If an interaction seems to contradict the player's model, it will stand out and will be incorporated with the model as part of the backdrop against which future decisions are made (the perceptual field from Chapter 3). In this way, learning to navigate a game space is the same process as learning to cope with our everyday physical space, which is why polish is so crucial. Polish gives players the grounding they need to cope with the new, unfamiliar topologies of game spaces and the unfamiliar physics which govern them.

Types of Polish

The end goal for a polish effect is the same in every case—to convey some sense of the physical properties of an object (weight or mass or whatever) by offering clues when objects interact and move. A car skidding across the road leaving skid marks, kicking up dust and smoke, and making a squealing noise are all clues inserted by the game designer to indicate that yes, in fact, this is rubber and this is a road, and the weight of the car is pushing the rubber tire into the road. All the subtleties of that interaction sell the perception that these objects are real.

Having identified the player's perception as what we're wanting to and are able to affect with different polish effects, let's dive down to the most basic level of individual effects. That is, let's look at the different ways in which it's possible to alter a player's perception of the physical reality of the game world without changing the simulation itself. These methods include animation, visual effects, sound effects, cinematic effects and tactile effects.

Animation

Animation is a well-established medium with a rich history spanning from early Disney masterpieces like "Snow White" to "Beauty and the Beast" and modern masterworks like "The Incredibles" and "Ratatouille." Along the way, a detailed set of best practices has emerged for animation, in the form of the principles of

155

animation.[1] Every new animator has to learn these principles. They comprise a universally applicable set of non-negotiable aesthetic guidelines. With respect to aesthetics, the conventional wisdom is that there's no accounting for taste. Different people will interpret aesthetic choices differently, regardless of the intent of the artist and independent of any sort of external, objective standard. The principles of animation represent just such a standard. If your animation has squash and stretch, it will be a better animation than one that doesn't. Remarkably, this appears to be true for all animations everywhere. This is why all new animators must learn and master the principles of animation. Another fascinating aspect of the principles of animation is that they apply to animation in a way that is analogous to the use of polish effects in a video game. That is to say, almost universally, the principles apply to selling the physical interaction between objects in an animation. This selling is directed squarely at the player's perception. What they've essentially got is a set of standards which enable the animator to directly change the viewer's perception of the physical nature of the objects in the animation. They've cracked the code of perception, essentially. They can modify perception directly by applying principles such as squash and stretch, overlapping action and so on, to the movement of objects in their animations.

Squash and stretch specifically illustrates something fascinating about animation, something which animators have known for many years. Emulating reality is not the most efficient path to manipulating someone's perception such that a world you're constructing seems believable and will engage the viewer. You can take shortcuts to perception, so to speak, ignoring the constraints of reality to create more convincing animation. Take the classic example of the bouncing ball animation (Figure 9.2), the first assignment given to every student of animation.

At the bottom, when the ball is in contact with the ground, it squashes way down, deforming and flattening out. When it rebounds upward, it stretches along the momentum line of the animation. In motion, this ball will appear much more satisfyingly squishy and ball-like. If you animate a static sphere falling, touching the ground and rising up again, it looks stiff and unnatural, lacking the sense of weight, presence and personality. What this illustrates is that you can change a person's perception of something without resorting to a direct emulation of the reality you're trying to portray.

As animation is applied to objects in a video game, an animated object typically replaces the visualization of a simulated object. It sits on top of the simulated object and changes the player's perception of its nature and character. It changes the player's perception of what it appears to be—a car, a jet or a ninja, whatever—but also by animating differently. The principles of animation apply to the looping animation of the character running, which is played back in sync with the motions of the underlying simulated object, which is driving its motion in space. That animation

[1] Frank Thomas and Ollie Johnston's "Principles of Physical Animation" are online at http://www.frankandollie.com/PhysicalAnimation.html

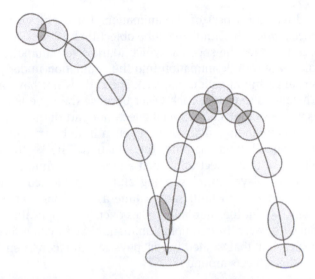

FIGURE **9.2 The changing shape of the ball as it bounces creates a realistic perception of a bouncing ball, even though the animation doesn't directly emulate a bouncing ball.**

itself, which starts life as a linear animation created by an animator, will have squash and stretch, overlapping action and all the things a good animation should have. Ipso facto, it is the animation itself, sitting on top of the simulated object, which conveys the sense of weight and presence, the physical properties of the object. The animated visualization *becomes* the object in the mind of the player, and so any physical properties it displays as it animates are perceived by the player as part of the motion of the object, even though they have nothing to do with the simulation. When animated effects become indistinguishable from programmed response, animation does just as good a job of creating the sense of weight, mass, presence and physicality.

For example, the run and jump animations of Jak from Jak and Daxter convey a sense of weight and presence that simply don't exist at the level of simulation. As Jak runs, he squashes and stretches with each footfall, has awesome overlapping action, and generally looks to be a real, breathing physical being made of flesh and bone and who is running across varied terrain. If you were to replace all the objects in Jak and Daxter with grey capsules representing the way in which the simulation sees them, the sense of weight, presence and personality would be lost.

So the principles of animation apply almost directly to the motion of objects in a game. With the exception of principles like staging, which rely on a controlled frame of reference and predictable camera behavior, it's safe to say that squash and stretch and all the other principles can be and are directly applied to characters in games like Guilty Gear, Viewtiful Joe and Ico, each of which features excellent linear animation layered atop simulated objects.

Another interesting thing to look at is hybrid solutions, where simulated objects have an animated visualization layered on top of them but where some parameter

of the simulation drives an aspect of the animation. For example, in the original Super Mario Brothers, when the simulated cube object that drives Mario's motion in space speeds up, so too does the speed at which Mario's run animation plays back increases. It's a nice way to link animation into the simulation underlying it. Note, though, that this change in animation playback speed does not have any effect on the simulation. The animation plays back faster because the cube is moving faster, not vice versa. As we've said, it's an artificial effect, not part of the simulation itself.

The line between animation and simulation gets a little blurry when procedural animation or active ragdoll solutions enter the equation. The keyframe animation dictates the perception of that object until such a time as the simulation takes over. For example, a football player running along and being tackled. The animation drives the impression of motion until such a time as the character is affected by another force, at which point the simulation takes over. The applicability to polish is essentially the same, however. In traditional animation, as in game feel, the goal is to convey the impression that something is physical and consistent and that it is interacting with other objects around it.

Visual Effects

Visual effects differ from animations in two fundamental ways.

One, visual effects typically wink in and out of existence to serve a short-term need for indication of interaction between two objects. A visual effect appears only momentarily at the intersection of two interacting objects: sparks shooting out when a car is scraping along a barrier, or a spray of splinters when a crate is destroyed, for example.

Two, visual effects appear to be caused by another object, but are not the object itself. With an animation, you have a visualization of character or an object and it plays back a linear series of frames. Through deft manipulation in the hands of an animator, that sequence of frames played back will cause the object to appear to have weight and presence and volume and all that good stuff. A visual effect appears to be caused by an object and emphasizes the interaction of that object with other objects. The effects in Soul Calibur are a great example of this. A sword swipe has a polygon trail following behind it, tracing its arc through the air. The trail effect is caused by the motion of the sword. When two swords clash, a jet of sparks flies off of them. The sparks themselves are not the object, nor is the trail, but each emphasizes the motion and physical nature of the object it supports.

Visual effects include particles, trails, sparks and other temporary indicators of interaction and movement. These effects are accomplished in a variety of ways, though most visual effects in modern games are made up of particles. A particle in a 3D game is a 2D plane which has a position in 3D space. It will "billboard"—always face the camera—and will typically not be affected by lighting or other forces in the simulation, though hooking a simulation into particles can be used to great effect, as it was in Kyle Gabler's excellent gamelet The Swarm (in which the avatar is a swarm of hazy black particles which cluster and pull toward the cursor and are

capable of picking up and throwing unsuspecting stick figures in the most charming manner imaginable). So a particle effect is a series of textured planes that always face the camera. The benefit of having a bunch of planes that always face the camera is that you can create an artificial sense of depth by painting it into a texture, which is then applied to each particle. Smoke particle system that has the appearance of a billowing 3D smoke is comprised of a bunch of planes, each showing a single painted image of smoke, which has the faked impression of depth painted into it. Because you never see the image from an angle, the impression is consistent and enables the series of planes to blend visually into a single plane, which reads as a cohesive pillar of billowing smoke.

One thing that's interesting to note is that the texture—the image itself that is on the particle—is not nearly as important as the motion of that particle. In many games (Nintendo games especially), when things collide with one another, the resulting visual effect might be comprised of an explosion of spinning, multicolored stars. Every single object in Super Mario Galaxy has little stars that shoot everywhere when Mario interacts with them. They make absolutely no sense when approached from a realistic, simulations point of view. But, like squash and stretch, they are a manipulation of the player's perception of the object without being an emulation of reality. In the same way that a real object would never squash rudely and stretch back again when it hit the ground, smashing a brick would never yield a geyser of multicolored stars. But as long as the motion of those stars is to blast out in a satisfying way and then fade out, the impression of physicality is effective without the constraint of realism. As in animation, realism is not necessarily a worthwhile goal. You can show interactions between objects and emphasize their physical nature without having to resort to emulating reality. No one would say that the sparks in Soul Calibur look real. However, real is not the goal. The perception that the impact is powerful is what we're after.

Sound Effects

Like animation, the discipline of creating sound effects is well understood. It is the same process as Foley for a film, with the caveat that sounds in a game must be repeatable. Often times, a whole range of sounds is created to represent a particular interaction, with one chosen at random at any given instance of the impact (or whatever event triggers the sound) in order to keep a sound effect from becoming stale. This prevents players from hearing the same sound over and over again, annoying or distracting them.

Playable Example

A sound effect can completely change the perception of an object in a game. To experience this, check out example CH09-1. This a recreation of a Java applet originally linked to me by the inimitable Kyle Gabler, of indie studio 2dBoy.

> The two red rubber balls come together. One starts at one side of the screen, the other at the opposite side. When the simulation starts, they fly toward each other and their paths cross at the center of the screen. Based on purely visual feedback, you'd assume that these objects were some kind of ghost ball. They appear to pass right through one another unimpeded and go on their merry way. Playing the simulation with sound yields a totally different perception. With sound, the two balls behave exactly the same way in terms of their appearance and motion, but when they cross at the center the ptoing! sound of a tennis ball is played. The effect is startling: instead of appearing to go through one another, the two balls seem to bounce off and rebound in opposite directions. What a difference a sound makes!

This is equally applicable to characters in a game. Derek Daniels, one of the designers of the feel of God of War, gave a great example of sound completely changing feel. For a particular attack of Kratos, an animator had created a detailed animation. Derek had implemented that animation and had tuned the move up, but the result somehow felt lacking. The animator was about to go back and redo the animation to improve the timing, but Derek said, no, hold on, let's get a sound in there. Sure enough, the sound was the missing piece of the puzzle; it made the move feel weighty, satisfying and appropriately violent.

In terms of sound effects, you can have impacts, grinds or loops. An impact happens when two objects run into one another at some speed that is, when a cannonball hits a stone wall, a racket hits a tennis ball or a giant hammer smashes the ground. At that moment, a sound effect will play to indicate the impact of one object and another. What's interesting about impact-mapped sound effects is that they can affect not only the perception of the objects interacting, but the surrounding environment as well. If that massive hammer hits the ground and the sound echoes and reverberates, the sense conveyed to the player is that this impact happened inside a giant warehouse or other massive, empty, interior space. If the impact is muffled, it will sound more like striking the ground outside. If you hear no reverberation, you can assume that sound waves just kept traveling outward instead of bouncing off of something and coming back.

A grind implies a prolonged interaction between two surfaces. One of my favorite grinding noises, which actually accompanies a move called grinding, is in Tony Hawk's Underground. In the game, it is possible to jump your skateboard up and grind it against a rail for a long period of time. It makes a very satisfying grinding, woody, metal noise. Essentially what you have is a short loop of sound that plays back over and over again but is modulated slightly so that it always sounds as though the objects are grinding together in slightly different ways as the weight on the board shifts around.

There are also looped sounds, which are essentially just sounds that repeat regardless of the interactions between objects and which convey the ongoing sound of something like an engine or a turbine.

The final thing that's interesting to note about sound effects is that they're less bound than visual effects in some way.

Sound effects, in the same manner as squash and stretch or a star-shaped particle effect, are not necessarily bound to realism. The record scratch for the King of All Cosmos speaks in Katamari Damacy or the orchestral hit when a special move is completed in Tony Hawk 3 prove that mapping an unexpected sound effect to a particular event can have delightful results. These have nothing to do with the reality of the things they are attempting to portray, but they feel satisfying. As in a cartoon, it's not necessary to limit your thinking about how to apply a sound effect to the emulation of reality. You can convey an impression of physicality with a noise much different from the apparent reality of the object.

Cinematic Effects

Cinematic effects are things like screen shake, changes in view angle, motion blur and Matrix-style slowdown. These are effects which are applied to the camera rather than an in-game object. As we've said, the camera in a game provides the players their eyes in the world, their organ of perception. It is the players' point of view and has a finite position in the world, a position which can be moved or changed just as with any other avatar. This is a vocabulary we've been taught over the years by constant exposure to big-budget filmmaking. When a giant explosion goes off on the screen, there is a slight delay, after which the screen appears to shake, as though the camera were responding to the jarring force of a shockwave caused by the explosion. The end result is the perception that a hugely weighty impact has occurred.

The point here is that these effects are applied to the in-game camera rather than to particular objects, but in so doing, the effects can change the perception of the physical properties of objects in the game. In a fighting game, if one player punches another and the result is a jarring screen shake, the perception for the player is that an impact of almost ludicrous force has taken place. Another effect often used by fighting games is the slow down or frame pause. When one character hits another with a particularly devastating move, the game may pause momentarily—20 milliseconds, perhaps—to emphasize the impact. The same effect was used in Nintendo's The Legend of Zelda: Twilight Princess and our own Off-Road Velociraptor Safari (Figure 9.3).

It's interesting to note that these kinds of effects have no analogy in everyday perception, but are nonetheless ingrained in our consciousness. As with comparing the temperature of the mug of tea and the glass of ice water, everyone will recognize screen shake as an indication of massive, concussive force. Likewise, a change in view angle gives the perception that an object is moving faster and faster. Motion blur has a similar effect on the perception of speed, blurring the movement of fast-moving objects as a camera would.

FIGURE **9.3 Off-Road Velociraptor Safari: when you hit a raptor, the game zooms in and goes into slow motion.**

Tactile Effects

Finally, there are tactile effects. In the current generation of input devices, this is limited mostly to controller shake or rumble, which is caused by the actuation of weight-loaded motors inside the input device, such as in the Xbox 360, PS2 and Wii controllers. Controller shake can be a bit of a blunt instrument because the motion is always rotational, but it can be used to great effect in games where it is cleverly fit to the metaphor presented. A gun has recoil, for example, and that motion is something rumble motors can simulate well. Most modern console shooters use a constant rumble effect to enhance the sensation of firing of a machine gun. For a single shot weapon such as a sniper rifle, it will be a single rumble. When shooting is the only control that triggers the motors, the effect can be quite powerful. Employing a totally different metaphor, games like Tony Hawk's Project 8 offer a constant low-level rumbling to simulate the grinding of a skateboard against various surfaces. In this case, too, the effect is quite powerful if used judiciously, allowing the feel of a particular interaction to be correlated across a third sense.

Other types of tactile effects include so-called "force feedback" devices. This is also known as *haptic* feedback. The notion is that the controller provides actual, physical resistance to displacement, forcing the user to work at pulling, pushing or rotating it. This is an active application of force administered in certain amounts and at certain times by the game's code, above and in addition to that caused by the springs that keep it in neutral position. These kinds of devices have been around for years in the form of flight sticks and steering wheels, though they have never entirely caught on. This is perhaps because haptic feedback can serve to enhance the perception that the thing being controlled in the game has a real, physical character, but more often it serves to enhance the fatigue of players' arms, wrists and hands.

Case Studies: Gears of War and Dawn of Sorrow

As I dug into an examination of all the various polish effects featured in Gears of War and Dawn of Sorrow, I began immediately to regret the decision to investigate these particular games. The sheer number of polish effects in these two is frankly staggering to catalog, let alone to contemplate creating from scratch. This is the nature of the polish beast, I fear. It's quite the rabbit hole in terms of development time. Polish has the reputation of being a dangerous phase to become stuck in or to enter in too early. Looking at games like these two, you can see why. There are just so many effects! You can always find some other polish effect to create, some better way to sell the interaction between objects. The trick, I think, is to focus on the overall perception you're creating and enhancing. This is why Dawn of Sorrow and Gears of War make for an interesting comparison; with Gears of War the vision seems to have been very clear and the result almost entirely cohesive. With Dawn of Sorrow, there are some clashes. Here's an in-depth examination of the polish of each going from individual effect, to general perception, to inferred physical properties.

Play the game and simply make a note of the effects that you observe as you play. I find it useful to frame this in terms of the four categories: animation, visual effects, sound effects and cinematic effects, working though each and listing out each individual effect.

Gears of War

Animations	Visual Effects	Sound Effects	Cinematic Effects	Tactile Effects
Run cycle—big, looping, heavy, lots of overlapping action		Foot steps—crunch and thud satisfyingly Clattering of armor and gear—sounds suitably heavy and complex, like metal against thick armor plating and leather	Slight bobbing in time with the run cycle	
Dive roll—quick and nimble	Roll dust—happens (oddly) just as the roll starts. Character's feet are suddenly obscured by a puff of dust as if by magic	Clattering of armor and gear—sounds a bit light for such a broad motion	Camera dips gently to follow rolling motion	

(Continued)

(Continued)

Animations	Visual Effects	Sound Effects	Cinematic Effects	Tactile Effects
Roadie Run— a hunkered down, awkward, heavy-looking run. Saving Private Starcraft	Gentle puffs of dust at each footfall	Clattering of armor and gear—sounds suitably heavy and complex, like metal against thick armor plating and leather	Camera bobs and sways as though held by a running cameraman	
Door kick— heavy impact with nice anticipation and a great sense of power	Dust particles explode from the door	Satisfying metallic crack as the impact causes the door to shatter and give way	Camera rears back and tilts in anticipation and shakes forward quickly as the kick is delivered	
Enter cover— heavy impact, like a linebacker tackle	Dust particles shake loose from the wall and ceiling and fall gently	Crunch and thud— sounds like a huge, complex object smushing up against a textured, mottled wall	Camera changes focus depending on direction character is facing, placing the character in the left or right of frame	
Barrier hop— quick and nimble in the hop but with nice follow-through and overlapping action on landing		Crunchy grinding noise as the character slides over the barrier, impact hit when he lands	Camera dips down to show character's feet as he lands before returning to standard over the shoulder	
Fire "Lancer" machine gun— powerful sense of the recoil of the gun, character	Muzzle flash particles at barrel of gun Smoke particles at barrel of gun Chunky gravel particles when	Deep, powerful machine gun sound Pinging of bullets off surfaces Sounds of shell casings hitting the ground	Screen shakes in time with bullets	Constant rumble to indicate recoil from machine gun fire

(Continued)

(*Continued*)

Animations	Visual Effects	Sound Effects	Cinematic Effects	Tactile Effects
stands in a wide stance and braces against the forces	bullets hit a wall or other surface Bullet holes created in walls, start glowing white then go to yellow, red			
Swing grenade— grenade seems heavy and massive. Character rears back and looks at grenade initially		Deep, satisfying swooping noise as grenade is swung, slight Doppler effect Sound of chain clanking	Camera view angle changes slightly to frame swinging grenade and improve sense of speed	
Throw grenade— great follow-through, grenade seems like a massive, heavy object		Chunky, metallic impact noise each time grenade hits the ground		

I've omitted a few of the effects—there are dozen and dozens—but this is a reasonable cross section, representing effects from each of the five types.

Castlevania: Dawn of Sorrow

The effects in Dawn of Sorrow are somewhat mind-boggling. For each creature (there are well more than 100), there are different sounds, visual effects and animations. Some, such as the bosses and larger enemies like the iron golem, even have their own specific cinematic effects. For every weapon the character wields, there are different animations and effects. What follows is a small subset of these effects, enough to draw conclusions and comparisons. Even without tactile effects (the Nintendo DS has no rumble motors) the amount of polish work on display here is truly staggering.

Animations	Visual Effects	Sound Effects	Cinematic Effects
	A purple trail follows Soma's every movement, enhancing the impression of speed and the feeling that he's some kind of ethereal being		
Run cycle—Very stylized, but with a nice sense of weight at each footfall. It's the transition animation going from one direction to another that really causes the impression of a floating, weightless character			
Attack with Axe "Golden Axe"—Huge, fully body motion as the character seems to heft the axe in a ponderous arc		Subtle swiping noise. Character grunts with effort	
Attack with Spear "Gungner"—Great anticipation as the spear is held up and powerful follow-through with overlapping action as the spear is swung. Nice delay holding the spear out for emphasis of weight		Air swipe Doppler noise	
Attack with Sword "Muramasa"—quick, snappy motion with nice overlapping action of the hair and blurred arm motion	For some reason, swords appear to shoot out at various angles from the sheath as the sword is swung. Sword arc is traced in the air	Air swipe Doppler noise	

(Continued)

(Continued)

Animations	Visual Effects	Sound Effects	Cinematic Effects
Jump—weird hover/ delay just before contacting the ground		Light rising scrape as Soma leaves the ground Light, clicking thud as feet hit the ground	
Double Jump— quick and nimble flipping motion, satisfying swishing of coat		Same light scraping noise as first jump	
Witch Soul shot— flings arm out satisfyingly	Ball of blue energy pulsating, flies quickly out	Abstract, reverberating magical noise	
	Trail of smaller particles gives the blue ball an almost comet-like aspect		
Hippogryph Jump— character stretches vertically and looks upward, flyings in that direction with great speed. On impact, flips upside down and compresses against the ceiling in a preternaturally nimble way, though there is nice recoil and overlapping action with the coat (as usual)		Sound like rushing air as the character flies upward Dry, plastic thud as the character impacts the ceiling	Screen shakes on ceiling impact
Destroy skeleton—as the skeleton is hit, it falls to pieces	Puff of dust as the skeleton pieces hit the ground	Slapping noise as the skeleton is hit Hollow woodblock sound as each piece hits the ground	

If you think listing things out this way make it seem as though there are a hell of a lot of effects, you're spot on. It boggles the mind that games like Guilty Gear and Soul Calibur manage to do such an amazing job of harmonizing animation, visuals, sounds and cinematic effects to clearly convey a unique feel for so many different characters. It's no wonder there are so many people on those teams, or that many different people may work on the same character exclusively for the entirety of production.

Though it's a little tedious with games as intricate as Dawn of Sorrow and Gears of War, it is useful to look at each animation as a separate effect. Sometimes one animation will support a particular perception while another one contradicts it. For example, the jumping, spinning and sliding animations in Dawn of War give the appearance that Soma is exceedingly quick, like some sort of preternatural gymnast. He's more squirrel than man, it appears. When running on flat ground, though, he appears to chug along rather lackadaisically, his feet sliding across the ground. This is particularly true if you change directions over and over again; he slides back and forth as though swimming gently through water, which is about as far from the tight, whipping, circular motions of his flips as it is possible to get.

The dive roll animation in Gears of War is more neutral; in my perception it neither supports nor detracts from the impression that the character is a human-shaped wrecking ball. I notice, however, that much of the action takes place off screen. Without confirming this with a designer at Epic, I would guess that this is because it's very difficult to create a rolling animation that is fast enough to feel responsive but which conveys the appropriate sense of weight.

Note that a single effect can support more than one perception, as when an animation shows both weight (Marcus Fenix is like an NFL linebacker, stretched horizontally and covered in a suit made of cinderblocks) and material (the overlapping action of the armor he wears makes it appear to be a heavy, composite metal of some kind).

There seem to be two currents of feel at odds here. Except for the quick and nimble flipping of double jump animation and the "hippogryph jump," Soma moves fluidly and lightly. He's nearly weightless, as though he'd be right at home in "Crouching Tiger, Hidden Dragon." His animation for switching directions and the constant purple trail of self copies that follow him around all support this perception, almost as though he's moving through something other than water. At certain points, however, his actions seem to have great impact, as when he collides with the ceiling during a "hippogryph jump" and causes the screen shake effect. During his run cycle, there is one moment of overlapping action where his head snaps downward that really lends a sense of weight and presence to his step, but the effect is diffused somewhat by the fact that his movement speed doesn't map perfectly to the movement of his feet. This is often referred to as "skating" by animators and is a common

problem in games, where the speed of animation playback is often matched dynamically to the speed of the object underlying the motion.

Hitting things with weapons also has a great sense of impact and weight, especially in the contrast between the heavy and light weapons and because of the spraying, exploding particles that most enemies spew when defeated. Again this mirrors the general perceptions of movement and interaction I get from Crouching Tiger. The characters move and float around like tissue paper on the wind until the moment their weapons clash, at which point there is a powerful sense of impact. None of the impacts in Dawn of Sorrow have the impression of weight, presence and impact of those in Gears of War, however.

Gears of War is like controlling a human-shaped wrecking ball. From the thumping run cycle to the camera-jarring kicking down of doors, each animation and accompanying effect enhances the perception that the thing you're controlling is huge and weighty. Every time the character interacts with the environment, such as when he presses against a wall to take cover, the effects combine to sell a sense that a large, meaty, complex object is mashing against a grimy, textured surface. Sprays of dust particles come off the walls and ceiling, and the sounds are deep and crunchy. The impression that the environment is malleable and reactive is further enhanced by the myriad effects that happen when bullets hit it. The interactions seem suitably sloppy, though, as bullet holes spray in a wide grouping and chunks of material come flying off each hole. Firing a gun seems like an appropriately jarring affair, emphasized by judicious use of controller shake and the deep, resonant gunshot sounds and accompanying impact effects. The fact that the characters react relatively little to both firing guns and being hit by them seems to further emphasize just how massive and burly these folks are.

Grouping the perceptions (such as mass, material and texture) into specific, observed physical properties and comparing them to one another we get:

	Gears of War	Dawn of Sorrow
Masses	Heavy and over-the-top massive	Light and ethereal but with surprising forces on impact
Velocity	Relatively slow moving; changes direction in an instant, however, and can make short, quick motions	Medium to fast. Changes direction in an instant, can attain great speeds with certain souls equipped
Momentum	No real momentum except in animations	No real momentum except in animations
Materials	Flesh, composites, metal	Some evidence of metals versus woods versus bone, but mostly

(Continued)

169

(Continued)

	Gears of War	Dawn of Sorrow
		in enemies. Character has a very slippery, lightweight character, almost like a bar of soap
Friction	Very high-friction, textured world	Sense of friction when character slides but otherwise everything seems to have enough friction to walk or else simply flies in an arbitrary manner
Gravity	Very high gravity; no vertical jumping	Very low gravity, some things (such as the character) seem to fly and float with little logic or prompting
Shape	Stout and thick, seems to be shaped like a human (pressing against things)	Shaped like a rectangle
Elasticity	None in evidence	None in evidence
Plasticity	None in evidence	None in evidence

Summary

In this chapter, we've examined the many different ways polish can be used to alter a player's perception of the physical reality of the game world without changing the simulation itself. Specifically, we looked at polish effects from three different angles:

- As individual, free-standing effects whose motion, size, shape and nature can be measured separately from the simulated objects in the game
- As groups of effects which convey nebulous, general perceptions to the player
- As observable physical properties that are inferred from groups of perceptions (such as msass, material and texture)

We also examined how animation, visual effects, sound effects, cinematic effects and tactile effects are used to affect player perception. Polish gives players the grounding they need to cope with the new, unfamiliar topologies of game spaces and the unfamiliar physics which govern them.

TEN

Metaphor Metrics

As a component of a game feel system, metaphor has two aspects, representation and treatment.

Representation is the idea of the thing, or what it appears to be. Is it a car, a gelatinous cube of meat or a plucky spike-haired hero in a neo-steampunk tropical wasteland? Is it a MacLaren F1 or is it Fatty from Run Fatty Run? Metaphor unifies the idea of the avatar, the idea of the world, and the idea of all the objects in the world. If you replace all the art, music and sound in a game with purely abstract shapes and colors, what you have removed is the representation. Imagine the game Diablo with graphics by Jackson Pollack and sound by Steve Reich. The fundamental functionality of the game is still intact, but the metaphorical representation is gone. While dribbles of paint and electronic pulses do not really represent anything, barbarians, buildings and cows give each object in the game some hook on which players can hang their conceptual hats.

Treatment is the cohesive whole formed by visual art, visual effects, sound effects, tactile effects and music. If you take away all the art, music and sound from a game but leave the core systems untouched, what you have removed is the treatment. Imagine the game Diablo with every object—avatars, townsfolk, creatures, environment—replaced by flat gray boxes. The fundamental functionality of the game is still intact, but both treatment and representation are gone. One could argue that flat gray boxes are a treatment of sorts, but you get the point.

We can measure the impact of metaphor on game feel in two ways. First, we want to identify the what. What does this thing appear to be? What is each object representing to the player at the conceptual level? Again, this will be something like a car, a train or a tall humanoid cat. Next, how will the player expect the thing to act? In other words, based on the metaphorical representation, what are the expected behaviors, effects, animations, motions, interactions and sounds?

We're also going to examine the role of treatment. Treatment dictates to a powerful degree how accurate a player will expect the nature and motion of an object to be relative to its representation. A player can rightly expect something that appears visually to be a photorealistic human to move and act as a person would. If that person is a stick figure, however, the expectations set are much different (and much easier to fulfill).

To generalize, the primary effect of metaphor on game feel is to prime a player with preconceptions about how given object should behave. The representation conveys an idea about what the thing is, and the treatment indicates its level of sophistication. The more response, context and polish seem to match the metaphor presented, the more cohesive, self-consistent and good-feeling the game will be.

Note that we're not making any judgments about what "matching" the metaphor means. It certainly doesn't mean that emulating reality is the way to go. There is a phenomenon similar to Masahiro Mori's Uncanny Valley at work with respect to how well the metaphorical representation of an object in a game matches the feel of that game. If a sound, animation or effect is close to matching the expectations set by the representation and treatment, but falls just short, it can be much more distracting than if it were completely abstract.

For example, in Doom 3, the treatment was intended to be realistic. But many objects in the world, when touched or shot, would spin and fly around in a wild, unrealistic way. If the treatment was more iconic, like a graphic novel, or if the metaphor was more abstract, with floating shapes instead of zombies, this would not have created dissonance for the player. As it is, because the treatment and metaphor in Doom 3 were intended to be realistic and serious, the fact that every zombie had the exact same pattern of dangling became distracting. Even the gunshot sound effects in the game Doom 3 did not seem to live up to the standard set by the realistic visual representation. The shots sounded like cap guns. If instead the shots were an abstract pulse or laser sound, they might have been easier to accept. Even something completely absurd like kittens meowing could have fit better, if the goal was to be absurd. There is a sweet spot where a game's metaphor can correspond perfectly to response, polish and context.

Case Studies: Mario Kart Wii and Project Gotham 3

To set the stage for understanding how this all comes together as a practical metric, it's useful to compare and contrast, in some detail, how metaphor is used in two very different games of the same genre. Let's dive in and look at Mario Kart Wii and Project Gotham 3.

Visually, both games start with cars in a racetrack environment lined up for the beginning of a race. Mario Kart is 3D and cartoony, and all the visuals are iconic and round. The environment is stylized, smooth, colorful and inviting. The graphics have some link to the real world, but they're highly symbolic. A tree is identified as a tree, but it's not a very specific tree, just a generalized idea of a tree. In contrast, the treatment in Project Gotham 3 is about as far from Mario Kart as it is possible to get while still representing the idea of cars at a racetrack. Project Gotham 3 strives for total photorealism. If the designers could achieve their ideal representation of forms in Project Gotham 3, it would

be like playing a movie. You could drive cars around a track, and you would drive past stuff that looked just like the stuff you would drive past in real life. The car you were driving and all the cars around you would look like moving photographs.

In terms of sound, there is much less environmental background in Mario Kart. Project Gotham has the revving of many, many engines, probably recorded from the real-life cars they are meant to represent. Project Gotham also has cheering spectators and all sorts of authentic noises. Depending on the starting point on the track, city or country, you also hear the appropriate background sounds. So Project Gotham strives for great realism in its soundscape as well. Mario Kart Wii represents many of the same things, but the sounds are similar to the visuals in that they are symbolic representations. The karts make these little rumbling noises in place of strictly realistic engine sounds. Even so, the sounds in Mario Kart are not quite in line with the stylized appearance of the karts. It's entirely possible that the sounds could be made much more fantastic and still achieve unity with the visual metaphor.

In both games, when the starting countdown happens, you hear dink-dink-dink DING. The series of noises are actually quite similar. In Project Gotham, it's most likely an actual recording whereas Mario Kart has more of a lo-fi feel. The countdown proceeds, and they're off!

As they start moving around the track, the environments are very different. In Mario Kart, the player encounters bizarre things like being fired out of a cannon or sucked down a warp pipe. In Project Gotham, cars are speeding around a realistic track that twists and turns in very real-world ways. And the motion mapping in Project Gotham is also more realistic than Mario Kart, which is more cartoony. In Project Gotham, driving the car is intentionally similar to driving a real car at high speeds. You shift and brake and drift the back end to bring the car around curves at the highest speed possible while not losing control and crashing. In Mario Kart Wii, if you don't press the Power Slide button as you come round a corner, you won't be able to carve the turn without running into something. Pressing the Power Slide button changes the friction properties of the car, increasing the floatiness of the car and enabling it to slide sideways. You can also improve the slide by wiggling the thumbstick and changing the color of the sparks. If you build up the sparks to the gold spark level by holding down your thumb, when you release you get a speed boost coming out of the turn. Clearly, the driving feels nothing like driving a real car. Driving Mario Kart Wii is a simulation of cartoon physics where Project Gotham takes a much more literal approach to driving physics.

In both games, the visuals and sound effects that happen in response to the motion are consistent with the style of each game. Smoke particle effects coming from the tires in Project Gotham are restrained and light, much like they would be in real life. Tire screeching noises are recordings of real cars.

In Mario Kart, there are a huge number of particles flying everywhere, and the puffs of smoke and sounds they make are all very exaggerated.

Now let's look at how well the metaphors in each game are executed to create good game feel. In terms of the interaction of objects and the game, this starts to get into context, in the sense that when objects interact, the way they behave has a huge impact on the way the game feels.

In Project Gotham, when the cars collide they just bounce off each other, which is not what you would expect based on the realistic visuals and sound. You would expect that if two cars that looked real, moved real and sounded real ran into each other, there would be a massive crash like you see on the NASCAR replays. Bits of car would go flying everywhere, things would catch on fire, one of the cars would spin out and all the others would swerve to avoid it or not—mayhem would ensue, and all the drivers would be under the yellow flag until the emergency vehicles cleaned things up. Oh, the humanity. In Project Gotham, the interactions are coded almost like a waterslide. It's like a bunch of big, round, smooth plastic objects falling down a waterslide and bumping off one another. Similarly, if a car runs into something in the environment, it comes to a gentle halt or else glances off and keeps going as though the walls were peanut oil. The cars just keep slip-sliding along, which is not at all what happens if a real car runs into a real wall, lamppost or chain-link fence. This is an unfortunate mismatch between metaphor and the feel conveyed by the response, context and the various polish elements.

Tellingly, the interaction between the cars in Mario Kart Wii is similar to that in Project Gotham. One car runs into another, you get a little sound, and the cars glance off one another with the same sort of waterslide feel. Objects never get hung up on each other. In the case of Mario Kart Wii, however, there's no dissonance. The karts' treatment is cartooned, which means the player's expectations are different. No one expects them to behave like real cars. The main difference between the relative feel of cars in Mario Kart Wii and Project Gotham is that in Mario Kart, some karts read as larger, heavier objects which can knock smaller karts around when they run into them. In this respect, the interaction between objects in Mario Kart Wii is actually more sophisticated than Project Gotham 3, in which the cars seem to have a uniform mass.

Overall, the two games are similar in just about every aspect except for their representation. But there is a huge difference in the dissonance or harmony of the various aspects of the games. In Mario Kart Wii, all the different aspects, from the cartoony representation to the abstract sounds to the motion that's produced to the way the karts interact, all those things seem to harmonize very well. Whereas Project Gotham 3 has harmony across visuals and sound, the glaring omission of commensurately detailed car interaction disrupts the unity of the game's feel significantly. This was actually due to an unfortunate legal hang rather than a bad design choice, but the result is

illustrative nonetheless. The result is that the cars in Project Gotham 3 simply do not meet expectations for how they should interact, creating significant dissonance in the photorealistic metaphor of the game. Mario Kart Wii does a much better job of harmonizing with its metaphor.

And this is what we are interested in measuring: the overall effect that metaphor has on the feel of an object with respect to the way it sets up expectations in the player about how objects should sound, how they should look, how they should behave, and how they should interact with one another. In this way, all pieces of a game's feel are affected by the metaphor that you choose and apply.

Real, Iconic and Abstract

Up to this point, we've made oblique references to the term realism. Let's nail that sucker down so we can get a better grip on how treatment modifies game feel. The way we've used realism thus far is as a measure of how similar something looks to a photograph or film. On the other end of that spectrum is cartoony. This is, I think, how most people apply the term realism, especially to graphics in games.

A slightly different approach is that used by Scott McCloud in Understanding Comics. He adds a third axis and changes "cartoony" to the much more descriptive "iconic" (see Figure 10.1). Although Scott's concept is summarized below, please consider reading his original explanation in "Understanding Comics," which is very well done.

On Scott's diagram, all visual representation exists somewhere in a triangle. At the far left point of the triangle is reality. At the far right is iconic. He defines the

FIGURE **10.1 Realistic, iconic and abstract: three types of representation.**

175

written word as the ultimate abstraction, the point of visual representation that is furthest from reality while still effectively conveying meaning. Between reality and pure meaning, there are various shades of iconic. That is, visuals which are abstracted from reality, but which still convey meaning. With the third axis, he separates iconic abstraction from what he calls "non-iconic" abstraction, which is probably what most of us think of as abstraction. Shapes, colors and lines; things which exist for their own sake and have no inherent meaning, which don't represent anything. This scale, while originally designed to apply to comics and other visual art can, with a little fudging, be applied to the representation of objects in a video game (Figure 10.2).

Gears of War fits somewhere between Project Gotham and Mario Kart Wii. There are some iconic elements, in the sense that the characters are large and bulky (not something you'd see in the real world of everyday experience), but the texture and lighting attempts to be hyper-realistic, in the way that the movie Alien attempts to visualize a world in which things are more sticky, more wet and more rim lit.

Call of Duty IV is even more realistic, trying to emulate photo-like visuals in a more staid way than Gears of War. There's not much stylization in the proportion of the characters, though there is a grainy, filmed look to the game that could be considered stylization. On the iconic side, Legend of Zelda: Wind Waker is highly iconic but represents a complete game experience in a world with its own self-referent, entirely consistent rules. If we move to the top of the triangle, toward the purely visually abstract, we have games like Everyday Shooter, in which the objects are geometric and musical abstractions with no apparent metaphor.

From a metrics point of view, what we're interested in are the implications for how elements of game should behave if the game is more or less realistic, iconic or

FIGURE **10.2 Some well-known games placed on the triangular diagram.**

abstract, with respect to game's overarching metaphor. For example, returning to Project Gotham 3, we located that game far over to the left of the diagram toward realism, and we can infer that everything in the game should behave as closely as possible to how things behave in the physical world as we perceive it. Everyday Shooter is very abstract, presenting us with a bizarre world where we're not really sure how things are going to react, which has the effect of setting expectations wide open. It would be hard to make objects in Everyday Shooter behave in a way that seemed wrong, but it leverages no expectations either. In an iconic game like Sly Cooper, which is far over to the right, we expect cartoon physics and are not disturbed if two things jiggle like Jello-o when they collide, as long as volume is maintained per the principles of animation.

Metaphor sets up expectations about the way things should look, move, sound, behave and interact. This is how metaphor affects game feel. When everything is in harmony, and all the player's expectations are met, it's a win for the designer and the player. When things aren't in harmony, it causes dissonance and frustration, and the player disengages from the game. If the visuals write a check that the game's physics can't cash, the player loses his or her belief in the self-consistent fidelity of the world.

Summary

We can measure the impact of metaphor on game feel by looking at response, context and polish, and by comparing them to the expectations set up by the metaphor applied to all the objects. This is a soft metric. Players will perceive things as they expect to perceive them, not necessarily as they really are. We want to know what perceptual expectations are being set up by metaphor and treatment.

If you've ever been to a wine tasting, it's easy to experience this phenomena in real life. If you put out eight bottles of wine and hide the labels, you'll get a very different result than if the tasters can see the labels. People expect famous, pricey wines to taste better—and results of a tasting will reveal that they do! The Chateau Mouton Rothschild will always rank higher than the Stags Leap Cabernet. But taste the wines blind, and you can get some very different results, as in the famous 1976 wine tasting in Paris, where California wines soundly whupped some of the top French chateaux in a blind tasting by famous French judges.

So be careful what expectations you set up and how. Ask the following questions:

- What do the objects in the game represent?

- Where does the treatment rest on the triangle diagram? How realistic, iconic or purely abstract is it?

- How well does the representation and treatment of objects in a game coincide with the way those objects behave? Based on the metaphorical representation, what are the expected behaviors, effects, animations, motions, interactions and sounds of the game?

- Does the metaphor set expectations that are in line with game feel for each element of the game? If not, either the metaphor or the game elements probably need to be adjusted.

ELEVEN

Rules Metrics

For our purposes here, a "rule" is an arbitrary, designed relationship between parameters or objects in a game. Arbitrary because there is no higher order guiding the creation of such relationships and designed because it is a relationship intentionally created by a designer. A few examples of rules by this definition:

- Collect 100 coins to get a star.
- Collect 5 stars to open a door.
- Orange triangles upgrade weapons.
- Defeating Woodman gets you the Leaf Shield.
- You can only hold two weapons at once.
- It costs 5 hearts to throw Holy Water.
- To score a capture, your team's flag must be in your base.
- It takes 3 hits to kill a Skelerang.
- Experience points required to level up increase exponentially.

It's fascinating to pull individual rules out like this and hold them, naked and shivering, up to the lightbulb of logic. Notice that they make no sense outside of the context of the systems into which they were so carefully crafted. Inside their proper context, though, they lend a sense of purpose and intent to actions in a game. Collecting coins has meaning precisely because it restores health, increases score and earns stars.

So what do rules like this have to do with game feel?

Changes in rules can alter the feel of a game in subtle but measurable ways. Having an incentive to collect coins changes the nature of your interaction with them and therefore can change the way it feels to collect them, or even how it feels to steer around an environment. To see how this works, we'll compare the way rules affect the feel of various games by dividing them up into high-, medium- and low-level rules, as set forth in Chapter 5:

- High-level rules consist of broad sets of goals that focus the player on a particular subset of motions, such as collecting coins. High-level rules can also take the form of health and damage systems.

- Mid-level rules are rules for specific objects in the game world that give immediate meaning to an action, such as capturing the flag in a capture-the-flag multiplayer game.

- Low-level rules further define the physical properties of individual objects, such as how much damage it takes an avatar to destroy an enemy.

The goal, as always, is to arrive at generalized intra-game measurements which enable us to compare the rules of one game to another with respect to how they change feel.

High-Level Rules

At the highest level, rules can serve to focus players on a certain subset of mechanics and, in so doing, change their perception of the game's feel. The designer is directing the player to perform certain actions. From all the available action choices in a game, the designer wants the player to make certain choices and institutes a reward system to reinforce that behavior. Through rewards, the game designer is communicating with the player, pointing out that certain actions are more fun, more satisfying, than others. Developing this certain set of skills, the designer is saying, is most worth your time.

This is similar to the effect the high-level construction of space has on a mechanic's feel because it's not overt; it's a general feeling. A high-level relationship like this doesn't slap you in the face and tell you to do something. Instead, it encourages you to play a certain way by leaving you a trail of breadcrumbs to follow. For example, collecting 100 coins in Super Mario 64 gives you a star, which in turn unlocks various star doors in the castle. Open enough star doors and you reach the boss level. Beat the boss level and you get access to more areas of the castle, the highest reward possible. There is a hierarchical reward structure involving coins, stars and areas of the castle. Essentially, the player is being rewarded for completing a challenge with access to new challenges, but the feeling is one of excitement and triumph. It's a classic—if somewhat sneaky—convention. The point, though, is that the meaning of collecting a coin goes all the way up to getting access to a new area, the highest reward in the game. As a result, coins seem quite valuable.

This sense that coins are valuable has a measurable effect in terms of game feel. Skills like precise turning, movement and jumping are emphasized, as are highly difficult skills like flying and swimming. Everywhere in the game, there are coins. To collect them requires a great deal of precision, especially when moving at top speeds. The coin gives the player a point of reference against which to measure skill, and a driving purpose for running, jumping, swimming and flying. It's like dribbling a soccer ball. Dribbling across an empty field may have some lowly kinesthetic appeal, but it's not going to keep you practicing for hours. What keeps you practicing for hours is the sensation of dribbling a soccer ball around two defenders

and kicking in the winning goal. (Or the potential for that sensation, at any rate.) The skills that the rules of a game successfully make important become important, worthwhile skills. The feel of the motion changes in proportion to the value created for it by high-level rules.

To get a clearer sense of just how powerful this effect can be, think about a time you played a game in which there were a great number of possible actions, but in which none of the actions seemed worthwhile. For me, a great example of this is Ratchet and Clank. In Ratchet and Clank, everything spews cogs, nuts and bolts. Everything. Lots of them. For me—and this is not true for everyone—playing Ratchet and Clank felt a little like vacuuming. There were so many of these little things that each individual one ceased to have meaning, making the action of having to chase down each individual cog and bolt feel like a tedious chore. Compounding matters was the unsophisticated relationship between collecting and buying. You collect a bunch of stuff and then take it to the gun vending machine. The tradeoff was too transparent. If you want a new weapon, spend a lot of time killing the same guys over and over again and vacuuming up detritus. Boo-urns.

Now think about a very important object in a game, an object you greatly desired. Why did you want it? It clearly has no importance outside the game, but somehow, some way, it was given some amount of relative importance by the cunning construction of rules.

Another interesting aspect of high-level rules is that they can make even a tedious action very fun or "addictive." For example, in the various Zelda games, there is grass everywhere. Using a sword, you hack your way through the grass. Of itself, this action isn't very satisfying, because the grass offers no resistance. But you keep doing it because there's a rule, an arbitrary relationship between unrelated things, that says when you cut down grass, a certain percentage of the time certain items will spawn out of that grass. Those items in turn have their own meaning. For example, sometimes you get rupees, and if you collect enough rupees, you can go buy special armor, bombs or other things that, in their own particular way, have their own relationship to the world and enable you to interact with objects you couldn't before, access new areas of the game and generally feel very rewarded. Cutting down grass might also give you arrows to refill your bow, because there is an arbitrary rule that you can run out of arrows. The rule could just as easily have been that you have infinite arrows, but then you would tend to use the bow all the time. Also, there are places where you need to fire an arrow in order to solve a puzzle, and cutting grass nearby will replenish your arrow supply if you are out. So in a certain sense, the feel of cutting down the grass is altered because the meaning of the reward for cutting down the grass changes. The meaning assigned to an action by a rule alters the feel.

The same principle applies to even simpler mechanics. For example, in Diablo, there's a rule that governs the drop rate of different items, from enemies to treasure chests. For every 100 or so enemies a player kills, one will drop an item that will upgrade the player's ability to kill enemies. So the player continuously has

an incentive to kill as many enemies as possible or click on treasure chests, even though the action itself is very tedious. The reward system compensates and changes the experience so that the player keeps coming back again and again.

Medium-Level Rules

Medium-level rules can give immediate meaning to action. In a game that emphasizes game feel—steering around objects and navigating space—a great deal of stock is put into the spacing (the context) of objects. Not only do you have to tune the speed and movement of avatars, but also their speed and movement against spatial context. The number, nature and spacing of objects in the world is the other half of game tuning. The same fundamental thing applies when objects in the world are given immediate, temporary importance by virtue of a rule system.

Think of Quake. If you're playing a game of Quake and your health is very low, when you see a health pack in the immediate vicinity, getting that becomes a very high priority. To avoid giving another player a point, you have to get that pack; therefore everything else has little meaning until you do. Given this rule, the objective of the game becomes getting your health back at the expense of everyone else. It's a simple, arbitrary rule that changes the way the player approaches the space of a level.

Now think about what happens when you're playing a game and you suddenly become aware that you're low on health. It could be a fighting game, such as Samurai Showdown 4, or a more staid affair such as The Legend of Zelda. Suddenly, every tiny motion seems a lot more important. You have a heightened awareness of every motion and are keenly attuned to the control, the feel, of the avatar. In this way, rules defining health and its meaning in a game can lend a sense of importance to an object in a spatial environment. This, in turn, can heavily affect the feel of that space.

The same thing applies to capturing a flag in Soldat. When you're holding the flag, you are the focus of all action in the game and the meaning of all your actions changes. You suddenly feel the situation is much more urgent, and you are no longer interested in engaging enemy players and fighting them. You want to get away from them as quickly as possible and return to your base. Instead of feeling like you are swooping in and out of terrain, in control, you are looking for the nearest exit. The movement of the avatar feels slower than it did just moments before. Even before it's grabbed, the flag object itself completely changes the way the players interpret the space and their movement through it. The locus of all action in the capture-the-flag level is the two flag areas. That's where everyone wants—and has—to go in order to score. So the entire meaning of the level is changed by the placement of the flags. When they are placed in different areas, the feel of the level and the feel of moving around it changes.

At the medium level of rules, immediate meaning can be conveyed to objects in the game world by arbitrary rules. This changes the feel of the mechanic in a

manner similar to the placement of static, non-rules-affected objects in the world by providing a meaningful context against which to balance the avatar's response to input. The added benefit is that collecting something that is valuable by virtue of the system's rules feels better and more satisfying than, say, deftly avoiding a pillar in Star Fox. These kinds of rules provide positive reinforcement for spatial mastery.

Low-Level Rules

At the lowest level, the level of kinesthetic interaction, rules can affect the feel of the game by changing the perceived properties of objects, especially as they interact with the avatar over time. For example, in Halo, there are little tiny guys with fins on their heads and the gigantic brutes. In general, you have to shoot an enemy a lot of times in Halo to reduce its health to zero (death). Again, this is just an arbitrary relationship. The amount of health something has relative to the amount of damage a weapon does can be defined in any way. When you shoot the little guys, you riddle them with bullets for a while, and they plop over and make a sad little noise. It takes a lot more hits to gun down a gigantic brute, which makes them feel larger and more massive, more imposing. Yet the mechanic is basically the same. The large number of shots it takes to penetrate their shields and finally kill them reinforces the perception of massive strength.

How much damage an object can sustain before being destroyed has a great effect on how the physical object is perceived. Shooting anything in Halo requires many shots, which make the game feel fairly massive, especially compared with a game like Dawn of Sorrow, where you can whack a skeleton once and bones go flying everywhere. It's very satisfying, but has a completely different feel than Halo. Small enemies die easily; medium-sized enemies take more hits, and game bosses require dozens of hits. The amount of damage something can take provides feedback on the assumed physical properties of the object. Like a blind man's cane, shooting things in the game world accomplishes a specific task—figuring out what things are most dangerous to you and which are impervious to your weapons so you don't waste time and resources on them. At the lowest level, you can convey a sense of physicality at a very kinesthetic level with an arbitrary rule about health and damage.

The same essential principle applies in fighting games with heavier or lighter moves. Compare a fierce kick with a light punch in Street Fighter II. Through the arbitrary rule that's applied, the fierce kick, which is a heavier, slow-moving attack, is made to do more damage. The sense that the fierce kick is heavy and weighty and really plows into enemies is emphasized by the rules. But it's entirely arbitrary. From the point of view of the system and how it's set up, there's no reason why a light punch couldn't do more damage than a fierce roundhouse kick. It feels right because it's in line with the physical nature of those objects as perceived by the player.

Case Studies: Street Fighter II and Cave Story

Now let's take a look at how all three levels of rules combine to enhance game feel. Consider the difference between rules in Street Fighter II and the indie classic Cave Story.

In Street Fighter II, the high-level rules affect the feel of interaction through the round structure (Figure 11.1). In Street Fighter, the gameplay is organized around "best of three"—if you win two rounds, you win the entire match. And in order to win the match, you must win two rounds. This has the effect of placing higher stakes on a round in which you face elimination. In each match, there's only one round—the first one—where this is not the case. After the first round has been played, one character will be facing elimination, which is a great way to raise the stakes and focus the player very intently on the individual motions and controls.

At the medium level, the amount of damage it takes to kill someone is important. This has a huge effect on the feel. The characters in Street Fighter II take a relatively large amount of damage to destroy. Accordingly, the perception that the characters are solid and massive is increased, reinforcing the visual and aural effects. These are large, detailed, well-animated characters. If they were to be defeated in one hit, it would belie the perception conveyed by their animations, sounds and metaphorical representation.

At the lowest level, there is different damage for different moves. Heavier moves do more damage and lighter rules do less damage.

In Cave Story, the high-level rules do a fantastic job of providing impetus for every action. Access to new areas and the surprisingly engaging periodic

FIGURE **11.1 The basic relationships in the system of Street Fighter II.**

story snippets provide a delightful carrot, egging the player ever onward. In addition, the arbitrary relationship between what guns you choose and how you choose to upgrade profoundly affects the skills that you end up using and learning later in the game (Figure 11.2). Here's how the rules work: at the start of Cave Story, you can only run and jump. As you progress, you can get a variety of weapons. Weapons include various beam weapons, a machine gun and a bubble gun, and they can be obtained from treasure chests or traded for at various locations in the game. There are nine different weapons, but the player is limited by the trading system to having only five at any time. Most weapons can be upgraded by collecting weapon energy dropped by enemies and will lose weapon energy if the player is hit. Non-weapon items in the game are plot-oriented, having no impact upon normal gameplay, although a few, such as the Booster (a type of jet pack) and the Life Pot, are useful.

Medium-level rules in Cave Story change the meaning of movement relative to various enemies, depending on health and weapon upgrade level. Being hit reduces both health and weapon energy. Health functions the same way it does in most games, increasing focus and attentiveness as it is lowered, and altering feel by altering behavior and meaning.

But the real genius of Cave Story's rules lies in the weapon upgrade system and how it's hooked into interaction with enemies. As weapon energy drops, it may become necessary to switch weapons quickly in order to finish off a particular creature, changing on the fly the relationships between weapon, damage, enemy health and weapon upgrade level. When fighting high health bosses, it becomes necessary to plan out which weapons to use in which order, assuming that the upgrade levels will be dropped. In preparation for a

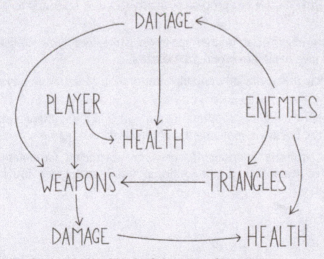

FIGURE **11.2 The basic relationships in the system of Cave Story.**

185

boss fight, players may find themselves doubling back to fight enemies over and over again, in an effort to power-up a seldom-used weapon. Just in case.

At the low level, the amount of damage it takes to destroy something in Cave Story is extraordinarily well balanced. The health of a given creature relative to the amount of damage dealt by which weapons at which level of upgrade is meticulously well balanced. The result is that every object in the world seems to be truly made of the same stuff. The more hits something takes before it pops into puffs of dust and a shower of bouncing orange triangles, the more substantive it is. Rarely do the physics of a single game feel so cohesive based solely on the balance and implementation of rules.

Summary

The arbitrary, designed relationship between parameters or objects in a game are the game's rules. They are arbitrary because there is no higher order guiding the creation of such relationships. They are designed because it is a relationship intentionally created by a designer. We characterized three types of rules: high, medium and low level, and examined how they affect game feel at each level, and how the work together at different levels of the game to convey an overall impression of game feel independent of, but reinforced by, the other metrics of game feel:

- Input—The physical construction of the device through which player intent is expressed to the system and how this changes game feel

- Response—How the system processes, modulates and responds to player input in real time

- Context—The effect of simulated space on game feel. How collision code and level design give meaning to real-time control

- Polish—Effects that artificially enhance impression of a unique physical reality in the game

- Metaphor—How the game's representation and treatment change player expectations about the behavior, movement and interactions of game objects

- Rules—How arbitrary relationships between abstracted variables in the game change player perception of game objects, define challenges and modify sensations of control

CHAPTER TWELVE

Asteroids

Chapters 12 through 16 feature in-depth examples that will provide recipes for the game feel of the games they describe. To develop these examples, we'll apply the classifications we built in Chapters 6 through 11, breaking down well-known existing games into input, response, context, polish, metaphor and rules. The idea underlying these breakdowns is not simply to clone these games, though that's certainly possible using this information. The idea is to better understand the hundreds of tiny implementation decisions that gave these games the feel they have. In many cases, these decisions seem counterintuitive—artificially changing gravity at the highest point of a jump, for example. All these little decisions and relationships together, though, are what make these games feel good.

The creators of these games did not follow a particular methodology. They noticed something that bothered them about the feel and tried different implementations until it felt better. Coming at it from a more structured place, we can look not only at the decisions they made inside their specific games, but make generalizations about why this worked the way it did and how it can be applied to all games. That's the idea, anyway. We want to understand the principles underlying these decisions outside of the context of specific games.

With that in mind, we're not interested in specific implementations in specific languages; you could achieve the same feel coding in Actionscript, C++ or Python. It really doesn't matter. Also, throughout these chapters I will reference specific examples. I highly recommend you go to http://www.game-feel.com and download the examples, experiencing the difference in feel at various points throughout the example. These things are better felt than described. For each demo, the idea was to expose the important parameters, enabling you to feel differences in game tuning without having to program anything. I recommend going to http://www.game-feel .com/examples/ and downloading each applet so you can follow along. These things are best felt.

At the start of every example section, I've provided a URL to a naked version of the system, with every parameter tuned to zero. Consider these an exercise in tuning. The pieces are all there; if you want a challenge, I suggest trying to recreate the feel of each game from this all-zero tuning.

The Feel of Asteroids

Asteroids redefined the meaning of "video game." It was the iPod of its time, as synonymous with video games as Apple's ubiquitous product is with digital music now. When the game was released in 1979, it sold more than 70,000 units, obliterating all previous sales records, including those set by Space Invaders the previous year. Space Invaders, itself a game so popular that it caused a national coin shortage in Japan, was left in the dust. Why was this? Why did Asteroids dominate? How could it handily overtake a game so overwhelmingly popular? The answer hinges on the game's unique feel.

Asteroids was, in essence, a rebalancing of the formula set down by the progenitor of all good-feeling games, Steve Russell's Spacewar!. As such, it featured programmatically simulated inertia and discrete tracking of velocity, acceleration and position of the ship. Pressing the thrust button added force into the simulation, accelerating the ship forward in whatever direction it was currently facing. Turning the ship was a much simpler affair, overwriting the ship's orientation to rotate it left or right.

The combination of this detailed simulation for position and the simple, direct rotation gave Asteroids both crisp precision and a flowing expressivity. It was as though the ship was always on the verge of being out of control, but it never actually was. The player's job was to steer and tame it. This feel was not novel. There had been numerous attempts to bring the Spacewar! feel to arcades, including Cinematronic's Space Wars and Atari's own Computer Space. The insight of Lyle Rains and Ed Logg in designing Asteroids was to find just the right combination of rules and spatial context for the tuning of the ship's movement. The spinning asteroids provided just the right context, dominating the screen space in a difficult but not oppressive way. They were just the right shape, size and speed for the motion of the ship, providing close shave after close shave and round after round of fluid, expressive excitement. The rules were simple, encouraged a very clear and particular set of skills and rewarded continued play.

By comparison, the feel of Space Invaders (Figure 12.1) was stiff and rigid. Its motion was limited to a small region at the bottom of the screen. Its left-right steering changed only the ship's position, and did so rather slowly. It is an enjoyable game but in terms of feel, it does not compare to the rich flowing motion of the ship in Asteroids.

William Hunter, curator of the excellent video game history Web site thedoteaters .com writes, "I was never much of a Space Invaders fan. ... But Asteroids, with its cool ship inertia and frighteningly close shaves between the rocks, is simply a masterpiece of design and programming. While the games that had inspired Asteroids, such as Spacewar! and Computer Space, had pioneered the concept of inertia in video games, the feeling of actual physics being played out in Logg's creation is another big draw of the game."[1]

[1] http://www.thedoteaters.com/p2_stage2.php

FIGURE **12.1 Compare the movement of the ships in Asteroids and Space Invaders.**

There are still games being made today that emulate the feel of Asteroids, such as Shred Nebula and Geometry Wars. The feel of Space Invaders, however, is all but gone from modern mechanic design.

Input

Asteroids' input space consists of five standard buttons (Figure 12.2). The buttons are far apart, making control a two-handed affair, though all five buttons can be pressed simultaneously. Though the possibility exists, there are no chorded moves in Asteroids.

Physically, the Asteroids cabinet is big and bulky, made out of wood. The surface in which the buttons are embedded is nice and smooth, made out of molded plastic; it feels good. The buttons themselves are big and springy and make a satisfying noise as they click down. When pressed, they become almost completely flush with the surface of the cabinet.

Each button has two states and sends the usual Boolean signals of ON, OFF and HELD.

Response

The incoming Boolean signals modulate parameters in the game in the following ways:

The Rotate Left/Right buttons rotate the ship along its axis clockwise and counterclockwise (Figure 12.3).

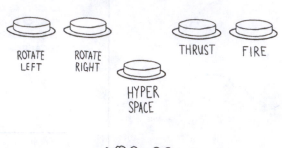

FIGURE **12.2 Five two-state buttons are the inputs for Asteroids.**

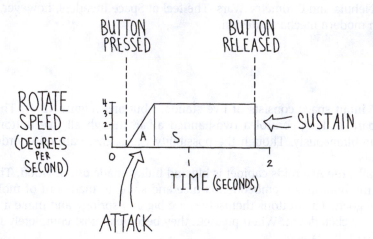

FIGURE **12.3 Attack, delay, sustain and release for the rotation in Asteroids. There is a very slight attack value.**

The Thrust button adds force along the local forward direction of the ship, limited by a maximum value. This progression is highly floaty, taking around three seconds to reach sustain and even longer to release (Figure 12.4).

The Fire button launches a bullet along the local forward direction of the ship, limited by a timed delay. The bullet inherits the velocity of the ship. Only four bullets can be on screen at one time.

The Hyper Space button sets the ship's position to a new, random value.

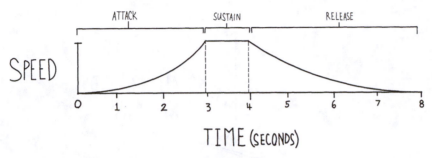

FIGURE **12.4 The ADSR envelope for thrust in Asteroids.**

Simulation

To create the feel of Asteroids, the ingredients are one ship avatar, two varieties of flying saucers, screen wrap and a healthy sprinkling of asteroids. Since the asteroids and alien spacecraft exist mostly to provide spatial context for the motion of the ship, we'll hold off discussing their behaviors and motion for now and instead focus on the ship.

Playable Example

Open example CH12-1 and try to recreate the feel of Asteroids. The necessary parameters are there, just zeroed out.

The ship avatar in Asteroids has two basic motions, accelerate and rotate (Figure 12.5). The rotational motion is crisp and precise while the acceleration is loose and sloppy. In both cases, the motion's frame of reference is the ship itself, a "local" motion.

The most important relationship to the specific feel of Asteroids is the decoupling of rotation from thrust. This is achieved by storing separate velocity values for the ship and for the thrust that gets added to it. If these values are not separated and the thrust velocity overwrites the ship velocity directly, the feel is more like a squirrely remote-controlled car than a smooth, flowing spacecraft.

Let's build the feel up from the beginning. First, we need a ship that rotates. The rotation of the ship in Asteroids is simple. If one of the two rotate buttons is held down, the game adds a small value to the ship's orientation in the corresponding direction, clockwise or counterclockwise. There's no simulation in the code, no acceleration to speed up or dampening to slow down. If the button is held down, the ship rotates. If not, it doesn't. However, there is a very slight Attack value applied to the input signals as they come in (Figure 12.6).

The ship does not go directly to full speed rotation from a standstill. There's a short ramp-up in speed, an Attack, over about a third of a second. It's subtle, but

191

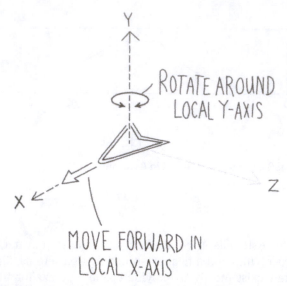

FIGURE **12.5 Dimensions of movement for the ship in Asteroids.**

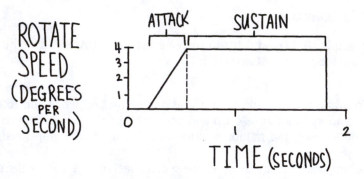

FIGURE **12.6 The attack takes only a quarter of a second, but its absence is noticeable.**

without it, the rotation feels stiff and robotic. An interesting thing to note is that, perceptually, it's just as though the ship had a very slight inertia that had to be overcome. From the player's point of view, it seems as though the ship took that third of a second to ramp up to full rotation speed.

Playable Example

To experience this subtle difference, open example CH12-2 and click on the "Raw Input" checkbox.

FIGURE **12.7 The different values that drive the thruster movement of Asteroids changing over time.**

Next we want the ship to move forward in response to the Thrust button. This motion will be relative to the current heading of the ship, which causes the left and right rotation to control the direction of the ship. If the forward acceleration were relative to the camera or to some other object in the world, the ship would be stuck moving in one direction, which would not be much like Asteroids at all. Now, if we set the position of the ship the same way we're setting the rotation, by overwriting it directly depending on whether or not the button is held down, the feel is stiff and inorganic. It's crisp, precise and responsive, but moves so differently from any object encountered in everyday life that the motion feels jarring and unsatisfying.

Playable Example

To experience this, click on the "Mode: Set Position" checkbox in example CH12-2.

This is clearly not what we want. The first big thing that's missing is static inertia. In Asteroids, the ship speeds up gradually to its maximum and continues moving at that speed indefinitely until another force acts on it. To get this sense of inertia, we'll separate position from velocity and have the Thrust button modulate acceleration instead of modifying position directly. In each frame, the acceleration value is added to the velocity value, which then updates the position value based on how far the ship has moved (Figure 12.7).

Playable Example

To experience this, click on the "Mode: Translate" checkbox in example CH12-1.

This is the feel of a frenetic racecar gripping the road with perfect sideways friction. It carves circles, without any hint of the desired Asteroids floatiness. The motion is interesting, even aesthetically pleasing, but it feels totally different from Asteroids because the rotation and thrust are now inextricably interconnected.

FIGURE **12.8 The most important relationship to the feel of Asteroids is the ship velocity to the thrust velocity.**

Turning changes heading instantly, every frame, while the lack of dampening causes the ship to go on forever without hope of slowing down. To arrive at the feel of Asteroids, the thrust vector must be separate from the ship's velocity. When the thrust button is pressed, instead of setting the modified ship velocity directly, a new vector is created using the ship's heading as its direction and the thrust speed as its magnitude. This is the thrust vector and when the thrust button is held, this vector is added to the ship's current velocity (Figure 12.8).

Great success! This change, between adding and overwriting velocity vectors, makes all the difference. We now have a simulation that can be tuned to the precise feel of Asteroids.

Playable Example

To experience this, click on the "Mode: Asteroids" checkbox in example CH12-2.

The final things to note are the limit on velocity, the screen wrapping effect and the very low dampening force.

An arbitrary maximum is applied to the ship's velocity vector. This value may change the feel slightly if it is set very high or very low, but primarily it serves as a catchall to prevent the ship from having runaway speed. If you're interested in changing this limit to see the difference, it's the "Max Velocity" parameter.

The screen wrap effect is achieved by detecting whenever the ship's position is greater than the size of the screen, then setting its position to the opposite side of the screen. For simplicity, this is done for the X and Y edges of the screen separately. The screen wrapping, like the Max Velocity parameter, is mostly a pragmatic measure. Without screen wrap in place, the motion of the ship avatar carries it off screen in a matter of seconds.

FIGURE **12.9 The relationships that create the feel of Asteroids.**

Finally, there's very little dampening on the motion of the ship. Once acceler-ated, it will keep going at speed for more than four seconds before coming to rest. This low friction produces a "spacey" feel. Though we Earthbound schlubs have never experienced frictionless motion, when we see it in a game it reads as space-like because of our exposure to news footage of astronauts and science fiction films such as "Apollo 13" and "2001: A Space Odyssey."

The final set of variables we're tweaking are these (their relationships are shown in Figure 12.9):

- Ship Rotation—How quickly the Y-axis orientation is changed clockwise or coun-terclockwise per frame

- Ship Position—The position of the ship in absolute space, expressed as an X posi-tion and a Y position

- Ship Velocity—The current direction and speed of the ship in absolute space

- Thrust Speed—The current thrust value

- Thrust Acceleration—The amount the thrust value will increase over time as the thrust button is held

- Thrust Velocity—A vector representing the force that gets added to the ship velocity when the thrust button is held. It gets its direction from the ship's cur-rent heading (which can be different from Ship Velocity) and its speed from the current Thrust Speed value

- Max Thrust Speed—Limits Thrust Speed to a hardcoded maximum value. Speed can not be greater than this amount

To summarize the simulation of Asteroids, when the game receives the signal for "thrust button held down," a force is applied along the ship's forward-facing axis. As the button is held, that force is increased according to the acceleration value,

to a predetermined maximum. Whatever direction the ship happens to be facing, the thrust is applied in that direction as an additive vector.[2] It doesn't simply overwrite the previous velocity vector of the ship, but rather gets added to it. This is crucial because it decouples the rotation of the ship from its thrust. This separation of thrust from rotation is the most important part of the feel of Asteroids. It enables the ship to rotate freely regardless of its current velocity. It gives the impression of frictionless motion as well as creates a slightly manic feeling of being constantly out of control. It's only when the thrust button is held that the orientation of the ship affects its velocity, and even then it's additive. The end result is highly floaty: when the player changes direction by rotating, it will take almost three seconds before the velocity of the ship is in line with its heading. In the case of the context and rules of Asteroids, this floatiness is both desirable and awesome.

Context

The only thing that really needs to be said about the asteroids in Asteroids is that they provide just the right spatial context for the ship's movement. The larger asteroids dominate a large amount of the screen, but they move very slowly and are easy to predict. Smaller asteroids take up less screen space but are much more difficult to dodge because they move much more quickly. In all cases, the ship moves faster than the asteroids themselves but because its motion is so wild and squirrely and because the constraint of screen wrapping applies equally to both the asteroids and the ship, every asteroid on the playfield feels unsettling. For me, it feels like being an experienced ice skater at a crowded public rink. When I go to a public skate, I can skate much more quickly than just about everyone on the ice because I played hockey as a kid. But I can't predict when people are going to fall or turn or if they're suddenly going to cut across me to head to the cocoa machine. As a result, I limit my speed and try to give everybody a wide berth. Even though I can stop and turn quickly, I don't have enough control to stop myself from running over or into someone's mom if she biffs it in front of me. Playing Asteroids feels a bit like an extremely crowded kids' night at the local rink. Except for the shooting and the subdividing asteroids, of course.

In terms of functionality, the asteroids are imparted with a random velocity at the beginning of the game. When shot, they break down into medium-sized asteroids and have an additional force applied to them in a random direction. They inherit the velocity of the larger asteroid that spawned them, though, so the likelihood of their speed going up rather than down is very high. The same thing happens when they split into the smallest asteroids. There's no particular insight here; the asteroids, as they get broken down, further clutter the field and become more difficult

[2] A vector is a combination of speed and direction. For example, driving 40 mph to the west would be a vector, where 40 mph is just a speed and west is just a direction.

to maneuver around. The ship moves very quickly and turns rapidly, but the turning never seems quick enough to truly react and get out of the way of an asteroid unless you've planned ahead.

The flying saucers are much more difficult to deal with than the asteroids, but they provide fundamentally the same function. They move in unpredictable patterns, going mostly horizontally but randomly moving up and down. And, of course, they shoot back. The closer you are to them, the more likely you are to be shot, so dealing with them feels a bit like poking a hornet's nest with a long stick.

Generally speaking, the feel of Asteroids is as much defined by the things to be avoided as it is by the motion of the ship itself. The constant, inescapable danger of the asteroids is compounded by the wily flying saucers, and the screen wrap means that you can never escape. These dangers give meaning to the quick, slippery motions of the ship, defining every subtle twist and turn and making it feel almost more out of control than in control.

Polish

Without a lot of processing power to spend, it would be perfectly reasonable for Asteroids to lack for polish effects of any kind. Instead, the Atari engineers rose to the challenge magnificently, with a masterful cohesion across visual and sound effects. Specifically, there is an excellent, consistent relationship between the visual size of objects and the sounds they make. For example, when a large asteroid is shot, it makes a deep, booming sound. A medium asteroid's explosion sound is higher pitched, and smaller asteroids are higher still. Similarly, the large flying saucer makes a lower pitched noise than the small one. Being the smallest objects in play, bullets make the highest pitched sound of all. Of all the sound effects, the thruster firing is the lowest and most rumbling, conveying the sense that it is a comparatively powerful device.

Other subtle but effective polish effects include a spray of particles when an asteroid is destroyed, the ship disintegrating into its component parts when destroyed, and the subtle but effective flashing of the vector line to indicate rocket flame. Because of the limited processing power, each individual effect is drop-dead simple. They harmonize so well, though, that the net effect is a powerful sense of the physical properties of the ship, flying saucers and asteroids. This is a great example of how cohesive, self-consistent effects can be more effective than gaudy, splashy ones that are applied willy-nilly.

Metaphor

As a metaphorical representation, Asteroids is very simple. There appears to be a space ship, but it's more Flash Gordon than NASA. The asteroids and flying saucers reinforce this science fiction theme. The treatment is highly iconic. It's not

approaching any sort of realism but it's also not venturing into the realm of the abstract. Each item—the ship, the rocket flames, the bullets, the asteroids—is iconic. They clearly are meant to represent a particular idea. Because the treatment applied to these objects is simple and consistent, there are few expectations being set up for the player. The theme is outer space, so the frictionless feel of the ship is certainly not clashing with the metaphorical representation, but neither is it inextricably linked with it. A car-like physics such as the one we experienced earlier might not seem so jarring because the visualization is so simple.

Rules

The main rules affecting the feel of Asteroids are those related to collision and destruction of the ship. At the start of the game, the player is arbitrarily given three lives. Running into anything—bullet, asteroid or saucer—destroys the player instantly and removes one of those lives. This serves to make the ship seem exceedingly fragile and to make extra lives seem like the most valuable commodity in the game. This sense of value also hooks into the points system: because you gain an extra life for every 10,000 points you score, destroying asteroids feels gratifying and worthwhile. A large asteroid is worth 20 points, a medium is worth 50 and a small is 100 points. This creates a nice value scale for the destruction of asteroids and provides constant incentive to destroy them.

What's really set up, though, is an awesome risk-reward relationship with the tiny flying saucers. Flying saucers are simultaneously the most dangerous and difficult to kill objects and the most valuable. For a large saucer, you get 200 points. For the small, extremely difficult to hit saucer, you get 1,000. So there's a lovely risk/reward tradeoff that happens, because you get so many more points for destroying this tiny flying saucer than for blasting another set of mundane asteroids. When you see one come across, even though it is shooting back at you and is an unpredictable, tiny target, you focus on it and steer toward it because there's the promise of a huge number of points, which moves you that much closer to getting an extra life.

Of course if you lose a life in the process of trying to shoot this damn thing, the point is moot. So there's this circumspect little calculation that happens in your brain about risk and reward. Is it worth it, is it not? How many lives do I have? Do I have a lot? Do I need the points? How close am I to getting extra life? And so on. This sense of value, risk and reward affects feel by driving the player closer to the tiny saucer. In so doing, they learn a whole new set of skills and experience just how out of control the ship is relative to the saucer's quick, precise motions and shots.

Summary

Asteroids was groundbreaking and hugely popular, in large measure because of its unique feel. Applying our taxonomy of game feel, it's easy to see why.

The input device was satisfying, though it only used Boolean on-off buttons, and it mapped well to how things moved in the game action. It also required both hands and five fingers, ensuring the player was challenged (but not too much) and engaged.

The response mapping was clear, simple and easy to follow.

But a lot of the "secret sauce" of Asteroids was in the simulation. Thrust is separated from rotation, creating the most important part of the feel of Asteroids. It creates the loose feel that is so crucial to the feel of the game.

In terms of context, the asteroids in Asteroids provide just the right spatial background for the ship's movement. The constant, inescapable danger of the asteroids is compounded by the wily flying saucers, and the screen wrap means that you can never escape. These dangers give meaning to the quick, slippery motions of the ship, defining every subtle twist and turn and making it feel almost more out of control than in control.

Adding to the overall feel, just the right amount of polish was used in Asteroids—not overdone, not underdone. Visual and sound effects are simple, but cohesive and self-consistent, making the most of the processing power available at the time.

The metaphor—outer space—is simple and iconic, setting up easy to exceed expectations of how "real" spaceships ought to behave in the mind of the player.

Finally, the rules in Asteroids are exceptionally well done, challenging the player to increase his or her skills in anticipation of greater rewards.

Overall, all of these elements were balanced beautifully to create a simple but wildly popular game. The man who conceived Asteroids, Lyle Rains, and the creative visionary who programmed and designed the game, Ed Logg, did everything right. It's no wonder Asteroids was such a hit in the United States and became Atari's best selling game of all time.

CHAPTER THIRTEEN

Super Mario Brothers

Super Mario Brothers was a breakout hit for video games as a medium.

In 1983, things looked a littles bleak for the future of digital games. "Video game" was a dirty word to retailers, and arcades were shutting their doors with frightening speed. Atari had flooded the market with inferior product, culminating with the much-lampooned E.T. The Extra-Terrestrial cartridge. Consumers lost interest, retailers lost money and doomsayers decried the fiery end of the video game fad. Enter Nintendo and its "Entertainment System." Improbably, a young industrial design graduate was about to change video games forever.

A quiet, unassuming man who is "very content" with his modest salary and seems genuinely bemused by his worldwide celebrity, Shigeru Miyamoto was an unlikely candidate for "world's most acclaimed game designer." As he flashes his trademark smile and casually explains his original sketches for Donkey Kong, you get the sense that he is as excited today about the idea as he was more than 20 years ago. Because there was simply no one else in the company available, Miyamoto was tapped by Nintendo president Hiroshi Yamauchi to create the game, Miyamoto's first. In the most emphatic and real sense, the future of Nintendo hung on the unproven industrial design graduate and his "Stubborn Gorilla." Against all odds, the game became a smash hit, in a stroke saving the ailing Nintendo and establishing Miyamoto's reputation.

While it was the first major hit of the burgeoning "platformer" game type, Donkey Kong still felt very stiff. The character in Donkey Kong, Jumpman,[1] could run left and right, climb ladders, and, of course, jump. His jump followed a specific, predetermined arc and he only ran at one speed. On or off, full speed or complete standstill. There was no gradual acceleration or deceleration and no control over the jump once you were in the air. It was a step forward—a charming, playful game with appealing characters, bright colors and detailed animations—but it still felt very stiff. Miyamoto knew that his games could feel much better. After a successful Donkey Kong sequel, he turned his attention to refining the movements of his now-Italian, now-plumber character in Mario Brothers.

[1]The naming of Mario was, apparently, a conciliatory gesture to the irate landlord of Nintendo of America's warehouse, Mario Segale.

Mario Brothers was different. This time, Mario jumped much higher, though his trajectory was still unalterable once he'd left the ground. The first hint of the powerful feel that was to come was in Mario's left and right movement. Instead of movement being binary-state (full speed or stopped), when the joystick was pressed, Mario now had three states: stopped, walking and running. As a result, he now sped up gradually, and the player could make quick tapping motions on the joystick to make small adjustments to his position. Likewise, once the joystick input stopped, there was a slight slide as Mario came to a halt. Mario now had inertia. This smooth feel was used in games like Asteroids and the venerable Spacewar! but had not yet found its way into a character-based game about jumping over obstacles and gaps. Mario Brothers was a modest hit, coming as it did at the end of the arcade era.

In 1986, all the elements came together. Super Mario Brothers combined a loose, fluid feel with a powerful character-driven metaphor and a charming, surreal treatment. Instead of one extra state inserted between standing and running, there were hundreds. Mario now accelerated gradually, without perceptible switches, up to his full speed. When the input stopped, he slid gradually to a halt. The game felt intuitive but deep: sloppier and more imprecise than Donkey Kong, but better for it. Somehow it felt more "real." It took the world by storm. The first truly universal hit video game, Super Mario Brothers sold more than 25 million copies worldwide, far and away the greatest selling game of all time. In a 1987 survey, Mario was more recognizable to American children than Mickey Mouse.

Miyamoto understood game feel not in terms of simulation but of simplification. First, he regarded the feel of a game artistically, as a composite aesthetic experience. At a time when the field was dominated by engineers who, in the tradition of Steve Russell, drew on complex, literalistic metaphors like the gravitational pull of black holes or landing a spacecraft on the moon, Miyamoto brought a refreshing, naïve perspective. He simply wanted to make fun, colorful games about whimsical characters that felt good to play. Second, he designed games holistically, taking into consideration both software and input device. (To this day, Miyamoto designs controllers as well as games, a rarity among designers, especially now, with the death of the arcade.) Finally, Miyamoto understood the power of metaphor and how it affected players' willingness to learn and master a complex system and their emotional attachment to it.

Miyamoto had intuited just how powerful the tactile, aesthetic feel afforded by instantaneous reaction to user input could be. Super Mario Brothers felt great, a shining example of possibility for virtual sensation.

Now the big question: just how was this feel created? How does one build a game that feels exactly like Super Mario? Like many questions surrounding game feel, this is a surprisingly difficult question to answer. Just thumb through this chapter and you'll see; even for a game as simple as Mario, there are a huge number of tiny but ultimately important decisions that must be accounted for. Individually,

FIGURE **13.1 The simple, but classic, NES controller.**

they often seem trifling and bizarre. Taken as a whole, they lead to the feel that sold more than 25 million copies.

Input

As an input device, we have the NES controller. The signals it sends are very simple, as we have said, and overall it has very little sensitivity as an input device. It feels pretty good to hold and use and is composed of a series of standard two-state buttons. One of its great strengths is its simplicity. When you hold it, it's almost impossible to press the wrong button since there are so few for each thumb to deal with (Figure 13.1).

Button	States	Signals	Combination
A	2	Boolean	B, any direction
B	2	Boolean	A, any direction
Up	2	Boolean	A, B One other direction at a time, except down
Down	2	Boolean	A, B One other direction at a time, except up
Left	2	Boolean	A, B One other direction at a time, except right
Right	2	Boolean	A, B One other direction at a time, except left

Each button sends a binary signal. Taken alone, this input data can be interpreted as "up" or "down." When measured over time, the signal can be interpreted as "up," "pressed," "down" or "released."

That's it. Not much more to say about the NES controller; as an input device it is among the simplest, most effective ever created. The plastic on the front is smooth and porous, the buttons springy and robust, and the overall package feels solid.

Note that we're using the keyboard to control the examples presented here, which will change the feel of control by allowing left and right to be pressed simultaneously and because this input uses multiple fingers instead of a single thumb.

Response

There are two avatars in Super Mario Brothers, Mario himself and the camera. Mario has freedom of movement along a 2D plane, X and Y, as shown in Figure 13.2.

Since the Mario avatar doesn't rotate at all, there's no distinction between local and global movement.

The camera (Figure 13.3) is indirectly controlled by the player via the position of the Mario avatar and moves in only one axis, X. Interestingly, it can never move to the left.

A Recipe for Mario

The feel of Super Mario Brothers lives primarily in the main Mario avatar.

If you want to create a game that feels exactly like Super Mario Brothers, the first thing you need is a rectangle. This is how the game views the object that millions of

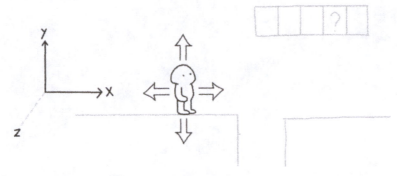

FIGURE **13.2 Mario moves in two dimensions, X and Y.**

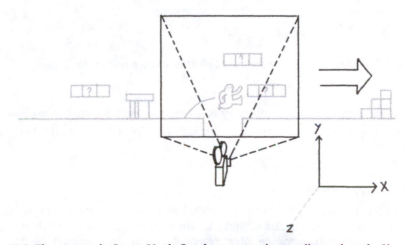

FIGURE **13.3 The camera in Super Mario Brothers moves in one dimension: the X-axis.**

us know and love as Mario. He's simply a rectangle. More specifically, he's a series of points that form a rectangular shape, but for our purposes it's reasonable to call him a rectangle. So let's start with our rectangle, sitting motionless in the center of the screen (Figure 13.4).

Playable Example

Open example CH13-1 to follow along. To begin, there is no motion, all the parameters are set to zero and the avatar is a blank rectangle in the middle of the screen.

The next obvious step is to have the rectangle move. The way Mario's simulation functions, there are two distinct subsystems at work, the horizontal (X-axis) movement and the more complex vertical (Y-axis) movement. To start, let's focus on the

FIGURE **13.4 The shape of Mario: a series of points forming a rectangle.**

horizontal movement. It's the interplay of these two systems that gives rise to the expressive, fluid feel of Mario, but they are kept mostly separate as far as the simulation is concerned.

Horizontal Movement

All horizontal movement in Mario is mapped to presses of the left or right directional pad buttons. The signals coming in are simple Booleans and they can't be pressed simultaneously because of a physical constraint imposed by the input device itself. As a result, at any given time there will be only one relevant signal coming in from the input device: left or right. The simplest way to map this input to a response in the game would be to store only a position for the rectangle. When either the left or right signal was detected, the rectangle's position would change by a certain amount in the corresponding direction. As long as the left button was held, the rectangle would move some distance per frame in the corresponding direction. This is the way that Donkey Kong works, changing position when the joystick is held in a direction. This is not, however, how the horizontal movement in Mario works. Figure 13.5 shows graphing of Mario's movement over time versus Donkey Kong (from Chapter 7).

Now, I like the feel of Donkey Kong. I think it's rather charming. It's hard to argue, however, that it's more expressive than Mario. Mario feels fluid and responsive while Donkey Kong feels stiff and robotic. Look again at the movement of each over time; you can see just how many more places it's possible for Mario be, how much more expressive potential there is for the player. The primary reason for this lies in the simulation. Super Mario Brothers has something resembling a

FIGURE **13.5 The movement of Donkey Kong and Mario.**

simulation of physical forces. It's a sort of first-year college physics level of simulation, but there are in fact stored values for acceleration, velocity and position. So while it's simple by the standards of modern physics simulations, it is a model of Newtonian physics. It may not be very accurate—the programmers only had 8-bit numbers to work with—but it is modeling things in a certain sense. It's not totally fake.

Donkey Kong has no such simulation. The character has a position and two states, and that's it. When you press the right button, the code simply takes the current position and adds a value to it. This new position gets drawn to the screen and becomes the current position and so the motion continues. The player moves at a constant rate if the joystick is held in one direction or another. There is no period of acceleration between standing still and running full speed. Likewise, when the input stops, there is no deceleration. Put another way, Jumpman's speed can only ever be equal to, say, five units per second or zero units per second. There is no in between. Donkey Kong takes the sensitive, expressive input of the joystick with all its states between center and fully expressed and clamps it down to a simple on or off response. Figure 13.6 shows the short attack phase of the movement in Donkey Kong. The movement starts the frame after the input is received, but there is a sensation of a slight attack because it takes some time to push the joystick from off to on.

Mario's horizontal movement incorporates separate values for acceleration, speed and position. When the signal for "left" is received, it applies an acceleration in each frame rather than feeding directly into position. For each frame when a directional button is held down, the acceleration value adds a certain amount to the velocity value. The velocity value in turn tells the rectangle how it should change its position. Instead of the boxy non-curve shown in Figure 13.6, the change in Mario's position looks like Figure 13.7.

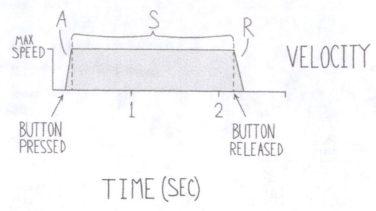

FIGURE **13.6 Donkey Kong's movement is very stiff.**

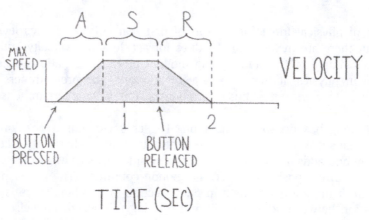

FIGURE **13.7 Mario's movement has a gradual ramp up to maximum speed, making it much more expressive.**

Playable Example

If you're following along in example CH13-1, you can experience what we've constructed up to this point by setting a high max speed value (try 2,000) and turning all the jump values and the deceleration value to zero. If you want, you can also switch the metaphor to rectangles.

Now steer back and forth by pressing the A and D keys. Notice anything? The speed value quickly runs away and becomes way too large. We need to clamp that down, put a limit on it. This limit is the max speed value, and it applies unilaterally to both left and right movement.

The other thing you'll notice at this point is that once set in motion, the rectangle will not slow down or stop. You can reverse direction, counteracting speed in one direction with acceleration until such time that the movement switches from right to left, but you can never come perfectly to a halt again. For this, we need a separate value to decelerate Mario back to a standstill. This is the deceleration or slowdown value. If Mario's running forward and suddenly I stop touching the controller, Mario will slide gently to a halt. The rate at which he comes to a stop is its own variable, unrelated to how fast you sped up. Now, with the deceleration value included, we're getting warmer, close to the horizontal movement feel of Mario.

The last piece of the puzzle involves the B-button. When the B-button is held, Mario "runs." The change is caused by a mapping of the B-button to changes in the simulation. Under the hood, when the game detects that the B-button is held, it changes the values for acceleration and it changes the max speed. When the B-button is held, the rate at which the character will accelerate is increased and his max speed is increased. In this way, the B-button is sort of a state modifier, mapped only to a change in the parameters of the simulation, not to a particular force.

This feel was different from games of the time featuring as it did two different accelerations and two different max velocities for running. The expressive power of such a seemingly simple change is in the interplay between the speeds. The perception of increased speed is created by the contrast. The run seems fast only when compared to the walk. Change both values up or down, and the run still seems like a run. What's important is the relationship between the two values. As long as that relationship is maintained, the impression of speed that comes from the contrast between walking and running will remain. This is very interesting; it is the relative relationships between speeds—rather than the speed values themselves—that seem to be most crucial to the feel.

Another interesting result of this change is just how much expressive power it lends to the horizontal movement. If you're at a standstill and you hold down B and start running, the curve describing the acceleration will be different—it's using higher values. Likewise, because you can press the B-button at any time, it's possible to feather the button and adjust speed very precisely. Try it now in the applet; start running and then try tapping B or holding it at various points in the acceleration to see how many different speeds there are between going from standing to walking, from walking to running and from standing to running. The number of different possible speeds is huge, adding surprising expressivity just with this one small change in response.

Finally, horizontal acceleration in the air is different than on the ground. This brings out a further contrast, one between acceleration speed on the ground, in the air and when running. When you're on the ground, you accelerate at a certain rate, which is different from the acceleration in the air. It's simply a different number that gets applied as a force each frame. As soon as you enter the air state, the horizontal acceleration number changes. Note that pressing and holding B has no effect in this instance—in the air state, all horizontal movement happens at the same rate. Also, this is acceleration, not speed, so you can be running as you jump and still

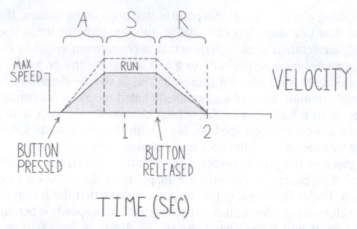

FIGURE **13.8 Horizontal movement in Mario.**

retain that speedy horizontal movement. What's reduced is your ability to modify that velocity by accelerating one way or another.

To sum up, the important values to the feel of Mario's horizontal movement are:

- Acceleration left
- Acceleration right
- Max speed
- Deceleration
- Running acceleration left
- Running acceleration right
- Running max speed—deceleration always remains the same
- Air acceleration left
- Air acceleration right

Note that deceleration remains the same regardless whether the run button is held or not. At this point, we have a rectangle which will accelerate gradually left and right to a maximum speed, slow down again gradually to a standstill, and accelerate faster to a higher top speed if the B-button is held (Figure 13.8).

Vertical Movement

The rectangle's vertical motion, the jumping of Mario, is a more complex series of relationships than those governing his movement on the ground. To start, there is a constant application of gravity. When you're moving left and right, gravity is always pulling the character down. That's simple enough: a constant downward force applied to the character. But this gravity force is variable. At the moment the jump

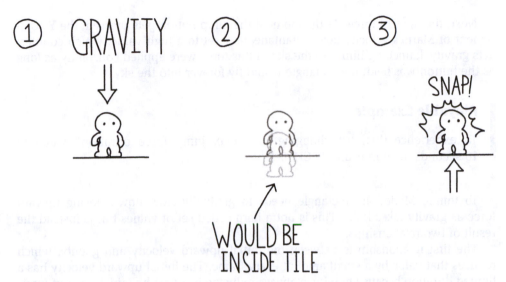

① GRAVITY ② ③ SNAP!

WOULD BE
INSIDE TILE

FIGURE **13.9 The collision code snaps Mario back outside of (but up against) any solid object, gravity must otherwise push him through. This happens every frame.**

button gets pressed, Mario is instantaneously imparted with a certain upward velocity, which counteracts the constant downward pull of gravity, launching him into a soaring, graceful arc. This upward velocity is gradually reduced as gravity takes hold again. At the apex of the jump, when velocity reaches 0, gravity is raised artificially by a factor of three, pulling Mario back to the ground with a much greater force than the one he overcame to get airborne in the first place. This artificially inflated gravity has a cap, however, as do all forces in Mario—there is a terminal velocity that will limit its downward motion. In addition to all of that, there is an artificial sensitivity created in the amount of time the jump button is held down. A tiny tap on the button will yield a small hop, while holding the button down extends the jump. This time sensitivity also has a range; there are minimum and maximum jump heights, enforced by limits on the minimum and maximum amount of time the jump will accept inputs.

If this sounds surprisingly complex, it definitely is. Let's step through each of the individual rules and interactions one at a time.

First, the rectangle needs a constant downward force. This is the force of gravity, constantly pulling the rectangle back to the ground. This force is applied all the time, even when the rectangle is pressed against the ground tiles. In each frame, the collision code looks at the position of the rectangle and the forces applied to it. From that, it infers what the rectangle's position would be in the next frame. If it would be inside a tile that's supposed to be solid, it snaps the rectangle's position to be flush against that tile. Though there is a gravity force applied to the rectangle in all places and at all times, the collision code keeps Mario from falling through the world.

211

Next, the upward force. At the moment the jump button gets pressed, the Y component of Mario's velocity gets instantaneously set to a high value, which counteracts gravity, launching him into the sky. If this force were applied constantly as long as the button was held, the rectangle would fly forever into the sky.

Playable Example

To experience this, try changing the "max jump force duration" value to 10 seconds or so in example CH13-1.

To mimic Mario, the rectangle needs to gradually slow down, losing upward force as gravity takes hold. This is not a hard-coded set of values but is instead the result of two relationships.

The first relationship is between the initial upward velocity and gravity, which reduces that value by a small amount every frame. The initial upward velocity has a limited duration because gravity is always reducing it. After the initial burst of force, there's nothing to keep the rectangle moving up. As a result, gravity will take hold and gradually slow the upward momentum until the rectangle is no longer moving upward. The result, assuming the character is moving horizontally at the time of the jump, is a graceful arc. This also has the effect of making the jump feel immediate, responsive and quick because the moment the input is received there is big, visible response.

The second relationship is between the time the jump button is held and the upward velocity. The jump is time-sensitive. A slight tap on the button will yield a small hop, while holding the button down longer will extend the jump. This time sensitivity also has a range constraining it; there are minimum and maximum jump heights, enforced by limits on the amount of time the jump will accept inputs. In terms of actual measurable response, if you hold the A-button for the full duration of the jump, you'll get a jump that's about five tiles high. If you tap the A-button as quickly as possible, the jump will be shallower, with a height of as little as one and a half tiles. The result is an expressive range of jump height, anywhere between one and a half tiles and about five tiles in height, which corresponds to releasing the button somewhere between one frame and about half a second (Figure 13.10).

The effect is a sort of early out for the jump. The player can choose to release the button early and in so doing accomplish a shallower jump.

At this point, with a time sensitive jump in place that applies the maximum jumping force as long as the jump button is held, the rectangle will jump satisfactorily. The only problem is in the height of the minimum jump: with this implementation, it is still very high. After all, the maximum jump power is still being applied to it for a certain amount of time. So the expressive range between the shortest jump and the tallest is very narrow.

To make this jump feel right, we'll need to artificially clamp the jump force in a way that may seem like something of a hack. Rest assured, though, this is the

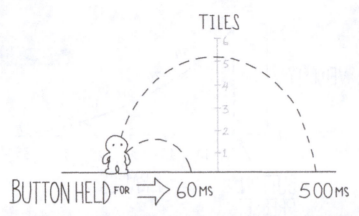

TILES

FIGURE **13.10 Jump height in Mario depends on how long the button is held, but only to a certain point.**

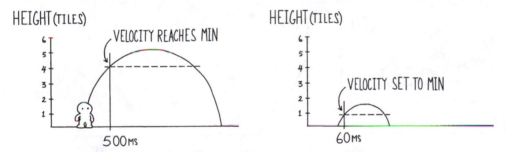

FIGURE **13.11 Upward velocity is artificially set lower when the player opts out by releasing the button early (thus getting a much smaller jump).**

keystone to getting the good-feeling Mario jump. The hack is this: if the game is in the jump state and it detects that the jump button is no longer being held, the game then checks to see if the Y velocity, the jump force, is above a certain threshold. If it is, it will artificially set the Y velocity to a specific, unchanging, lower value. The value is close to zero but is not actually zero. Weird, eh? Even if you only tap the jump button for one frame or two frames, it still receives the full upward velocity. It's just that when the button is released earlier, it artificially sets the jump force to a lower number before it allows the jump to take its course. The effect is that you float just a little bit more upward from the point of release and always fall with that nice, flowing arc (Figure 13.11). It feels a lot better than the wide variation of arcs you would get otherwise.

An example with actual numbers will help visualize this more clearly. When the button is held down for the maximum time allowed (giving the maximum jump height), the progression of upward velocity might go something like the jump shown in Figure 13.12.

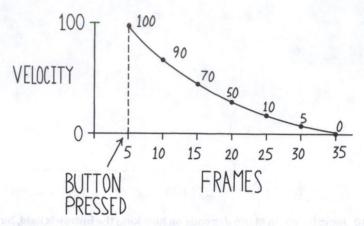

FIGURE **13.12 Falloff in upward velocity over time.**

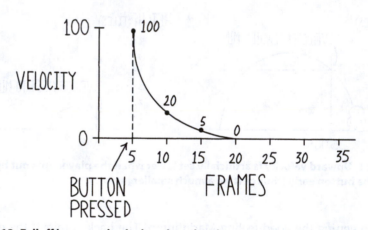

FIGURE **13.13 Falloff in upward velocity when the player opts out early.**

So on the first frame after the button is pressed, the jump force is 100 in the Y direction. This large force will propel the rectangle upward quickly. In the next frame, the force will have been reduced only slightly by gravity, to something like 90. In each subsequent frame, the force in the Y direction is lowered only slightly until eventually the maximum jump time is hit. At this point, the input is no longer important, and the jump force falls off gradually to zero, at which point the rectangle begins to fall back to the ground (Figure 13.13).

Contrast this with the shortest possible hop, where you're effectively getting a jump at the minimum power, which is much lower than the velocity of the full jump. It will give you the full power jump (100) at the first frame, but by the second or third frame, the jump force has already been set to the lower hard-coded value (20).

Instead of setting the value to 90, 80, 70 and so on until the full height jump arc has been completed, it sets it right to 20, the velocity at which the jump stops listening to button input regardless. Similarly, if you hold the button for half of the range of the jump, it might go 90, 80, 70, 60, 50 then to the preset 20. The result is that jump will always have the same arc, especially at the end. The duration of the button just changes how high (and consequently how far) it will go.

Now back to the jump in progress. If you'll recall, the rectangle has only reached the apex of the jump, the point at which vertical component of velocity is reduced to zero (by gravity acting on it over time). Now it has to fall back to the ground. Interestingly, after the tipping point, gravity changes. If you're running along and you press jump, gravity is the same normal value it always was. You're imparted with a negative Y velocity and it sends you upward, temporarily overcoming the weaker pull of gravity. The upward force will only be added for a certain amount of time, though, as gravity gradually takes hold and slows you down until you have no upward force. Once you reach the peak of your jump, instead of just allowing the natural pull of gravity to bring you back to the ground, the gravity is artificially increased, sucking you back down to the ground. It applies this stronger gravity whenever you're falling, whether you've just reached the peak of a jump, walked off the edge of a platform or bumped into an overhead block (which sets your vertical velocity to zero).

Try setting the fall gravity to the same level as the negative gravity and see what happens. The jump seems to take far too long and you begin to feel as though you've been out of control of the character for far too long. The impression of weight is also affected, making the rectangle seem far lighter than it ought to. In a word, it feels weird.

The final piece of the fall is a clamp on the possible falling speed. Just as the horizontal speed has a maximum, so too does the vertical. When you're falling, there's a terminal velocity that is definable by code. It's hard-coded. If you don't limit it, you can really feel the difference. When you jump from somewhere high, you'll get going really quickly before you hit the ground and it'll feel weird. If instead you set this number very low, it will feel like opening an umbrella in a cartoon or something, where you can actually feel the artificial clamp take hold. You can tell it's not the natural arc of the fall. Try both—setting the terminal velocity to something very high or very low—to get a sense of it.

At this point, we have a rectangle that has gravity applied to it and will jump to different heights when the jump button is held down for shorter or longer periods. These periods are limited by maximum and minimum time values, however, which define a certain expressive range of possible jump heights. The arc of the jump will always feel the same, however, because if the game detects that the jump button is no longer held while the jump force is being applied, it will artificially set the value to a lower value. This value never changes, so the end of every jump will have approximately the same arc. When the arc has completed, an artificially high gravity value pulls the rectangle back to the ground quickly and efficiently, decreasing the time during which the player has reduced control of the character and enhancing

the perception of weighty, close to real-world gravity (even if the character is leaping around like a flea). Finally, the speed at which it is possible for the rectangle to fall is clamped to prevent it from getting too high and feeling unnatural.

To sum up, the important values to the feel of Mario's vertical movement are:

- Gravity
- Initial jump force
- Minimum jump button hold time
- Maximum jump button hold time
- Reduced jump velocity
- Falling gravity (about three times normal gravity)
- Terminal velocity (maximum falling speed)

Finally, there is one small crossover between vertical and horizontal movement. In Super Mario Brothers, if you press jump while you're moving faster than the normal walk speed, you'll get a small extra jump boost. The initial jump force will be slightly higher, so the height of the overall jump will go up slightly. If you're anywhere between the full, running maximum speed and the normal walking maximum speed, you get a little bit of extra jump velocity. Jumping from a standstill, you can reach a height just under five tiles. If you get a running start (holding B) you can just about get over and land on a five-tile-high surface. This height boost is not commensurate to the speed at which you're moving at the time of takeoff; you get the height boost or not, depending on whether you're over the normal max speed when the jump button is pressed.

Collision and Interaction

Next comes collision, where Mario's world becomes solid.

Mario is a rectangle, one tile high. A tile is a nice way to simplify the layout, position and properties of things in a 2D game. Instead of having to store detailed positions for each object, we can create a grid of tiles and reference their position with simple two-number combinations. Typically, tile (0,0) is in the upper left hand corner of the screen. The tile below it is (0,1), the tile to the right of it is (1,0) and so on. If we store a list of all these tiles, we can easily find out where a tile is in relation to any other tile (Figure 13.14). If, when you make your list, you specify the type of tile it is—sky or brick or pipe or whatever—you can then check to see whether or not Mario can pass through that tile.

So, to make Mario collide with things, we look at his velocity. By knowing his direction and speed, we can tell which tile he will be in the next frame. If the tile is, say, a brick tile which Mario is unable to pass through, we place him on top of it instead of allowing him to go through (Figure 13.15).

This is pertinent when you have, say, an air tile below Mario in one frame and a ground tile the next. If you know this, you know that Mario should be falling, but

0,0	1,0	2,0	3,0
0,1	1,1	2,1	3,1
0,2	1,2	2,2	3,2
0,3	1,3	2,3	3,3

FIGURE **13.14 Tiles in Mario.**

FIGURE **13.15 Instead of going through the tile Mario is placed on top of it.**

that he's just about to land back on the ground again. This is how simple collisions are done. Without getting into unnecessary detail, the feel of a simple tile-based collision system like this is very slippery. Because there is no simulation of friction—the dampening that slows Mario back down again —applied based on what material he's sliding across, the feels is that of a bar of soap sliding across wet tile. He won't get caught or hung up on anything, and the overall sensation is very loose and sloppy. In the case of Mario, this is a huge part of the appeal. This is, of course, not always the case. To create the satisfying carving motion of a car or bike turning is to simulate the friction between tire and ground. But Mario essentially has no friction. Being pressed against a wall of blocks does not slow his jump force; he's free to slip slide across everything.

So now we have a rectangle that slips and slides across the environment, never getting stuck and always feeling perfectly solid. Only the rare spring platforms feel as though they have a bit of give. The rest of the objects in the world are like polished marble, and Mario himself is equally unyielding and smooth.

The next little particular that the rectangle needs is to have its Y velocity set to zero in every frame. As noted earlier, gravity gets applied to every frame, even when Mario is colliding with the ground. In each frame, his collision places him up a little bit, back on top of the block, and in each frame his Y velocity gets set back to zero. When falling, the gravity force will set the Y velocity to something very high (the fall gravity) to pull the rectangle downward. If you don't set that Y velocity to zero when he's in contact with a tile, a great deal of force gets built up and "stored" in a weird way. The collision still keeps you out of the ground but if you walk off the cliff, you plummet down because you have this huge negative velocity built up. It feels really weird. Instead, you want your Y velocity to be guaranteed to be zero when a fall starts so gravity will pull the rectangle gradually and appropriately to the ground.

The opposite case (when the character jumps and hits a tile above) also needs the Y velocity set to zero. If you hit the ceiling and the Y velocity is not zero, you'll stick to the ceiling (as you do in Super Contra). Mario still wants to move up every frame. The collision will stop him from moving through the tile, but it will have no effect on his upward velocity. To get the right feel, you have to set Y velocity to zero whenever a collision is detected, whether it's from above or below.

Another little behavior particular to the original Mario is the lack of height boosts for bouncing off an enemy's back. When you hit a turtle's back, it sets you to the same state as if you'd released the jump button after the minimum amount of time. The rebound off a turtle or Goomba is a tiny little hop, as with the minimum strength jump. This changed in later games such as Super Mario World, where holding down the jump button while bouncing off the back of an enemy would give you a massive height boost, much higher than that afforded by a regular jump.

The only objects in the game that give Mario a height boost are the springy platforms. But you must jump just at the right time. It's wicked hard, though, because the window for doing it properly is extremely small. In the later games, simply holding down jump while bouncing off an enemy or jump platform will give you the extra boost, which to me feels better as an implementation.

To wrap up the movement of the primary Mario avatar, there is one particularly rare special case that's worth mentioning. If you get a mushroom and you're too tall to walk under a one-tile-high brick, you can slide under it. If you're small, you can just run through. But if you're big Mario, you have to build up a head of steam and slide in there. The case the game has to deal with is: what do you do when you stop ducking? In some games, you just can't stop ducking—you're forced to remain in the duck state. Mario enables you to stand up, which puts you in a weird, unique, single case game state where you can't move or do anything (even duck). It pushes you right, locked out of input, until you're free of any collisions. It's a bit stopgap, but I guess it covers a weird case that Mario can get into.

FIGURE **13.16 Camera scrolling zones in Mario.**

Finally, we come to the movement of the camera, which functions as a second, if indirectly controlled, avatar. Clearly, the feel of Mario includes the motion of the camera and the game would not feel quite correct unless the camera moves properly with the avatar. First, the camera moves only to the right. Once it has moved right, it cannot be moved back to the left. To me, this feels a bit oppressive and it's unclear whether this was a technically motivated decision or a design one. Either way, it has the effect of cramping up the screen and encouraging constant forward motion. If the player goes to the left, the fact that the camera does not move feels abrupt, halting and unyielding. When moving to the right, the screen scrolls at the same speed as the character. The only small, important thing for feel is the small zone extending from about 25 per cent of the screen width from the left edge to the center. Inside this zone, the scrolling speed is reduced. The effect is a gradual, though rough, speeding up of the camera as the character accelerates from a stand-still (Figure 13.16).

And there you have it! This is the simulation that creates the feel of Mario in all its dirty, exhaustive details. What strikes me about it is just how seat-of-the-pants many of the decisions and particulars are. Stuff like manually setting the Y velocity to a lower, artificial value when the jump button is released early and swapping out the normal gravity value for one three times higher seems like it would have the opposite of the intended outcome. Why do those particular changes make the game feel better? I'll attempt to address such questions at a more general level in the Principles of Game Feel section. For now, though, I recommend fiddling around with the final, composed applet a bit. Really dig in and change some of the parameters.

FIGURE **13.17 States in Mario—stuck and dead are special cases.**

At the end of this chapter, I've listed the tunings for Super Mario World and Mario 2. See if you can arrive at them on your own, just by tweaking the numbers.

States

States are the final piece of the Mario feel puzzle from the standpoint of someone trying to construct a perfect-feeling Mario stand-in. By state I mean a specific set of instructions about how the game will respond to input. When a game has more than one state it means that the same input might result in a different response from the game, depending on what the character is doing at the time of the input. A simple example from Mario is illustrated by different horizontal acceleration in jumping state versus the running state. In the running state, the acceleration is a very high value, speeding Mario up very quickly from a standstill. In the air state, that value is drastically reduced. Effectively, the change in state maps the same input to multiple responses in the game. As long as the player has a way to conceptualize a change in state, such as when Mario leaps into the air, the fact that the result for a particular input has changed is not jarring or distracting. In fact, it offers more expressive potential.

The states in Super Mario Brothers are idle, walking, running, jumping, stuck and dead (Figure 13.17).

For the record, this is how things are organized under the hood in Mario. More or less. As long as the relationships are maintained, the implementation is more or less irrelevant, but structuring things this way certainly makes it easier to get the desired feel.

Context

Our rectangle is now happily sliding around. It feels great to leap around and run and change directions. Right? Well, perhaps. Returning to example CH13-1, run

around a bit. Notice anything weird? Right, there's nothing in the level. It's an endless field of blankness. Time to add context.

A level design trick that originated with Super Mario Brothers or was at least used heavily in it is the "Fortune Favors the Bold" approach. Running full speed to the right and attempting to quickly adjust to changes in the environment makes the game much easier by virtue of the level design itself. The levels are set up to encourage (and in many later levels, necessitate) this kind of bullish charge-ahead play. It's simply how the level is laid out: the jumps and obstacles are easier when the player is moving at the maximum speed possible. Since that speed was predictable once the mechanic was complete, it was possible to design the levels to match.

It seems to me that this was the intended experience of the game, as a whole. Even the camera avatar's behavior seems to encourage this behavior, by constantly blocking the path behind the player. You can't go back, the game seems to say, so you might as well go forward as quick as possible.

As a general rule, the spacing of the objects in Super Mario Brothers is about four tiles high. To accurately recreate the feel of Mario, you need a level that's built this way. This is because while the character can actually jump close to five tiles in height, jumping to an object four tiles high is much easier and drops the character onto the platform just at the shallow part of the jumping arc. Jumping to a platform that's just below the maximum height of the character's highest jump just feels better.

Playable Example

To experiment, try placing platforms at various heights in example CH13-1. There are platforms of various heights to jump up to. Notice how the four-high platform matches the jump best. Like Goldilocks' porridge. Best reference ever.

The relative imprecision of the Mario mechanic makes it necessary to give the player plenty of room for overshoot, in both the horizontal and vertical directions. Part of that is making most platforms' height about four tiles apart. The other part is stretching all platforms in the game horizontally. Now try removing some sections of ground in example CH13-1 to see what happens if you construct a level that has mostly single-tile wide platforms to land on. Again, this hooks into the overall design goal that the player should be running full speed to the right at all times. Tiny, single-tile platforms encourage a more plodding approach, where each jump is considered carefully before it's executed.

Another aspect of the context that plays heavily into the tuning of the rectangle's motion is the movement of enemies in the game. This is something we don't normally think of with respect to level design, but the motion of the AI characters actually has a huge bearing on the way the mechanic will feel. Their motion dominates certain areas of the screen space, changing the player's ideas about the spatial topology. An area enclosed by two tiles suddenly becomes a bit of a death trap

if there are two turtles wandering around in there. Similarly, jumping up a set of stairs becomes an entirely different interaction when there's a hammer brother at the top. For a striking example, look at the first level in which 10 (the floating cloud guy who tosses those red spiny bug-turtles) appears. Most of the level is flat with almost no skillful jumping required, but the entire thing feels hurried and oppressive because of the ceaseless shower of enemies raining down from on high.

Enemies, and this is no accident, move along the ground at approximately the same rate as Mario's maximum walking speed. You can sync up with the speed of the enemies' movement if you drop out of running. The result is that you can jump into the midst of a group of enemies, walk temporarily for a precise amount of time and then jump out again without feeling too out of control and without plowing into the enemies themselves.

Challenge is also defined by context, as it is in most heavily spatially oriented games. In the later levels, the jumps become a bit wider, requiring more specific, precise landings. To further ratchet up the difficulty, you must do a large number of these precise jumps in rapid succession. At the same time, there are far more enemies. Where once there was one Goomba, there will be three in a row followed by two turtles. Then things like bullet bills and hammer brothers begin to appear, and the meaning of even the simplest jump and motion changes. It may seem an obvious point, but it's interesting to examine the ways in which challenge is constructed via the addition of enemies. There's almost always an optimal path that, if the player's running full speed, will take him or her through unscathed without too much hassle. The game feels like a course to be run and perfected rather than like a space to explore slowly and methodically.

To get the feel of Mario, you need blocks that are four tiles high and are spaced far apart horizontally. Pits in the ground are in a range from two blocks wide to six, with six feeling quite risky to jump across. The difficultly ramp up happens based on adding more of these wide, difficult jumps. They require a great deal of precision and force the player to do them in rapid succession. In addition, the later levels become littered with increasing numbers and increasingly fast and unpredictably moving enemies. These enemies serve, by their motion, to dominate areas of the screen space and make it feel more unsafe and oppressive. In the game's later levels, no place feels safe, and it seems a mad dash of survival to reach the end.

Indeed, there are lots of one-tile-wide blocks on 8-1 and 8-2, as well as lots of single-tile pits you can run across. In addition, many pits get as wide as five or six tiles, which leaves very little margin for error. Technically, Mario can jump 10 horizontal tiles at a full run, but it's almost never used in the game because it's so difficult to do.

Polish

Up to this point, what we have is a bunch of rectangles moving and sliding around. To examine the various polish effects, let's turn on the character-based treatment. So as not to infringe, I've created "Scarfman" as a Mario stand-in.

Playable Example

Open CH13-2 to see the rectangle replaced with a character and the various tiles and enemies given some kind of representation.

First, animation effects. The character has a run cycle. When the motion of the rectangle is activated, the visual representation now sitting on top of it plays back a series of frames. It's a very short and simple series of frames, but it's an animation nonetheless, and it conveys some new and different things to the players about the nature of the object they're controlling.

One of the crucial parts of the feel of Mario is that the playback of the frames of this running animation are synced up perfectly with the simulated motion underneath it. This was and is a big deal where feel is concerned; even today many games don't successfully accomplish the sense that the avatar is truly and accurately representative of the simulated object underneath it. This is typically called "foot slip" by animators and is a particular problem in video games because of the unpredictable, participatory nature of avatar movement.

The fact that Mario really nailed this relationship between animation and avatar movement was a big deal, even in this primitive, 8-bit context. The perception conveyed is that this is a little guy running along the ground and his feet are planting at each step because the speed of animation is perfectly matched to the speed of movement of the object.

If the underlying simulated object is moving faster or slower than the animated object, it's very easy to pick up on that discrepancy. It's a very subtle clue but it's something that humans are very good at observing. We have a lot of practice observing and coping with our immediate physical surroundings at this tactile, interactive level, so as soon as something doesn't match up, it becomes immediately obvious. The net result is that, in the player's mind, the animated character and the moving object beneath become separate entities, which makes it more difficult for the player to engage in and believe in the reality of the game world. Something is lost because you can see behind the curtain, see the simulation.

Another important animated effect is the little slide that Mario does when he's in the process of reversing direction. If you reverse direction while Mario's running, he puts his hand up and assumes a little sliding pose. In the case of the Super Mario Brothers, this is not a separate animation that gets played back. Rather, when you apply the acceleration in the opposite direction, the character slows down. This is another consequence of Mario's simulated approach; instead of having a canned set of frames played back for, say, a foot plant and direction change, the natural force of the acceleration gradually counteracts the current velocity and Mario slows to a halt, reverses direction and slowly speeds up going the other way. The animated effect occurs if and only if the player is holding down a direction which is opposite from the current direction of the character. So the underlying simulation has not changed, but the animated effect on top of it is emphasizing and enhancing the

perception of what's going on physically with the simulated objects. The character is running in one direction, the player presses the other direction, the character goes into a slide until the direction change is complete, and then the character resumes the run animation (albeit at the lowest speed, speeding up gradually to match the speed increase of the simulated rectangle). To put it another way, the animation effects are there to enhance and emphasize what's happening with the underlying simulation, rather than wagging the dog the way the animations in, say, Prince of Persia did.

Another animated effect that's crucial to the feel of Mario is the jiggle of bricks. It seems like such a silly thing, but when you're small Mario and you hit a brick from underneath, it sort of jiggles. It jiggles in a very satisfying, very cartoony sort of way, but it adds a lot to the sensation of interaction. It doesn't actually affect the simulation—it doesn't move the brick, changing its permanent position—it's just a layered on animated effect that gives an impression of mass to the character. This is especially true in the contrast between hitting a brick when you're small as opposed to when you're large Mario. Small Mario causes the brick to seem loose and jiggly when it's hit, but that interaction also tells you that small Mario has a certain amount of mass. If he can jiggle a brick loose, he's striking with some force, clearly. When you're large and you can smash the bricks, it shows you that the larger Mario is quite a bit more massive. It shows you that where diminutive Mario simply loosened the brick, big Mario has the force to smash it spectacularly, causing brick detritus to rain down.

Playable Example

Check out how the feel changes if you turn off both of these effects in example CH13-2 to see just how much they sell the notion that this is a physical, malleable world.

Visual Effects

As we have defined them, there are very few visual effects in Mario. There was very little processing power to work with on the NES, so there couldn't be sprays of particles everywhere to emphasize every interaction. The trend over the years has been toward more and more visual effects in the Mario game—the recent New Super Mario Brothers and Mario Galaxy have almost ludicrous amounts of particles flying everywhere all the time. In the original Mario, everything seems clean and smooth. There aren't even modest little puffs of dust or smoke when Mario enters the slide pose to change directions. It seems as though every surface is pristine and smooth, without a hint of dust or gravel. The only visual effect of note is the broken brick particles that spawn and fly down when a tile is smashed. Again, though, look at just how much is lost if this effect is removed. It just doesn't feel satisfying to smash bricks when they simply disappear. Removing this effect removes one of the few,

highly important clues the player has to derive notions about the physical nature of this world.

Sound Effects

The sound effects in Mario are paramount. I've replaced them in my demos to avoid infringing on Nintendo's intellectual property, but note their nature. The rising, slide-whistle noise for jumping roughly matches the height change of Mario as he flies upward, further harmonizing with the motion and the sensation of holding down the button in emphasis to get a higher jump.

There's one collision noise—when Mario's head hits a block or when a fireball hits a wall—that sounds like a large rubber band being tweaked. It varies slightly in pitch to stay fresh-sounding, but the impression it conveys is one of a silly, rubbery world. It fits very well with the jiggle of the blocks when they're hit by small Mario and in general convey a sense of jiggly, bouncy movement. This would seem to be selling a different impression than the smooth, frictionless collision simulation, but because of the jiggle of the bricks, it matches well and makes the world seem more alive and the physics more exaggerated than the more staid collision interactions would suggest.

The brick breaking sound is particularly satisfying—it truly does convey the sense of a crumbling stone object, even with the limitations of the NES sound board.

Metaphor

Being as iconic as it is, it's a little weird to look at Super Mario Brothers with an eye to examining how the metaphorical representation it presents affects our expectations about how things will behave and act in its world. But humor me here, let's take a poke and see what we can see.

First, let's give Mario's treatment a place on the three-axis scale between realistic, iconic and abstract. Obviously, Mario's not realistic. The treatment, such as it is, is far toward the iconic side of the diagram and indeed begins to creep up toward pure abstraction. It's very surreal. What, for example, is a Goomba? What does it represent? A turtle in Mario looks something like a turtle, but it's clearly not attempting to meaningfully convey turtleness, if that makes sense. These turtles are fast-moving, dangerous creatures. In general, the creatures and objects represented have very little grounding in meaning or reality. Their meaning is conveyed by their functionality in the game, which is to present danger and to dominate areas of space. They're not abstract shapes and lines either, though. They're definitely meant to be creatures of some kind who obey their own bizarre rules of physics and behavior. They simply tend toward the surreal. There's very little meaning imbued in these objects other than the function they serve in the game.

What does that imply for the way that we expect things in this world to behave? Well, we're not grounded in expectations about how these things should behave.

We don't expect that because Mario is slightly portly that when he comes up to a pipe or some wall that's taller than he is that he'll have to heft and sweat his way laboriously over the top. Because the treatment is so surreal, we aren't bound by that expectation. He's not a photorealistic representation of a plumber. He doesn't look like the plumber who came and cleared that hair clog from your shower. We can accept that he leaps like a flea.

In its abstractness and surrealness, Mario plays very well into the type of physical interactions and movements that it sets up. Mario flies through the air like a flea getting this gigantic, spontaneous upward force and yet needs no wind up, no anticipation, no pole to vault with. It's very organic and expressive but it has very little to do with the way that things behave in our own physical reality.

But that's okay because both the metaphor and treatment are surreal. The abstract and surreal motions of the objects and the way things feel and function don't seem odd. Even the interactions between objects, which so often seem like a block of ice sliding across a gymnasium floor, fit in just fine because of the dream-like metaphor and lo-fi treatment. The metaphor is setting up very few expectations, so all bets are off.

The one place that Mario does actually lean into expectations is in the use of an iconic human to represent states. Because Mario appears identifiably human, we can look at him and say ah, yes, he's on the ground running now, or hey, he's in the air jumping now. When he's on the ground and running along, it's apparent to the player that he's in a different state than when he's in the air or when he's swimming. It's easy to accept that when he's in the air, he has less control, because it's obvious to the player that a different state has been entered. It's odd that there's any control in the air, as this is not the way that things work in the real world, but the visual cue effectively conveys the change and maintains a sort of logical cohesion, even if it is rather surreal. You can definitely tell that Mario, as an iconic human, is in a different state of being when he's in the air than when he's on the ground. It's a nice visual metaphor for changes in state. It uses the fact that he appears human to tie in the logic of the states and how they function.

Rules

At the lowest level, there are a lot of really interesting rules about enemy interactions that give the player clues about the physical nature of Mario and the world in which he exists, which ultimately change the feel of interacting with that world. For example, Goombas are weaker and less substantial than turtles. A Goomba is killed in one stomp and gets wiped out of existence. A turtle can be stomped and killed in one hit but leaves behind a shell. The fact that the shell remains seems to indicate that it is more massive than the body of a Goomba. A shell can't be destroyed as easily as a Goomba can be stomped. By the same token, winged turtles seem more powerful and massive than those without. You have to stomp them twice: once to knock their wings off—the wings are not very well attached, apparently—and once

to knock them out of their shells. There's this sort of hierarchy of powerfulness amongst the creatures, from Goomba to turtle to winged turtle. Bowser is the most powerful creature of all; he can't be stomped. You have to drop him into lava.

The other thing all these interactions tell us is that Mario himself is quite massive. These creatures are all about the same size as him, but he can stomp anything in the game to death with relative ease. One assumes that his apartment is free of cockroaches.

At the medium level, there are three power-ups that have an immediate effect on the spatial topology. You see them and you want them for the immediate benefits they convey. So you focus in on grabbing that star, mushroom or fire flower. You're going to go out of your way to get it. Unless, of course, you already have the fully powered up fire flower, in which case the flower and mushroom become meaningless and can be ignored. These are temporary effects but each changes the feel of the game significantly. Going from small to big, you can smash bricks and you can be less afraid of enemies because if they hit you, you simply turn small again. Fire flowers enable you to run forward with impunity, dispatching enemies left and right without having to stomp them. The whole feel and flow of the game are altered because you no longer have to fear most standard enemies. They no longer dominate certain areas of space, so the game suddenly feels more open. The star is the ultimate temporary power-up, enabling you to run through enemies at leisure. With the star, the challenge is temporarily reduced to jumping exclusively. This feels more open, more free.

Finally, at the highest level of long-period rules, there are 1-ups and coins. Score in the game is mostly irrelevant, a throwback to an earlier age of arcade gaming. I never pay attention to or try to beat my score in Super Mario Brothers. Extra lives, however, I'm very interested in. Super Mario Brothers is a difficult game and you are given only three lives at the outset, leaving very little margin of error. When I see a 1-up mushroom, then, I get very excited and immediately focus all my attention toward attaining it. But the desire is tempered by the knowledge that if I die in the attempt, the effort will have been wasted. The reward is almost directly proportional to the risk. It feels like walking on eggshells. By virtue of the rules—lives are the rarest commodity and there are very few of them—it seems like the highest possible reward, so I'm willing to undertake a huge risk to get it.

Coins give a low-level sense of constant reward. Because collecting 100 coins gives you a huge reward, an extra life, it always feels like you're doing something useful as you collect them. Useful, but mundane. It's not like the excitement of the fast-moving extra life mushroom. You might go a little out of your way to collect a coin, but you wouldn't risk dying over it.

So in order for a game to feel like Mario, the metaphor should be surreal. It doesn't have to be an Italian plumber running around huge pipes and dealing with abstract, surreal monsters that vaguely resemble turtles and bullets, but putting Mario with the movement he has on a street corner in downtown New York will seem a bit off. Similarly, a photorealistic treatment will clash with the surrealism of the movement and interactions. To have that Mario feel, the treatment should be

iconic, bordering on the purely abstract. Again, it doesn't have to be Mario specifically. As Scarfman shows, though, it ought to be a little guy.

Summary

Bet you'll never look at Mario the same way, eh? I know that I certainly don't after such an in-depth examination. The other major takeaway here is that game feel, even in a seemingly simple game like Super Mario Brothers, is really freaking complex. All the tiny little decisions that meld together to comprise the feel of Mario boggle the mind. Especially in the area of simulation and response to input, there are a surprising number of small but important decisions. This examination gives us a nice vocabulary for addressing things like whether the game keeps track of acceleration and velocity or whether it's simply tracking and updating position and how that will change feel.

At this point, then, you should have a very clear idea of the depth of detail that goes into creating a good-feeling game. If you're creating a game from scratch, you must be prepared. Keep your mind open to the possibility of changing any part of the system with the goal of improving the feel, the perception. As Mario proves, even things that seem hacky, such as artificially setting a jump velocity in the middle of a jump, may turn out to feel better than a more pedantic approach to simulation.

CHAPTER FOURTEEN

Bionic Commando

Bionic Commando was released in December 1988 for the Nintendo Entertainment System. At the time, the notion of the "platformer" game had been so well established by Super Mario Brothers, it was difficult to imagine a similar game that was not, at some level, a Mario clone.

Many companies scrambled to capitalize on the apparent gold rush by differentiating without deviating; they created their own characters and worlds in an attempt to separate them from the hoards of similar product, but always emulated the feel and functionality of Mario. The recipe for a platformer, as set down by Mario, seemed clear and immutable and woe to those who tried to stray too far from it. The one staple, the one ingredient that seemed non-negotiable, was jumping.

Then came Bionic Commando. Not only is it one of the best-feeling games ever created for the Nintendo Entertainment System, but it asks a fascinating "what if" question: What if we made a platformer where the avatar couldn't jump? What would that be like?

Bionic Commando answers this question with the eponymous bionic arm. Instead of jumping, the character can make a fulcrum of anything, connecting to and swinging from most objects in the game. The construction of the bionic grappling claw and exactly how it's meant to integrate with Ladd, the commando in question, is unclear. But as a means of transportation it enables the character to swing around with a loping, easy grace. This is especially apparent when contrasted with the rigid movement of the character on the ground. On the ground, he feels like a lump, an unappealing blocky chunk of matter that ambles along without inertia or appeal. As soon as he starts swinging, he comes to life. In swinging, the control feels expressive, improvisational and liberating. It feels like a continuous process of cheating gravity, saving yourself from falling at the last possible moment over and over again. In that respect, it's similar to juggling, unicycling or riding a bike.

It's almost as though the character is a performer in Cirque de Soleil. While everything else in the world seems bound by the simple, boring rules of reality, Ladd is free to break through with unexpected skill, soaring around the world in a way that seems improbable but not impossible. That sense translates to the player's impression of control. Personally, as I play the game, I feel as though I'm learning a

229

FIGURE **14.1 Each input on the NES controller is a simple button with two states, "on" or "off."**

complex skill, but one that is grounded in a mundane reality. The feeling is analogous to learning a new skill, like juggling, in the real world.

Now let's see how this effect was achieved, applying our taxonomy of game feel.

Input

In Bionic Commando, the NES controller is used in a way very similar to that of Super Mario Brothers. There is a lot less chording of inputs and a lot more emphasis on states, but the usage is similar enough to gloss over. Just recall that the NES controller has the directional pad and two buttons, A and B, and is a simple input device (Figure 14.1). There are six buttons used for active gameplay, and each of those buttons is very low sensitivity. Taken as a whole, it's a very low-sensitivity input device.

The shape feels good to hold, it has a satisfying weight, and the smooth texture is pleasing to the touch.

Response

As with Mario, if you want to create a game that feels the same as Bionic Commando, you're going to be dealing primarily with response. Unlike Mario, however, Bionic Commando relies on animation more than simulation for its expressive feel. This illustrates once again our principle that game feel exists in the player rather than in the computer. It's all about how the player perceives the motion and control rather than the accuracy or robustness of the simulation. This is particularly evident in Bionic Commando, where there is almost no simulation of the sort found in Super Mario Brothers.

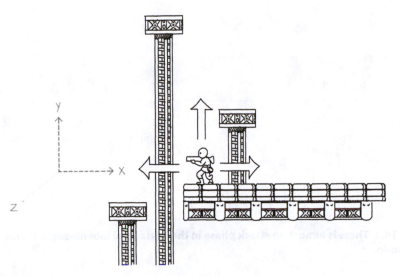

FIGURE **14.2 Ladd moves in two dimensions, X and Y.**

As always, the first things to examine are the objects that move in response to a player's input. What are the avatars and how do they move? Like Mario, Bionic Commando has two avatars: the main character, which is directly controlled, and the camera, which is indirectly controlled.

The character, Ladd, has freedom of movement in the same XY plane as Mario (Figure 14.2). He moves horizontally, left and right, and he's able to swing up and drop down. The motion is relative to the view; pressing left on the directional pad moves the character to the left of the screen and vice versa, and there is no rotation.

Horizontal Movement

With respect to horizontal X-axis movement, the game is only tracking the position of the avatar. Unlike the rudimentary simulation of Newtonian physics that Mario uses, there's no acceleration or velocity. When you press left on the directional pad button, the character goes immediately from standstill to his maximum speed run, with zero acceleration. On or off, full speed or standstill, just like Donkey Kong. So there's very little simulation here. The input passes directly into the motion of the character. Hold down the button, he'll move at his maximum speed in one direction. Press the other direction, he doesn't decelerate or accelerate, he just moves full speed in the other direction. That's where the sort of stiff, robotic feel comes from. You release the button and he stops immediately with no semblance of an organic, fluid motion (Figure 14.3). Nothing in our world moves like this, so the impression can only seem robotic. There's a certain tradeoff in the precise, per-pixel positioning of the character that's possible, but there's certainly no intrinsic appeal to this motion. By itself, this motion could not carry a game.

231

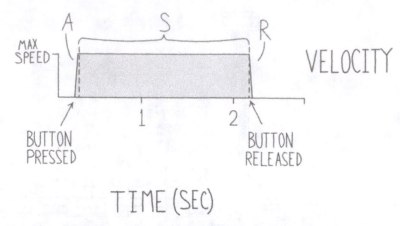

FIGURE **14.3 There is almost no attack phase in the horizontal movement of Bionic Commando.**

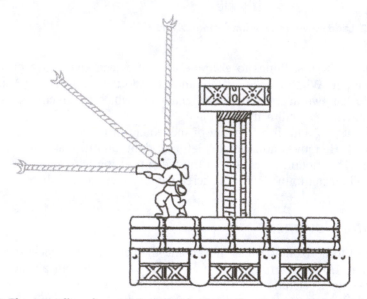

FIGURE **14.4 The grappling claw can shoot out in three directions relative to Ladd.**

In terms of vertical movement, the character can move in Y direction by falling and by using the grappling claw. There is no jump. All vertical movement happens via the grapple, which shoots out in one of three possible directions relative to the character: vertically, horizontally or diagonally (Figure 14.4).

Vertically, the motion is fairly staid. If the claw latches onto something, you can pull yourself directly up. If the thing you're latched onto is a particular type of tile, the character will pull through the platform and end up standing on top of it. It's a predetermined, animated motion, with no player control other than initializing it at

FIGURE **14.5 The feel of swinging comes from the playback of animation rather than simulated parameters.**

the start. Horizontally, you can attach the grapple to barrels and certain walls and pull yourself toward them. In the case of both of these grapple directions, when you hook onto something, the result is not very dynamic. There are interesting-feeling interactions between the claw and enemies, which we'll get to when talking about polish and collision, but the default, connect-to-something interaction feels plain, rigid, dull. The real expressivity of Bionic Commando comes from the diagonal firing of the grappling hook.

When the grappling hook is fired diagonally and connects to something, the character enters the swinging state. The swing state is what the feel of Bionic Commando is all about. Interestingly, the swing is not at all simulated. There are no parameters being tracked for acceleration or velocity. It's just a predetermined set of frames, played back linearly, which show the Bionic Commando character swings back and forth like a pendulum.

At the apex of the swing, the frames are closer together, indicating a change in speed as he reaches the end of the arc, reverses direction and swings the other way.

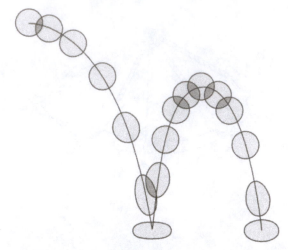

FIGURE **14.6 The appearance of a ball bouncing as conveyed by frames of animation played back in sequence.**

Likewise, he accelerates through the swipe of the arc. This is nothing particularly revolutionary; the same effect is used to convey the acceleration and slowdown of an animated ball bouncing (Figure 14.6).

This is how animation works. An animator makes things appear to speed up or slow down by grouping drawings closer together or pushing them further apart. If the drawings are grouped closer together, the impression is that the object is slowing down. As they separate, the object seems to speed up. This is a great-looking motion because it's well animated. The perception is of a fluid, arcing motion. What differentiates the swinging in Bionic Commando is the fact that the predetermined frames contain information about position. As the swinging frames are shown, the game maintains information about the position of the character at each frame of the swing, which is used for things like damage and collision. The feel, though, is of a smooth, hypnotic pendulum.

The character will exit the swinging state if the corresponding directional pad button is held during the apex frame. That is, if you're swinging from left to right and you hold down the right directional pad button, the character will release and fly off to the right. The horizontal velocity is not variable, mind you. You don't get more or less velocity for swinging more or less, but you do get launched in the direction you were moving which, because the release always happens on the same frame of the swing animation, is a slightly upward horizontal trajectory. From the player's perspective, you hold the button for the direction you want to release for some time before the actual release happens. The result of this pre-holding is a sense of pushing the character in the direction you want him to go, anticipating the release. This is very interesting, as holding the button has no ramification for the playback of the swinging state frames unless it happens on one of the two apex frames and is in

the proper direction. But the sense is that you're pushing the character the way you want to go, nudging the pendulum in the right direction. It's sort of a placebo sensation, something akin to waving your hands at a bowling ball after you've thrown it down the lane. Again, it's all about the player's perception. It *feels* as though pushing on the directional pad affects the momentum of the character, so the reality—that the game could care less about input unless it's at the apex frames—is irrelevant. It is at this point, at the moment the character releases from the swing, that gravity takes hold.

What's interesting about the application of gravity in Bionic Commando is that it is the only truly simulated parameter in the entire game. Unlike when the character is running on the ground (having only his position set each frame or swinging back and forth with predetermined frames of animation), when the character is affected by gravity, he has velocity, downward acceleration and position. This is the only motion that uses any sort of simulated Newtonian physics. Even when he walks off a platform, the fall is slightly artificial. The character accelerates downward when he walks off the edge of a platform, eventually reaching the terminal velocity, but the game is setting that value artificially high as soon as you step off the platform. So when you step off the platform, immediately you are sort of flying at this artificially high speed. As soon as you step off the edge, it gets set higher than it normally would be. It doesn't start at zero and ramp up slowly. And that feels pretty weird.

When you release from the grappling hook and you're flying through the air, though, the gravity takes hold very gradually, very naturally, and feels organic. Eventually, as with Mario, the fall caps out at a terminal velocity to prevent weird, uneven-feeling falls from various heights. In a sort of inversion of the way gravity in Mario functions, you're soaring through the air in a beautiful arc, flowing up and down with different wavelengths. And once you've released, you're immediately free to attach to the next point. Any other valid object, any other pixel on the entire screen can be connected to as long as it's flagged as such. So there's this wonderful expressivity in swinging, releasing, swinging, releasing, as you fly around, and you can connect to almost anything. The sense is one of masterful improvisation, of freedom to use the environment as you see fit. If you were to play the first level 100 times and trace the paths of motion each time, the results would be different curves, different motions each time. As they would be with Super Mario Brothers.

Again, this all comes from the simulation of vertical motion. The simulation of this one parameter—gravity—serves to create a graceful, flowing feeling. The speed of horizontal motion is hard coded, as it is in all other instances.

Another thing that adds to this feeling of expressivity is that the swing, the arc of the pendulum, is based on the length of the chain. The grapple fires outward at a certain rate, and as soon as it contacts a surface, it either attaches or retracts. So as you are flying through the air or if you are sitting on the ground and you fire the grappling hook out, it can connect at a shorter or longer length, depending on how far away the object is that you've connected to. If it's far away you get the full swing, and it will be a large sweeping arc. When it's a shorter chain, you get

a much smaller arc. It still plays back the exact same frames of animation but it reduces the horizontal distance between the frames proportional to the length of the cable. The result is that a short swing back and forth takes the same amount of time and it plays back the same frames as the maximum length swing. It simply travels less distance horizontally. You even get the same amount of vertical and horizontal movement upon release. The reason this is more expressive is because as you are swinging around, the arc that you are flowing through can be less or more, greater or smaller depending on the length of the grapple. You have a lot of choice about when you fire the grappling hook, and you can really use that ability to choose the length of the swing as you move from one connection to the next.

Collision

The collision model in Bionic Commando is fundamentally the same as the collision model in Mario. The implementation is more or less identical, but the feel is totally different. While Mario feels like a block of ice gliding along smooth wood flooring, the character-to-ground interaction in Bionic Commando feels sticky and somewhat unnatural. The collision code still checks to see where the character is going to be in the next frame and places him on top of tiles he's not supposed to be able to go through, but because the basic horizontal movement is not loose at all, the sensation is difficult to reconcile with an everyday experience. Instead of a block of ice sliding loosely across a smooth surface, it's like trying to slide a box of Arm and Hammer across a patch of carpet. But even less physical-feeling than that: there's no sense of friction, no matter how small. Nothing in our experience of everyday life behaves the way Ladd does when he runs horizontally across his environment.

The main difference between the collision of Mario and that of Bionic Commando is that there are tiles which Ladd can pass through under certain circumstances. This happens because there are two types of tiles that can be collided with: connectable and impassable. A tile can be "flagged" as one, the other or both simultaneously.

A connectible tile is one the grappling hook can attach to. You can't walk through it—it's considered solid when you're running on the ground—but any pixel on a connectible tile is a valid connection point for the grapple claw. In this sense, all tiles are considered solid when you're on the ground. In the air, on the other hand, all bets are off. If you are running around left and right on the ground and you bonk into a barrel or a wall, the collision code will stop you. If you connect to that same connectable-flagged tile, start swinging and then release such that your trajectory takes you up into the tile, you can swing partially through it. If the platform's thick, you can swing, release to boost up into it, and then connect again to a higher point even as the character is overlapping it, inside it. Once you reach a certain height within the object, if you detach from your swing again, the collision will think your feet are colliding with the platform you're currently in and you'll snap to the nearest valid ground tile above it, landing on it as though you'd fallen from above. You can use this to climb through platforms.

Impassable tiles can't be connected to or penetrated under any circumstances. Even the swinging trick will not allow Ladd to pass. This makes for cave and tunnel ceilings that feel extraordinarily thick and solid. Assuming that the tiles are flagged as both connectable and impassible, of course. If tiles are flagged just as impassable, the grappling hook will ricochet off of them without connecting. If you flag a tile as both connectible and impassable, the result will be that the character can connect to it, can swing off of it, but if he tries to swing up into it, his head will just bang against it and he'll fall off.

Another factor, which is an aspect of the collision system, is that because the collisions are turned off while you're swinging, if you are swinging in a horizontal arc and your arc takes you to the point where you would be inside an impassably flagged tile, the character will bounce off and go into a special state where you cannot fire the grappling hook at all. You can't control him again until he touches solid ground.

Camera

In Bionic Commando, as in Mario, the camera is indirectly controlled. The camera follows the position of the character avatar, which is controlled by the player. The levels scroll much farther vertically and horizontally than in Mario, however, so there's a high-level sense of freedom, of unbounded motion. This is crucial to the feel of Bionic Commando. Without this freedom, the swinging mechanic becomes cramped and claustrophobic; the context is wrong for the tuning of the avatar. This was a problem for the feel of the 2004 swinging/grappling game Wik and the Fable of Souls by Reflexive Entertainment. The treatment, metaphor, highly polished animations and visuals and mouse-driven control are all much more expressive and beautiful than those of Bionic Commando. But the screen in Wik and the Fable of Souls does not scroll, constraining all motion to a single unmoving frame.

A swinging mechanic of this type needs room to breathe, room to roam. This is a context concern, as it's all about how the spatial layout affects the feel of the mechanic, but I mention it here because the camera in Bionic Commando moves freely most of the time so the contrast is difficult to imagine. The camera will pan happily up, down, left and right unless it reaches what is defined as a screen edge zone, at which point it will stop scrolling and the character can run all the way to the edge of the screen and push against it as though it were a solid bank of tiles, which it effectively is.

The only special behavior of the camera, apart from stopping at the various screen edges (vertical or horizontal), is a dead zone at the center of the screen. When Ladd is within this zone, the camera does not track his motion at all. As soon as he crosses the threshold and moves out of the zone, the camera begins tracking on his position again. In the running state, this dead zone of non-movement for the camera extends to take up about a third of the screen, centered horizontally (Figure 14.7).

FIGURE **14.7 There is a "dead zone" for camera movement in the center of the screen. When the avatar is inside it, the camera does not move.**

If you stand in the dead center of the screen, you can run about one-sixth of the total screen distance to the left or right before the camera starts panning with Ladd and tracking on him. So from the center of the screen, there's a rather large area where the camera simply won't track on the character at all, but as soon as he crosses that threshold, the camera will track on him at exactly his movement speed, keeping him in exactly the same relative position on the screen.

This horizontal dead zone affects the horizontal motion of the camera only. There is a separate dead zone affecting the vertical motion of the camera. The vertical dead zone does not affect the horizontal-only motion of running left and right. Instead it comes into play when the character is falling or swinging (the only times when the character can move vertically, either up or down). When the character swings upward, he can fly upward a ways before the camera starts tracking on him, and the same when he falls. If you walk off a platform, or if you are dropping from a swinging state, it will take a little while for the camera to track on the character as he falls first through the dead zone, which doesn't move the camera, and then when he hits the edge of the dead zone, at which point the camera will start tracking on him at the speed he's moving. Compared to the horizontal dead zone, however, the vertical one is narrow (Figure 14.8).

The last small detail that affects camera behavior is the changing size of the dead zones. As soon as you connect the grappling hook to a point and start swinging, the horizontal dead zone gets a lot larger, so you can swing almost all the way out to the edge of the screen. It's a much larger dead zone than simply the one-third of the screen. The resulting feel of these dead zones and their changes relative to states

FIGURE **14.8 The dead zone for vertical movement is much narrower in the vertical (Y) dimension.**

is twofold. First, because the dead zone when swinging is much larger, the camera often goes from moving to stopped at the moment the grapple attaches. This serves to improve the feeling that the grapple is anchoring the character to a particular spot. Second, the potential for nausea with such a lively character is surprisingly high. If the camera were to track on the character at all times—during the pendulum swinging motion, especially—the game would be nearly unplayable.

Playable Example

To experience this, try changing the horizontal and vertical dead zones in example CH14-1 to zero.

Context

The high-level layout of levels in Bionic Commando conveys a sense of openness and freedom. The camera is fixed from a side perspective, meaning the player can't see what's past the edge of the screen, but because the motion of the camera is free-scrolling, the feel is open, unbounded. The camera keeps scrolling and scrolling, up and down, left and right, as Ladd moves, giving the impression that the world goes on forever. Or for some distance, at least.

This gives a sense of exploration and discovery, of freedom. Knytt, a side-scrolling game by indie auteur Nifflas, takes this type of freedom to its beautiful

extreme by creating a world that seems to go on forever, screen after screen, world after world. However, this is different from the sense conveyed by games such as Shadow of the Colossus or Oblivion, which enable you to stare at a point in the distance and then ride off to find that point. The view in Bionic Commando is narrow, focused. The impression of a large, sprawling area is there, but you must view it with blinders, one screen at a time.

As noted earlier, this sense is bounded by the edge of the screen, but only in certain places. Within the game itself, it's possible to get a sense of how a constrained, claustrophobic arrangement of space affects the overall feel—in each Neutral Zone, there is a single-screen room. Try swinging freely around this room. It just isn't happening. Even when you get connected to a surface, anywhere you swing will take you right into a wall. Now imagine if every level were constrained to one screen like this. Yowch. Thankfully, most of the levels are laid out in a long, stretched horizontal pattern without much to constrain the character's motion or to limit his or her space. The overall feel is one of openness and freedom. The levels that embrace this type of layout, like the first level, are the best feeling levels. Those that stray, hemming the player in and taking away the freedom to improvise and swing around, take away much of what makes the game feel good.

At the level of immediate object avoidance and path plotting, Bionic Commando generally feels more like a sparsely attended mall than a crowded sidewalk. There are the occasional things to be avoided, but there's no real need for constant worry about what's moving toward you and how to avoid it. Because the swinging mechanic in itself requires so much focus, adding other objects to avoid and deal with is not strictly necessary. Accordingly, though they often appear cluttered with obstacles, most of the levels are deceptively open due to the fact that, when swinging, the character can move through many vertical platforms. Unless something is flagged as impassable, it's more of a resource to be utilized than an obstacle to be avoided. This means that the only things that really provide mid-level spatial context, changing the feel at the level of immediate spatial avoidance and path-plotting, are impassable tiles, enemies and enemy projectiles.

As the levels progress, the trend is toward providing fewer and fewer connect points and toward enemies that dominate larger and larger areas of space. For example, one later level features a purely upward climb, ascending a tall tower. The higher you get, the fewer places to connect are provided. Fewer connection points mean a greater chance that you'll fall and have to start climbing all over again. At the same time, there are flying enemies whose attack is a lightning beam of sorts that swipes across the top of the screen, taking away most available possible connection points in the places the player most wants to go. This may be a bit of a mistake on the part of the designers; the best levels are those which provide a lot of texture, a lot of places to connect the grapple. On the earlier levels, especially the very first level, there are a huge number of possible connection points relative to where you're trying to get. What this does is give you a huge amount of expressivity and improvisation. Functionally, if you have an entire area where all the platforms are flagged just as "connect" and not as "impassable," you can go and swing anywhere and it feels

great, it's awesome. It's by far the best-feeling part of the entire game when you can approach an enemy who's shooting at you from behind a barrel in any number of different ways. You could do it 100 times and each time it would be something slightly different.

In the later levels, you end up in situations where you have to do a whole series of swings connecting to nothing but loud speakers or lights or whatever those tall things are at the top of poles, meaning that your potential connection area is very small relative to the total area of the screen. These things detract from the pure, improvisational feel on display in the earlier levels. You have to think about what you're doing so you time things correctly, but they dominate such a huge area of the screen that you lose that expressive feel. As soon as you start taking away connection points and screen space, you lose the ability to improvise and do all these other interesting, expressive things.

The impression of speed in the game comes from the motion of the static background objects, which have a great deal of texture and variety. Things in the environment move quickly, relative to the character, creating the illusion of motion. There's not much to tell besides that, apart from the difference between the horizontal and vertical motions. When swinging, grapple after grapple, at the longest length of the grapple, the player moves much more quickly horizontally than vertically. You can pull quickly upward with a purely vertical grapple, but in general, the perception is that the horizontal speed of the character is much faster than the vertical. Except for falling, of course, which seems quicker than any motion in the game.

We discussed the lowest level of context, the physical collisions and interactions between objects, earlier. Again, on the ground it's like a box of Arm and Hammer on rough carpet or something. In the air, the character only collides with impassible tiles, so the impression is one of being above or apart from the world, soaring past it. When you do collide with an impassable tile in the air, it's like having your wings torn off. I always feel a bit like Icarus as I come crashing down. Mythological, this is, not Kid.

Polish

In terms of polish effects, the real selling point for the impression of physicality of Bionic Commando lies in the character's animations and the sound effects triggered by the grapple claw. The animations of the character include subtle clues like standing on tiptoe and reacting in an appropriate and satisfying way when the grappling hook gets fired upward. These animations alone sell the sense that this character is solid and real, made of flesh and metal. You can really feel him shift his weight on his feet, even though all that's happening visually is a three-pixel change. The subtle weight shift enables us to see the results of launching the grapple and it seems a hefty, solid, metal object.

Another great animation is in the firing of the grapple. As the grapple is launched, the character counterbalances by raising his back foot up as he fires.

241

As soon as the grappling hook gets attached to something, he immediately plants his foot down and seems to shift his weight back again. It's a very subtle visual cue, but it's masterfully executed and it conveys perfectly the sense of physicality of the character. (I had always assumed—based on the animations, really—that the reason Ladd couldn't jump was because of the weight of his giant metal arm. Ten frames of animation, and I'm inferring that his body has so much metal in it that he can't jump. Talk about bang for buck!)

Another animation that goes a long way toward selling this world and the objects in it as real and physical is the pendulum animation. Ladd swings back and forth, easing out at each apex before doing a snappy about-face and swinging back the other direction. Tremendous. It's just a series of positions defining space, but also the shape of the character as he moves through there really conveys the sense of swing and motion, and it's all being done through this series of frames. Kudos go to the animator for getting the most out of very few pixels, conveying the sense that the character is swinging back and forth, slowing down at the apex of the arc, reversing direction, and swinging back.

Another great animation effect is the satisfying bounce of the green and white collectibles that are spawned when you destroy certain enemies. They bounce satisfyingly with a parabolic arc that's similar to the bouncing-ball animation that we looked at earlier. They slow at the top of the arc and gradually bounce to the floor as they lose momentum. The fact that you can grab these out of the air with the grappling hook feels wonderful even though it is essentially just a proximity check that snaps the object to the grappling hook. The impression that you get is this wonderfully tactile sense that you've reached out and grabbed this thing and you're pulling it back to yourself, making the little grappling hook a surrogate for your own hand. It feels like reaching out to grab a bouncy ball you've dropped onto concrete.

Sound effects also sell the physical nature of this world. There are no visual effects to speak of—most likely because of a processing power deficit—so it's up to the animations and sounds to convey everything.

The most important sounds are those caused by the grapple itself. The sequence starts with the grapple extend sound which, like the jump noise in Mario, is a rising tone. It matches the animation of the grapple cable extending outward in the same way that the rising slide whistle tone in Super Mario Brothers matches his upward movement as he jumps. If the grapple does not connect to anything, there are no further sounds. If it does connect to something, the result is an extremely satisfying "ka-chink!" As simple as it is, it still manages to convey a sort of reverberation, a series of two quick sounds. Most players interpret it as an impact followed by the claw closing and digging into the surface. It's awesomely effective for what it is. It makes the claw feel like metal and the surfaces feel like crumbly stone. Finally, if the grapple hits a surface it cannot connect to, the result is a dull, rubbery thud. These three sounds will be heard hundreds of times over the course of the game. Every time the character moves, the noises indicating that the grapple is extending and connecting or rebounding play. In the case of Bionic Commando, these sounds sell a heavy, metallic set of interactions very effectively. There isn't a whole

242

wonderful palate of sound effects to work with on the Nintendo soundboard, but they really nailed it with these three sounds.

Overall, the few polish elements in Bionic Commando convey what they have to: a sense that the character has some weight and heft, that he's made of flesh and steel, and that his bionic claw interacts with the environment at a powerful tactile level. Things that seem to me conspicuously absent are a reasonable grunting noise for when the character is hit (he squeaks like a kitten), a noise for destroying large objects such as walls and cranes (there is no sound whatsoever) as well as footsteps for the character and enemies.

Metaphor

Conceptually, the character in the game appears to be a little army man. He happens to have a metallic, bionic arm, though, so one assumes that the character is not intended to be realistic. Later in the game, this impression is reinforced by the fact that you encounter crane-riding midget soldiers, bizarre insects and animals, and flying jetpack soldiers with what appear to be Ghostbusters-style proton backpacks. Everything's a bit absurd.

Harmonizing with what's conveyed conceptually, the treatment matches this surreal-but-real metaphor with a colorful, blocky, iconic aesthetic. The characters and enemies are distorted icons of themselves with no particular attempt toward realism. Most things are identifiable—a moth monster, a soldier dressed in red, a soldier throwing grenades—but they're far toward the "meaning" side of the scale. That said, the representation is less surreal than that of Mario, and so there are a few more expectations set up for the player about the way that they're going to behave.

In terms of expectations, one expects that a cartoony army guy will run around with some weight and presence, but that his physics may be commensurately cartooned. In other words, because the treatment is so colorful, there's not much set up about expectations beyond the basics of moving and running around, and the effects of gravity and so on. It's a little bit inexplicable that he wouldn't be able to make a little tiny hop over a small barrel, but the way they're selling it, it almost looks as though he's huge and heavy and is not only imbued with a large, heavy grappling hook arm thing but also might have a body made of metal or some part of him is bionic and made out of metal. Perhaps he needs to use the grappling hook to move himself around because he's so heavy and ponderous. The air seems to be his natural environment. This is the element of metaphor which makes Bionic Commando so satisfying—Ladd swings through the air like a monkey, Tarzan or Spiderman, tapping into a common childhood fantasy about cheating gravity.

Rules

Bionic Commando, like Mario, features a hierarchy of power, based on the relative health of the various enemies. Like Goombas, the army guys that run left and right

or parachute in are very weak. You blast through them in one shot of any weapon. The enemies who crouch behind barrels take three hits to kill with your most basic weapon, so they seem immediately more powerful through the low-level rule of having more health. And so it goes, up to the larger bosses who take many shots to kill with the most basic weapon. As you move through the game, you find that there are these different classes of guys. You've got your guys who take one hit to kill (the most basic and simple guys), and then you have stuff that takes a couple of hits to kill and it makes sort of a different noise when it gets hit before you are able to destroy it, so those guys seem a lot more powerful. Through the low-level rule of health, you have a lot of interesting indications about the sort of mass and solidity and physical nature of the objects that you're shooting at and eventually destroying. Certain enemies appear throughout the game, and each enemy type will always take the same number of shots to destroy, so they provide a benchmark for how powerful your weapon is. If your weapon is more powerful, they take fewer hits to kill.

At this same low level of interaction, the player has health. This is an arbitrary rule that lends a sense of toughness—or fragility—to the player. It's very interesting that at the start of the game, the character can be killed in one hit. He is "green" both literally and figuratively. As you destroy enemies, they drop small packets. Collecting enough of these will add a health box, a small green icon, at the top left. From the point at which you're awarded your first health box, when you're hit by an enemy or enemy bullet, you lose a health box rather than an all important continue (or life, if you like), which will be lost if damage is received and there are no remaining health boxes. You can have as many as 10 of these health boxes, so they can be a powerful bulwark against damage. Interestingly, the amount of damage an enemy inflicts on the character with a particular interaction gives a sense of the power of that interaction. Running into an enemy or being hit by an enemy bullet subtracts only one health box, where hitting spikes will cost you three. It's odd, but bullets hurt as much as running into an enemy's foot. Pits make you lose a lot of health. They are a lot more dangerous than being shot by or colliding with an enemy.

This health system extends upward to a higher-level rule about continues. If you run out of lives, it's game over. This makes you think very carefully about your immediate environment when your health has dropped to zero, because lives are the rarest commodity in the game. You can find them, but they're quite rare. They're important because if you lose all of your lives, you lose and have to start over. There's no such thing as a save game in Bionic Commando. To defeat the game, you must play through the whole thing, beginning to end, in one session. So when you start to get low on health, it really heightens your senses and makes you think a little more closely about what you're doing.

Hooked into the health of enemies are the rules related to weapons and their relative strengths. Certain weapons of yours do more damage and so seem more powerful. For example, the rocket launcher destroys things that the normal rifle takes two or three hits to destroy. In the contrast between the two results, the rocket launcher is given a sense of being more powerful.

The final thing to look at with respect to rules is the feel of shooting. The B-button is mapped to a basic shooting mechanic, which creates a new object each time the button is pressed. The new object is a bullet, which launches in the direction the character is facing and fires off in the direction of that velocity at a constant, predetermined speed. The "rule" that changes the feel is the same one in Megaman: only an arbitrary, finite number of shots can be on the screen at a given time. For example, if you fire two shots and they have to travel the full width of the screen before disappearing, you're not going to be able to fire another shot until the first of those shots has traveled off the screen, which can take a substantial amount of time. Whereas if you are standing one or two tiles away from the thing that you're shooting at, both of those shots will be destroyed and cleared from the imposed constraint on the total number of shots very quickly, and you'll be able to shoot again immediately. The practical upshot of this is that when you're much closer to the object that you're shooting at, you can fire much more rapidly. The interesting feel here is that the farther away your target is, the more precise you have to be with the shots, while when you get really close, you can just really mash on the shot button and get a quick reaction, about as quickly as you can press the button.

Summary

Bionic Commando broke new ground and showed that a "platformer" game didn't have to be a Mario clone to have great game feel. It achieved this with a character, Ladd, who couldn't jump, and who seemed bulky and clumsy on the ground, but who could move effortlessly through the air by swinging on his bionic grappling claw. In swinging, Ladd comes to life. The control feels expressive, improvisational and liberating, a continuous process of cheating gravity, saving yourself from falling at the last possible moment over and over again. Like an albatross, on the ground he was clumsy and outside of his "natural" environment—but in the air, he was an absolute joy to experience.

The designer of Bionic Commando, Tokuro Fujiwara, achieved an optimal mix of game feel elements. In particular, the expressive feel of Bionic Commando comes from the diagonal firing of the grappling hook and the vertical movement of the character. The perception of a fluid, arcing motion is very powerful. Fujiwara achieved a wonderful sense of freedom in swinging and releasing as you fly around. And the fact that you can connect to almost anything gives the game a sense of masterful improvisation, of being able to use the environment as you see fit.

Bionic Commando proved that it was possible to have flowing, organic sensations of control using the low-sensitive inputs of the NES controller and without directly cloning Mario. That the feel is so good is a remarkable testament to the fact that game feel ultimately lives in the mind of the player. The playback of a series of 10 animated frames combined with the ability to attach to any point on the screen gave the game its great feel.

CHAPTER FIFTEEN

Super Mario 64

My first act as a newly licensed driver was to drive around town tracking down a Nintendo 64. The North American release of the Nintendo 64 system happened just after my sixteenth birthday, and the only thing I wanted more than a driver's license was a copy of Super Mario 64. In my mind, the car was simply a way to quickly get from store to store, an expedient for tracking down the elusive console. I told my girlfriend at the time that, so sorry, we'll have to do the movie thing another time. I have a date with an Italian plumber.

When I sat down with the game, I was transported back in time. I was sitting cross-legged and red-faced at my friend's house down the block, playing Super Mario Brothers for the first time. Even as I struggled to come to terms with the skills needed to traverse this new and vibrant world, I felt that it was OK to suck because it was fun just to noodle around and bump into things. It was difficult and disorienting, as Super Mario Brothers had been when I was 9, but it was beyond doubt that the time spent learning would pay huge dividends. The world was physical, tactile and self-consistent. Learning to control Mario felt like learning to drive, something I'd just experienced. It was overwhelming and complex but also engendered with new, liberating possibility. Any amount of frustration seemed worth the effort. I couldn't stop playing. Around every corner there were new kinds of tactile interactions and each one seemed to jibe with the others, building and reinforcing my impression that this world has its own physics. Here was a reality, whole and consistent, but with different laws governing it. Through the highly sensitive Mario tool, it was possible to interact with this world tactilely and physically, the way I interacted with my world. But it was so much more interesting because in this world I could jump and side somersault, spin and kick. I could *fly*. Every bit of skill I gained made the world seem that much larger, that much more robust.

Even today, the game still has the ability to capture me. I check the timing of a jump or look at how the character speeds up over time and find myself, five minutes later, trying to get just one more star so I can unlock the flying cap.

Picking apart the mechanics makes the cohesive nature of Mario 64's world seem all the more remarkable. The physics are an illusion. Bizarre, improbable relationships are set up between variables, forces and the behaviors of objects. Gravity doubles when the character reaches the apex of his jump, for example, and if you duck

while running above a certain speed, the character begins to slide. Yet these relationships are what define the feel of Mario 64; a litany of odd, seemingly arbitrary, interdependent relationships that improbably improve the feel of control and interaction. Giles Goddard wrote, "Mario's movement is based on good physics, but you have bits on top that you plug in so you can do things you shouldn't be able to do."[1]

What's Important?

What's going on here? Why does Mario 64 feel the way it does? What are the clues, effects and relationships that define the feel of Mario 64?

The most important relationship is between the camera and the character. In Mario 64, the basic movement is camera-relative. The forces added by thumbstick input to drive the running and steering movements are applied with respect to the position and orientation of the camera. Unlike Tomb Raider, Resident Evil and other early forays into 3D freedom of movement, Mario's movement always depends on the position and orientation of the camera. You can see this in action by simply holding down the N64 controller. When Mario reaches a point just under the camera, he begins freaking out, running in an endless circle. This is because downward movement always moves Mario toward the camera. When he reaches a point directly beneath it, he ends up running in circles.

Another relationship is between the displacement of the analog stick and the speed of Mario's movement. Mario 64 was the first game to nail rate-based 3D control with an analog stick. Displacing the thumbstick farther from center changes the speed at which Mario moves. It's not acceleration, but a mapping directly to the rate at which he'll move. Interestingly, because it will always take a certain amount of time to displace the thumbstick from center, there is a slight speeding up effect as the thumbstick goes from center to a direction.

Animation is another huge part of the feel of Mario 64. When Mario runs, his feet never slip. The animation seems to match perfectly to the speed at which he's moving, grounding him, making him and every piece of ground beneath him seem more real, more vivid. In changing direction, Mario arcs slightly. When the thumbstick rapidly changes position, the character will not follow it one to one but will rather arc around to follow at a slight distance. As this happens, the Mario character leans slightly into the turn, as if shifting his weight to compensate. If the thumbstick goes from one direction to the direction roughly opposite it—left to right, for example—the character appears to plant his foot, slide slightly and reverse direction. The simulation is just doing its thing, unchanged, but this foot-plant animation sells the impression that Mario is a physical being, albeit a cartoony one, walking across a real environment. These animations are applied across every possible interaction, enhancing the feel of control and interaction between Mario and his environment.

[1]http://www.miyamotoshrine.com/kong/features/mario64/

Another important relationship to the feel of Mario 64 is the one between the movement of the avatar and the spacing of objects in the world. The spacing of objects relative to jump distances and heights in Mario 64 is immaculately tuned. It's clear that a set of guidelines for the basic spatial relationships between objects was set down and rigorously followed throughout the game. Objects are spaced and sized to match perfectly the height and distance of Mario's jump. This is especially apparent using the wall kick mechanic, which requires the player to jump back and forth between two walls repeatedly. These relationships are perfectly tuned throughout the game.

The levels in Mario 64 also tend to avoid places that will cause camera trouble by creating large, self-contained worlds that primarily feature tall, round structures. The camera can always look inward and is generally free of obstructions. This has the added benefits of focusing players on the important objects and areas, showing them their objectives ahead of time, and of providing a powerful sense of high-level space by enabling players to climb to the top of massive structures and look down, as if from the top of a mountain or tall building. The layouts of the levels play into the strengths of the mechanics, camera and free-roaming 3D perspective in the best possible way. When the environments become tight, closed-in caves, the camera is often switched to a fixed position "security cam" to compensate. These levels, while nice for contrast, often seem weak by comparison.

Also related to the spacing of objects and how it feels to move between them, the design of challenges in the game emphasizes the best parts of the feel. I notice that there aren't many goals that require precise stomping of things, especially moving things. Stomping a Goomba was a casualty of the transition to 3D for this reason; relative to how the character moves, it's very difficult to precisely place a butt-stomp. Stuff like pounding the pole to release the Chain Whomp on Bomb-Omb Battlefield feels awkward and isn't used much as a result. This effect is mitigated to some degree by placing a shadow beneath Mario wherever he goes, but it's rare that the player is challenged to land on anything smaller than about five Marios in width. If it's smaller than that, it's just too difficult to ever be enjoyable.

The feel of Mario 64 is a conceptual, if not literal, translation of Super Mario Brothers into a new, 3D context. It still offers a relatively simple interface to a highly complex system of physical, tactile interactions. The input space is much more complex than the one that controlled the earlier 2D Mario games, but it accesses a set of loose-feeling, physically satisfying maneuvers of great depth and complexity.

Once again we'll examine the input device, the N64 controller, and the individual inputs on that device, as well as the types of signals those inputs send to the game. From there, we'll look at what each modulates in the game and how this happens over time and space. Next, we'll examine the relationships and interdependencies between those modulations and examine the simulation that gives rise to them in detail. The relationships between this simulated motion and the spatial context that gives it meaning are next, followed by a look at how polish effects sell the feel of physical, tactile interaction. We'll also look at Mario 64 as a metaphorical representation and what expectations it sets up for the player about the interactions between Mario and his environment. To close, we'll look at the ways in which rules profoundly

affect the player's perception of the value and physical properties of the various objects and enemies in the world, and how this changes feel by emphasizing certain interactions and mechanics.

Input

The input for Super Mario 64 is the Nintendo 64 controller, which has 10 standard buttons, one directional pad and one thumbstick (Figure 15.1).

Despite its odd shape, the controller fits comfortably in the hands and feels good to hold. The plastic is smooth, and the standard buttons have a nice, spongy quality. They are functional, if not as crisp and lively as those used in modern controllers. The shoulder buttons and Z-button on the bottom of the controller are slightly poppier than those on the front of the controller, reaching their depressed state more quickly. The analog thumbstick, the first of its kind to be included in a mass produced highly successful controller, feels a little crusty by today's standards, almost like there's fine sandpaper in the base of it. It's also longer and includes a much more powerful

FIGURE **15.1 The various inputs on the N64 controller.**

spring than modern controllers' thumbsticks. Compared to the thumbsticks in my Xbox 360 and Playstation 2 controllers, the spring seems to take roughly twice as much force to displace. Movements feel much more emphatic and the pushback of the stick against my thumb is much more noticeable. As a result, players receive more proprioceptive feedback (see Chapter 1) and can more accurately gauge movements between full on and full off. This is used to great effect in Mario 64, especially in the sections where Mario needs to tiptoe past sleeping enemies. It doesn't feel as smooth as a modern thumbstick and it's weirdly loose in its socket when at rest, but there is a stronger sense of its position in space. Finally, the housing of the thumbstick is not smooth. Instead, it has eight points or grooves, as seen in Figure 15.2.

This is something Nintendo has done consistently with each of their thumbsticks, right up to the modern Wii nunchuck controller. This causes the thumbstick to come to rest in one of these eight cardinal directions when it's pulled or pushed against the housing. There is some benefit in guiding the player to one of eight directions, but the cost is in feel. It feels weirdly jarring to roll the thumbstick in circles, and some sensitivity is lost in the space between the grooves. The clicking noise the thumbstick makes as the thumbstick is rolled across the grooves is pleasurable, but I prefer the tactile feel of a smooth circular housing.

Applying our taxonomy for input devices, we see that there are 14 discrete buttons:

- A
- B
- C-buttons
 1. up, down, left, right
- Directional Pad
 1. up, left, down, right
- Z
- Shoulder L
- Shoulder R
- Start

FIGURE **15.2 The grooved thumbstick housing on the N64 controller provides a different sensation than a smooth housing (such as on a Playstation 2 controller).**

$$-1 \vdash \quad \dashv 1 \quad = \quad (-0.51, 0.78)$$

FIGURE **15.3 The signals sent by the N64 thumbstick.**

The one continuous input is the thumbstick. The motion of the thumbstick is linear rather than rotational, and it moves along the X- and Z-axes. The X- and Z-motion of the thumbstick is integrated; it moves in both axes at the same time. Being spring-loaded, the device measures force rather than position, and it is an indirect control input. You don't touch where you want to indicate, like a touchscreen.

In terms of signals, the buttons send the usual binary signals of "up," "pressed," "down" or "released." The thumbstick sends a continuous stream of input based on its displacement from center in the form of two axis values, one for X and one for Z. These values will be a float between -1 and 1 (Figure 15.3).

Response

Super Mario 64 has two avatars, Mario and Lakitu (the cameraman). Both can be directly controlled, though Lakitu defaults to being indirectly controlled when his movement is not being overridden by player input.

The Mario avatar maps input signals to modulation in many of the same ways as its predecessors did, using basic button presses, multi-button chorded inputs, time-sensitive inputs and state-sensitive inputs to add forces to a simple simulation. It doesn't have any mapping of button presses to modulation of simulation parameters, though. You can't hold down B to run faster than you did in Super Mario Brothers. Basic jumping is almost identical, however, with an upward force being added over time to a maximum depending on how long the button is held. Like the original Super Mario Brothers, being in the air is a separate state in which the steering force is present but reduced. In Mario 64, this jump also "locks" Mario into facing a particular direction once he's left the ground, and the steering changes slightly. Rather than arcing and turning when left and right are pressed, the steering forces are applied laterally (Figure 15.4).

FIGURE **15.4 The in-air steering force of Mario 64 becomes side to side rather than rotational (as it is on the ground).**

Recipe and Simulation

In addition to the basic jump, there are various jumps of different trajectories triggered by different button combinations, by pressing buttons in sequence over time, or under particular circumstances such as being in contact with a wall (for a Wall Kick) or moving at a certain speed and having just landed (for a Triple Jump). In each case, the jumps can be steered in the air at the same reduced rate in directions relative to the way the player was facing when the initial jump happened. Let's look under the hood, at the simulation driving these motions and at the ways in which input signals modulate the parameters of this simulation.

The simulation of driving the controllable motion in Mario 64 is constructed using a top-down approach. Each parameter that's modulated by input is simulated very simply, with clearly defined, hard-coded relationships. Apart from the collision, there's no general-purpose, applicable-everywhere code. It's all about specific esoteric relationships between inputs, motion and time. Because these relationships are defined specifically and only in as much as they need to be, it's possible to talk about motions and the simulation that drive them as one.

To build the feel of Mario 64, the first ingredients are a capsule and a flat plane (Figure 15.5).

Playable Example

To follow along, open example CH15-1.

FIGURE **15.5 The starting point for Mario 64—a capsule and a plane.**

The basis of the simulation is gravity and collision. The capsule should be pulled down each frame and, upon coming into contact with the ground, sit on top of it. Once in contact with the ground, the capsule behaves as though it has a great deal of friction. Standing still, it will not slip or slide around, and it will remain rooted to the spot. In motion, the result is the same, except when the incline of the ground underneath the capsule is greater than about 45 degrees. Running uphill when the incline is greater than a 45-degree angle relative to the horizontal will slow the capsule down, applying a force against the forward running force corresponding to the angle of the incline. As long as the resulting velocity keeps going forward, the capsule can still run up the hill, albeit slowly. At about a 60-degree angle, for example, the capsule still makes it up the hill. At some point—around 75 degrees of incline—the forward force will be insufficient to overcome the incline-added opposite force. When this happens, the capsule enters a new state, the slide. In the slide state, there is much less friction, and the capsule slides down the hill at a rate and direction corresponding to the angle of the incline. The steeper the incline, the faster the slide, and if the incline leans to one direction or another, the capsule will slide that way. It is possible to steer slightly left or right while in this sliding mode, a reduced-force version of the normal steering, which we will address presently. This sliding state will also be triggered if Mario steps onto a steep incline from the top and is moving in a downhill direction.

The result of all this is that there is a constantly reinforced impression of texture. The interactions between capsule and ground are subtle, and they sell the impression that there is a slip threshold for the bottom of Mario's shoes, where he will lose his footing, break loose and slide and that despite his highly cartoony motions, there is a nuanced reality to the way his feet interact with the ground. He can slide

down a hill he was able to climb up, just as may happen if you scale the steep side of a gravel-covered mountain while hiking. In addition, the relative incline of terrain becomes very important in terms of spatial context, creating a soft boundary for the edges of levels, and giving a more satisfying aspect to the climbing of high mountaintops and structures. You can't just run up a steep incline, so being at the top of a treacherous mountain feels more like an accomplishment. There are also whole sections of the game devoted to the sliding and steering mechanics, such as the penguin race segments on the Cool, Cool Mountain level.

The sides of the capsule slide across objects with almost no friction whatsoever. As with most racing games and other games we've discussed, collisions with the side of the capsule are waterslide-like. Instead of being hung up or caught, the capsule flows over objects with grace and ease. As in other games, this has nothing to do with accurately modeling our physical reality and everything to do with how annoying it would be to constantly get hung up on every object you came into contact with.

The final result of the basic collision interactions is an object with a constantly changing feel of momentum and friction. The incline and sliding stuff is a delightfully cheap trick in this respect, reinforcing the tactile, physical relationship between Mario and the ground every time there is a variation in the incline of the terrain beneath him. This lends a subtlety and nuance to these interactions, and the level design exploits this feel masterfully by providing much variation in types and layouts of terrain.

As the capsule moves across the landscape, it is mostly unimpeded by objects it runs into. Unless it's a head-on collision, the lack of side friction will enable it to slide past. This enables players to very often be "close enough," without having to be exact in their steering. The impression is simply that the character goes where you want. The reality, as far as the simulation is concerned, is a lot of weird collisions with objects that are resolved by simply redirecting the player to flow along the edge of the object that was collided with. Again, the level design does a great job of playing into this by providing more flowing, angular, waterside-like passages than blocky, hard edged things that might stop the capsule in its tracks.

As a final note on collision, it's worth saying that there are many different ways to achieve this same result, none of which will be addressed here. There are many excellent books that address the technical details of implementing a collision system, such as *Real Time Collision Detection* by Christer Ericson (Morgan Kaufmann, ISBN 1558607323).

Running Speed and Direction

The thumbstick creates a velocity, relative to the camera, from a combination of the X- and Y-axis data. This gives Mario a direction in which to run. Once he has this direction, he will run in this direction at a rate of speed corresponding to how a thumbstick is displaced (Figure 15.6).

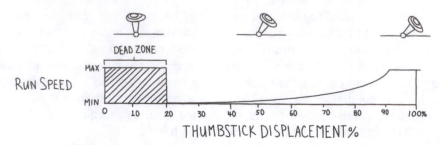

FIGURE **15.6 Spatial displacement of the thumbstick versus forward speed of Mario.**

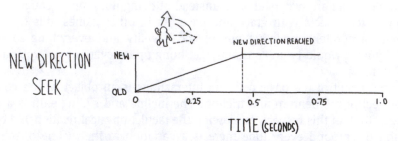

FIGURE **15.7 The result of blending between current and desired direction each frame; Mario takes a short time to reach his new direction, causing a carving motion.**

When the direction he's headed in changes and he has a forward speed of zero, he simply snaps to that new direction with zero frames in between. If his speed is greater than zero, though, it will take him a short time to go from his current direction to a new direction (Figure 15.7). This is not a time-based relationship; the desired direction gets blended with the current direction every frame until they're identical. This is what gives Mario a slightly smooth, carving motion when he changes direction. Without this, Mario's movement feels stiff and robotic.

If a rapid change in his direction is greater than a certain angle, however, he will enter a different state, stop for a few frames, plant his foot, then take off in the new direction, as shown in Figure 15.8.

If you press the A-button during this time, the result is a special jump, the side somersault, which always produces the same upward force (it is not time sensitive). Figure 15.9 shows the arc of this side somersault.

Units of Measurement

As we've said, there's no standard unit for measurement in a video game. For vertical measurements of height, I'm using Mario as a ruler. He's a good point of reference because he's always on screen, and his height is consistent to the distance we're trying to measure regardless of camera position. We could also measure jump heights in castle bricks, trees, standard blocks or anything else, but using Mario makes the most sense.

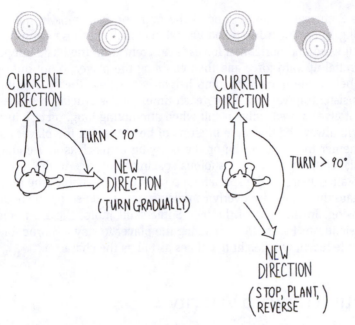

FIGURE **15.8** **If the direction change in a single frame is greater than about 90 degrees, the result is a foot plant, slide and direction reversal. Otherwise, Mario turns gradually.**

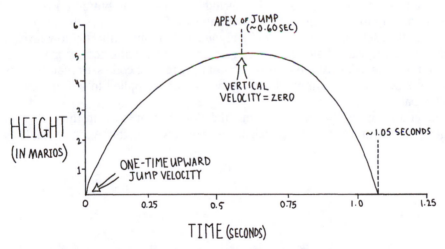

FIGURE **15.9** **The Side Somersault jump. Note that force is only applied once (it doesn't matter if the button is held down) and that velocity is set to zero at the jump's apex.**

The Side Somersault jump is one of the four special jumps in the game, along with the Long Jump Triple Jump and Back Somersault. In these jumps, the modulation of the upward and horizontal forces is different from the basic jump. Instead of adding an initial upward force and then enabling the player to opt out by releasing the button before the maximum jump height is reached, the special jumps give a specific, consistent upward trajectory each time. This is crucial to the feel of Mario 64 because it gives a predictable result when attempting long, precise jumps. A special jump will always be the same in terms of height, so all the player has to worry about is whether the platform he or she is trying to reach is low enough or close enough. This, coupled with the fastidious spacing of objects in the level (to be just the right distance apart for the special jump trajectories), enables the player to accurately navigate this otherwise overly complex space, made so by the addition of the third dimension. In the case of the Side Somersault jump, the arc is much higher than the basic jump (Figure 15.9) enabling the player to stay airborne for more than a second while reaching a height five times as tall as the character.

Modulating Upward Velocity

The basic jump in Mario 64, triggered by the A-button, functions almost exactly the way it did in earlier incarnations of Mario, adjusting the velocity based on how long the button is held. The binary signal from the A-button modulates upward velocity, causing the avatar to accelerate upward, countering the constant pull of gravity.

The attack part of the envelope is affected by holding the button down for more or less time, up to a maximum. The initial upward force is always the same; releasing the button sets the upward velocity immediately to an artificially low level. This continues the upward trajectory (which continues to be affected by gravity) for a certain time, the delay. At the apex of the jump, when the code sees that the upward Y-speed is zero or less, a much higher gravity force is applied to pull the character quickly back down to the ground.

The end result of all these subtle modifications is that, as with the earlier Mario games, Mario's jump is variable in height based on how long the "A-button held down"

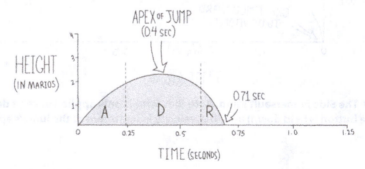

FIGURE **15.10 Mario's basic jump.**

input signal is received. In addition, the jump always has the same shallow arc for its delay, has little if any sustain, and has a much higher gravity force pulling it downward during its release. The feel is an illusion of satisfying emphasis. Hold the button down longer and you get a higher jump. Tap or feather it to get a shallower, more sensitive hop. Even though the maximum jump will terminate its upward force at a certain point no matter what (the limit point at which the max jump height is defined), when you want the maximum you will find yourself holding the button down for almost the entire duration of the jump. Also, you press the button more emphatically when you want a higher jump. In terms of what happens in the game, how hard you press the button makes no difference, but because of the setup of upward thrust with a small window for opt out, you feel as though you're emphasizing the desire for a higher jump and that the game is responding appropriately.

When the character hits the ground after a jump, there is a short window in which pressing the button again will cause another, different jump. In the game's manual, this is called the continuous jump. This jump is accompanied by a different, more vertically stretched character animation but functions identically to the normal jump, with the exception of the initial upward velocity. The initial jump force is much higher, causing the character to move more quickly upward and to have a higher potential height. This jump is still time sensitive, enabling the user to opt out by releasing the button, and also requiring that the button be held to achieve the maximum height (Figure 15.11).

The Continuous Jump has the same modified gravity applied to it at its apex and opt out points, but because the initial force is higher, it takes longer to complete and affords both higher and longer jump trajectories.

The Continuous Jump can be triggered regardless of how fast the character is moving in a direction. From the Continuous Jump, it's possible to do the Triple Jump. To do the Triple Jump, the character must be moving greater than about half speed, just at the transition point where the walking and running animations switch.

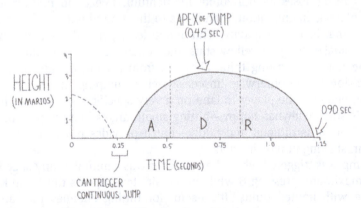

FIGURE **15.11 The ADSR envelope of the Continuous Jump.**

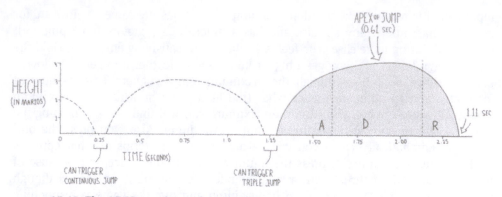

FIGURE **15.12 The ADSR envelope of the Triple Jump.**

The principle is the same as with the Continuous Jump—press the button in a short window after landing—but it requires that the character be moving more than a certain speed. Slower than that and the third jump in the sequence will be another basic jump.

Unlike the Continuous Jump, the Triple Jump (Figure 15.12) is not time sensitive, eschewing the opt-out control for a predictable trajectory, like the Long Jump or Side Somersault. It is the second highest jump after the Back Somersault and the second farthest horizontally after the Long Jump.

Once in the air state, the modulations mapped to each buttons' signal change. Pressing B and Z take on different meanings. In each case, the response is another "move" consisting of a specific animation and a predetermined motion. The benefits of these special moves are very similar to those conveyed by the special jumps; because their result is a very predictable movement in space, they prune complexity and enable the player to get a more predictable result for their input.

When in the air state, the Z-button on input triggers the "ground pound" move, where the capsule loses all horizontal momentum, freezes in mid-air for a short time while playing an animation, then drops to the ground with greater gravity than even the normal increased gravity. This move feels particularly emphatic, including a screen shake, spray of yellow stars and concussion wave of dust particles on impact. The really interesting thing about it, from a control standpoint, is that it brings precision to the otherwise imprecise act of jumping. It halts all horizontal momentum, enabling the player to land on a very specific spot beneath him or her. The result is still somewhat sloppy—hitting small targets like the post that releases the Chain Whomp is difficult and fiddly—but it provides much more precision in landing than steering in the air offers.

If the jump was triggered while the character was running at any speed less than his or her maximum, pressing B while in the air state triggers the Jump Kick move. It's a move with limited utility. It's useful for hitting enemies that are elevated slightly off the ground, such as the "Boo" enemies in the Big Boo's Haunt level, and

not much else. It's remarkable for its animation effect—Mario's foot gets disproportionately large to emphasize the impact of the kick.

If the jump was triggered while the character was running at maximum speed, the resulting move is a Dive Attack. The Dive Attack has a long horizontal trajectory, similar to the Long Jump, but it is instead triggered in the air. It also counts as an attack, meaning that hitting an enemy in the resulting slide state will damage them instead of you. At the end of it, after landing on the ground, Mario enters the same slide state as is caused by the basic slide attack. The Dive Attack can be triggered from any jump except the Triple Jump and Long Jump, presumably to prevent the player from getting too far in one jump and circumventing too much of the challenge. From the simulation's point of view, the Dive Attack halts all vertical Y-axis motion the moment the input is received, setting it immediately to zero. A horizontal force is then added in the direction the character is facing. Once the character comes back into contact with the ground, the state is set to slide instead of the default running state. This gives the controls an "aftertouch." Using the Dive Attack can get you that last little bit of horizontal momentum you need, or it can convert to attack mode on the fly if you're about to land dangerously close to an enemy. Because it goes back to the slide state, it feels a bit like a crash landing. It can take quite a while for the stand back up animation to play and return control to the player, furthering the impression that this is a bit of haphazard maneuver. It is possible to jump back out of this slide with a small hop, however, which can be triggered from this attack slide state by input from either the A- or B-button. This little hop seems a compromise, meant to mitigate the problem of seeming unresponsiveness caused by locking the player out of control for so long after the slide state.

There is one other type of jump possible in Mario, the Wall Kick. The Wall Kick is by far the most complex move to pull off in Super Mario 64, requiring the following conditions be met:

- Character moving at a certain speed horizontally

- Character in the Air State

- Character in contact with a wall within the last 20 ms

- Thumbstick quickly pulled in the direction from the momentum that carried it into the wall (similar to the trigger for the Side Somersault)

- A-button pressed

This requires that the player run the character quickly toward a wall, jump into that wall with sufficient force and within about a fifth of a second, press the opposite direction on the thumbstick and tap the A-button quickly. Talk about your hand-cramping maneuvers! The mapping, however, is very natural. The player pulls the thumbstick immediately away from the wall in the direction he or she wants to go and press A to jump, the same function that is always mapped to the A-button. The window for completion is fairly wide, enabling the player a degree of leeway. For example, if the player hits the wall with great force, pressing the thumbstick in

a direction roughly away from the wall and pressing A somewhere close to that motion will still cause the Wall Kick to occur. Even if the star particles and fall animation for a strong collision have started, the Wall Kick will take priority.

Switches to Ducking or Sliding States

When the signal for "Z-button held" is received, it always corresponds to a state change. The switch happens as soon as the input for "button on" is received, though the animation of the character going from standing to ducking takes about a tenth of a second to complete.

If the capsule has zero velocity, the character enters the normal ducking state. From here, the thumbstick motion enables crawling. Crawling functions similar to running, with extremely slow forward motion, more looseness between desired and actual direction, and no concept of foot plant or direction change. The feel is very plodding but it is precise, providing a great amount of spatial accuracy. This is emphasized by the level construction in areas with long, thin planks across large precipitous drops. The crawl enables slow but steady progress that is all but guaranteed to take the player safely across. To me, this always represented a risk/reward tradeoff. Impatient, I always opt for the risk of running full speed across the planks rather than having to crawl laboriously.

Also noteworthy is the progression of behaviors when the player presses the jump button while in the crawling state. First, the character transitions directly from crawling to jumping. After landing, the character goes back into the running state and will continue running around as normal—Z-button still held—until the thumbstick input stops entirely, at which point the standing to ducking animation will play again, and the character will return to the ducking state. This is a nod to the fact that crawling is rarely used. The designer assumes that if the player jumps, he or she would always rather go back to running first. Crawling takes a back seat to all other motions, so doing so must be very deliberate on the part of the player.

Pressing the B-button in the normal ducking state triggers the Trip Attack, a rarely used stationary attack that will destroy some enemies within a very short radius. It's almost never used.

Finally, pressing the A-button in the normal ducking state triggers the Back Somersault special jump. The Back Somersault is the highest jump in Mario's acrobatic repertoire, enabling him to accomplish very high jumps with very little horizontal motion. It's useful when you want to move mostly vertically, onto a small shelf, outcropping or platform high above. The drawback of this jump is that its horizontal movement is backward relative to the direction Mario is facing. The player cannot use this jump to leap up and grab onto a ledge; to do this, the character must face toward the ledge.

If the Z-button is pressed while the character is moving, the slide state is entered. We discussed the slide state earlier with respect to collision; now let's examine

FIGURE **15.13 Running to duck-sliding.**

the steering possible in the slide state, the various forms it can take and the feel of each.

There are three way to enter the slide state: by intentionally pressing duck while moving at speed, by running up a hill that is too steep and sliding back down, and by running forward onto a steep incline.

When the slide state is entered into intentionally, the result is the character animating into a crouching position, like Figure 15.13.

This happens when the character's speed is greater than zero when the Z-button input is received. In the slide state, there is a high friction value applied to each frame, which will quickly slow the character to stop on flat ground. At very low speeds, the character will enter the slide state very briefly before quickly slowing to a halt and transitioning back into the crawling state. Running at full speed, the slide will last just longer than one second.

From this sliding state, the A-button input triggers the Long Jump, a jump which emphasizes horizontal speed rather than vertical height. It's the opposite from the Back Somersault in that it's all about traversing long distances horizontally, making huge flying leaps from platform to platform. Like the Back Somersault, the Long Jump is not time sensitive. It's still steerable in the air, but initial jump force added is unaffected by how long the button is held. One height, one distance, and again, much of the level geometry plays into this predictability, giving the player a better chance of accurately judging and correctly completing particular jumps. The main difference between this jump and the other jumps is that it receives not only a vertical but a horizontal force at the time it's triggered.

Pressing B from the sliding state triggers the Slide Tackle maneuver, which is rarely used. It adds a certain amount of horizontal force and sees the character bounce up and down twice before coming to rest. It is an attack move, though, so any enemies hit while the character is in this state will be damaged. This is the same attack slide state caused by the Dive Attack, so it's also possible to cancel out of this slide with a small hop that can be triggered by either A- or B-button presses.

Triggering Attack Moves

Pressing the B-button triggers a simple punch attack. Accompanying this is a very small amount of forward movement, mostly for emphasis. Like the Jump Kick, Mario's fist expands at the completion of his punch to emphasize the power of the move. Also like the kick, this move looks a bit odd under close examination; it seems as though Mario's gaining volume in his fist rather than squashing and stretching properly.

Though it has limited utility in fighting enemies or getting around, this move is used more frequently than things like the Trip and Jump Kick because it is often required in boss fights. Pressing B when near something will make the character grab it or pick it up. While holding something, Mario moves much more slowly and has a weighed-down animation, giving the thing he's holding a terrific sense of weight and presence.

Pressing the B-button three times in rapid succession causes first an additional punch and then a Jump Kick. Again, these are rarely used and so do not contribute significantly to the game's feel.

If the B-button is pressed when the character is moving at full speed in a particular direction, a Slide Attack is the result. The Slide Attack is the most basic form of the slide attack state that happens after a Dive Attack. The character gets a small amount of additional horizontal force but enters the slide state, quickly being slowed down by friction. This is an attack, so it will damage enemies that are hit while in this state. It is possible to cancel out of this state with the small hop, as with the Dive Attack and Slide Tackle.

The big picture is very much a top-down simulation in which each parameter is simulated only with the detail it needs to be. A bunch of special cases strung together with specially defined relationships. You can almost feel the designers plugging holes, saying things like "hmmm, well, it feels too cheap to climb up hills without resistance, so let's make him slide back down. Oh, this sliding is kind of cool, what happens if we enable the player to steer it? Ah, okay, just grab the steering from the running state and plug it in with reduced values. Cool, okay, that feels good …"

Many times, it seems like the designers were simply asking "what if" questions and then answering them with mechanics. What if Mario could grab Bowser by the tail and swing him? What if you could ride a turtle shell around like a skateboard? I've glossed over many of these supporting mechanics, including flying, swimming and walking underwater with the Metal Cap. This is because I have limited space; I wanted to cover the basics. However, the impact of these supporting mechanics should not be underestimated. They add a great deal of texture and variety to the feel of Mario 64, which would lose much if they were removed. Especially important is the crossover sensations caused by the contrast between mechanics. Swimming seems floaty because it's different from running. One of the most important parts of the feel of Mario 64, however, is the fact that each mechanic seems to maintain the same laws of physics. The controls for flying may have nothing to do with running

around on the ground or swimming, but they feel as though they do. Flying feels as though it's defying the same gravity that pulls you downward when completing a Long Jump. This is perhaps one of the most overlooked aspects of game feel: the crossover sensation. If there are multiple separate mechanics in play, do they seem beholden to the same laws of physics. Do they seem to be part of the same world?

To summarize, the thumbstick provides the bulk of the moment to moment input, mapping as it does physical displacement to both direction and rate of the character. This relationship is camera-relative and therefore is an intuitive, natural mapping, though it also includes a slight looseness that gives Mario a certain amount of carving motion. Also, the relationship between terrain incline, friction and thumbstick-driven motion creates a great sense of interaction between character and ground, and is constantly updating the impression in the player's mind via changes in incline and terrain. The rest of the inputs serve to put Mario in different states, such as ducking or jumping, but the relationships of importance are between how fast he moves forward, how much thrust gets applied in his Y-direction, and the resulting trajectories, which are precise but highly malleable, enabling in-air steering. The end result provides a huge number of moves which feed in predictable ways into a simple physics system. Each of these moves can be steered by thumbstick input after having been triggered, and many moves can be chained and combined, giving the user a great expressivity both in the choice of moves and in the way those moves play out. Combined with the layout of levels, this enables just the right amount of freedom for the player.

Lakitu the Cameraman

The second avatar is "Lakitu," also known as the camera. The camera is indirectly controlled most of the time. Even when directly controlled, the camera has two crucial relationships: between Mario's position and its own and between Mario's orientation and its own (Figure 15.14).

There is a circular area of influence between Mario and camera. From the camera's position, a circular zone spreads outward for a certain distance. When Mario reaches the outside of this radius, the default behavior of the camera avatar is to follow Mario's position at a slight remove.

If he's running straight away from the camera, the camera will follow at the same speed, maintaining the distance relationship.

If he runs directly at the camera by holding down on the thumbstick, the camera will pull backward, away from the onrushing Mario (Figure 15.15). This pull back is limited to a very slow rate, however, and if the character is running at full speed toward the camera, he'll quickly close the distance. When this happens, when the Mario avatar gets within a certain, short radius of the camera, the camera will freeze in place, tracking on the avatar from a stationary position. Because all character motion is camera-relative, however, once he gets beneath the camera, he runs in an odd looping pattern around the camera as though it were an invisible maypole.

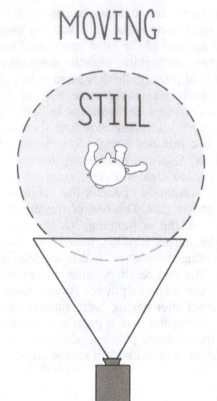

FIGURE **15.14 There are two camera zones in Mario 64, stationary and following.**

If the movement of the Mario avatar is purely side to side, neither running toward nor away from the camera but parallel to it, the motion of the camera is rotational only. Again like a security camera, it will rotate to look at the Mario avatar, but never change its position in space. This rotation starts by tracking on Mario's exact position, but gradually interpolates into tracking a position ahead of him, shifting him to the right or left of the frame and showing more of what's coming up in front of him as he runs.

These two effects, positional changes based on character-camera distance and rotational changes based on left-to-right movement, blend together. The result is that running at a diagonal will slowly turn the camera in the direction that Mario is running and it will do a reasonably good job of showing objects in that direction. In addition, if the player presses the left or right C-button, the camera will be pushed about 20 degrees in the direction indicated. It will slowly drift back to its original orientation, but it momentarily provides additional angles of view.

When Mario jumps, the camera attempts to stay still as long as possible. Mario 64 lead designer Yoshiaki Koizumi addressed this problem in his talk at the Montreal

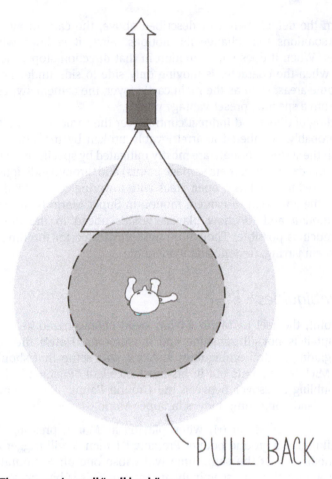

PULL BACK

FIGURE **15.15 The camera's small "pull back" zone.**

International Games Summit in 2008, as reported in Gamasutra: "In Mario games, players press a button to jump and camera follows. Koizumi noted that this camera pitch can make some people ill. There are various theories, he explained, about why this occurs—for example, a disconnect between the sense of motion and the lack of motion sensed by the inner ear. In the case of Mario, Koizumi continued, rapid and repeated screen scrolling was most likely to cause this discomfort, so he thought of ways to minimize this. Nintendo's solution was to implement a 'vertical shake cushion'—when Mario's in the center of the screen, the camera won't pan, but if he's about to go off, it will."[2]

When at rest, the camera, using the Mario avatar as its pivot point, slowly orients itself to face the direction the avatar is currently facing.

[2]http://www.gamasutra.com/php-bin/news_index.php?story=16386

Apart from the default behavior described above, the camera avatar has many special case solutions that change its motions. First, it collides with walls and other surfaces. When it does so, its motion in that direction stops, the same essential effect as when the character is moving only side to side under normal circumstances. In some areas, such as the main castle foyer, the camera switches to a fixed perspective from a specific, preset vantage point.

This blending of direct and indirect control over the camera is admittedly clumsy and would probably be labeled as irretrievably broken by modern standards. The problems with the system, though, are mostly mitigated by specific case hole-plugging (as with predefined security camera vantage points) and through judicious level design, which emphasized mostly large, open areas with towering central landmarks.

In general, the approach of camera motion in Super Mario 64 attempts to avoid superfluous motion and to show players what's ahead in the direction they're traveling as much as possible. Though quite sophisticated for the time, experienced today it can seem jarring, frenetic and inadequate.

Control Ambiguities

Up to this point, the feel of Mario 64 has been characterized as unambiguously wonderful. But it is not all sunshine and mushrooms. Here's the rub: there are some rather glaring control ambiguities in Mario 64's setup that should have been resolved. As Mick West points out in his most excellent "Pushing Buttons" article,[3] there is a troubling crossover between the Ground Pound, Back Somersault (here called backflip) and Long Jump moves in Super Mario 64:

> In Nintendo's Super Mario 64, when playing as Mario, pressing A to jump then R1 will trigger a ground pound. Pressing R1 then A will trigger a backflip. Pressing them both at the same time will cause one of: a ground pound, a backflip or a normal jump, seemingly at random. This is bad because the user has no control; they are doing the same thing over and over, yet getting different results.
>
> This problem also shows up in Mario when you try to do a long jump, which is done by running, then jumping by pressing A+R1. Sometimes while attempting this you will do a Ground Pound by accident. This is not the fault of the player. To the player it appeared they did everything right, but the results were not what they expected.

Context

As has been alluded to, the spacing of the objects in the levels of Super Mario 64 has a hugely positive effect on the overall feel of the game. Relative to the avatar's

[3]http://cowboyprogramming.com/2007/01/02/pushhing-buttons/

movement, levels were constructed with three specific spatial relationships in mind: vertical height, horizontal distance and the size of platforms.

It's fine and well to say that the spatial context of Mario 64 matches perfectly with the tuning of its mechanic, but what does this actually mean? From the standpoint of the pragmatic level designer, what did this mean in terms of actually placing polygons? And how was the mechanic tuned, relative to the movement of the character? What was the mechanic designer's role in this process? First, I believe that in the case of Mario 64, as in most high profile Nintendo games, these two were one and the same. At least, initially. Anecdotally, the prototype form of Mario 64 was a "gameplay garden," a test level which included a near-final version of Mario, complete with animations and moves, and a wealth of different things for him to interact with. As the jump heights and trajectories were tuned, so were the distances between objects. The Wall Kick and walls spaced the right amount apart were created simultaneously. This meant that as the mechanics were evolving, so too were the general rules about how far apart objects should be spaced, how big or small they should be, and what kinds of environments would be built around them and out of them. Simply put, the size, nature and spacing of objects were part of the same system as the height of Mario's jumps and the speed of his running and turning. These guidelines seem to consist of four primary spatial relationships: vertical height, horizontal distance, the X/Z dimensions of each walkable platform and the angle of incline of each piece of terrain.

By vertical height I mean the distance between a given current position of the character and some other, higher position. The vertical height of objects relative to one another comes in three distinct and premeditated flavors. First there are objects which can be scaled by a basic jump. Many blocks are spaced at just the right height for the basic jump. They're lower than the apex of the jump to enable a wide range of jumps to land on them, as were the blocks in Super Mario Brothers. Other jumps are clearly just right for the Back Somersault, Side Somersault or Triple Jump. For example, at the beginning of Whomp's Fortress, there's a wall that is the perfect height for a Side Somersault. On the Shifting Sand Land level, there's a platform with a Flying Cap block on top of it that is perfectly spaced for the Triple Jump. Throughout the levels in Mario 64, these relationships are maintained. As you play, you quickly become accustomed to not only the predictable height of the various jumps at your disposal, but the fact that the environment seems tailor-made for the heights of these jumps. It becomes easy to walk around a level to see which ledges are basic jump height, which are Triple Jump or Back Somersault height, and which are too high to reach by jumping. I also note that there are many unforced opportunities to use higher jumps. Especially in the earlier levels such as Whomp's Fortress; Cool, Cool Mountain; and Bomb-Omb Battlefield, there always seems to be a way to circumvent the normal path—which emphasizes jumps at the basic height—by using a Side Somersault or Back Somersault to get higher earlier.

When I say horizontal distance, I mean the distance from one point to another along the same plane. Rather than trying to ascend to a higher platform, the horizontal distance of a jump dictates how wide a chasm Mario can cross. Can I make

269

it across this gorge or patch of lava in one Long Jump or Triple Jump? Or do I need to use a basic jump and pull back slightly on the stick because I need to land on the small portion of a moving platform that isn't currently covered with scalding lava? As with the relationships between vertical objects, there are various specific relationships between the position of horizontal objects in space that are maintained throughout the levels in Mario 64. Some platforms are clearly spaced to be just the right distance relative to the basic jump, where others can only be accomplished with the Long Jump. In each case, it becomes easier and easier for players to eye-ball these relationships as they play through the game. If a jump looks to be just the right distance to clear with a Long Jump, it almost always is. And, as was the case with earlier Mario games, increasing challenge usually means longer, more precise horizontal jumps.

Of course, each jump represents a trajectory, including both horizontal and vertical movement. To land on a platform, whether it's a tiny shelf of rock far above and behind the character or whether it's a wide platform over a gorge directly ahead, requires movement in both the vertical and horizontal. What Mario 64 does wonderfully is to present the player with consistent vertical and horizontal relationships throughout the game, regardless of what else is going on in the level. As a result, the complex, imprecise motions of Mario through 3D space become manageable, predictable skills that can be learned and mastered. This feels great; the player almost always gets the result he or she was after. The onus, then, is on the player to plan and execute maneuvers more accurately and skillfully.

A platform's dimension refers to how much landing or maneuvering space it provides.

Relative to the speed at which the character runs when on the ground, the levels are very open, without much obstruction. The running is a very precise, responsive motion with no floatiness or looseness, so there is little emphasis in the design of most levels on running very precise patterns. Releasing the thumbstick brings the character to a halt immediately, so there's no real risk of unintentionally running into or falling off of something. The game says: wait until you're ready. It's supposed to feel easy and safe just to move around the world by running, and it does. The levels in which it is not so safe—Lethal Lava Land and the three Bowser stages—are genuinely unnerving by comparison, requiring an unaccustomed amount of focus on the character's exact position on the ground. Keeping the player scrambling forward for extended periods of time and taking away the safety net makes the game feel very different. That both feels exist in the same game speaks to the fact that the designers had a deep understanding of what they were doing in constructing each type of level. More than that, the different sensations create an excellent and rich contrast which enhances each.

As we noted when talking about collision and response, Mario 64 models friction, especially with respect to the angle of incline of the terrain beneath him. The character has a certain coefficient of friction, which can be overcome and send him slipping and sliding. In this way, incline is used throughout the levels as soft boundary and soft punishment. If you're not supposed to go somewhere, there will be a

steep incline to turn you back. It's a gentle, negative reinforcement with a clear, logical physical relationship. You can't climb up and over the wall in Bomb-Omb Battlefield because you start to slip and slide back down if you try. It feels futile, quickly getting the message across without painfully overt constraints such as an invisible wall or other contrived boundary. In this way, what's been accomplished is a victimless blame shift, a hallmark of good level design. Player don't feel the direct intervention of the designer like some deus ex machina dipping in to wag a disapproving finger and tell them where they can and can't go. The physical relationship between incline and slide is consistent throughout the game, so the limit feels like a logical consequence rather than an overt constraint.

Finally, it's worth noting the overall spatial layouts of most Mario 64 levels and the effect that has on the high-level spatial feel of traversing them. For the most part, the spatial layouts of Mario 64 levels are like zones of a theme park, with the important features poking prominently above the landscape, visible from any vantage point. The tower in Whomp's Fortress, the central spire in Bomb-Omb Battlefield, and the giant snowman central to Snowman's land are all designed to provide an instant point of reference and include many of the level's important star-giving interactions. Two benefits of this landmark-focused approach are improved camera behavior and a delightful sense of vastness and exploration. The camera motion in Mario 64 was a sore point for many players and critics, but one of the instances in which it always works well is in following the Mario avatar around a spire or pillar. Once at the top of a huge structure, the camera is free to look around and down, surveying the ant-like surroundings far below. This feels great, like hiking Superstition Mountain, El Capitan in Yosemite or the Space Needle and peering down on all the places you've just been. This doesn't affect the moment-to-moment feel of interaction, but it certainly lends a highly positive high-level sense of space to the proceedings.

Polish

The primary area of emphasis for all polish effects in Mario 64 is the interaction between Mario's body and the ground beneath him. Generally speaking, the pertinent polish effects are the animations, which are mostly in sync with the speed at which the avatar moves, jumps and otherwise interacts with the environment and which show the character leaning into turns, planting his feet and otherwise being a believable physical being. In harmony with these detailed and excellent animations, the sounds and visual effects adhere to a three-tiered structure, corresponding across senses. Impacts come in three varieties: light, medium and hard, and each type of interaction has a special animation, visual effect and sound effect. Combined with the ubiquitous footstep sounds and sliding noise, these effects serve to convince us of a Mario who exists in a believable, physical world of his own and who interacts with it in a logical, law-driven way.

Because it made the most sense for this particular game, I have pointed out many of the important polish effects as they occurred, while discussing the simulation.

Animation

To begin, uncheck the animated character in the Mario 64 example, and examine the change in feel. Without the animation, much of the sense of weight and presence is lost. The grey capsule doesn't seem to arc, turn or carve when moving, nor does it feel as satisfying to launch it into the air. In addition, moves like the Ground Pound and foot plant seem downright odd without a character animation on top of them to give them meaning.

Visual Effects

The primary visual effects are puffs of dust and sprays of yellow stars. The white dust particles happen when Mario slides or plants a foot to reverse direction, and in a concussive wave spreading out from the point of impact after a Ground Pound. In the case of the sliding over terrain, the dust kicking up sells the impression that friction has been overcome briefly and that the surface of Mario's feet is sliding loosely across gravel or dirt, kicking up dust. After the Ground Pound move, the particles spread outward quickly, further emphasizing the power of the impact.

The yellow stars happen wherever Mario collides with a solid object at a high velocity. This is the highest tier of impact, and the stars spray out with corresponding force. The effect has very little basis in reality, but because the motion of the particles is so violent, the impression is sufficiently emphatic. Regardless what the things flying out are, they move quickly so the feel is of a powerful impact.

Sound Effects

Try unchecking sound effects in the Super Mario 64 example, and observe how much of the impression of physicality is lost. I find it difficult, even with the sounds disabled, not to fill them in with my mind. The most important sound effects to the feel of Mario 64 are the three-tiered impact sounds, Mario's footsteps and the satisfying whisssshing sound of sliding.

Like the visual effects, the sounds accompanying impacts come in three varieties: low, medium and hard. The low sound is high pitched and click-like, while the medium sound has much more bass, sounding almost like a drum. The hard impact is over the top, a cartoony, rubbery twang. The relationship between these sounds, though they are not especially realistic, is one of increasing power and emphasis. This correlates well to the corresponding animations and visual effects, selling an impression of subtlety and nuance in interaction. When he punches, you hear this sort of Doppler effect, the swinging of his fists going through the air. When he does the butt stomp, when he hits the ground, it has a sort of reverberating crash noise. So in general, the sound effects of Mario are huge and they're trending a lot more realistic and this is probably a factor of the capacity of the hardware as much as it

is the artistic intent. But the sound effects are really selling this as a physical world that you can really interact with.

Mario's footsteps happen in time with the playback of his animation, emphasizing his interaction with the ground at every step. The sounds change based on the material he's currently standing on, offering additional clues as to what that material might be (it looks like metal and, thanks to clanking footsteps, sounds like it as well).

Finally, Mario's bizarre ululations, grunts and exclamations. Mario's rising pitched yells correspond to his jumps the same way that the rising slide whistle-like tone accompanied the jumping in earlier Mario games. As the pitch rises, so does Mario. The feel is subconsciously satisfying, a further harmonizing between motion and sound.

So, in lieu of a lot of detailed visual polish effects which started to happen in the later three Mario games, especially Mario Galaxy, the sound effects, combining as they do with the animations, are what's really selling the physical nature of interaction in this world.

Cinematic Effects

The only noteworthy cinematic effect used is screen shake, which is applied extensively to many objects throughout the world. It's a very gentle shake to avoid jarring the player overmuch, but it does a nice job of selling the weight of such objects as Bowser, large metal cannonballs and King Thwomp.

Metaphor

The metaphorical representation is essentially the same as in previous Mario games. We've got a sort of tubby Italian plumber running around a cartoony, oddly surreal, but richly physical world. In the case of Mario 64, everything feels a lot more realistic than it did in the original Super Mario Brothers. There are walls; there are bricks that are definable as bricks. In some areas, there really appears to be marble floors or wooden doors. Everything has been rendered at a much higher level of fidelity and in that rendering has lost some of the surrealism it had in two dimensions.

In terms of treatment, the transition to three dimensions has brought more realism. The pipes, hillsides, castles and other structures with real-world analogies are now much more representational than abstract. This is a necessary concession for moving into 3D, but it is interesting to note that in order to match this new treatment, the sounds really did need to be changed to sound more "realistic." They couldn't just be the bizarre, chirp-type noises of the original Super Mario Brothers. Mario's physical interactions need to seem a little more sensible and logical. That said, the treatment is still very bright, very smooth and very clearly more iconic than realistic. Mario's proportions are more iconic than ever, and most of the

textures on most of the objects are highly iconic. Trees are trees and water is water, but only in the most generic, notional sense.

The metaphorical representation is not setting a huge number of expectations about behavior in the mind of the player because it's obviously sort of absurdist and surreal. The juxtaposition of the plumber and all the bizarre creatures that really have no sense or meaning outside of the context of the game again works in Mario's favor, enabling his rich, detailed physical interactions to seem all the more compelling because they exceed their treatment. But that treatment is turning a lot more realistic and therefore to match with that, the game needed to have a feel of control, a simulation and corresponding effects that were much more detailed than in any previous Mario game.

Rules

The rules of Mario 64 are excellent and three stand out as affecting feel most profoundly: the relationship between coins and health; the relationship between coins, stars, star doors and boss levels; and the rule of threes as it is applied to boss damage.

Coins and slices of health correspond directly. Picking up one coin will restore one empty slice of health. This makes coins desirable as a way to prolong life and causes players to seek them out if their health is less than full. The danger of dying due to health loss is remote—coins are so ubiquitous that it's difficult to actually end up with 0/8 health slices—but the affect on feel is to emphasize coin collection whenever health is low. This puts more importance on specific navigation while running and on precision jumping to claim coins floating in the air. In addition, the fact that various objects cause Mario to lose more or less health creates a scale of danger that feels quite physical. Lava, in addition to launching Mario screaming upward while holding his backside, takes off two healths. Being hit by a Goomba takes only one. Ipso facto, the lava is more dangerous, more physically damaging. It *feels* more harmful.

One hundred coins are worth one star. One star opens the first star door, granting access to a new level. Three stars open two more levels. Eight stars enable you to attack Bowser's first stronghold and get access to an entirely new area of the castle, complete with additional star doors. This cascade effect hooks coins into the highest level of reward and achievement in the game, the unlocking of new areas of the castle. This, again, puts a premium on the low-level skills of precise steering and jumping that will enable the player to effectively sour the level, collecting every coin.

The system for enemy damage primarily sells the difference between bosses and basic enemies. Bosses take three powerful hits, whether it's Big Bomb-Omb being tossed onto his big round butt, or Bowser being hurled into explosive landmines. Small, simple enemies are destroyed in one or two hits. For this reason, regular enemies such as Goombas feel fragile and insubstantial when compared to the massive boss creatures.

Finally, the high-level rules of Mario 64. The big one is the lack of time limit. You're free, essentially, to explore. Even the ordering of the goals and levels is loosely enforced. You can choose to max out each world as you go, or to pick and choose goals as you go. Even the linear progression of goals in the levels can be circumventing in many cases. The overall sense is that around every corner, another joyful discovery awaits, if only you're skilled enough to get there.

Summary

In Super Mario 64, if you examine these relationships individually from a design perspective, they seem to make no sense. Like squash and stretch in an animation, "realism" is ignored in favor of player perception. But Mario 64 nevertheless manages to feel powerfully tactile and cohesive. How? The secret is this: everything—the effects, the relationships, the control—is tuned based on its impact on the player's perception. From tiny, subtle clues, the player infers broad generalizations about the physics of this world. When these conceptions are ultimately confirmed by additional interactions, the world begins to seem "real." The polish is exactly what it needs to be, selling a robust, nuanced sense of physical interaction with the smallest possible clues. The size, spacing and nature of objects in Mario's world are almost perfectly balanced against his motion. In fact, nearly everything about Super Mario 64 is in harmony with a single, cohesive vision of a unique physical reality. The world is fantastic, but it's self-consistent, and stands up to scrutiny, even when perceived actively.

CHAPTER SIXTEEN

Raptor Safari

More than any other type of game, players go pants-on-head crazy over the feel of driving games. This is, perhaps, unsurprising. People love cars, drive cars all day and in some cases, fetishize them in rather dubious ways. Everyone in our society has a huge amount of experiential background against which they compare the feel of driving a virtual car against. People, in short, have a lot of perceptual data about the feel of driving and riding in cars, and this heavily influences their perception of driving mechanics in games. More than any other type of game, people are critical of and sensitive to the feel of controlling something that looks like a car. For this reason, there has been a huge amount of energy spent perfecting various flavors of driving mechanics over the years. To the layperson, games like Gran Turismo, Project Gotham and Ridge Racer may not seem appreciably different. But to the enthusiast, there are subtle differences in flavor, texture and feel that make all the difference in the world. There are indeed people in this world who treat driving simulations like fine wine.

Raptor Safari, a game by Flashbang Studios (Figure 16.1), provides a window into just how difficult, intricate and time-consuming it can be to create and to give a leg up toward creating your own good-feeling driving mechanic. But it should be noted that of the popular retail games that feature a driving mechanic, Raptor Safari probably has the most in common with the tuning of cars in Grand Theft Auto 3. Many of the ideas and structures, if not the specific implementations, can be generalized and applied to all driving mechanics. Just bear in mind how deep the rabbit hole goes in terms of the feel of driving games and players' sensitivity to subtle changes in it. Whether the treatment is photorealistic or iconic, if you're going to create a game where the avatar is represented as a car, be prepared for an obscene amount of tweaking and tuning to get it to a place where it feels right to players.

Game Overview

Off-Road Velociraptor Safari is a 3D browser-based game, created in about two months by a team of six people. At the time this was written, three and a half million raptors have been slaughtered by 90,000 users who've played the game 550,000 times. Many players commented on the especially enjoyable feel of the game and

FIGURE **16.1 Off-Road Velociraptor Safari by Flashbang Studios.**

cited it as a reason for the game's addictive quality. It uses a very simple interface of six keyboard keys to control an advanced physical simulation including, among other things, separate values for shock compression, per-tire forward and side friction, motor speed, velocity, mass, drag and angular dampening. Compare this to the simplicity of simulation in a Bionic Commando or an Asteroids and you see how quickly complexity can increase with just a few additional variables. You can quickly find yourself in the realm of Excel spreadsheets, needing some visualization to track all the relationships and interdependencies.

Luckily, the design document for Raptor Safari was not complex and provided a consistent vision to guide us through development. It consisted of the following, scrawled on a whiteboard:

Physics-based Jeep + ragdoll raptors = awesome

The final game matched the design document almost exactly. Driving the Jeep around feels great; there's a powerful sense of weight and mass as the large blocky body of the Jeep compresses the shocks of each individual tire and as they squish and push back. The Jeep does not flip over too easily, but it's clear that rolling and crashing the Jeep is not only possible but encouraged via the damage and stunt systems. It has a sense of weight and presence and feels to players as though it is a large and heavy vehicle with responsive steering with which they can navigate the environment easily. Crunching tire sounds, engine revving and crashing noises of various kinds further lend credibility to the impression of physicality, especially supporting the sense of friction with pitch-modulated sounds of tires digging into dirt. Slow-motion camerawork at moments of impact or during long jumps further emphasizes the physical nature of the interactions. Crashing into trees and rocks creates loud, metallic crunching noises and can cause pieces of the jeep to smash

FIGURE **16.2 The online popularity of Raptor Safari—the inimitable Derek Yu models an oh-so-sexy Raptor Safari shirt.**

and break off or be dislodged and left hanging. Hitting something at higher velocities causes louder sounds with more crashing and breaking of glass.

At some point, the player will hit a raptor. The silly puff of feathers, the squealing noise, the satisfying thud and the fact the raptor then goes into "ragdoll" mode all give the player positive feedback. The interaction has a sort of extreme sports bloopers appeal, but with virtual ragdoll raptors instead of some poor motorcyclist flying over hay bales, or a cowboy being gored by a bull. It's a victimless pleasure. The experience of hitting a raptor feels gratifying, interesting and worthwhile in and of itself. The ragdoll raptors have "over the shoulder" appeal. People walking by someone playing the game often stop and want to know more about this irreverent game in which you run over feathery ragdoll raptors that look like parrots in an off-road Jeep. These interactions—flipping the jeep, destroying it, hitting raptors, capturing them with tow cables—are all supported by the system's rules. Our goal was to have the game recognize, and reward, every possible permutation of interaction the player could have with the world. A sampling of some of the special interactions that the system recognizes:

- Raptor on raptor: hitting one raptor with another
- Live specimen: chasing a raptor into a capture point without knocking it out
- Clothesline: hitting a raptor with the chain only

- Pickup: snagging an unconscious raptor with the tow cable

- Barrel roll: flip the Jeep along its forward-facing axis

In addition, there are high-level goals driven by an Xbox-Live-like achievement system that gives the players specific goals to chase to encourage subsequent play-throughs. For example, there are achievements for destroying the Jeep entirely, for balancing on two wheels for 10 seconds and for throwing a raptor more than 50 meters into a capture point. Between this good-feeling, low-level interaction, the joy of pummeling ragdoll raptors, and the varied and interesting high-level rules, we built something that a lot of people enjoyed.

Let's take a look under the hood—if you'll pardon the phrase—and see how the feel of Raptor Safari was created.

Input

As a casual, downloadable game, we chose to use the standard computer keyboard. Specifically, the W, A, S, D, B and space keys.

The game uses only discrete inputs; there is no mouse or thumbstick providing a continuous stream of input. Again, each of the six buttons sends a binary signal. Taken alone, this input data can be interpreted as "up" or "down." When measured over time, the signal can be interpreted as "up," "pressed," "down" and "released."

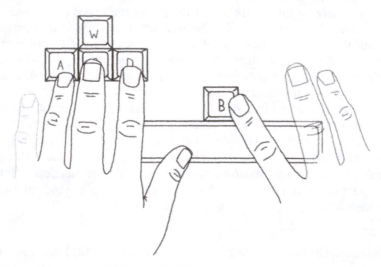

FIGURE **16.3 The input space for Raptor Safari.**

Response

The simple binary signals for each button are fed into Unity's input manager, where they are parsed and processed before being mapped to specific parameters in the game. The input manager interprets everything as an axis, even keyboard presses. In so doing, it assigns the following properties:

- Gravity: Speed in units per second; the axis falls toward neutral when no buttons are pressed.
- Sensitivity: Speed in units per second that the axis will move toward the target value.
- Snap: If enabled, the axis value will reset to zero when pressing a button of the opposite direction.

What this means is that there's already a softness applied to each input, filtering it before it is fed into the simulation. The result of this filtering is envelopes for each button that look like Figures 16.4 through 16.7.

Applying our taxonomy for response, we can see that the jeep moves linearly in the Z-direction, while rotating around the Y-axis to turn left and right. It has freedom of movement and rotation in all three axes, though, and can tumble, roll or fly in any direction, X, Y or Z (Figure 16.8).

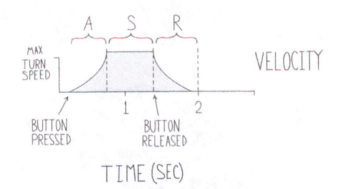

FIGURE **16.4 Left/Right Turning (Gravity = 3, Dead = 0.001, Sensitivity =2).**

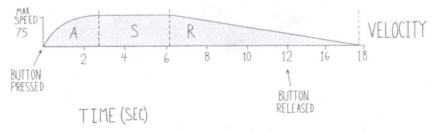

FIGURE **16.5 Forward (Gravity = 3, Dead = 0.001, Sensitivity = 3).**

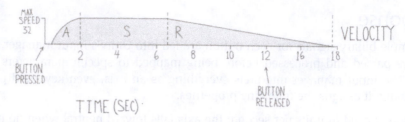

FIGURE **16.6 Backward (Gravity = 3, Dead = 0.001, Sensitivity = 3).**

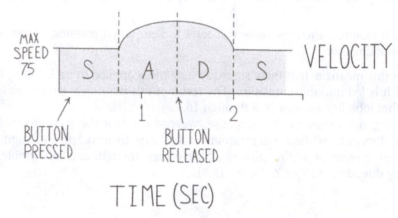

FIGURE **16.7 Backward (Gravity = 3, Dead = 0.001, Sensitivity = 3).**

FIGURE **16.8 Dimensions of movement in Raptor Safari.**

The Jeep's motion is relative to itself; forces get applied in the direction it's facing and using its own coordinate space as a reference. In addition, the rotational and linear movements are controlled by separate buttons rather than one integrated control for each.

Simulation

The body of the Jeep is a large box which has been defined as a "rigidbody," meaning that it has been registered as a physical object by the built-in Ageia PhysX™ physics engine. What this means is that its motions and interactions are already being simulated in a very detailed, robust way. For example, the engine already keeps track of the following parameters:

- Mass
- Drag
- Velocity
- Angular velocity
- Position
- Rotation

So far, so simple. The system is still comprehensible and can be kept in one's mind with relative ease. If you'll recall the simulation that drove Mario's movement, however, we've already eclipsed it in terms of the number of different things that are being tracked.

Each tire is tracked individually. Interestingly, there is no physical simulation of the tires. At least, they're not physically simulated objects the way that the body of the Jeep is. They don't have mass, nor do they collide with other objects in the world. Instead, the position of the tires and their functionality are determined by four raycasts, which start at each of the four wheel wells of the Jeep and extend downward. A raycast is basically an arrow, starting at a certain point and going for a certain distance in a particular direction. Visualize it like Figure 16.9.

The visualization of the tires (the 3D model representing each of them) has its position set at the point where the raycast intersects the ground below it. That is, the raycast will shoot down a certain amount from its starting point up in the wheel well. If the raycast doesn't hit anything, it doesn't do anything and the wheel gets set to the maximum distance beneath the Jeep, which is a predefined number. In this case, it's enough effect to make the Jeep look normal, with its tires situated properly in the wheel wells. If the raycast does hit something before reaching its defined maximum distance—the ground, say—it has a programmed response. Depending on how close the place that was hit is to the starting point of the ray up in the wheel well, a force gets applied to the body of the Jeep, pushing it. The further "compressed" the suspension is, the larger the force.

FIGURE **16.9 The four raycasts going downward out of the Jeep's wheel wells.**

The result is that forces are constantly acting on each of the four corners of the Jeep, under the wheel wells, where the tires would be, pushing upward like a set of shocks attached to tires. The only weirdness that's caused by this is the fact that when the Jeep passes over a rapid shift in terrain height, like a curb, you can actually see the tires snap up or down. If you watch closely, you can see this happen even in Grand Theft Auto 4. To combat this small but potentially annoying movement, Raptor Safari always interpolates between the current position of the tire and its next desired position, guaranteeing that the motion will be relatively smooth. There are still some cases where the tires seem to behave a bit weirdly, but overall the effect is solid.

Now, if you set up a system like this and just drop the Jeep onto some terrain, it would start rocking back and forth with increasing force, eventually with such force that it might get launched up into the air (Figure 16.10).

To combat this effect, a dampening value must be applied to each upward suspension force such that as it pushes upward from fully compressed, it quickly decreases in force. As it approaches equilibrium, in other words, it applies less and less force, like Figure 16.11.

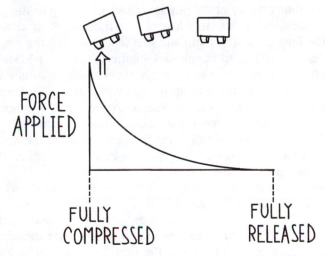

FIGURE **16.11 The force is reduced as the raycast returns to its normal length.**

So up to this point we have a big block representing a Jeep that, if dropped on to some terrain, will float above it because of the counteracting forces of four tires simulated by short raycasts. In terms of tweakable parameters we have:

- Global
 1. Gravity
- Jeep
 1. Mass
 2. Special Jeep gravity (some extra gravity applied only to the Jeep to make it seem less like a hovercraft)

- Tire
 1. Raycast max distance
 2. Raycast min distance
 3. Suspension force
 4. Suspension dampening.

Yipe! Well, you can see how these things start to get mind-bendingly complex in a big hurry. We don't even have the Jeep moving yet and we've already got a much more complicated simulation than anything we've talked about up to this point.

Now, the movement of the Jeep. The Jeep actually tracks two values for its velocity: the actual current velocity of the physics object according to the physics engine and a separate "desired" value, which could be thought of as motor speed. For example, say the Jeep goes off a jump and gets launched into the air. Say its actual horizontal velocity according to the physics engine in the air is 30 km/hr. Since it's flying through the air, it will have this same horizontal velocity until acted upon by some other force. It's still possible to hit the gas while in the air like this. The tires will spin quickly and the engine will rev. The desired speed, the motor speed, of the Jeep goes up to some amount above the actual horizontal speed. Let's say it goes as high as 50 km/hr. The Jeep is still flying through the air so the actual horizontal speed remains the same, but the desired speed is now much higher. What happens when the Jeep lands back on the ground?

When the Jeep hits the ground, you don't want to immediately set its velocity to 50. That would feel weird and artificial. You want it to have some kind of friction simulation that causes it to "catch" as it comes back in to contact with the ground. But if the engine's been revved up too much and the tires are spinning much more quickly than the actual speed of the car, the tires "slip" if they're above a certain threshold, the way that real car tires on a real road will slip and peel out if they're accelerated too quickly. So this separation between actual and desired velocity gets us two things. First, our Jeep can have a different desired heading and desired speed when it's in the air. You can go soaring through the air, gas it and turn, and have those changes manifested as soon as the Jeep comes back into contact with the ground. This is in line with players' expectations. If it doesn't happen this way, it seems weird and artificial. Second, we can simulate the type of slipping that happens when friction is overcome by a tire that's broken free.

The way this is implemented in Raptor Safari is shown in Figure 16.12. As you can see, there are indeed two separate parameters for actual velocity and desired velocity. Interestingly, the actual velocity is never reached, because of the friction forces applied to each tire in both the front and side directions. In fact, all motion of the Jeep is driven by the tires. Each tire maintains its own individual velocity and two friction values that counteract it: side friction and forward friction.

As the tires turn, the direction of their velocity may change. The friction forces apply in amounts commensurate to the direction of each tire's velocity, though always more to the side than to the front. This is what creates the carving effect

FIGURE **16.12 The force is reduced as the raycast returns to its normal length.**

FLOAT CARVE

FIGURE **16.13 The feel of a car "carving" as it turns comes from a special, high friction value applied sideways on the tires.**

when the Jeep begins to turn. Because the forward friction is much less than the side friction, instead of spinning on its axis even as it turns like the ship in Asteroids, the jeep seems to dig into the ground, creating an arcing, curving motion rather than a floaty, sliding turn (Figure 16.13).

Finally, each friction value for each tire has a particular slip threshold. This simulates the effect we mentioned earlier, where the tires will get spinning so quickly that they will break loose and slip, overcoming the friction that holds them to the ground. Figure 16.14 shows the way it works.

As with the Jeep body proper, each tire has both an actual and desired velocity. In each frame, the game examines the difference between the desired velocity and the actual velocity. If this number, the difference between motor speed and actual speed, is above a certain threshold, the friction values, both side and front, are adjusted according to the graph in Figure 16.14. It's a gradual application but it produces the intended effect. If the motor speed is much, much higher than the actual speed, the tires break loose and slide. Note that this effect also works if the car is sliding sideways with great force, as when the jeep gets launched and spun simultaneously, landing at an awkward angle. The overall effect is a sensation of friction approximating what a player expects from a real car.

The Tow Chain

Deploying the chain is actually a physical process. It probably doesn't have to be, but it worked out so well that we stuck with it. The chain goes from being non-simulated to being simulated, unfurling as the back door (also physically simulated) pops out backward. The result is a sort of jiggling in of the whole jeep rig in response to this change in mass and balance, one that looks appropriate and satisfying.

The center of gravity of the Jeep changes depending on whether the chain's out and depending on whether there's a raptor attached to it. If you think the Jeep is squirrely and difficult to control with a raptor attached now, you should see it when the center of gravity isn't shifted backward and down. Through this artificial center of gravity shift, though, we were able to get the Jeep to a reasonably controllable state with chain in or out and with or without raptors attached. The result is reasonably unwieldy without being overly so and promotes the development of high-level skills involving prediction and intuition. You can, through lots of play, get a feel for

FIGURE **16.14 The slip threshold—past a certain speed, the tires will break loose.**

how to effectively swing raptors around and get them and the Jeep to do what you want. There was one consequence, though: sometimes when the Jeep is flying and spinning through the air, its behavior is a bit odd-looking. It's clear that the center of gravity is outside the Jeep. We decided that it was worth it to have stable driving.

Finally, the chain will break under a large amount of stress. There's a fine balance between having it break too easily and not easily enough. The tests we used were accelerating from a standstill with a raptor attached and wrapping the chain around a tree. The player had to be able to accelerate from a stop with the tow cable unfurled and a heavy raptor attached without breaking the chain, but the chain should almost always break if you swing it and wrap it around a tree.

Context

At the highest level of spatial context, we created a world that was very open. There are lots of places to go, higher levels and lower levels, but in general, there's a sense that you're in a vast, open area with lots of tall mountains surrounding it, but there's also an ocean and it sort of goes on forever. And the free-roaming, exploring nature of the game with very little constraint further emphasizes this sensation.

So in general, it feels much more like a large, open valley than any sort of cloistered-in city (Figure 16.15). And there are a couple places where that impression is sort of part of the contrast, by having closed-in canyons or areas that are under outcroppings of rocks or have lots and lots of trees in them. But in general, the impression of space at the highest level is very open and wide.

And if you see a place on the map, odds are you can find a way to travel there. So it has that sort of high-level, exploratory appeal, like World of Warcraft or

FIGURE **16.15 The wide open space of Raptor Safari.**

289

FIGURE 16.16 Objects and textures in Raptor Safari create the impression of speed and provide mid-level context.

Oblivion, in microcosm. The entire gameplay field is about two kilometers square in the measurement we use in the game itself for speed.

At the medium level, we have a really nice impression of speed going on because of all the textures on the ground and because of all the small plants and trees and environmental object as the Jeep travels around. There's a nice impression that it's moving fairly quickly as it's rolling around the level and zipping between objects (Figure 16.16).

In terms of the number of objects, nature of the objects and the spacing of objects, we've provided what I feel is a nice contrast between big, wide-open areas and penned in, small areas, where you have to do a lot of obstacle avoidance.

But again, since we're not punishing players for running into stuff—in fact, we're rewarding them with points for damaging the Jeep. The sensation is positive, regardless of whether you're running into something or not. And of course, we created the raptors as a reward for crashing into things. So you chase them down and run into them.

We're giving a lot of meaning to the amount of turn that the car has relative to its forward velocity because you have to chase down with a fairly high degree of accuracy a moving target and the raptor who will always be fleeing away from you, albeit at a slower speed than you.

The game provides a variety of goals and well-spaced environment objects that emphasize precise movement andluming. In addition, the goals provide incentive to attempt huge jumps and to seek out areas that accommodate such launches. So in that sense, it's much more like an open street with sort of some very specific goals in it that we've provided in terms of running into the raptor and steering around things.

So in general, this affects the field by tuning your sensitivity to the medium level of interaction primarily. You're steering around things and you're steering toward raptors. And at the most basic level, this is primarily what we're doing—object avoidance or trying to accurately track down moving objects. So in that sense, the focus of the mechanic through the context is put on the spacing of objects and how to steer in and around the trees.

We hit a fairly good balance here. Maybe we could have removed a couple of trees to make it a bit easier just to drive across the environment, but the speed of the forward motion of the Jeep and the amount that it turns are balanced relative to the spacing of objects, which is fairly wide in general.

At the lowest level of tactile interaction, the game does not do the typical waterslide collision methodology of most racing games. Because we have a wide-open world that flows and you can drive to any area, we didn't feel it was necessary to put so much emphasis on slip sliding away from objects.

In fact, because you want to ram into raptors, we made the collisions a little bit stickier than you typically find in a racing game, meaning that when you've collided with a raptor, it really feels as though it's interacting with the hood of the car and sort of flying sideways and getting crunched around and mashed up against things.

And this extends, perhaps, a little bit negatively to your interactions with trees and other objects in the environment. It is possible to be going at the maximum speed with a boost, crash into a tree and completely lose all momentum. We tried to mitigate this with polish effects such as loud crashing sounds that get more emphatic and sound more destructive depending on the velocity of the collision. But there's only so much you can do without actually simulating deformation of the car or doing some more advanced particle effects than we did.

So in general, the simulation, the tactile level of collision—the tactile context—feels much like a real car with the caveat that it doesn't get deformed or destroyed past the superficial destruction of the doors and hood.

Polish

In terms of polish effects, most of the interactions are conveyed by the simulation itself, so there's not a huge amount being done. The primary work affecting the feel of the game is in the sound effects, where a lot of attention was paid to what the sound effects were conveying about the physical interactions of the car with its environment, especially the tires with the ground.

There are two layers of sound effects, the engine-revving noise and the crusty, dirt-crumbling noise, and their pitch is modulated based on the angle of the car turning, the amount of force that's being applied, friction-wise, to the car's tires. Further, based on the overall speed of the car, the engine noise is modulated as well.

As a result, you really get a sense that the car is speeding up and revving up, and this further enhances the impression of speed, but with respect to the pitch

modulation of the turning, it really gives the sense that you're carving into the dirt. The pitch goes up and you can almost hear the tires spinning and squealing as they crunch through the gravel dirt on the ground.

In terms of collision, we did three levels of different sounds, and we're pulling randomly from a list of different sounds in order to avoid hearing the same sound over and over again and fatiguing the player's ear. But there are three levels of sounds.

At the lowest level of collision, there's a threshold, and at the lowest level of collision threshold, it's a very low-velocity collision. It's just sort of a plastic-sounding thud, like if you bump your friend's car in bumper-to-bumper while you're waiting at a light. If you give the car a love tap, that's the kind of sound we got there.

At the medium level, there's a satisfying crash or crumpling sound with some metal and maybe a little bit of glass breaking. It's obviously a much more powerful collision than the love tap, but it's not over the top. And then we reserve for the most destructive collisions—the highest velocity of collisions—a class of sounds that includes metal rending and have a long after-effect sound of crunching glass and breaking and smashing that goes on for quite some time.

And even higher than that, we have a separate class of sounds that we trigger when only a piece of the Jeep gets broken off, and that's the most destructive and violent-sounding noise. In addition, when the Jeep hits a raptor, we're making a special organic thudding noise. It sounds a little like hitting a side of beef with a baseball bat; and that, as well, comes in different levels.

It will be louder and more emphatic if the speed of the collision is much higher. So in that respect, we're giving additional sensitivity and conveying another power sense of physicality through modulating the sound depending on the strength of collision.

In terms of visual effects, there are very few. And as the Jeep is driving around, dust particles get kicked up under the tires. If the Jeep is carving with a certain amount of force—if the amount of friction being applied to the wheels is above a certain amount, then a tire mark graphic will be placed on the environment where the tire was touching.

In addition to these effects, we are also doing some cinematic trickery. Whenever there's a stunt—that is, whenever the Jeep flies a certain height above the environment—a slow-motion cam occurs to emphasize that stunt, and the same thing happens if you run into a raptor. The game goes into slow motion and the camera zooms in on the point of interaction to further emphasize the weight and impact of the collision.

And that's pretty much it. We're doing some parametric animation stuff with a main character in terms of animation effects, such as the visualization of the tire spin according to the code, which technically could be considered an animated or polish effect. And when the Jeep turns left or right, the monocled, pith-helmeted raptor driver turns his head to the left and right, which is an animated effect driven by a parameter, but not directly affecting it. And then when you start backing up, he sort of puts one arm back and looks over his shoulder the way a normal driver would.

And really, that's all the polish effects there are in Raptor Safari. It's fairly barren in terms of extraneous polish effects applied to improve the impression of physicality and the interaction between objects. Pretty much everything is done in simulation.

So overall, the effects, or the limited number of effects—especially the sound effects—serve just to improve the impression that this is a real car. In fact, the sound effects were taken from actual car collisions. And that the raptors are big, mushy pieces of flesh made out of meat, bone and feathers, and when they come into contact with the much weightier, more massive car, they get owned, basically.

Metaphor

In terms of metaphorical representation, the metaphor is a nearly photorealistic Jeep, or at least a Jeep that is properly proportioned and is clearly attempting to be a somewhat realistic representation of a Jeep. It is not a cartooned Jeep and the treatment is not intended to be iconic, particularly (Figure 16.17).

The environment is much lower resolution and looks less like an attempt to be realistic. There's a bit of a disconnect between the Jeep and the environment, as well as a slight disconnect between the Jeep and the raptors. The raptors look very painterly and colorful, whereas the Jeep looks like it's turning a little bit toward realism, and the environment seems to be more fantastical.

But overall, the expectation is that this car will behave like a real car. We're mitigating this expectation in some degree by the silliness of what's going on and the absurdness of a monocled, pith-helmeted raptor driving a Jeep around and running over other raptors, and especially by the silly sound effects and the puffs of feathers and things that fly up.

FIGURE **16.17 The Jeep in Raptor Safari is close to photorealistic.**

FIGURE **16.18 The protagonist of Raptor Safari: a raptor with a monocle and pith helmet.**

We're setting up the expectation that, though it kind of looks like a real Jeep, don't expect it to handle the same way with the same degree of accuracy as a Gran Turismo. Don't apply the highest level of simulation standard.

So again, in terms of representation, we've got a Jeep driving around a somewhat fantastical world with some surreal elements in terms of big, feathery, parrot-looking raptors being run over by another raptor in the Jeep (Figure 16.18). The treatment on the Jeep is realistic, the treatment on the environment is more fantastical and the treatment on the raptors is more painterly and iconic. So there's a little bit of a disconnect there, but it holds water reasonably well. This silliness also makes the whole thing feel more abstract and surreal.

Rules

The high-level rules we created have a huge effect on the feel of Raptor Safari. You can do no wrong. You get points for everything. Humorously, it is literally impossible to score zero points. If you end a five minute round with zero points, you earn an "A for Effort" bonus, which gives you 50 points. That was our philosophy; to recognize and reward every possible action. As a result, every possible action feels rewarding to some degree.

So hitting a raptor, you get a bonus; trashing the Jeep—destroying part of the Jeep—you get bonus points for that. Doing stunts—launching yourself off of high objects and doing flips and barrel rolls—you get rewarded for that.

Every single possible combination of interaction, such as grabbing one raptor with the tow cable and hitting another raptor with that, we emphasized with a special bonus. And the reason we did this was to make the entire experience feels

always positively rewarding. The challenge is the timer. You have to score as many points as possible within the allotted time, and the allotted time is very low—five minutes.

So you can never fail at Raptor Safari. The lowest possible score is 50 points (the "A for Effort" bonus). But we wanted to enable players to always compare their score with their previous score and with everyone else's score in the world through the achievement system and high-score list.

Every individual action feels rewarding to some degree, but the actions that you take start to feel more and less rewarding. So for example, if you spend an entire round focusing on running over raptors and your score is 200,000, that will feel like a reasonable score because you've run over a lot of raptors and perhaps thrown them into the raptor catchers and gotten points for it, and there's a satisfaction there.

But if you do another play through the game of another five-minute round, and you do a bunch of stunts and get these crazy high-flying jumps and spins (that gives you a much higher score) then doing stunts is going to feel more rewarding than capturing raptors. So it's all about developing a scale of relative reward for the player to model internally and experiment with.

With the medium-level rules affecting feel, we're steering the player toward raptors and orbs and jumps that cause the Jeep to go flying huge distances and do spins and so on. That's essentially the behavior that we're encouraging, and because of that, the feel changes slightly.

You always steer toward raptors and, because of the way the combo system is structured, you always want to steer toward the next thing, whatever it is, as quickly as possible to keep your current combo going because getting an orb continues your raptor-hit combo, which would continue your stunt combo. All the different combo systems are linked into one.

The net result is that you feel that you're trying to chain together these different combo elements as you move throughout the level, and you're always looking for the next thing to hit and gravitating toward it, which makes you feel as though you always want the Jeep to go faster and you don't really care too much about running into things. You're always just focused on what the next thing is that you're going to try and steer toward and how you're going to get there.

And finally, at the lowest level, there isn't really a concept of health of objects in Raptor Safari past the fact that hitting the raptor once with your massive Jeep or with the tow cable will stun it or kill it, depending on your perspective, and knock it out. So the impression that's conveyed there is that the Jeep is much more massive than the raptors.

Summary

Most of the feel of Raptor Safari resides in the complex physical simulation. The high-level rules reward every behavior and guide the player toward ever higher

levels of skill in a variety of different areas. We built the game very much with a bottom-up mindset; first was the simulation of the Jeep and the ragdoll raptors. That was tuned fastidiously. Then we built out a larger world, and populated it with lots of ramps and raptors. When we were comfortable that the feel of just driving around and smacking raptors felt satisfying, we emphasized every possible physical interaction with bonuses and scoring events, including a damage system, a stunt-reward system, a raptor reward system, and rewards for collecting the random orbs scattered throughout the environment. On top of this, we layered a combo system that provided rewards not only for doing many of the same types of events in a row but rewarded across systems, giving extra bonus time to all open combs whenever a new event was completed, regardless of its type. The five-minute round timer combined with the all-skills-rewarded approach plus the high-level achievement goals created a game that feels good and keeps players coming back.

CHAPTER SEVENTEEN

Principles of Game Feel

After exploring what game feel is and how to measure it, and stepping through a number of examples using our taxonomy of game feel—input, response, context, polish, metaphor and rules—it's time to set forth some general principles for creating games with good game feel. They are:

- Predictable results—When players take action, they get the response they expect.

- Instantaneous response—The player feels the response to their input is immediate.

- Easy but deep—The game takes minutes to learn but a lifetime to master.

- Novelty—Though the result of an input is predictable, there is enough subtlety and expressiveness to keep the controls feeling fresh and interesting through hours and hours of play.

- Appealing response—The sensation of control is aesthetically appealing and compelling, separate from context.

- Organic motion—Controlling the avatar creates appealing arcs of motion.

- Harmony—Each element of a game's feel supports a single, cohesive perception of a unique physical reality for the player.

In many ways, these principles are similar to the principles of animation, which are well known and well-proven.[1] The seven principles of game feel described here may not be complete, but they are a good starting point.

[1] Once again, refer to Frank and Ollie: http://www.frankandollie.com/PhysicalAnimation.html

Predictable Results

When players take action, they should get the response they expect. This doesn't mean that the game is easy or that the controls must be simple. What it means is that there's no interference between intent and outcome for the player. The result of pressing a button or moving a Wiimote might be complex and difficult to manage, but this is different from feeling that the game is giving a different result for the same input. When the result is predictable for the player, the controls can be learned and mastered. Even if it seems exceedingly difficult, the player can engage with the challenge of the game. When the controls seem random, continuing to play seems pointless. There's no point in practicing if the game just gives a random result.

Creating predictable results seems like an easy task from a game designer's point of view. But, as Mick West has said, "On the face of it, this appears a simple problem: you just map buttons to events. However, due to the non-precise way that different players press buttons and perceive events, problems of ambiguity arise, which lead to frustration and a feeling of unresponsiveness. The player thinks he has hit the correct button at the correct time, but, as he's not a robot, the intent of his input is ambiguous and cannot be resolved satisfactorily with a simple mapping."

To paraphrase Will Wright, designing a game is half computer programming and half people programming. Creating real-time controls that always give the player the result he or she expects is difficult because expectations live in the player's mind.

The problem is the difference between the hard precision of a computer and the soft nature of human perception. To a computer everything is precise. The A-button was pressed 14 ms after the Z-button or the player pressed jump 9 ms after the character walked off the cliff. The game can't know what the player expects. So when creating a system of real-time control, we as game designers must attempt to mold player expectations indirectly through mapping, metaphorical representation and art treatment. The player's perception of what happened trumps the computer's. We have to program the player's perception via the computer.

Three pitfalls will cause players to feel that the results of their input are more random than predictable: control ambiguity, state overwhelm and staging.

Control Ambiguity

When mapping input to response, game designers sometimes create unintentional control ambiguities. In Mario 64, pressing the A- and Z-buttons at the same time will give a random result, either a ground pound or a long jump. The game will see inputs in terms of milliseconds, knowing which one came first. To the player, however, the result seems inconsistent. Mick West explains, "In [Super Mario 64] pressing [the A-button] to jump then R1 … triggers a ground pound. Pressing R1 before A triggers a backflip. Pressing them at the same time causes either a ground pound,

a backflip or a normal jump, seemingly at random—the player has no control. The player can press these two buttons simultaneously over and over, and never figure out how to control each of these three actions properly."

For a game to provide consistent, predictable results for input, these control ambiguities must be resolved. Mick has some great strategies for identifying and resolving these problems in his series of articles on responsiveness.[2]

State Overwhelm

One way game designers make low-sensitivity inputs more expressive is by changing mappings depending on what's happening in the game. For example, in Super Mario Brothers, when Mario jumps, it's easy for the player to perceive that he's in the air as opposed to the ground. Though the result of pressing left or right has changed—the response is much less—it does not seem surprising or jarring because Mario's clearly in a different state. It doesn't seem random.

If I hand my mom the Playstation 2 controller and turn her loose on Tony Hawk's Underground, however, she's totally overwhelmed. This is because in Tony Hawk there are many different states and it's not clear to inexperienced players when the state switches happen. When the player does not perceive the state change, inputs begin to feel random. The skater in Tony Hawk's Underground can be in the air state, the ground state, the manual state, the runout state, the grinding state or the lip trick state. In each of these states, each of the 12 buttons on the Playstation 2 controller does something different. On top of that, there are many "chorded" inputs; pressing two buttons at the same time gives a different result than each individually. Pressing left and the X-button at the same time is different from pressing left or X individually, for example. This means that there are literally dozens of moves mapped to each button. It's easy to understand why my mom feels overwhelmed. There are so many results for input, her input might as well be random.

If inputs seem to yield random results, the rational response is to mash buttons randomly. This is what many first-time players of fighting games do, pressing random buttons without a clear intent other than simply to do *something.* Eventually, patterns emerge and you learn what input gives what response. But when you first start playing, there are so many states, so many possible moves, that it might as well be a random result for input.

Staging

If the result of an input is difficult for the player to perceive, it becomes unpredictable and uncontrollable. When the player cannot process what the result of an input was—if it happens too fast or gets lost in other motions—the player will not

[2]http://cowboyprogramming.com/2008/05/30/measuring-responsiveness-in-video-games/

have a clear sense of what the result was and it will seem random. This is related to the Staging principle of animation, explained by John Lasseter: "An action is staged so that it is understood. To stage an idea clearly, the audience's eye must be led to exactly where it needs to be at the right moment. It is important that when staging an action, that only one idea be seen by the audience at a time."[3]

In real-time control, this means providing clear, immediate feedback. This often means exaggerating the result of an input with particle effects. The goal is to make it clear to the player what the result of an input was so it can be reproduced at-will.

As game designers, we need to remember that we have very little time to hook the players. If they don't feel successful and oriented within the first couple minutes, we've lost them. The lowest-order feedback loop, the first thing they'll encounter, is game feel, the moment-to-moment control. If it doesn't feel good at an intuitive level, giving them predictable results they can sink their teeth into, they'll stop playing.

Predictability also means inference. From the first few minutes of a game, the player can extrapolate a clear picture of the structure of the entire game. This is a good thing; it gives the player traction, mitigating the clumsy disorienting feeling of learning a new mechanic. In Super Mario Brothers, I know that if I fall into a hole, I will lose a life. It only takes one hole to figure that out; I'll avoid holes for the rest of the game. But just because something is reproducible doesn't mean it's predictable. A predictable result should reveal as much about the possibilities you haven't tried as about the ones you have.

Instantaneous Response

Games that feel good respond immediately to input. This doesn't necessarily mean a short attack phase. For example, the Warthog controls in Halo are loose and flowing, but still feel responsive. When the player moves the reticule, the Warthog immediately starts seeking on the new direction indicated (Figure 17.1).

The farther the new direction is from the current direction the Warthog is facing, the faster it will move to try to get there. As a result, the largest, most obvious response happens moments after the change in input. The response feels instantaneous, even if the release phase is long and drawn out (Figure 17.2).

This closely relates to the Slow-In, Slow-Out principle of animation: "As action starts, we have more drawings near the starting pose, one or two in the middle, and more drawings near the next pose. Fewer drawings make the action faster and more drawings make the action slower. Slow-ins and slow-outs soften the action, making it more life-like. For a gag action, we may omit some slow-out or slow-ins for shock appeal or the surprise element. This will give more snap to the scene."[4]

[3]http://www.anticipation.info/texte/lasseter/principles2-4.html
[4]http://www.frankandollie.com/PhysicalAnimation.html

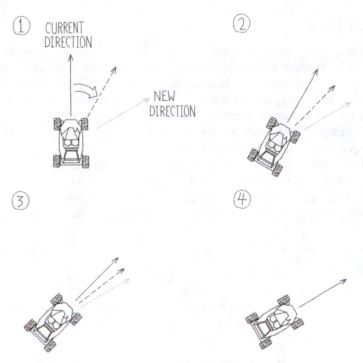

FIGURE **17.1 The loose but responsive feel of the Warthog in Halo.**

FIGURE **17.2 The ADSR envelope of Warthog turning in Halo.**

The difference is that in a video game, response time is important. If easing in takes too long, the player will perceive the game as sluggish and unresponsive. What feels bad is when there is a delay longer than about 100 ms between when the player tries to do something and when he or she perceives the result of that action. To maintain the impression of responsiveness, the result of input must be perceived by the player as immediate. The attack phase can take 10 seconds but will still feel responsive as long as there is some obvious result within 70 to 100 ms of the input.

301

Easy but Deep

There's an old game design maxim: good games take minutes to learn but a life-time to master. Another way to say this is "low skill floor, high skill ceiling." The basic skills are easy to learn, but there are always new levels of mastery to aspire to. There's always something new to learn. Good-feeling games often have this property.

The most elegant way to make a game easy to learn is to exploit natural map-pings. For example, the motion of the ship in Geometry Wars closely matches the physical movement of the thumbstick input that drives it (Figure 17.3).

The relationship between the input and the thing being controlled in the game is obvious and intuitive. Similarly, exploiting standard mappings of input to response leverages assumable common knowledge to avoid making the player learn something new. A steering wheel turning a car; a mouse moving a cursor;

FIGURE **17.3 The movement of the avatar in Geometry Wars: Retro Evolved is a natural mapping.**

and the W, A, S, D keys moving an avatar are examples of established cultural standards for control.

Other ways to make a game easy to learn are tutorials and "helpers"—auto aim, dynamic difficulty adjustment, so-called "rubber banding" rules (like the blue shell in Mario Kart) and so on. Making a game easier to learn is a straightforward process of iteration. The really difficult problem is how to make a game deep.

Creating a game with depth is a difficult, unpredictable process. This is why games that have this property are so valued; a game designer cannot predict which combination of elements will give rise to a system that people spend endless hours obsessively practicing. Fortunately, video game designers have control over not only mapping of input to response, but challenges as well. We get to design the challenges that define the skills as well as the basic movements themselves.

If the game seems to lack depth, it's possible to change the relationship between input and response sensitivity. Adding additional sensitivity to the controls enables more subtlety and nuance to the interactions. Supporting these new, more expressive interactions with rules (goals and challenges) and context (spatial layout) enables the designer to craft the feel of the game at various levels, making it deeper. For example, tracking how long it takes to complete a specific action—racing from point A to point B, for example—is one way to add depth. Even with a simple set of controls, getting a better time is almost always possible. The first time the player completes the race sets the benchmark. The next time he or she plays the race, the knowledge gained from the first play through will probably make it easier to get a better time. Each play through, though, it will become harder and harder to improve. Eventually, the player will have to start changing and experimenting with different strategies in order to improve his or her time. Figuring out new ways to optimize his or her time, the player is reaching new levels of skill and unlocking new sensations of control. In a deep game, this process can go on much longer than in a shallow one. This simple rule—recording the time it took to complete an action and showing the result to the player—unlocks whole layers of skill learning and optimization the player would never have experienced otherwise.

Another strategy is to enable multiple players to compete, directly or indirectly. Examples of direct competition are games like Quake and Street Fighter II, where players directly attack one another. Indirect competition happens when a game has a leader board. Players are alone while playing the game but their scores get recorded and posted for comparison.

Enabling competition between players effectively makes the skill ceiling infinite. You can never be complete—as when you get 120 stars in Mario 64—you can only be better than someone else.

Novelty

Though the result of an input is predictable, there should be enough small, subtle differences in response to keep controls feeling fresh and interesting.

One enemy of novelty is linear animation. Even in a game like Jak and Daxter, where the linear animation is of uncommonly high quality, it's very easy to tell that Jak is doing the same punch every time. The problem is that, once exhausted, even quality content gets boring. Watching Jak punch for the ten thousandth time is significantly less compelling than it was the first time. For a sensation of control to hold the player's interest, it needs to feel novel and interesting even after hours of play. Even repetitive actions should feel fresh each time you trigger them.

Many games attempt to solve this problem with mountains of additional content, running the player through a series of increasingly challenging and varied levels that give new and interesting context to the virtual sensation to keep it from feeling stale. Another approach is to introduce more mechanics—additions and modifications to virtual sensation—over the course of the game. For example, Castlevania: Dawn of Sorrow does a great job of constantly adding new virtual sensations through different "souls" and weapons, each of which adds a different feel to the underlying movement or augments it with new states (such as the ability to jump twice without landing).

Another approach is to increase the sophistication of the global physics simulation. Physics games make control feel novel because the player will never be able to offer the same input twice. While the player may be able to consistently achieve the same result in Ski Stunt Simulator—jumping a ravine then doing a backflip over a wooden hut, for example—no two runs will ever be the same. The parameters that govern the simulation will react identically each time, players can't perceive the subtle differences in their own input. The system is more sensitive than the player's perception, much like the real world. Because our perception is keenly tuned to physical reality, we subconsciously expect certain things to happen when objects interact and move. One thing we expect is that no motion will ever be exactly the same twice. This is the nature of reality: messy and imprecise. No one person can punch exactly the same way twice or throw a discus or javelin the same way twice. If we see the same action happening in the same way over and over again without subtle variation, it starts to look wrong.

Appealing Response

When completely removed from its context, real-time control should still be engaging and aesthetically appealing. What's important here is to separate meaning from appeal. Context is very important to create meaning in a virtual sensation, as well as to provide a point of reference for scale, speed and weight, but is separate from naked appeal. A virtual sensation has appeal when it's fun to play and tinker with in a completely empty space.

Playable Example

Try each of the sensations of control in example CH17-2 to experience how appealing they are without the benefit of spatial context. The "High Input, High Reaction" test has much more appeal because its motion is more complicated, fluid and organic-looking than the other three. Indie game designer Kyle Gabler does a fantastic job of making games with this kind of basic appeal; Attack of the Killer Swarm and Gravity Head in particular are super appealing.

Additional effects and baked-on animation can also add to appeal. The animations in Jak and Daxter add a lot of appeal to an otherwise bland sensation of control. Most of the techniques used to animate Jak come from traditional animation—squash and stretch and so on. But Jak's movement, which is simple when separated from the layer of animation on top of it, seems organic, complex and appealing. In New Super Mario Brothers there is a similar effect: if Mario were just a cube, the virtual sensation would not be as appealing. As it is, Mario's run cycle speeds up gradually and slows down again as he starts and stops, throwing up dust particles both as he runs and if he quickly changes directions.

The other part of appeal is making sure that no matter what input the player gives the system, the result is compelling. This is especially important for things like crashes and failure states. An enlightened approach is to spend more time on the failure states, making them varied and interesting, since this is where the player will spend most of the time. For example, in the game Ski Stunt Simulator, it's fun to crash and mangle the skier. Because the skier is a "ragdoll" physics rig, complete with constraints to simulate joints and different, individual masses for each limb, crashing him produces a satisfying, organic-looking result. It's not just one canned animation playing back every time. He'll smack his head, tumble down a ravine or impale himself on a cliff side. In a sort of extreme sports mishap kind of way, it's very appealing to watch him crash and go limp as his body contorts and tumbles. There's a very visceral "oooh daaaamn!" kind of reaction, one that has a hugely positive effect both on learning and capture. Because the failure state is so much fun, learning is much easier and frustration mitigated. If you try a run numerous times and still aren't successful, you can always crash the skier intentionally a few times to put a smile on your face. Likewise, observers will often be "captured" by Ski Stunt Simulator's organic look, especially when the skier crashes, enticing them to play.

Organic Motion

Good-feeling games produce flowing, organic motion (see Figure 17.4). This is true of Asteroids, Super Mario Brothers, Half Life and Gran Turismo.

FIGURE **17.4 Flowing curves of motion in Asteroids and Super Mario Brothers.**

Whether it's the motion of the avatar itself, animation that's layered on top of it or both, curved, arcing motions are more appealing. In fact, this is one of the principles of animation, i.e., arcs. "All actions, with few exceptions (such as the animation of a mechanical device), follow an arc or slightly circular path. This is especially true of the human figure and the action of animals. Arcs give animation a more natural action and better flow. Think of natural movements in the terms of a pendulum swinging. All arm movement, head turns and even eye movements are executed on an arc."[5]

In animation, this means arranging frames along a curved path. In a video game it comes down to mapping and simulation.

Setting the position of an avatar every frame, as with the horizontal movement in Donkey Kong, Contra, and Ghosts and Goblins, produces a linear motion, which will feel rigid and stilted. Changing an internally simulated velocity with forces, such as using the thruster in Asteroids, creates a more flowing, organic motion.

Harmony

Each element of a game's feel should support a single, cohesive perception of a unique physical reality.

Video game worlds are perceived actively, as we have said. Unfortunately for game designers, active perception is more acute than passive. People are extremely sensitive to perception at the level of everyday physical interactions. If something's even slightly off—a ball doesn't bounce right, a book doesn't tip over correctly, a car doesn't steer as expected—people will notice. We can't help it. We spend all day every day honing the skills of perception so that we can successfully navigate and cope with the world around us. This makes designing game worlds very difficult because any tiny inconsistency becomes glaringly obvious.

[5]http://www.frankandollie.com/PhysicalAnimation.html

FIGURE **17.5 Treatment changes expectations about sound, motion and behavior.**

The best-feeling games maintain harmony across the six elements of game feel. If an object in the game looks like a car, controlling it has to feel like steering a car. It should grip the road properly, carving and tilting and bouncing over bumps. It also has to sound like a car, from the revving of the engine to the crumbling noise of tires on dirt to the screech of rubber against road. If the car runs into something, that interaction most also be perfect. If it hits a building, it should crumble and break, and the car should be twisted and mangled.

If we attempt to make a game world appear photorealistic, we're setting ourselves up for failure. To be in harmony, the visuals must all behave just the way they do in real life, and stand up to the deep, multi-sensory scrutiny of active perception. Sounds must correspond to visuals that correspond to motion. And not just passively perceived animated motion, as in a Pixar film. The object has to look, sound, feel and move properly even as the player noodles it around and manipulates it in unpredictable ways.

Expectations about how things behave, however, are malleable. Even if we have a very common object like a car, the expectations about how it will behave can be toned down by the treatment. If it's a cartoony, iconic car, the player will not expect it to behave realistically. A good way to think of this is consistency of abstraction. If the level of abstraction is the same across visuals; sounds; and motion, simulation and rules, the game is in harmony. Making a game more iconic than realistic makes it much easier to meet or exceed player expectations for harmony across all the elements of a game.

The most difficult piece of harmony is motion. It's very difficult for player-controlled simulated motions to always produce perfectly cohesive motion. For example, in most games that feature a running character, it's possible to run the character into a wall. Not only is it not hurt by this, but it continues to run while pressed up against the wall in a silly way. The impression that it's a badass space marine or whatever is lost. The game Gears of War surmounts this problem by turning

pressing against surfaces into a mechanic, in a single stroke creating an interesting game dynamic and an uncommonly cohesive physical reality. The sounds and particles and animations all work together with the programmed rules about taking cover and pressing against objects. Because of this, Gears of War's unique physical reality stands up well under the scrutiny of active perception.

The pragmatic reality of game production means that some small inconsistencies will creep into every game. Being aware of each element of the game's feel and the way it will change the player's perception of the game's unique physical reality can help to avoid and mitigate these little annoyances. This is more important than most game designers realize. Every time a character's arm clips through a building or a plank of wood goes sailing off into the distance at the slightest touch, the players' impression of the game world as cohesive is further eroded. If this happens too often, they may stop playing entirely.

Ownership

The best virtual sensations contribute significantly to the feeling of ownership. This happens after the player has fully learned the mechanic and mastered most of the challenges presented by the game, at the point most games get put down. In the game industry, this is often termed "replayability" and is spoken of in hushed tones because of the obvious correlation between games that have this quality and games that do very well financially. Really, this phenomenon is all about ownership: if players feels a personal investment in a game, they'll keep playing it. If they keep playing it, they will start to evangelize it. Once mastered, a virtual sensation that has enough sensitivity enables improvisation, which often gives rise to unique forms of self-expression.

Improvisation in a game is the ability to create new and interesting combinations of motion in real time, adapting and reacting to the game's environment in a fluid, organic way, without forethought. This is an intensely pleasurable experience, a flow experience. When your skill is matching up well to the challenge you've undertaken, you get into the flow state, which is universally described as being a wonderful, life-enriching experience. To enable such improvisation, a mechanic needs to have not only a lot of sensitivity (between its input and reaction) but to be very flexible in how it interacts with objects in its environment.

Some games, like Tony Hawk's Underground, achieve a sense of ownership through a huge number of states and a context that's well spaced with a lot of utility in a ton of different instances. The player can use any number of states to traverse the environment, using each object in many different ways. All the objects are well spaced relative to one another, which again fosters improvisation by making it easy to transfer successfully between any two objects from any direction of approach. Invariably, no two combinations will be the same because you'll use different objects in different ways, and choose different paths to take depending on the situation. You improvise, making snap judgments about which objects to traverse.

At the highest level of play, this becomes even more expressive, with players finding and practicing long "lines" of chained moves used on certain objects. They seek out aesthetically appealing states rather than high-scoring ones, recording videos of their most appealing lines and uploading them to the Web to share. To these players, Tony Hawk is a form of interpretive dance, enabled by the fact that all the objects have a very high degree of utility from just about any state or relative position.

Other games, like Ski Stunt Simulator, are more fluid and achieve ownership through extremely high input sensitivity and subtlety. Minute differences in the angle of skis to ground, for example, produce a totally different kind of landing. Because there are global rules about object interaction in Ski Stunt—a crash occurs if the skis hit at a certain angle or when the skier's head hits the ground—there's a lot of space for interesting improvisation and expression. For example, when the skier is extended, standing his full height, he raises his arms in the air. If you're in the air, about to hit your head and trigger a crash state, you can extend the skier's arms to prevent his head from hitting. This ability isn't explicitly defined but, instead, is a product of the recombination of a few simple rules (e.g., you can move the skier's arms up, crash is only triggered when his head hits).

When multiple players are involved, expression becomes communication, which opens a whole new realm of powerful social experiences. In Battlefield 2, for example, if you sneak up on someone and stab him with a knife, his state goes from alive to dead. In that context, knifing an enemy player is just playing the game, and slightly embarrassing the enemy player who allowed himself to be snuck up on. If once the player is dead, however, you continue to knife the corpse, this action has a totally different meaning. It's directly insulting and belittling to the player, who has to watch from his corpse's perspective as he's stabbed over and over again until respawn.

Summary

The underlying goal of all the principles discussed in this chapter—predictable results, instantaneous response, easy but deep, novelty, appealing response, organic motion and harmony—is to create a feeling of control and mastery so strong that it becomes a tool for self-expression. This feeling creates a strong sense of ownership, which is what happens when players can express themselves in a meaningful way through a game. Any artifacts the game creates based on their inputs (replays and so forth) become an important commodity, and players begin to identify with the game and their achievements in it in a very powerful, transparent way. Players start to feel pride in their accomplishments, and develop a desire to share them with others.

EIGHTEEN

Games I Want to Make

In his book *Chris Crawford on Game Design*, Chris Crawford provides a section entitled "Games I'd Like to Make." I found that to be the most interesting and inspiring part of the entire book, because it shows the principles he espouses throughout the book in action. Here is this problem of creativity, he says, here is an approach to solving it and here are some of my stabs at applying this approach. As I've been writing this book, examining game feel, a number of ideas for games have occurred to me. I'd like to share them, for better or worse, in the hope that someone someday may make them or that they may give rise to an interesting idea. One of them, Tune, I've already built a prototype of, and you can find it at http://www.steveswink .com/tune/.

1,000 Marios

In examining games with respect to the number of avatars that the player controls, something occurred to me: why so few? Why does the player control only one object at a time? I began brainstorming examples of games that controlled more than the usual two or three avatars and, interestingly, didn't come up with much. I'm talking about direct control, correction cycle control, real physical game feel kind of control. I realize that there are plenty of real-time strategy games where the player controls lots of little units indirectly. I'm talking about control at the responsive, kinesthetic level.

If you look for games where the player controls more than the staple character or a camera there just isn't much out there. A few obscure mini-games, perhaps, and some awesome but abridged indie experiments like Kyle Gabler's The Swarm and Student Showcase finalist Empyreal Nocturne. Nothing large in scope or budget, though. Perhaps complexity is the reason: Fusion Frenzy for the Xbox featured a mini-game where the player controlled a character with one thumbstick and a bomb with the other but it was gallingly, frustratingly difficult. I think this is because

the designers of that mini-game were asking the wrong questions, though. They seemed to be asking, "How many different ways can we have the players attack one another?" The idea of controlling a bomb and a character separately was just one experiment among many and if it was hard to control, so be it. We're not hanging the whole thing on this one control scheme. Players will choose the games they like and ignore the rest anyway. On to the next idea!

I think a better question is: what would controlling 1,000 Marios simultaneously feel like? And what kind of game could you make from that? Notice that this is more bottom-up than top-down. Instead of trying to impose the constraints of a mini-game from the top down—short duration, multiple players, about killing one another and so on—we're simply asking what it would feel like to control all these little guys at the same time. If you had direct, kinesthetic, good feeling control more than 10, 100 or even 1,000 little Mario-like characters in a typical platforming level, what would that feel like? I bet it would feel like controlling a fluid. A liquid made of plumbers, if you will.

It's worth prototyping, I think, to find out what kind of gameplay would emerge. Only actually making it and playing with it will yield that result, but I suspect there could be a lot of interesting and very different challenges there. Getting all of the characters to the end of the level unscathed seems like an obvious one. Or what if it were a puzzle game where the objective was to kill all the little Marios? Pits would fill in with Mario corpses, pipes would become clogged and enemies would be overwhelmed. "How can I dispose of all these Marios?!" the player would ask. Seems worth exploring, no?

In addition, it's interesting to me that control over objects in a game always seems to be either on or off. It's a forgone conclusion that what the player controls can't change, or that if it does change, it must be a one-for-one swap. What if it changed fluidly and organically, or if it could tolerate half tones? For example, what if in the 1,000 Mario prototype there was also a cursor avatar, driven by the mouse. As a visualization, it would be a circle, extending outward from the center of the cursor. Things at the very center would be controlled 100 per cent by the player. As the Marios were farther from the center, the amount of influence exerted by the player's controls would fall off (Figure 18.1).

And why stop here? What would it be like to control 100 Asteroids ships, or 1,000 cars in Gran Turismo simultaneously? Or what if you controlled 100 Marios and 100 Asteroids ships at the same time? Breaking free of the notion of one-avatar control seems to yield a wealth of possibilities.

For a couple games that challenge the notion of one-avatar control in their own fascinating ways, check out Farbs' ROM CHECK FAIL (Figure 18.2) and Gamelab's Arcadia. In ROM CHECK FAIL, the avatar is constantly transforming, becoming a new, recognizable avatar from a classic game every so often. One moment you might be Link from The Legend of Zelda and the next you might be the ship from Defender or the avatar from Space Invaders. The context and rules change as well, with enemies and environments from various games randomly juxtaposed. I love

FIGURE **18.1 Controlling a thousand Marios would feel weird, possibly awesome.**

FIGURE **18.2 ROM CHECK FAIL by Farbs.**

FIGURE **18.3 Arcadia by Gamelab.**

how this game constantly changes the meaning of relationships between the movement of the avatar, the spatial context and the rules that govern it.

Arcadia (Figure 18.3) tasks the player with controlling four super simple games (such as a platformer and a driving game) at once using a mouse cursor. The meaning of the avatar changes as the cursor moves into each quadrant, seamlessly changing what the input is mapped to. By moving between each game, the player can effectively—if spastically—control four separate little avatars with one input.

Window on the World

Originally espoused by one of my students, Orion Burcham, this is a wonderful idea about the potential for interplay between the tactile world of a game and the real, physical world around us. It works like this: you take a handheld device, such as a Nintendo DS or Sony PSP, and attach to it a device with highly sensitive accelerometers that recognize subtle changes in both position and rotation. On the screen appears a first-person view of a game world. As you move the handheld device around, the view on the screen changes at the same rate, making it appear as though it's a view, a portal into another world. (You can see his proof-of-concept video at http://www.youtube.com/watch?v=scmpg8AfOzE.)

To play the game, the player would have to stand up, hold the device aloft and walk around. Walking forward would move the avatar in the game world forward at the same rate, and rotating the thing would rotate the avatar. The key is in a

one-to-one relationship between the physical movement of the handheld and the apparent movement of the in-game avatar, which ultimately boils down to a (nontrivial) technological problem.

I'm reminded of a piece I saw at The San Francisco Museum of Modern Art many years ago by video artist Janet Cardiff. You traded your credit card for a handheld video camera with a built-in digital screen and were then ushered over to a particular bench and told to sit down, put on your headphones, press play on the video camera and be careful. The cryptic addendum to the instructions read "follow the motion of the camera."

After pressing play, a video appeared on the screen, roughly from the perspective of the bench. By holding the camera up, you could match the onscreen image to your current surroundings in the museum. And then, it started to move, up from the bench, across the foyer and up the stairs to the second level of the museum. I need hardly say that one felt compelled to follow, to keep the view on the screen aligned with reality. The experience was unlike anything I'd ever felt before. Very quickly, I lost track of who was real and who was in the video. Many times I almost ran into a real person in front of me, and sidestepped to avoid a person who was only in the video. The video led a winding trail up and out into the stairwell. The blurring between my reality and that of the video was so striking that I can still recall the exact path of the video nine years later. It was awesome and unlike anything I've experienced before or since.

I think the potential for the Window on the World concept is similar. Such an interface could serve to make the ordinary extraordinary. If the line were blurred between real-world tactile experience and virtual tactile experience, the result could be quite compelling indeed. Virtual creatures and items could be hidden behind bus stops and mailboxes. You might find a power-up embedded in your couch and have to move the couch to reach it. This, I should think, would be awesome.

Games like Eye of Judgment for the Playstation 3 and the surprisingly (or not— heh) popular Eyetoy are beginning to explore the potential for inserting the virtual into the real. This has a great potential for creating a new frontier of game feel.

Spatial Relationships and Intimacy

Another interesting question that comes to mind when looking at all the different ways game feel is applied in the realm of game design is: why is it always about skill, challenge and mastery? I think we have, as an industry, a pernicious mental lock that prevents us from going to some interesting places. We have the ability to create a simulated sense of physical, tactile interaction, right? Haven't we just spent an entire book talking about all the different ways we can and do sell the impression that our virtual things are interacting at the kinesthetic level of everyday life? So how come it's always shooting accuracy, steering precision or other kinds of skilled manipulation? Why don't we try to represent the tactile sensation of dipping your hand into a bag of beans or caressing someone's neck?

Probably it's because we need to grow up. In so doing, we might just unlock a vast new realm of game feel, one that corresponds to the breadth of human tactile experience instead of the tiny slice we address now.

For whatever reason, and the reasons are many and well lamented, our little industry is completely puerile when it comes to sex. We have big-bosomed vixens, babes with guns and cutie-pie anime girls: fantasies for teenage boys. To claim otherwise is intellectual dishonesty. Anyhow, what's pertinent to our design challenge is the fact that the sex we have in the games we have now isn't sexy.

For me, sexuality is much more about intimacy and sensuality. Pornography in the traditional sense—ramming it home, as it were—is pretty horrifying. Though (as my girlfriend points out) being "ravaged" has a certain fantasy appeal, one wouldn't want to make a game where the focus was, ah, thrusty.

So, putting aside the possibility of the game being about actual intercourse, and limiting ourselves to a single player experience (the role of virtual chat rooms with avatars who engage in animated sex being well covered), we're left making a game about intimacy. What, then, are the mechanics of personal intimacy?

Proximity is a necessity, to be sure. It's interesting, though, that it is possible to be intimate without actual physical contact. The simple act of moving into another's personal space immediately heightens physical intimacy. As long the person is not a stranger or unwelcome, simply being close can be intimate.

> For instance, there is a game in which a couple may try to see how close they can get to each other without actually touching. Another game involves running hands along the contours of a person's body without touching him or her. These techniques often heighten sexual arousal. When a person enters someone else's personal space for the purpose of being intimate, it is physical intimacy, regardless of the lack of actual physical contact.[1]

Recently, I went to see "The Departed," which I enjoyed. There is a sex scene in the film which struck me as very sensual, very sexy and which included only some kissing and mild undressing. In fact, the scene caused a friend of mine to, involuntarily, shout out "Holy guacamole!" in the middle of the theater, to general hilarity. The moment at which the scene pivots from uncertainty to extreme sexiness is a moment of physical intimacy without any touching. Vera Farmiga's character is sitting on her kitchen counter and Leonardo DiCaprio is face to face with her. Great moment. This is not to say that touching should be omitted from consideration, I'm merely pointing out that the proximity of two people seems to be a prerequisite to intimacy.

So that's a possible direction, some kind of interpersonal simulator, where you play as a guy or girl trying to become intimate with another person by making advances in the right order or with the right finesse, with interesting control mechanics related to eye contact, body position and language, proximity and picking up on subtle cues. Sounds pretty boring, though, and similar to the territory Façade and others are aiming for. Also—and this may constitute a significant heresy—I think

[1]http://europecasinoguide.com/index.php?option=com_datingguide&page=Physical_intimacy.html

trying to translate film or literature into interactive form is, as an approach, entirely too complicated. The scene's success depends almost entirely on context: the attachment to those characters built across an hour of excellent film and the details of this particular encounter (it's raining and Leo was apparently without a jacket, Vera's moving out of her apartment so the lighting is diffuse and so on …) Even when approached with powerful intelligence and determination—that kind of procedural context generation being dutifully attacked by the Interactive Storytelling Battalion who are bivouacked in what seems to be a relatively strong position—I think our goal of making a sensual game could be much, much simpler.

In fact, my solution to the problem of designing a game about intimacy hinges on simple touch. Before I go there, though, I think it's also important to note that smell (candles or incense), sight (candles or low lighting) and sound (Barry White or whatever) are also traditionally integral to "setting the mood" for intimacy and sensual enjoyment. We're not going to get smell, but we can certainly hit sight and sound. I think a great treatment would be something like Peter Miller's "Eros Ex Math" series. The goal would be to leverage the brain's imaginative capacities, offloading a goodly helping of sexy interpretation to the player's mind. So, we've got our look. For sound, simple breathing.

Now to answer the heroic question posed of Harvey Smith by David Jaffee—that's all well and good … but how do we make a game of it?

The Touch

One mechanic of sensual pleasure which I've always found fascinating is touch. Specifically, extremely light fingertip-to-skin touching. I find, without getting too ribald, that touching a woman's skin as lightly as possible while varying the speed and pattern of the contact of each fingertip (so that there is no discernable pattern) is extremely effective in providing sensual pleasure. As it turns out, there's an interesting scientific explanation having to do with the way the somatosensory system interprets input over time—if it's in a straight line the neurons are able to predict and anticipate the stimulus and are prepared for it. If there's no pattern, it's much more exciting and stimulating. This is why it's difficult, if not impossible, to tickle yourself.

The game is very simple, requiring the player to touch the undulating Miller forms as lightly as possible without breaking contact, without stopping and without a discernable pattern. Shallow breathing in the background quickens in pace to indicate system state, getting faster as you succeed, with an advancing round structure for pacing (complete one round, move on to the next). As an area is touched, it lights up, a gradient glow expanding from the point of contact. Touching the same area over and over again yields diminishing returns, with variations in surface and movement speed providing additional difficulty.

There are two control implementations that come to mind, one of which requires some non-standard input device configurations. The non-standard configuration

would be wearing the P5 Glove (degree of finger curl to indicate the strength of the touch) while moving the mouse with the same hand (to indicate position).

I'd simulate the skin as a series of spring hulls, each with slightly more stiffness than the last, to create a sort of layer cake effect, and then test to see whether and where each layer was depressed, touching the layer below as a gauge of pressure.

A keyboard and mouse version of this would separate the touching pressure from the pattern of movement. The touch pressure would be a separate, smaller picture-in-picture window where the player would use the mouse to keep the appropriate (light) pressure on the skin, which would scroll right to left to increase difficulty. Meanwhile, the player would have to press keyboard buttons with the other hand to indicate the area to be stimulated. An interesting idea I have here is that of a keyboard "mashing" scheme, where instead of four buttons indicating directions to steer in, the whole left side of the keyboard is active, from the ~ key in the upper left to the B key in the lower right. Any key within this range is a valid press, but to succeed you must press keys out of vertical or horizontal order and, again, hitting the same area while it's still illuminated produces diminishing returns.

Invisible Avatars

In separating polish effects from simulated interactions, an interesting question occurred to me. Would it be possible to create an impression of physicality using *only* polish effects? Could you create a game with good feel that featured an invisible avatar. I pondered this for a while, and did up a couple small tests. I found it felt best if the camera still tracked on the avatar and so gave a sense that it was running into things, represented by the view stopping. At the Experimental Gameplay Sessions at the Game Developer's Conference this year, I was delighted to see that a gent named Matthew Korba was thinking along the same lines. He created a game called Wrath of Transparentor about an invisible monster rampaging through various environments. So, yes, it is possible to create feel without simulation, and yes, it can feel good. This seems like a bit of a "no duh" given the great feel of certain first-person shooters (where the avatar is never seen) but I'd love to see this idea explored further.

What about a game where a complete simulation was running but the only visualization was the polish effects, the interactions between objects? I'm picturing a world that's completely white, but that enables players to paint on surfaces whenever their avatar comes into contact with them. The game would be about building an image of the world by exploring it tactilely.

Tune

My favorite part of creating a game is tuning a mechanic's feel. I think that's just about the best thing in the world, apart from scoring a wicked breakaway goal and

FIGURE **18.4 Tune—a game about game tuning.**

eating my weight in naan bread. So I thought, hey, would it be possible to make a game *about* game tuning? Would it be possible to give the experience of tuning a mechanic to feel just right to other people, people who don't care to program their own game?

Tune (Figure 18.4) is a game about game design, about tuning game mechanics. Besides controlling the game in the typical way, the player must constantly change the balance of parameters against one another. Depending on the current goal, different tunings of the mechanic will be more or less effective. The successful players will be constantly experimenting with the various parameters, looking for the tuning that best equips them to complete the current goal. Each goal brings a new challenge, and may require a different tuning.

Tune began life as an assignment for my gameplay and game design students at the Art Institute of Phoenix. One of the goals of my class is to give students a taste of game design in a very real, practical way. This means, among other things, taking a series of abstract numbers and balancing them against each other—tuning them—to achieve a specific, fun feel. In lieu of having students actually program a game (the major at AIPX is "Game Art and Design," but the focus is primarily on art), I created a simple physics-based jumping mechanic and exposed a few of the most relevant parameters as simple text entry fields (Figure 18.5). I then told the students simply, "Here is a mechanic; make it fun," and turned them loose.

Playable Example

Try it out yourself: http://www.steveswink.com/Jumper/Info_Jumper_03.htm.

130	Spring Power
6	Rotate Power
-15	Gravity
1	Physics Time

FIGURE **18.5 The original Jumper Mechanic Tuning assignment from my class at the Art Institute of Phoenix.**

The result was surprisingly fun. The assignment quickly became a favorite; I created more mechanics to tune and expanded on the idea. As I did, it occurred to me that I could provide the same kind of structure and experience—me standing behind the student saying, "Here is a mechanic, make it fun"—within the game system. This was the genesis of Tune.

Summary

All of these ideas are, of course, incomplete. If one of them strikes your fancy, please make it. Ideas are a multiplier of execution; they have no inherent value unless you make something of them. I'd love to see a game where you play as a shadow, or a game about echolocation, or a game about maintaining eye contact. Comparatively little has been done with the amazing medium of game feel and its malleable active perception. Let's change that, eh?

CHAPTER NINETEEN

The Future of Game Feel

Today we have some great-feeling games. There are not as many as there might be, but as we've seen, the ones that manipulate human perception in a positive way, fooling the senses into registering a particular set of sensations, have excellent feel. By examining a few of these in depth, we have sought to generalize their effectiveness and reveal the ideas and practices that enable us to create similarly great-feeling games.

This final chapter examines some of the problems for game feel as a medium for expression and the ways in which these problems are being solved, or could be solved, in the future. It's also interesting to ask whether we're asking the right questions about game feel. Given that it exists primarily as an impression in the player's mind and that all control over virtual objects must be mediated by an input device of some kind, what are the most fruitful avenues for improving game feel?

In keeping with the structure of the rest of the book, this chapter covers the six pieces of the game feel system in turn, starting with input and ending with rules.

The Future of Input

A crucial problem identified by the Human Computer Interaction community is bandwidth. The expressive potential of current input devices is vastly outstripped by the potential for corresponding response from the computer. As educator and researcher Robert J.K. Jacob put it, "Given the current state of the art, computer input and output are quite asymmetric. The amount of information or bandwidth that is communicated from computer to user is typically far greater than the bandwidth from user to computer. Graphics, animations, audio and other media can output large amounts of information rapidly, but we do not yet have means of inputting comparably large amounts of information from the user."[1]

[1]http://www.cs.tufts.edu/~jacob/papers/sdcr.pdf

The question seems to be, how can we make this input feel more natural? In this context, natural means more like interactions in real life. The ultimate goal is often stated as overcoming "The Gulf of Execution"—the gap between users' intentions and the physical action of the input device that ultimately translates those intentions turns them into actions in the computer. With due respect to this as a fundamental goal of interaction designers, researchers and anyone else who seeks to reduce the pain and annoyance of working with computers, this is wrongheaded with respect to video games. There can be, and is, a great, beautiful pleasure in overcoming the so-called Gulf of Execution. In a video game, some obfuscation is necessary and desirable; if intent and action merge, there's no challenge and no learning, and much of the fundamental pleasure of gameplay is lost. If we pave over the Gulf of Execution, we lose the opportunity to surf the rogue waves of learning, challenge and mastery.

The problem lies in designing the right kind of obfuscation. This is one of the central problems that keeps game designers up late of nights: the difference between an exquisite gameplay challenge and an annoying usability issue. What is the "right" way to challenge and frustrate a player? We know that some frustration is good because there is no challenge without the potential for failure. But the right kind of challenge, the right kind of roadblock between intent and execution— that is the elusive quarry many game designers seek. So with respect to input devices, it's cool to try to make things more natural and expressive, to increase the bandwidth; but the thing to keep in mind is that there are games that hit the sweet spot of challenge, games that feel great, using only three buttons. Spacewar! still feels good.

What all this has to do with input devices and their design is the difference between natural and realistic. For example, a mouse makes sense to most people because it is a direct positional transposition. Move the thing on the desk and it moves some corresponding amount on the screen, depending on the control-display ratio. A touch screen, however, always has control-display unity. You touch the screen at the point you want the interaction expressed. Where the mouse is indirect, requiring the logical leap from on-desk movement to on screen, the touch screen integrates both. The touch screen better bridges the Gulf of Execution.

But have you ever played a memorable game on a touch screen kiosk? If the input isn't getting transposed into something interesting, if it isn't a simple interface to a complex system, the playful enjoyment evaporates. With that in mind, what we should be looking at are the behaviors that feel most natural, the easy, instinctual relationships between input and resulting response. These are not the same as the interactions we have with real life. There is a separation—a crucial one— between reality and intuitive controls. We can't simply stumble forward on this ceaseless quest to make the input devices "realistic." This defeats one of the fundamental strengths, one of the great joys of controlling something in game, the amplification of input. Again, the phrase "a megaphone for your thumbs" comes to mind to describe the sensation of using a small piece of plastic to control a complex, digitally rendered, physically simulated car.

THE FUTURE OF INPUT

In the apparent quest to make computer input mirror real-world interaction—to make it more "natural"—we may be ignoring the crucial fact that it feels good to control a complex system with simple inputs. This is what makes learning things in a game more fun than learning things in real life. Real life is complex, dirty and difficult to master. A game can be clean and simple to master. Through a simple input device with little bandwidth, we can truly interface with a highly complex system and experience the joy of manipulating it.

The Wiimote

In the same paper quoted above, Robert J.K. Jacob also says, "Future input mechanisms may continue ... toward naturalness and expressivity by enabling users to perform 'natural' gestures or operations and transducing them for computer input."

This seems quite prescient given the success of Nintendo's Wii console and the attempts by Sony and Microsoft to emulate that success. The Wiimote, however, is perhaps the best possible illustration of the clash between what seems more natural and expressive and what makes for good game feel. This is especially apparent playing The Legend of Zelda: Twilight Princess. For every sword swipe, you have to swipe the Wiimote. It doesn't feel better; in fact, it feels like unnecessary obfuscation between intent and the in-game action. Why not just press a button, as in The Legend of Zelda: Wind Waker?

One of the most enjoyable things about Wind Waker is the depth of the sword fighting and the emphasis on mastering it in the game. On the first island in the game, a master swordsman trains you. There are various thresholds of training, measured by how many times in a row you can hit the master in one-on-one sword combat without being hit yourself. As you defeat each level of challenge, you are rewarded with new sword techniques that can be used throughout the game. At the highest level, you have to hit the master something like 500 times in a row without being hit yourself. I actually managed to do this, and did it very early in the game. The commensurate reward was a much deeper level of satisfaction and enjoyment throughout the rest of the game because the skills that I as a player had spent time practicing prepared me for success and enabled me to feel powerful and in control for the rest of the game.

This sensation is, by virtue of the Wiimote gesture-triggered controls, entirely missing from Twilight Princess. Since there's just no precision in flailing the Wiimote around wildly, there's nothing gained by it. It is obfuscation of player intent because it uses a highly sensitive input (high input sensitivity) to trigger a very small variety of actions, all of which are prerecorded animations (low reaction sensitivity). In this way, the designers have effectively removed the enjoyable feelings of mastery that were possible in the Wind Waker sword-fighting mechanics, when they would otherwise carry over to Twilight Princess. The sensation of deftly dodging and weaving around and looking for an opening to strike no longer exists. With the Wiimote, it feels like flailing imprecision.

Now, it may be the fact that the Wiimote is a first-pass technology and as such lacks sophistication. It may also be that the Wiimote senses relative position rather than absolute and is hampered by this constraint. The Wiimote is a tantalizing beacon of possibility, though, because it indicates a device, perhaps two generations from now,[2] that might bring fully 3D absolute position sensing to a widely adopted home console. Basically, we want to be able to have an input device that understands movement and rotation in all three dimensions. We want a device with the positional sensitivity of a mouse that can be moved left and right, up and down and be rotated along all three axes. From there, we can always clamp back down to two dimensions (or even one dimension), and we have access to rotational and positional movement along all three axes.

This is what everyone thought the Wii would be. The way it turned out, it's more like a mouse cursor with annoying screen-edge boundaries plus rotational sensitivity in three dimensions of accelerometers. It doesn't know up from down. It knows forward and backward because of the pointer end. What was truly desirable was a device that knew and understood fully 3D spatial positioning, so a player could control something by moving the object up, down, left and right, and the designer could map those movements directly to something in a game. Unfortunately, with the Wiimote, there turns out to be a lot of obfuscation between Wiimote flailing input and game response, as opposed to pressing a button to get a sword swing. And it's the wrong kind of obfuscation.

Haptic Devices

Another direction of input device development that shows promise in terms of game feel is so-called haptic devices. Haptic devices were first implemented in commercial aircraft to combat the numbing effect of servo-driven controls. In a lightweight aircraft without servo controls, the pilot can feel directly through the controls if the plane is approaching a stall. The control stick begins to shake as the plane's angle of attack approaches the dangerous stalling point, an important indicator to the pilot that it's time to adjust course in order to avoid an open-bucket funeral. In a large jetliner, the sophistication of the controls leaves the pilot completely removed from a direct tactile sense of the aerodynamic forces acting on the plane, the result of which is a dangerous disconnect between the pilot and the "feel" of the plane. To combat this effect, the plane's onboard systems measure the angle of attack and provide an artificial shaking force when the plane approaches the known angle of stalling, simulating the feel of earlier aircraft. This is known as haptic feedback, and it enables the pilot to better control the plane by improving the feel of control. It may trouble you to learn that your safe landing relies on the pilot's Dual Shock

[2]At the time of this writing, Nintendo has just announced "Wii Motion Plus," which may provide the full 3D spatial sensing originally promised by the Wiimote. That would be awesome.

FIGURE **19.1 The circular motion of rumble motors in a Sony Dualshock controller.**

functioning properly, but these have been in effective use for many years. Haptic feedback is serious business, and has true practical applications.

As applied to game feel, this kind of rumble has become a common feature of modern console controllers, such as the Xbox 360 and PS2 controllers (Figure 19.1). The potential for improvement in the future is in a more sophisticated kind of rumble. Currently, the controller shake effect is provided by a very simple set of rotating weights. The weights rotate and the controller vibrates in time.

Tactile rumble effects could be improved by incorporating three adjustable types of motion:

- Rapidity of shake: This happens already in current generation controller rumble. A rumble motor can rotate once, or at any interval up to its maximum vibration (many times per second).

- Linear and rotational motion: In addition to spinning, gyroscopic weights, devices would have weights that moved side to side, forward and back and up and down.

- Softness of shake: Instead of black and white—either moving or not—devices would have shades of grey, ranging from very light vibrations to very powerful vibrations.

No doubt this kind of technology has been and continues to be developed, but is still too expensive or flimsy for mass production. It could improve the feel of a game significantly, however, by providing a much wider expressive palette of tactile sensation. A whole range of combinatorial possibilities might open up: a light side-to-side motion happening twice a second or a violent up-and-down motion happening once. An impact force on the right side of the avatar could shake the controller hard to the left one time, whereas a gentle caressing of one object against another

might give the slightest of high-speed vibrations. I can see a game where running a character's hand across various objects and sensing their textures via multi-directional vibration would be a core mechanic. This is a relatively untapped frontier for enhancing game feel.

A variation of haptic feedback is so-called "force feedback," in which there are physical actuators that push back against the controls. These have been in common use for many years in specialty flight sticks and steering wheel controllers used by hardcore flight and driving simulation enthusiasts. In these cases, the game's code will feed into the active motion of the steering wheel or flight stick, causing it to wrench or pull at certain moments, in response to certain events. The reason these haven't caught on is that force feedback is almost always used as a blunt instrument, as a special effect. It's almost never used to tell the player something subtle about the state of game objects. At least, not the way that something like an ongoing engine sound does. When playing a driving game that modulates engine pitch based on how fast the car is going, there is a constant stream of feedback to adjust to conditions in the game. Force feedback seems to come out of nowhere, giving the impression that the once inert steering wheel is suddenly and distractingly jumping to life. What's lacking is subtlety, nuance and the bang-for-buck appeal of controlling a large response with little input. You don't want to feel like you're fighting the input device to get your intention realized. You just want the thing in the game to do what it's supposed to do, what you think it should do. When it misbehaves, the gulf of execution is wider and frustration greater. This is perhaps why force feedback devices continue to be relegated to the niche of automobile and aircraft aficionados whose epicurean tactile tastes demand as authentic an experience as possible. For the general game playing public, however, building a life-size cockpit is unfeasible and having their controller fight them for dominance is more annoyance than enhancement where game feel is concerned.

That said, the potential is rather tantalizing. A hyper-sensitive haptic device that provides game feel at the level of true, graspable tactile physical experience? Sign me up. With the right tuning and the right subtlety, players could feel a virtual object the way they feel a ball, a cushion or a lump of clay. The Novint Falcon (Figure 19.2) is a low-cost commercial device that purports to provide this sensation precisely. As an input device, it also recognizes movement in all three dimensions. In principle, this sounds great: here we have an input device with a low-ish price point that enables input in three dimensions and provides a powerful resistance force in all three dimensions, which can be used to model tactile interactions. In fact, the Falcon ships with a software demo that features a virtual tactile sphere. You can change the type of surface from sandpaper to gravel, from hard to soft, from honey to water, and feel the difference by probing around with the input device. And there's definitely potential there. If you put the device behind the screen on which the demo is running, a somewhat convincing illusion begins to coalesce, a sense that you're actually touching something that isn't quite there. The problem is, it must all be done through this thick, unwieldy knob. It's like touching a ball with a disembodied door knob.

FIGURE **19.2 The Novint Falcon.**

The other difficulty with the device is fatigue. This is the true and nigh-insurmountable problem with actuated devices. Personally, when I played the demo games included with the device for about 10 minutes, I had to go ice my wrist. Granted, my wrists are like fragile, atrophied worms, but the resulting fatigue meant I could not—did not want to—play again. It burned with fiery pain! This seems to me another disconnect between the desire for increasingly natural, realistic inputs that afford greater bandwidth and the things that actually make the expedient of manipulating things in a digital world desirable. Playing the Katamari Damacy clone included with the Falcon left me feeling like I'd bowled 20 frames in 20 minutes. The amount of motion I got from the game for my struggle just didn't seem worth the effort. The Novint Falcon ignores the fact that one of the great appeals of controlling something in a game is large response for small input.

We want a megaphone for our thumbs, not a controller that fights back. If the grasping nub of the device were less cumbersome and if it had a great deal more freedom like the more traditional (and expensive) pen-and-arm haptic devices, though, this might be a different story.

Plus, a haptic device always needs some kind of anchor. The ultimate haptic device would be holdable like a controller or Wiimote, and yet still give you the physical pushback. The technological challenges involved in doing this—creating force out of nothing—are far from trivial, to be sure. On the plus side, joystick/thumbstick springs provide almost this same kind of feedback—it's just not modulated by code. So ultimately, without a very subtle, nuanced approach—the ability to feel the difference between carpet and counter or something—haptic devices are not likely to become a powerful tool for creating game feel. It's likely that the porn industry will be at the forefront of using this technology if it does reach the requisite

level of sophistication in widespread commercial application. Until that time, it will remain an interesting but ultimately fruitless branch of the input device family tree.

So as far as the future goes for input devices and their potential to affect game feel, the path seems set. We will see incremental refinements rather than evolutionary leaps, and the advances will primarily be technological. Better rumble motors, better positional sensing, and better-feeling physical construction of input devices will make the games that they control feel better. Just as the feel of Lost Planet for the Xbox 360 is better than Bionic Commando for the NES, so future generations of input devices will lend a better, if not revolutionary, feel to the virtual objects they control.

The Future of Response

What is the future of game feel with respect to response? Assuming that the input is going to come in as a series of signals, what are the different ways that the game will respond to those signals, and how is it possible for these to grow and change, evolving as they do, the possibilities and meaning, of game feel?

Think about the oldest car you've ever driven. What did it feel like? How responsive was it in terms of steering or braking? How were the shocks? For me, it was my friend's 1970 SS Chevrolet Chevelle. On top of weighing three and a half tons, it had no power steering, a wide wheel base and only the most notional of shocks. The car was a burly beast and hard to handle. Trying to drive it was an exhausting exercise; it felt like trying to steer an aircraft carrier with a rocket engine attached. Now think of the newest car you've driven. How did it feel by comparison? In my case, this would be my dad's new Toyota Camry Hybrid. This car is exceedingly smooth and quiet. It is truly effortless to drive. The contrast here is most instructive, as it mirrors the difference between the feel of early games and their modern counterparts.

The Evolution of Response in Mario

The original Super Mario Brothers was, as we saw in Chapter 13, a simple implementation of Newtonian physics. It had velocity, acceleration and position, and it dealt with rudimentary forces such as gravity. That said, Mario's approach to simulation should be categorized as top-down rather than bottom-up. It only simulates the parameters it needs, and it does so in the simplest way possible. This was as much a limitation of the hardware as it was a design decision, though the result was an excellent, if particular, feel.

With respect to how the game interpreted and responded to input, Super Mario also featured time-sensitive response, different states and chording. Jump force was based on how long the button was held down; there were different states that assigned different meanings to the directional pad and A-button while Mario was in the air; and Mario made use of chorded inputs, modifying the response of the

directional pad buttons when the B-button was held down. It was ahead of its time in many respects.

This formula would be iterated but not deviated from for the next several years. Super Mario 2, Super Mario 3 and Super Mario World all used essentially the same approach, adding more states and more time-sensitive mechanics. With Super Mario World, there were more buttons to chord with and more states, but the basic building blocks were the same. The response to input was evolutionary, not revolutionary.

Super Mario 64 took a fundamentally different approach. Instead of colliding with tiles, Mario was moving in three dimensions and so had to collide with individual polygons. Coins rolled down hills gently after spewing from enemies, and thrown blocks would fly, slide and collide satisfyingly with other objects. You could race massive penguins down slippery slopes.

More than anything else, though, the Mario avatar himself was simulated much more robustly, with a blend of pre-determined moves and thumbstick input, each of which added its own particular, predictable forces into the Mario physics system. He had his own mass and velocity and could collide with anything anywhere in the world, always giving a predictable, simulated response. Again, there were more inputs to deal with, more states and more chording. The addition of the thumbstick as a much more sensitive input device took some of the onus off the simulation in terms of providing the largest part of the expressivity and sensitivity, but there were still an increasing number of specific, time-sensitive jumps, and each direction of the thumbstick still chorded with various buttons to produce different results.

The fundamental difference with Super Mario 64's simulation, though, was that it was more bottom-up than top-down. Instead of simulating only what was necessary, a more generic approach was followed, allowing for a much wider range of results. Much of the system was built to address generic cases of objects moving with certain forces, and this physics modeling could be applied to many different objects. As a result, there are many different physical exploits in Mario 64.[3] From this basic system, the tuning emerged, albeit with many specific case tweaks overwriting the underlying simulation. The difference is starting bottom-up with the system rather than cherry-picking the needed parameters and coding them in top-down.

Mario Sunshine iterated on Mario 64's approach, adding an additional set of states incorporating the water-driven jetpack and a fairly robust water simulation that brought buoyancy into play.

Finally, Super Mario Galaxy starts with the mostly bottom-up simulation of Mario 64 and adds in further layers of complexity by doing some very interesting

[3]If you want your mind blown, go to Youtube and search for "How to Beat Super Mario 64." At about 17:38, the mad, mad exploits begin. Using a series of physics system glitches, this gentleman completes the entire game using only 16 stars out of the "required" 70. This is one hallmark of bottom-up systems: unexpected or "emergent" behavior.

things with malleable gravity, a third avatar (the cursor), and by recognizing very sophisticated gestural inputs.

This begs the question: what's next? Mario is certainly not the end-all and be-all of games, of course, but it is interesting to examine the different ways in which Mario has responded to his ever-changing input devices. When there's a new Mario game, it's almost always been accompanied by a new input design. And each time, he seems to have a more sophisticated simulation driving his movement and is doing different and novel things in response to that input, interpreting and parsing it in increasingly sophisticated ways. In fact, through the years, Mario has touched on most of the issues relevant to the effect programmed response to input has on game feel. At first his simulation was top-down, built out to simulate only the barest parameters needed in the simplest way. Eventually his simulation became more bottom-up, more robust and generically applicable, with more sophistication and special rules about changing gravity and so on. Likewise, his response to input started simply but comprehensively, featuring sensitivity across time, space and states. These responses to input also grew in sophistication over time until he was using many different chorded inputs, had many different states, and had a plethora of moves that were sensitive across time. In his most recent outing, he adds gesture recognition to the list of ways he interprets input signals and responds to them.

Interpretation and Simulation

There are two main ways in which game feel will be significantly influenced by response (as it defined in this book).

The first is input parsing and recognition. There are myriad ways for a game, having received input signals from an input device, to interpret, transpose or refactor them across time, space, states and so on. As we have more and more processing power to throw around, these various ways to process input signals may have a significant effect on what it means to control something in a game.

The second is simulation. The more processing power that is thrown at a physics simulation, the more robust, intricate and powerful the simulation can become. I hesitate to use the term "realistic," though this is often how physics programmers have described their goal to me, as a quest for ever-increasing realism. I think a more laudable goal is an interesting, self-consistent, stable simulation, but I believe this is actually what they—and players—mean when they say realistic to begin with. Regardless, interpretation and simulation seem to be the two main ways game feel will change in the future with respect to a game's response to input.

Interpretation

Interpretation has had its basic palette since the earliest days of video games. By virtue of the game's code, input can be given different meaning across time, as in a combo, Jak's jump or Guitar Hero. An input might have a different meaning when objects in the game are at different points in space, as in Strange Attractors, or the

meaning of various inputs might change depending on the state of the avatar, as in Tony Hawk's Underground. These are the basics, the tested and true. The question is, how might we expect these interpretation layers between input and response to evolve as games mature? What directions will this evolution take, and how will it affect game feel?

An obvious example of complex input parsing is gesture recognition. It's used extensively on the Wii, from the swing of a racket in Wii Sports: Tennis to the wag of hips in Wario Ware: Smooth Moves. In fact, there is an entire suite of tools for gesture creation, AiLive, provided by Nintendo to developers to ease the process of recognizing a series of inputs from the Wiimote as a specific gesture and facilitate its mapping to a response in the game. Before this, there came games such as Black and White, which attempted to do essentially the same thing using the mouse as an input device.

The problem with all these systems is they turn complex input into a simple response. You flail around, making huge sweeping gestures, and the result ends up the same as a button press. In some cases, as with Wii Sports: Bowling, the player may perceive the game as having recognized the subtlety and nuance of the gesture, but usually not. Usually the large, sweeping inputs are mapped to what would normally be mapped to a single button press. The result feels profoundly unsatisfying, like lighting a massive firecracker and having it go off with a pathetic whimper. For this reason, the notion of mapping a hugely sensitive movement to a binary, yes-or-no response from the game via gesture may turn out to be a red herring. In the future, we can expect to see more Bowling and less Twilight Princess. Bowling looks not only for the gesture, but for the rotation of the Wiimote and the speed of the accelerometers at the time of release, and then it bases the curve and velocity of the ball on that. It layers gesture with a dash of subtlety and nuance in receiving the inputs, in other words. Imagining where that could go shows a more promising future for gesture recognition.

One thing that doesn't seem to happen much is a complete exploration even of current input devices and how they can be utilized. Though they're often perceived as silly gimmicks by players, things like swapping controller ports in the battle against Psycho Mantis in Metal Gear Solid, and having to close and open the DS to "stamp" the map in The Legend of Zelda: Phantom Hourglass, are gratifying and refreshing. Before these games, it was unlikely that players had considered closing and opening the DS or unplugging a controller as a meaningful input. But the system can detect these things; they're part of the input space. What these interactions bring into relief is just how narrow our thinking is about particular input devices. Games like Okami and Mojib Ribbon take the thumbstick to interesting new places, using the inherent sensitivity to mediate accurate drawing.

Why don't we do more of this? Why isn't there a game that uses the entire keyboard to control one or multiple objects? It's a combination of technical constraints like keyboard matrix problems and established conventions about how inputs are used, for sure. But, jeez, why hasn't anyone even tried these things? This is an important question, but one which will continue to go unanswered because of the inherent risk in addressing it.

Simulation

In the future, it's likely that we'll see much more detailed, robust and intricate simulations of physical reality. This may or may not be such a good thing. More intricate, detailed simulations will bring us an entirely new expressive palette. Most interesting is the potential to redefine what being an avatar means and what it means to control it. In the future, we might be able to control a curling column of smoke, a liquid or 10,000 tiny birds. Things like Loco Roco, Mercury, Gish and Winds of Athena indicate that this is at least an interesting area that should continue to be explored. But there is a danger present, looming in the background both of our construction of visuals and in the way in which we simulate objects in game. The danger is the flawed notion of realism. Again, reality isn't much fun. To enhance the impression of physicality to unprecedented levels and forge ahead into bold new types of interaction with advanced simulation are exciting prospects, so long as we remember that our goal is to entertain and delight. Simulating reality tete-a-tete is a waste of time. If players want reality, they can step away from the computer.

To make a broad generalization, increasing sophistication in simulation means adopting an increasingly bottom-up approach. A physics engine seeks to create a general set of rules that will successfully and satisfactorily resolve any specific interaction of any objects anywhere in the game world. Or, at least get as close as possible to doing that. Let's put technological issues aside for a moment, though, and go pie in the sky. Pretend we have a super-advanced physical simulation that will handle the interaction of any two objects with any properties in a smart, appealing way. What does that buy us? How does the feel of our game improve?

The first and most obvious result is increasingly sophisticated results at the level of intimate physical interaction. So in this case, the goal of increasing realism in the simulation translates to simulating the physical interaction of objects in the world at a higher level of detail, which improves the inferred physical reality of the world. This is on its way regardless, as it will be pushed by football games and other sports games as a way for humanoid-looking things to collide and interact satisfyingly. Instead of using pre-created linear animation or animation *only* to drive the motion of characters, we'll see hybrid models where ragdolls are driven by animation and vice versa. For example, two football players colliding perfectly, transitioning between their animations into active ragdolls that look proper.

My hope is that this technology will find other uses in the expression of more creative worlds with physical properties that deviate from pedantic imitation. Really, though, here the simulation is just being used as a polish effect; it has no effect on gameplay. Madden 2020 will probably play the same as Madden 2009 except for the active ragdoll simulation that makes the character's hyper-complex tackling and dogpiling interactions more believable. With luck, the simulation will have caught up to the photorealism of the treatment by then and the two will harmonize into a satisfying, cohesive whole rather than the mismatch we see currently.

Crysis seems to go to a whole lot of trouble to simulate things in immaculate detail but does not do much with this simulation gameplay-wise. You can destroy

trees at any point on their trunk, push your way through lush vegetation, or cause spectacular detonations, but the relevance of these interactions seems to be next to nil as far as the game is concerned. Compare this to a game like Half Life 2, where physical interaction is paramount, and the difference becomes clear.

The huge benefit here is more complex, believable interactions, especially at the low and mid-levels of context—you can really push through crowds and interact with people. I think this has myriad applications, and not just for sports and action. It will be effective for representing things like interpersonal relationships and intimacy, where touch and distance play a huge role.

The other interesting thing that an improbably robust simulation buys us is the potential for exquisite new types of physics-based gameplay. Matthew Wegner, CEO and technical wizard of our company, Flashbang Studios, defines physics games as "a game where the player primarily interacts with the mechanics of a complex physics system." This is separate from something like Super Mario Brothers which, while it simulates physical, Newtonian forces—gravity, velocity and so on—takes a top-down approach rather than a bottom-up one. It's simulating only what it has to, rather than starting with a robust but generic simulation and building game feel out of that. If you start with a physics simulation that's meant to cover a wide variety of cases and includes built-in notions of force, velocity, shape, gravity, friction and drag for every object, the feel—and types of gameplay—will be different from a game like Mario, which only simulates the barest minimum of what it needs to achieve the desired feel. From more complex systems like this arise what are generally referred to as physics games. Examples of physics games include Armadillo Run, Truck Dismount, Ragdoll Kung Fu, Ragdoll Masters, Little Big Planet, NobiNobi Boy, Toribash, Flatout, Carmageddon, World of Goo and Cell Factor.

The idea is essentially to start, bottom up, with a robust full-featured physical simulation and then find and emphasize enjoyable interactions in the system itself. The system is created first and the gameplay grows out of it, relying on the robustness and flexibility of this system to find the enjoyable play. For example, Truck Dismount includes a physically simulated ragdoll, a truck and some other props. To score points, you must mangle the ragdoll—cause it to be hit by the highest possible forces—by creative use of the various forces and props. You can tip the truck over onto the avatar, place it on the front of the truck as the truck hits the wall or any number of other creative variants.

If jazz is music for musicians, Ski Stunt Simulator is a game for game designers. It's brutally difficult to learn but vastly rewarding once mastered, which makes it a game that almost no one has played outside of the small and devoted community of masochists and enthusiasts who actually learned to play and master its ridiculously difficult controls. Ski Stunt Simulator—created by researcher Michel Van De Panne at the University of British Columbia—is perhaps the finest example of an academic project with real ramifications for contemporary video game design. It is, in itself, a beautiful little game, but what it really indicates is a new way to create game controls: by simulating muscles rather than arbitrary forces. The rig in Ski Stunt Simulator is a controlled, active ragdoll.

Physical Control over Complex Objects

A great question for game design: what if the player played as _____? So in this case, instead of playing as some sort of god-perspective creature that adds arbitrary forces to an object, we're putting the player in the role of muscles. The forces that enable the thing to move come, literally, from within it, in the form of springs that change size and so on.

This is a wholly different and altogether unexplored area of design, probably because it's really hard to design for and to play. Some potential future directions for simulations are indicated in games like Chronic Logic's Bridge Builder and 2dBoy's World of Goo. In both of these games, the player constructs and controls massive, compound physical objects out of smaller component parts. Real-time control over objects like this indicates a fascinating possible direction for game feel. In fact, Chronic Logic's Gish pushed in this direction, giving the player control over a complex blob of springs. It was a unique, awesome feel, far ahead of its time.

Another interesting possibility for real-time control would be fluid, fog or smoke simulations. What would it be like to exercise real-time control over a fluid? Archer Maclean's Mercury for the Playstation Portable indicates that there's potential there, but I'd like to experience the sensation of control that would come from steering a lot more fluid around. Ditto fog or smoke. What would that feel like? I hope to someday find out.

Similarly, having control over flocks of creatures that employ the simple Boids flocking algorithms could provide a very interesting feel.

All in all, response is the game feel component ripest for future improvement. It is in response that the game designer primarily defines a game's feel and so it is here that the largest potential for the advancement of feel exists. Some opportunities still exist for improving the feel of a game simply by simulating physical interactions in greater detail, but the rewards for this realism-minded approach are rapidly diminishing. The real goldmine lies in simulations of complex phenomena such as fluids, gasses or flocks of birds. Even using more traditional simulations of Newtonian physics, there are huge opportunities to control objects in novel ways or to build fascinating, complex objects out of simulated components such as springs and weights. Simulating muscles rather than simulating arbitrary forces is just one of the galaxy of possibilities that have yet to be explored in depth.

The Future of Context

Context, as we define it in this book, is the backdrop against which the motion of avatars and all other objects in a game is given meaning. It's the other half of game tuning. As an example, you were asked, in Chapter 5, to imagine Mario 64 standing in a blank field of whiteness, like the place where they get the guns in the Matrix, and to consider the following question: does the motion of Mario have any meaning in this blank field of whiteness? And the answer, of course, was no. Without a wall,

there can be no Wall Kick. This extends to all the mechanics of Mario and Mario 64, from the complicated ones like the Long Jump, the Triple Jump and the Wall Kick, that rely on direct physical interaction with environmental objects, all the way down to his most basic low-level movement, which is him running around relative to the player's displacement of the thumb stick on the N64 controller. Even at the lowest level of motion the speed at which he runs around and how quickly he turns and so on have no meaning without the context of the Castle Courtyard or Bomb-Omb Battlefield.

At every level, context gives meaning to motion. In any game, this a key component of true game feel, which we have defined as an ongoing correction cycle in which you are controlling one or more objects, and where the spatial manipulation is important, where steering around a space and whether or not you run into things, and so on, is actually an important part of the game.

In order to tune the motion of an avatar, you have to have a space to tune against, and it's basically just that simple. A racing game needs a track, stuff on the side of the road and hills that extend in the distance. It needs track pieces that have different levels of curves. Without a track underneath it, the tuning of the car's forward speed relative to how quickly you can turn the car left and right, whether or not it slides and the point at which the friction slips have no meaning. These are all little, but very important, details.

Matthew Wegner gave a great example of this when he was talking about physics tuning in Raptor Safari. He first tuned the Jeep to a very specific set of parameters, and he had created an environment in which to tune it. But he found that, because the environment didn't have any hills that were past a certain level of sharpness, as soon as one of the artists started putting together a bunch of hilly terrain, every time the Jeep would run over a hill, it would bottom out and lose all of its momentum. That's just one example of how a small detail of spatial layout can affect the feel of the game profoundly. And it is in this interplay between space and motion that most of game feel is created.

So space is crucially important; it's the other half of tuning game feel. For this reason, games that have the best feel are often the ones in which the mechanic and the spatial context were created simultaneously. This is the notion of creating a gameplay garden in which you create the tuning of your mechanic. The idea is that you populate a particular space with a whole bunch of different objects, and you space them apart at different intervals, and you try a bunch of different shapes of objects and configurations, and then you tune your mechanic, trying it against all these different possibilities. The objective is to have as many different possibilities as you can so that you're exploring the space as fully as possible while you're creating it, and you can make informed decisions about how a change in a particular parameter or the speed of movement changes the interaction of the character and the space around it on many different levels.

Context also provides the point of reference against which the impression of speed is created, as described in Chapter 8. This is the same phenomenon that you see if you're driving down the freeway and there's nothing on either side of

335

you—you lose the impression of speed and end up in a bizarre realm of high-way hypnosis which may be detrimental to your health if followed to its ultimate conclusion.

Another way context gives spatial meaning to the motion of avatars and affects game feel is at the highest level of spatial awareness. We discussed this in depth in Chapter 8. It's the difference between the sprawling open world of World of Warcraft and the hemmed-in tight worlds of Tony Hawk. World of Warcraft conveys an overriding sense of massive openness and space, while in Tony Hawk, the relative speed of the character and the density of the objects make it feel as though the environment is very tightly packed and that things are flying at you constantly. In the earlier Tony Hawk games this was less evident, but in the later games the character's movement speed has increased to such a degree that all the environments feel very tightly spaced, and as the games progress, the environments started to be spread farther and farther apart to try and counteract this impression.

Finally, spatial context defines challenge by limiting space. If you have an object moving through space and there's nothing around it, there is no challenge. There's nothing to steer around and nothing against which to measure the building of skills. On the other hand, if you have a bunch of objects tightly packed, steering around them can be a real chore, and suddenly the speed of an object's movement and its turning radius take on a great deal of meaning. This is the way that game designers create challenges over the course of a game, as we have said. In the early levels, objects will be spaced far apart, and any obstacles, enemies or moving objects that come at you are slow-moving, easier to deal with and easier to steer around. As the game progresses, things become increasingly closed-in, the margin of error shrinks: you have to jump to a tiny little platform, or you have to steer around increasingly difficult turns and so on. This is how difficulty is ranked across such games.

What we've identified here is four different ways that spatial context affects the game feel: as a foil for mechanic tuning, by creating the impression of speed, as a high-level spatial awareness and by limiting space.

The question is, how will these four different ways of spatial context affecting game feel project into the future? How will these things evolve and change, if at all, and how will they alter the way that games will feel 20, 30 or 50 years from now?

First, regarding the impression of speed, that seems to have been very well worked out as a natural consequence of building today's games. In games like Burn-Out, the impression of speed is hugely effective: it's got view angle changes and blurring, great sound effects, and objects appear to move by very, very quickly and believably. Even earlier games like Sonic had a fantastic impression of speed by effectively manipulating static objects relative to the speed of movement of the Sonic character.

And it's not just about going fast. At the other end of the speed spectrum, we've had some great explorations of very intentionally plodding, slow-moving objects in gameplay, for example, the large, hulking colossi in Shadow of the Colossus. Or with Thief: The Dark Project, where the character is forced to move intentionally slowly, and the interesting gameplay ramifications of that are fully explored.

In the future, the lessons we have learned regarding speed will serve us well, and are not likely to be modified extensively.

However, at the lowest level of tactile and physical interaction, as we examined in the Future of Response section, there are likely to be a lot more interesting simulations. In terms of the way that this affects context, it's likely that we'll end up with much more reactive physical context for objects. A great example of this—a peek into the future, if you like—is the type of interaction in games like LocoRoco, which have an extremely expressive, squishy quality to them. Their whole environments have a feel, and the fact that the environment has that different squishy feel completely changes the way that you feel about the motion of the LocoRoco avatar.

To see an interesting counter-example, you can look at something like Gish, where virtually all the tiles that Gish interacts with are solid and are in direct contrast to Gish himself who is a big, squishy blob of springs.

We may also see additional sensitivity via environmental interaction. For example, in the Tony Hawk games, the feel of the game is very much a collaboration between the motion of the avatar and the objects in the environment. In Tony Hawk's Underground, there were so many different objects that you could interact with, and so many different ways to interact with them, that what begins to emerge is a real sense of expressivity. If the player comes up to an R.V., for example, there are lots of choices to make: wall right up the side of it, jump and grind the top of it, manual across the top of it, or manual up to the side of it and then wall right up to a grind across the top of it. All these different choices exist because of the richness of potential interactions with any given object in the world. As a result, a hugely beautiful, expressive quality emerges, and actually begins to feel like freedom and personal expression. You can traverse the world in your own style.

Games like Assassin's Creed and the newer Prince of Persia have picked up some of this torch and are carrying it off into an interesting future. However, much of the player's sense of personal expression starts to disappear when the designers allow technology to begin wagging the dog. It's important not to obsess on making the character's every physical, tactile interaction with the environment so perfect that they forget to include a skill for the player to learn and master. (This is what happened in the earlier Tony Hawk games.) We need to continue to emphasize mechanics that play on the natural instinct of people to learn and become familiar with their immediate space.

At the mid-level, we're basically doing pretty well. The state-of-the-art in terms of immediate space manipulation and path plotting is getting more interesting. For example, in Hitman: Blood Money, the designers actually created the impression of a really thick crowd that you had to push through (in the Mardi Gras level) in order to get where you were going. Assassin's Creed does this fairly effectively as well, and these kinds of interactions feel very interesting, but still don't quite have the impetus behind them. They look cool but haven't quite found their context.

The medium level of spatial interaction—at the level of having to steer around various objects and the creation of challenge by limiting space—is very well understood and unlikely to change much in the future. Games like Street Fighter are

entirely about manipulating space in interesting and creative ways. We know how to create challenge in games by limiting space.

But one area which has not been explored, and which has a great potential for redefining what a game means and to really make a game feel different, is in the importance of spatial relationships other than simple object avoidance. So if you look at a game like Passage, by Jason Rohrer, or his later Gravitation, or a game like The Marriage, by Rod Humble, they're expressing deep, meaningful themes through spatial interaction. They do a lot of work with rules, and Rod is convinced that rules can potentially be an expressive medium as effective as literature or art, film and so on. But many of the rules they have defined are about spatial relationships. For example, in Passage, you have a single character that walks along, and as a single character can fit through many different tight little spaces, but then the character meets a woman and they become life mates, one presumes, because a little heart comes up, and then they walk together, and together they can't fit through as many spaces. And so in that changed spatial relationship, he's saying something about the human condition and the nature of relationships. It's a very fascinating direction that could potentially be extremely fruitful.

We need to rethink our understanding of the meaning of spatial relationships in video game context and to look for the expressive potential beyond simply building a challenge out of having to avoid stuff, and so on. There's a huge potential for games about physical intimacy, which is very much about intimate spatial relationships, and about interpersonal spatial dynamics. For example, what's the difference when someone's facing one direction as opposed to another? What does it mean when someone's standing directly in front of you staring at your face as opposed to sitting across the room? How might convincing eye contact between player and avatar be exploited? The possibilities for exploiting cultural conventions and non-verbal communication are endless.

At the highest level of spatial interaction, we simply need to pay a little more attention to what we're doing. There are games that create a really beautiful and effective high-level sense of spatial awareness, such as World of Warcraft. Many multiplayer online games fail where World of Warcraft succeeds in creating the sense of having huge, beautiful open vistas to traverse. Games like Tribes and Battlefield II start to get a similar feel, where there's a huge sense of openness and possibility. In these games, you can really get that pleasurable sensation of traveling through an interesting and open space.

Too many games will make things really big but will lose the important spatial architectural details that convey the sense of a very large open space or construct a good-feeling smaller space. There's a potential for a huge amount of expressivity and manipulation in the way that the player views the feel of the game through this high-level interpretation of space. We can make players feel small and insignificant by making things large and imposing the same way that centering (placing a character in a film frame) at the bottom, very small, makes them feel small and insignificant. We can get that same kind of feel, but in the first person, or we can get the

opposite where the character's very large and powerful relative to everything in the world, and we can express things through that.

As an interesting side note, that sense of traveling and traversal was one of the things that was lost in Mario Galaxy when they transitioned from having a cohesive, single-direction, gravity-bound world that had a large sense of space. Mario Galaxy can be disorienting, with a sense of nothingness all around, and the only thing to pay attention to is the particular small planetoid the character is on. It seems to me that Mario Galaxy lost a lot because players had no ability or chance to map their own a space and engage with it at a level of increasing familiarity. It's comforting to develop that familiarity. That's one of the fundamental pleasures of playing the game.

In the future, then, it's unlikely much will change overall in terms of context and the way that it affects game feel. But note that there are some great opportunities to create better-feeling worlds at the highest level of spatial awareness. With a judicious application of architectural knowledge and a deeper understanding of spatial activity, and flow and balance, there's a lot to be gained. We'll be able to really change the way the player feels about a particular space to our expressive benefit.

In general, though, the greatest benefit that we can experience is to simply be more aware of how important context is to feel and to be aware that context is the second half of tuning a game. It's not just the motion of the avatar, but also the position and location, and nature and shape, of the objects that surround that avatar that give it its richness, its interactions, its meaning.

The Future of Polish

Polish is currently the massive, weighty bicep of the game industry. As our processing power has increased, and our ability to spend that processing power on increasingly detailed effects that sell the impression of physicality, we've gone to a very good place with regards to polish.

For example, try playing Lost Planet. It's astounding how tactile and kinesthetic the interactions between the objects begin to feel with so many effects involved in each object, and how they harmonize perfectly. We've got artificial effects that sell the nature of the interactions between objects down pat.

Even so, graphics and sound have been "blind" a little bit more than necessary to what's really going on in the player's mind. As Chris Crawford says, we are spending all our time on speaking and we should be spending the time on having the computer better listen and think. As we move forward into the future of game feel, we may need to pull back a bit from the current level of polish that's being added to games. For example, if you look at a casual game such as Chuzzle or Peggle, the game is almost entirely made up of "polish elements": little sprays of particles, little animations of hairs drifting down, things exploding. Every single interaction has this artificial layer of gloss on top of it. And it's beginning to become rather gaudy,

like Mario Galaxy. It's as though every single object in the world is just waiting to explode, like it had this stored-up potential energy, and the moment you touch it, it throws up a shower of particles and little star pieces, and all this stuff flies everywhere. But to very little purpose.

Too much polish is distracting because it makes it difficult to wrap your brain around the physical sensation being conveyed. Contrast this with things like the little puffs of smoke that come up as Mario slides his feet around. Those are great because they are easy to make sense of. But when every single object sprays stuff everywhere, how does that reconcile with the experience of physical reality?

In contrast, if you look at something like Shadow of the Colossus, it really harmonizes its use of polish effects with its mechanics and the id—the metaphorical idea that it's trying to convey of these massive objects moving around. Every little effect is intended to support the single impression of physicality; in this case, it's the massive, massive colossi walking around. So it's important to think very carefully about what physical sense you're trying to convey, and to consider whether or not that sense harmonizes with your metaphor and the simulation that you're running.

In the future, as more processing power is devoted to polish effects, they'll support increasingly advanced simulations, with more potential for excellent game feel. And these polish effects may go overboard but, in general, they will serve to create a better impression of physicality and improve the feel of a game—as long as they are used judiciously.

The Future of Metaphor

When we defined metaphor with respect to game feel (in Chapter 10), we broke it down by representation and treatment. It's what the thing appears to be: its metaphorical representation, and treatment, how the art is executed—and whether it's very realistic, very iconic or very abstract.

We also examined the different ways in which combinations of representation and treatment can affect the expectations that we set up in the mind of the player about how things will behave. We explored how those expectations can be manipulated to our benefit. And we also looked at how the expectations we are setting up can be confounded when they don't deliver in the mind of the player. In particular, we asserted that games which strive for real-world fidelity set themselves up to fail, because it is extremely difficult to meet expectations based on real-world experience.

The example we used was a photorealistic car driving game. Players "step into the car" and immediately load up all their preconceptions about what a car is. They will view every interaction they have with this digital car through the perceptual field of *a priori* knowledge that they've built up about every car they've ever driven in, as well as the cars that they've seen in film and TV, and cars that they've read about, and the way that those objects interact and behave. This is a really significant issue in game design. It's the uncanny valley of game feel, when the treatment and

representation approach photorealism but the feel of the game, the interaction of the objects, the way that they behave are nowhere close to that level of representation.

Obviously, this is a huge pitfall to be avoided.

For metaphor to evolve, we need to explore the areas that are in the realm of the iconic and the abstract. And we see this happening already, especially in the indie games movement with games like Everyday Shooter, Pixel Junk Eden and Flower. All of these games—like Katamari Damacy—favor surrealism and eschew the notion that something has to be representative of the real world to be meaningful, to have interesting interactions and to give rise to great game feel.

The idea is to think of iconic or abstract games in terms not only of changing representation, but in terms of metaphor. What do we play as? Why do we always have to play as a character? Or why do we always have to play as cars, or things that fly, or bikes, or objects that we pilot already in the real world?

Why can't we pilot a giant cat bus with 20 legs that ferries bizarre rabbit-like creatures from place to place? Or why can't we play as fear and investigate what would that mean? What if you made a game where you played as fear and then somehow had tactile interactions with characters and an environment, or something like that? What would a physical tactile interaction be for a conceptual idea like that be? Or what if you played as a disease or a germ, and your gameplay goal was to approach different vectors of infection? The future is wide open for an acceleration of the extremely positive trend of choosing bizarre metaphorical representation for what it is you control and exploring the physics of a surreal world, even at the level of tactile interactions. We might see a group of bizarre polygonal birds that fly around and attack giant, amorphous ships in a bizarre grey cloud environment or abstract vector objects that swoop and soar like biplanes. Or controlling just a fluid or a giant worm that crawls through the ground.

Whatever it is, the clear direction is toward metaphorical representation with non-realistic constructs and mechanics. This is a hugely positive thing. One of the greatest possible tools for game design is role shifting, where even if you have a fairly mundane setup idea for a game, just simply switching what you play as can entirely change the notion of what the game is, and can unlock new and interesting areas of gameplay that we've never considered.

For example, when students enroll in my entry-level Game Playing Game Design Class at the Art Institute of Phoenix, one of their first assignments is to make a board game with three unique goals. And invariably, one of the first games that comes back is an orcs versus elves game with little characters that move across square tiles, have hit points and attack points and so on. And they capture castles, perhaps, and move across the field.

The immediate question for them is, "What if, instead of playing as the orcs and the elves, you played as the castle?" They have to consider how the castle would feel about all of this capturing, and what if the castle's goal was just to be built up as large as possible and didn't really care about which army was containing it? So it might breach its own wall to let an invading army in if it thought that army had more money to build its parapets higher. Pushing this notion a bit further, what if

you played as a little gopher trying to build its home in the center of the field where all these fantasy creatures were battling? Or what if you played as the weather, and your objective was just to beat down all artificially constructed structures and to end the conflict by making everyone so miserable and wet and cold that they'd never want to fight again?

The idea is just to take a critical and creative eye to the notion of metaphor. Shift what the player plays as and, therefore, develop new areas of gameplay. With respect to game feel, we're still going to be representing some sort of physical tactile interaction. But now we have this window on a world that is potentially unbounded by the natural physical laws as we understand them.

If we can distill to its essence the language of physical interaction that we as humans latch onto, and then re-contextualize it into something purely abstract and fascinating, then we'll be going in the right direction.

The Future of Rules

Rules are perhaps the most explored area of game design, going back thousands of years across all of human culture. A board game constructed out of physical components is given meaning purely and only by the rules that govern the interactions of those components. That's where the play comes from. For example, there's Go, from ancient China; the Egyptian game Senate, which is 5,000 years old; Mancala, from Africa; chess, from India and Persia via Southern Europe; and countless others. All these different games rely purely on rules and their exploration.

We also have a relatively large body of literature, things like Johan Huinzinga's Homo Ludens which does a fantastic job of exploring the nature of rules. There is even a book, Rules of Play by Eric Zimmerman and Katie Salen, which does a fantastic job of applying the lessons of the development of traditional game rules to digital video game design. What this book adds to the literature is the taxonomy of categorizing rules into three levels. To recap:

- High-level rules give a certain meaning to a specific object in a game and make it seem more desirable or less desirable.

- Medium-level rules give immediate special meaning to a particular action, defining feel in the same way the spacing of objects in the environment changes it.

- Low-level rules can define feel in terms of physical properties like mass and toughness through things like the number of hits it takes to destroy an enemy.

If we consider the interactions between these three levels, there are plenty of places that game developers today haven't really explored.

This comes into really clear relief with a game like Castlevania: Dawn of Sorrow for the DS. By virtue of its immaculately constructed rules, Dawn of Sorrow transcends its genre and becomes something quite beautiful and original. It's a

really wonderful game. Every single enemy in the entire game represents a potential power-up, and an elaborate reward schedule ensures you have to kill every enemy a certain number of times in order to get the drop of their soul, which you can then equip, making it an ability. Every single creature in the game you fight, or that you interact with, has the potential to become a new ability. And it's a great excitement when you encounter a new creature, because you realize that if you kill it 20 times in a row, maybe it'll drop its soul and you can equip that like a weapon. Potentially this could be some great ability that you'll use to improve your abilities throughout the rest of the game. The rules of the game enable your interactions to become more pleasurable throughout the rest of the game.

When designing video games, we often get carried away by the beautiful expressiveness of the game itself. We get so excited by the fact that we can drive things around or steer them around and manipulate them, and that physical, tactile level (low-level rules), that we lose sight of one of our greatest potential assets, which is assigning meaning to things in a game (the medium- and high-level rules). It's important not to overlook the careful construction of elaborate but arbitrary relationships between objects and the rules that harmonize and apply the game metaphor.

For example, in any of the Zelda games, whenever a player gets the Hookshot, it's always very exciting. Winning certain items drives up the level of excitement because the items upgrade, change and improve the player's abilities to interact with that world.

Going forward, we need to think more about the ways we can change the meaning of spatial relationships between objects by altering the abstract relationships between those objects at all levels.

For example, games like Gravitation and Passage by Jason Rohrer and The Marriage by Rod Humble indicate a fascinating possible direction. These games move away from challenge and trying to create emotions of triumph and enjoyment and collection, and so on. Instead, they use rules to develop very deep and meaningful statements and about the human condition. Rohrer and Humble are finding a level of expressivity that no one thought was possible in video games. And so I think that that's a very beautiful and very fascinating direction that we can explore with respect to rules.

As an aside, it's interesting to note that all three of these games incorporate spatial interaction as part of their rules. When one character interacts with another, there's a huge amount of conceptual meaning assigned to that interaction. And it's a very different type of conceptual meaning than "collecting a hundred coins gives me a star, which gives me access to new areas of the castle." It's a much deeper, more thoughtful, more nuanced and emotionally satisfying type of relationship.

In the future, it's going to become increasingly important to think about the ways in which we can manipulate the arbitrary relationships between abstract variables and expand the range of expression and connection possible in games.

Summary

As an art form, video games have the potential to be the ultimate blending of creativity and technology to engage, entertain, stimulate, teach and touch our emotions in a uniquely *participatory* way. And without good game feel, the participatory nature of games is severely compromised. Fortunately, there are many fruitful avenues for improving game feel, such as:

- Input devices with better rumble motors, better positional sensing and better-feeling physical construction. Future generations of input devices will lend a better, if not revolutionary, feel to the virtual objects they control.

- Game responsiveness that simulates complex phenomena such as fluids, gasses or flocks of birds. Even using more traditional simulations of Newtonian physics, there are huge opportunities to control objects in novel ways or to build fascinating, complex objects out of simulated components such as springs and weights. Simulating muscles rather than simulating arbitrary forces is just one of the galaxy of possibilities that have yet to be explored in depth. Response is the area of greatest potential for improving game feel.

- More attention to context, which has less potential for improving game feel, but nevertheless presents opportunities to create better-feeling worlds at the highest level of spatial awareness. With a judicious application of architectural knowledge and a deeper understanding of spatial activity, flow and balance, we'll be able to really change the way the player feels about a particular space to our expressive benefit.

- The judicious use of polish effects, which will support increasingly advanced simulations as the available processing power increases, with more potential for excellent game feel.

- The controlling metaphors for games can be exploited in massively creative new ways to develop undreamt-of areas of gameplay. Games provide a window on a world that is potentially unbounded by the natural physical laws as we understand them. If we can distill to its essence the language of physical interaction that we as humans latch onto, and then re-contextualize it into something purely abstract and fascinating, then we'll be going in the right direction.

- More emphasis on how we use rules to manipulate the arbitrary relationships between abstract variables will expand the range of expression and connection possible in games.

The future of game feel is obviously a subset of the future of games. And the future is wide open and exciting. Not only is the technology continuing to evolve, but so are the creative disciplines that make good games possible. We are developing a body of re-usable knowledge about how different aspects of games work and how they can evolve. This book is a small attempt to add to that knowledge. The sooner we stop re-inventing wheels, the faster we move games to the next level.

INDEX

Printed in the USA
CPSIA information can be obtained
at www.ICGtesting.com
LVHW020518090823
754680LV00006B/461